TRADITIONAL KOREAN PAINTING
A Lost Art Rediscovered

TRADITIONAL KOREAN PAINTING

A Lost Art Rediscovered

Za-yong Zo
(Cho Cha-yong)

U Fan Lee
(Lee U-hwan)

Translated by John Bester

KODANSHA INTERNATIONAL
Tokyo and New York

NOTE TO THE READER: All Korean, Japanese, and Chinese personal names appear in the text in the traditional order, family name first. Korean names and words have been romanized in a slightly modified version of the McCune—Reischauer system; Japanese, in the Modified Hepburn system; and Chinese, in Pinyin. The authors' names appear on the title page first in each author's preferred spelling but in the Western order to avoid library cataloging errors, and then in parentheses in the traditional order using the romanization system followed throughout this book.

Adapted from the original Japanese edition of *Richō no Minga* published by Kodansha Ltd.

Cataloging-in-Publication Data is available from the Library of Congress.

Distributed in the United States by Kodansha International/USA Ltd., 114 Fifth Avenue, New York, New York. Published by Kodansha International Ltd., 17–14 Otowa 1-chome, Bunkyo-ku, Tokyo 112 and Kodansha International/USA Ltd., 114 Fifth Avenue, New York, New York 10011.

Copyright © 1990 Kodansha International Ltd. All rights reserved. Printed in Japan.

First edition, 1990

ISBN 0-87011-997-4

ISBN 4-7700-1497-x (Japan)

CONTENTS

The Color Plates

KOREAN DATES

Koguryǒ	37 B.C.–A.D. 668
Paekche	18 B.C.–A.D. 660
Silla	57 B.C.–A.D. 935
Koryǒ	918–1392
Yi	1392–1910

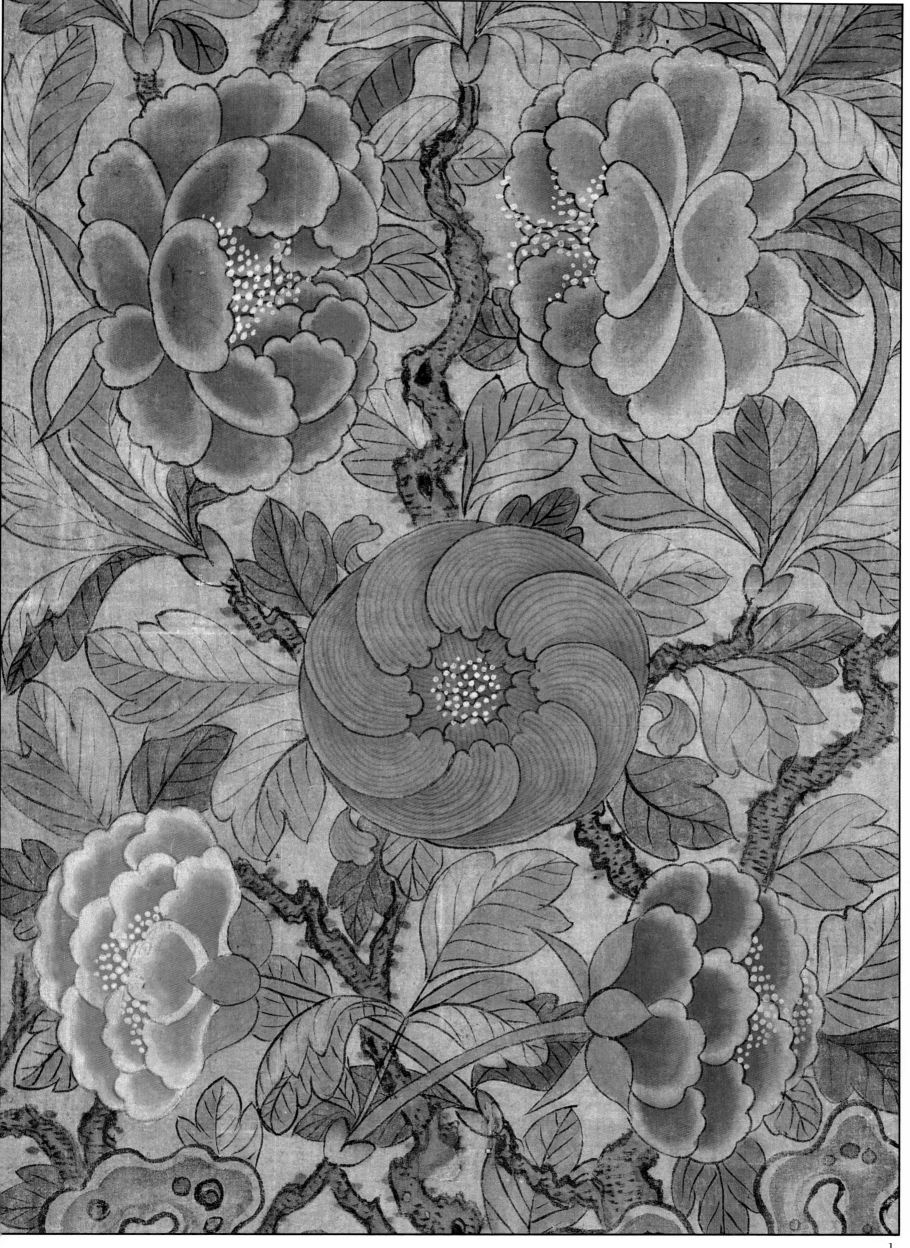

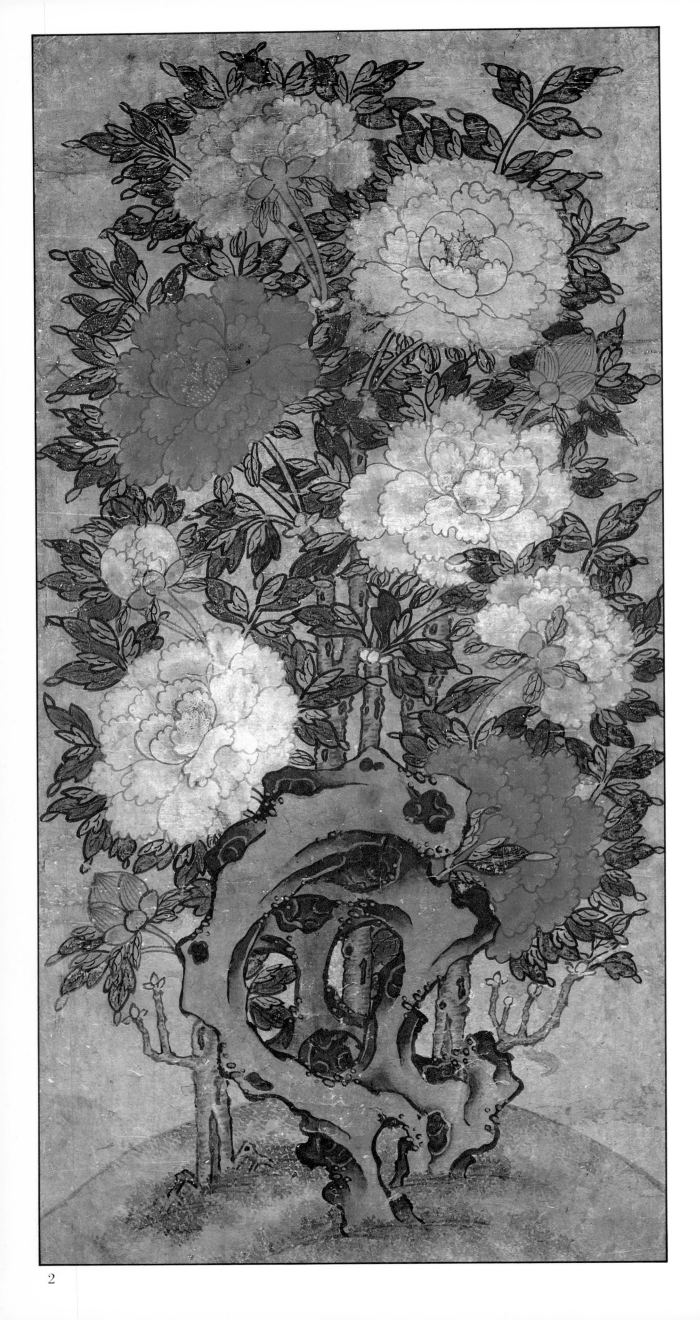

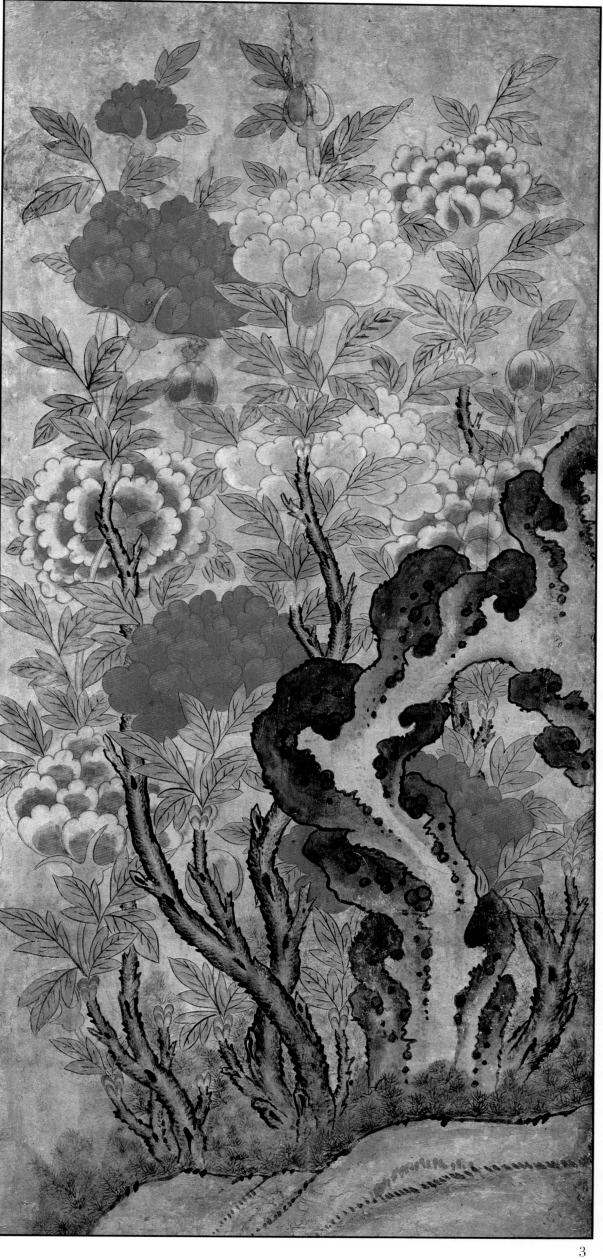

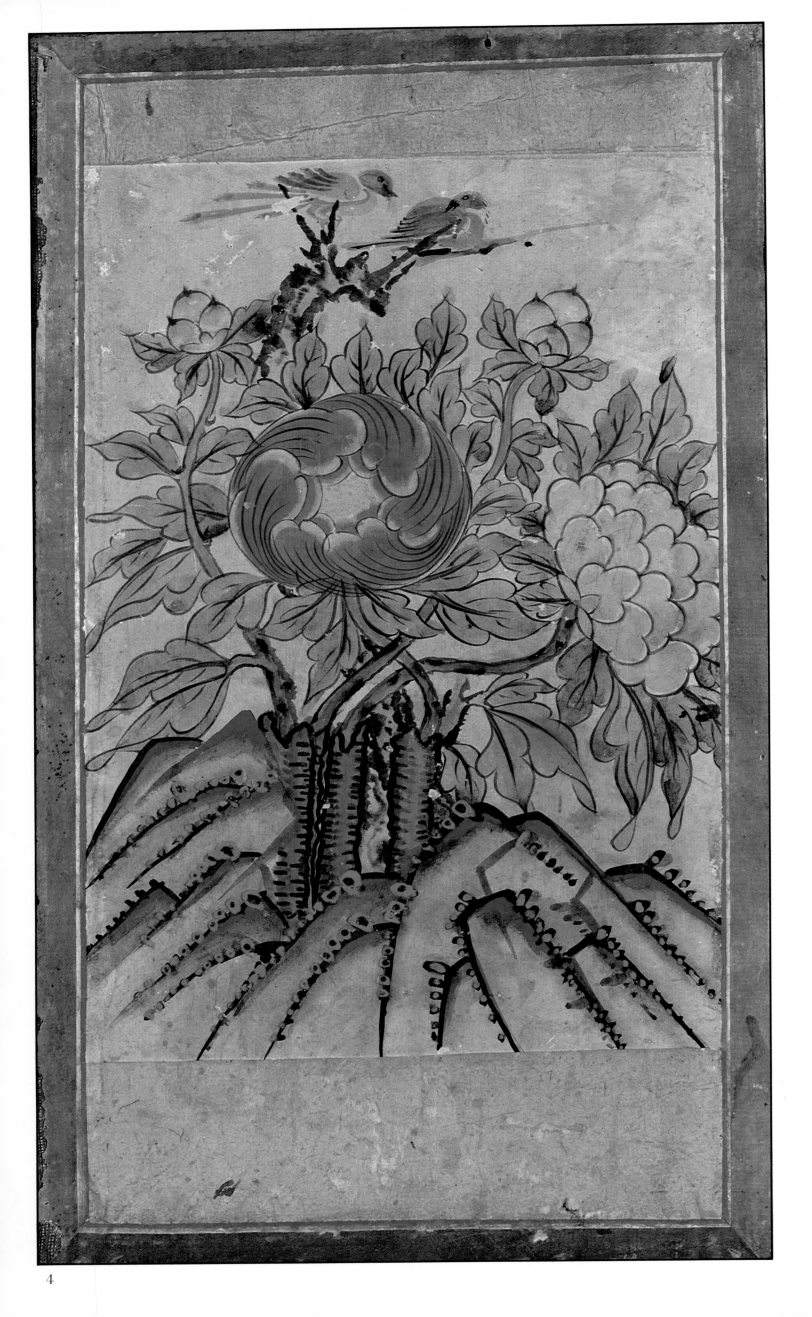

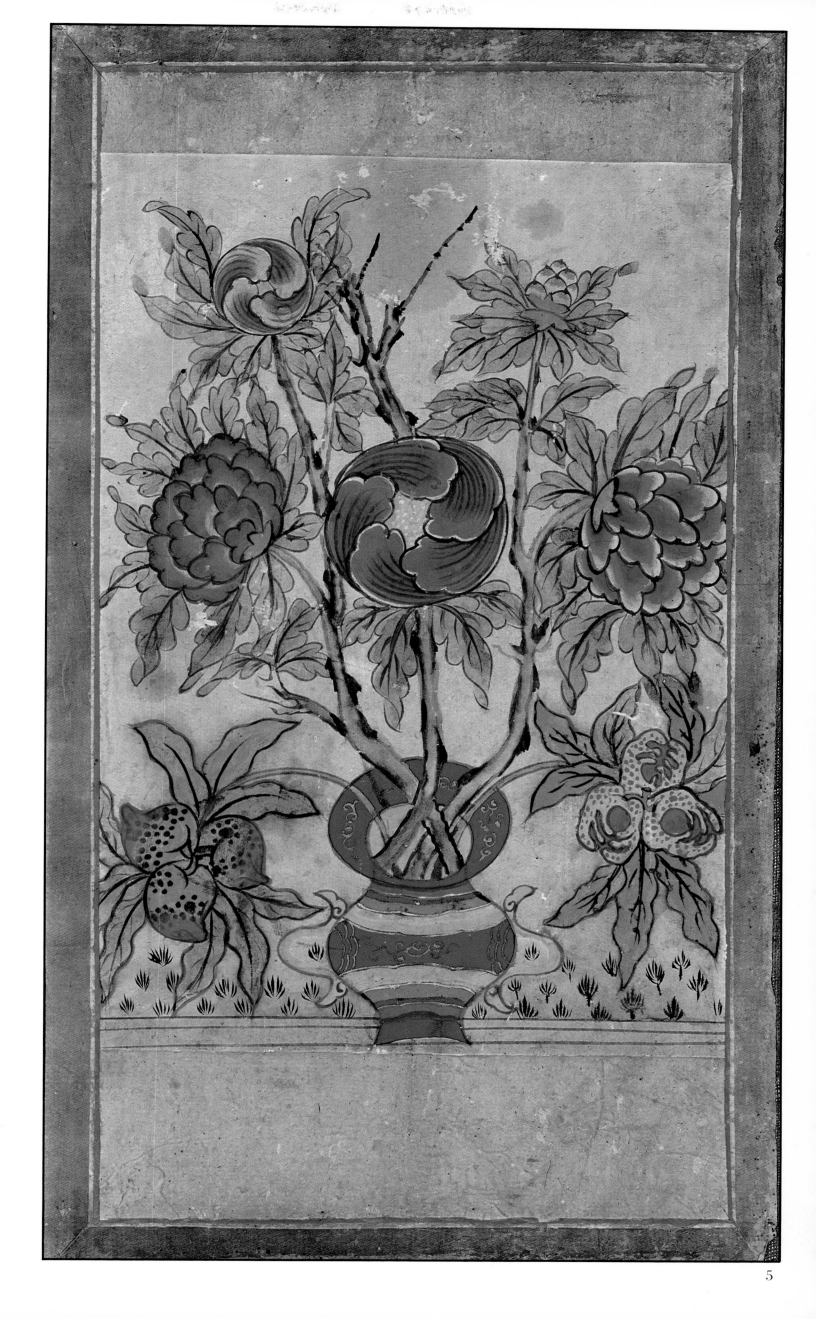

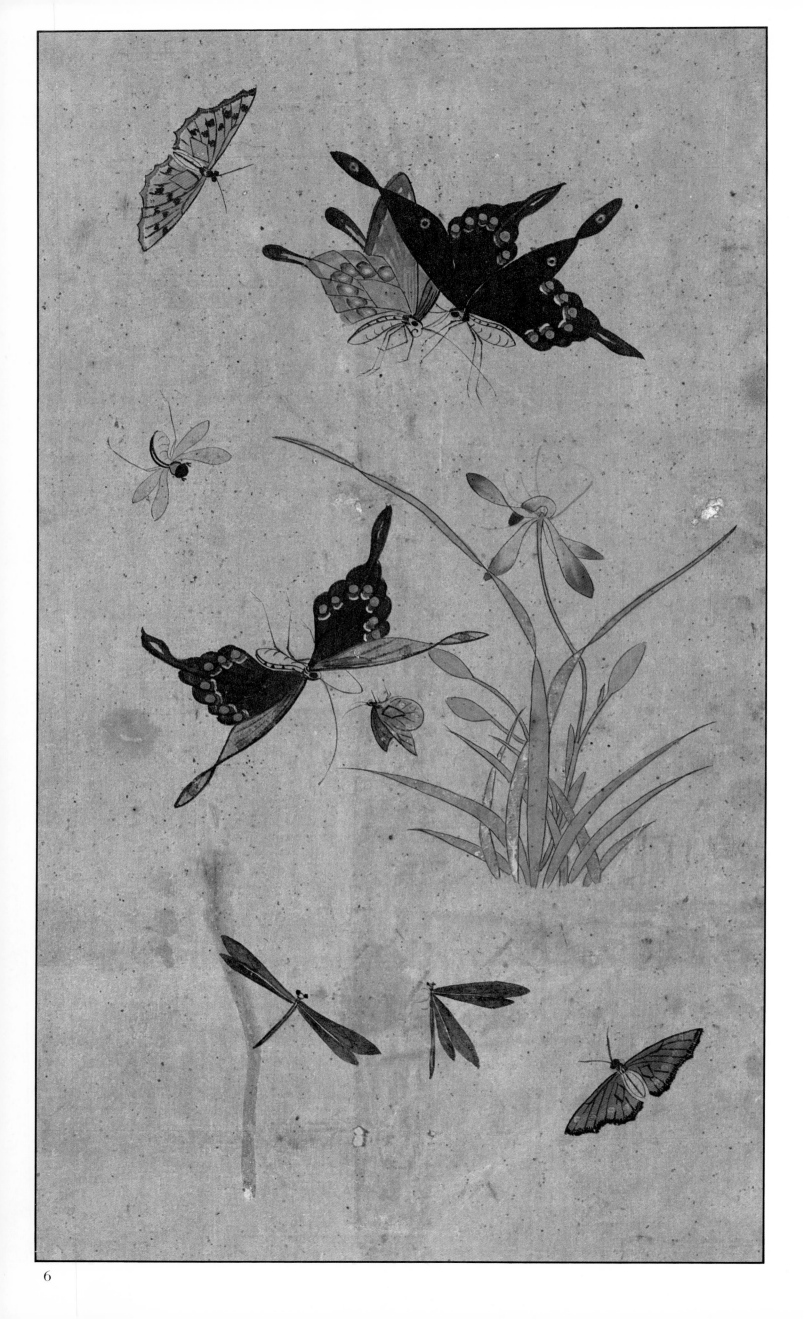

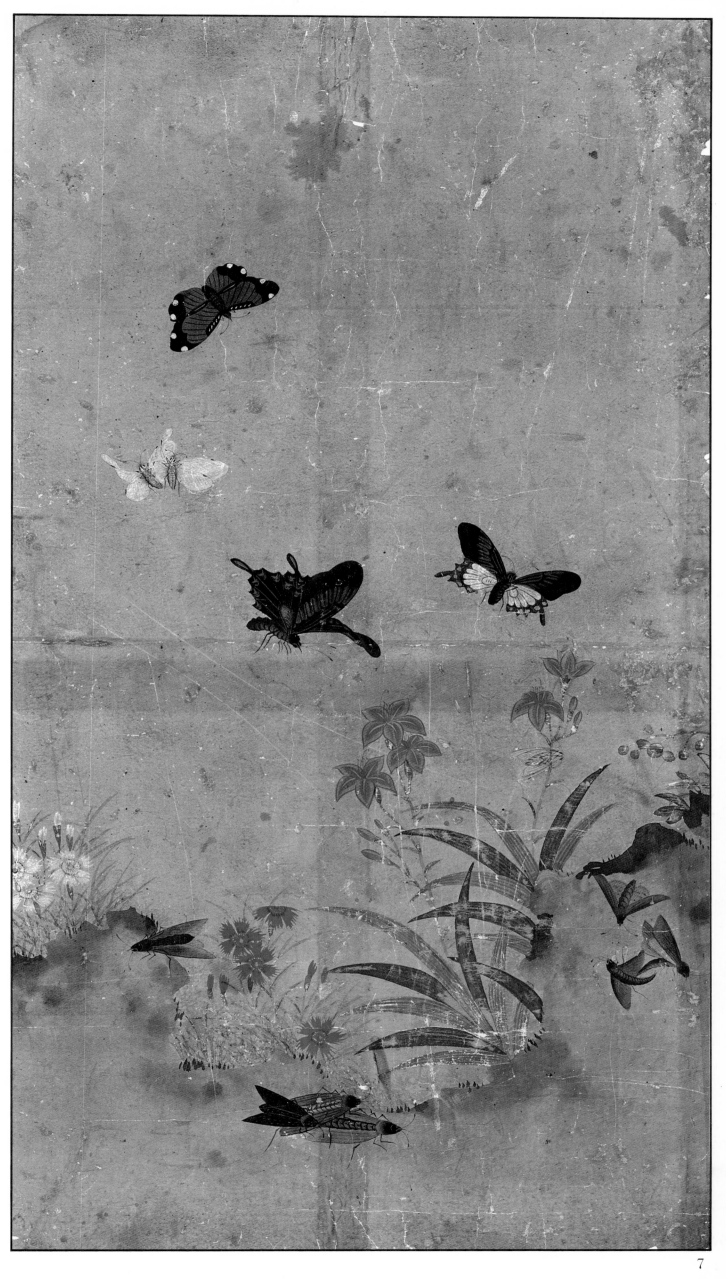

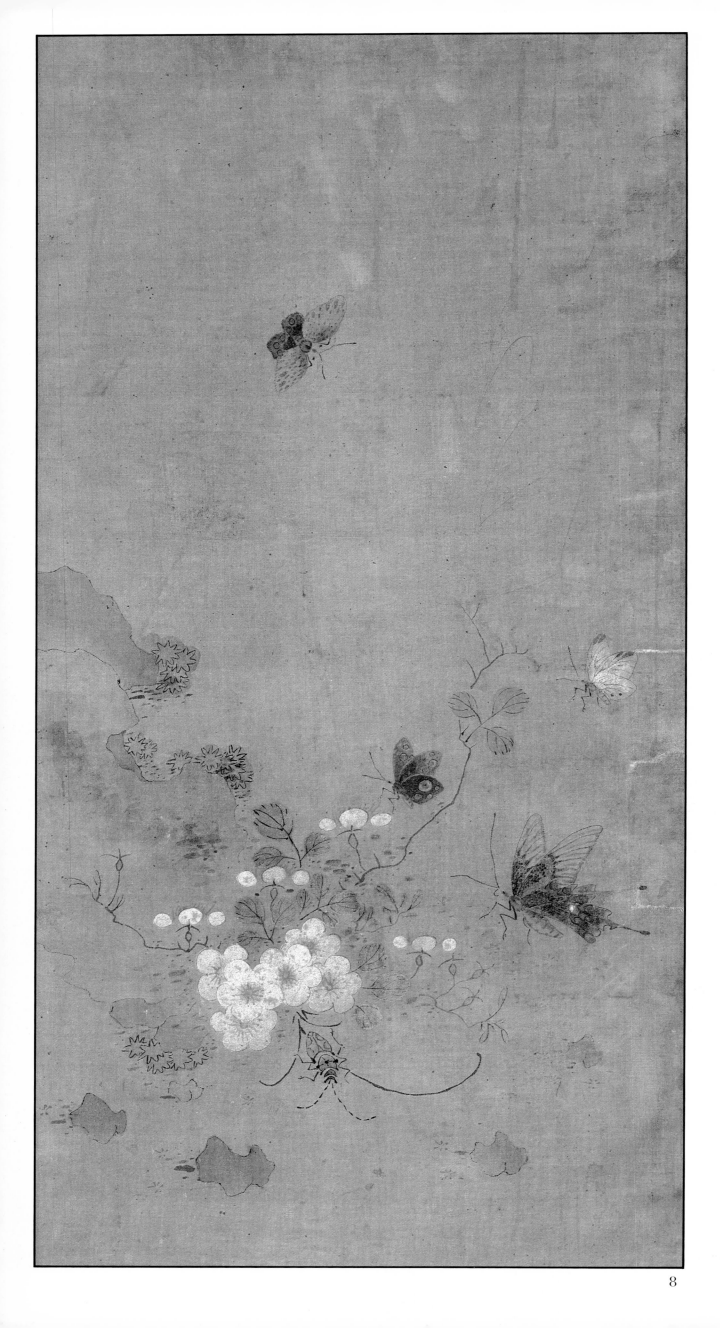

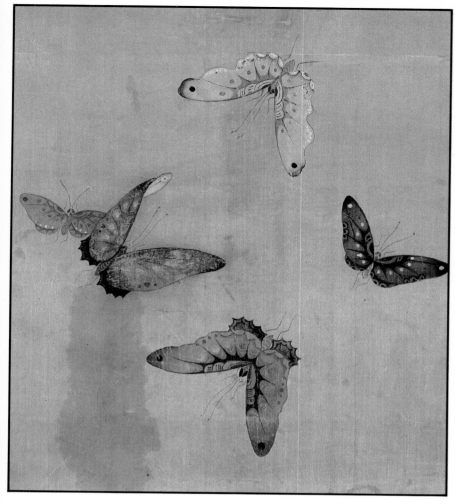 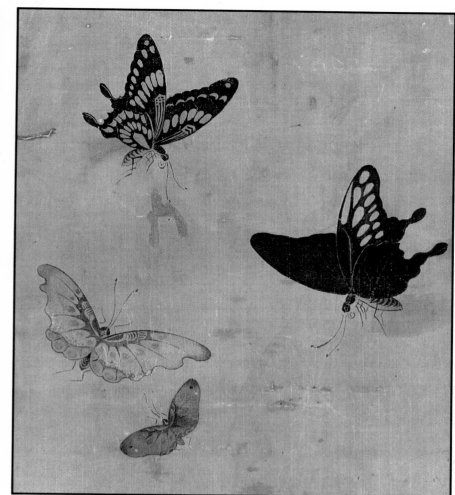

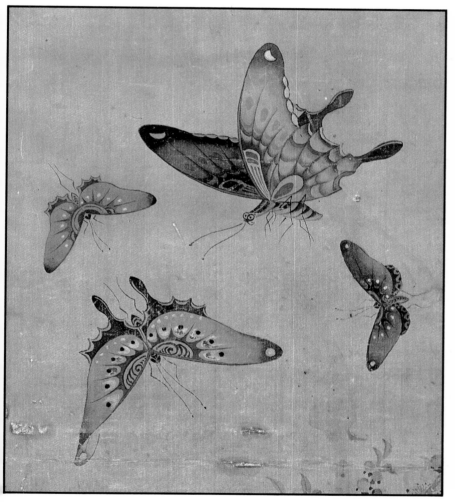 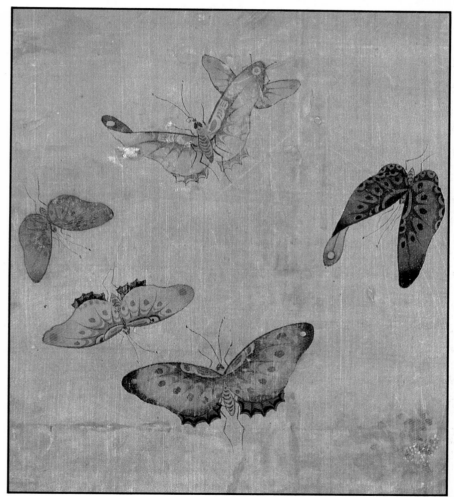

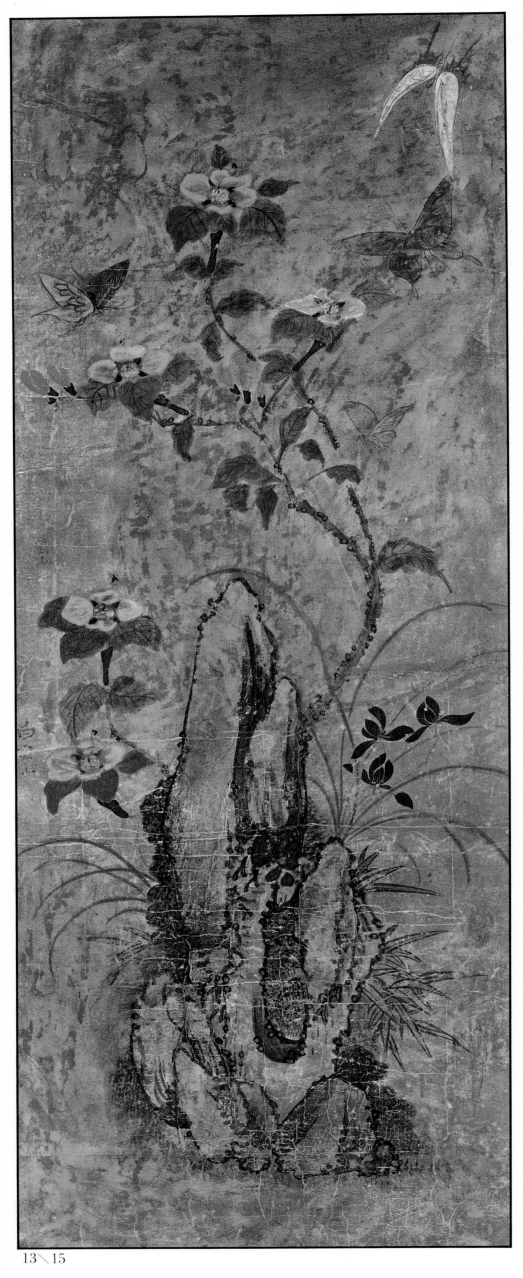

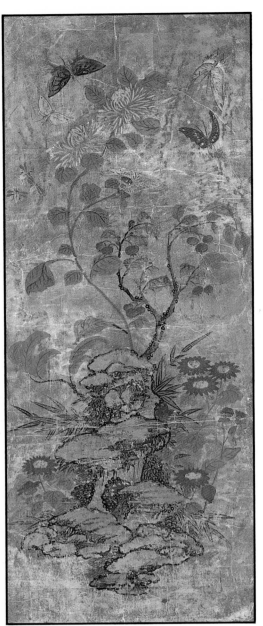

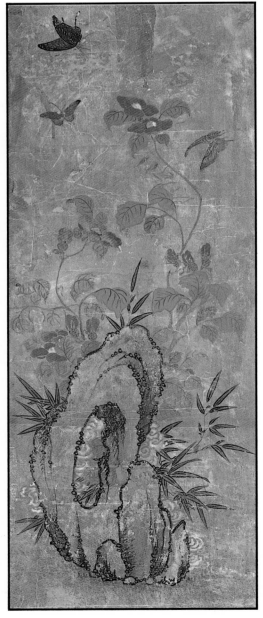

13\15

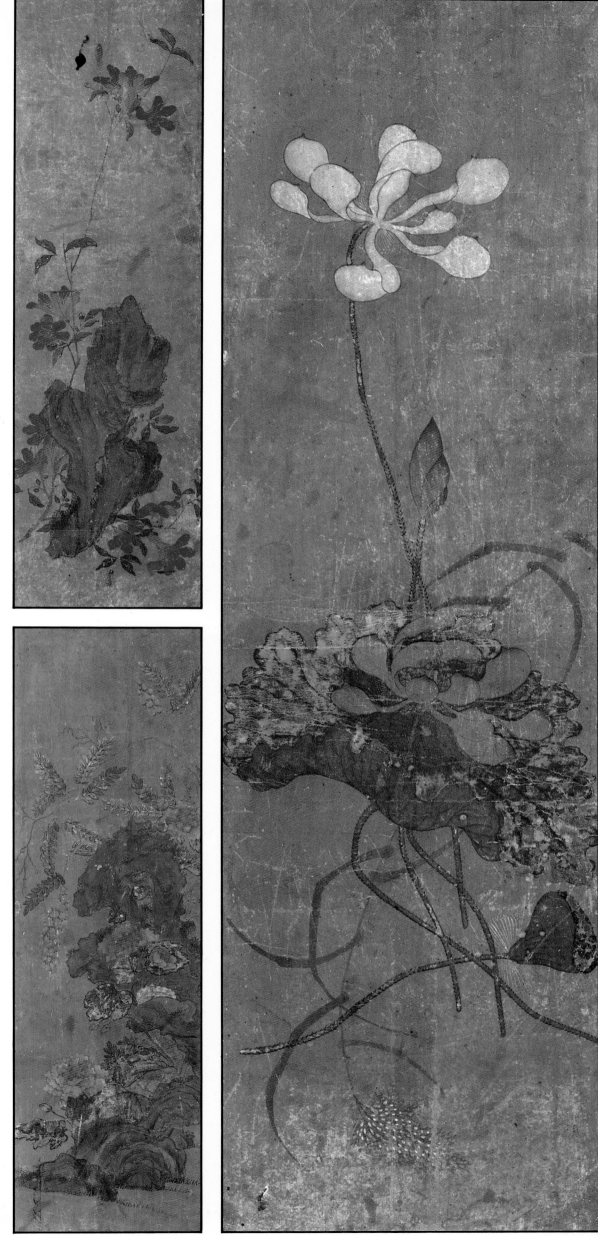

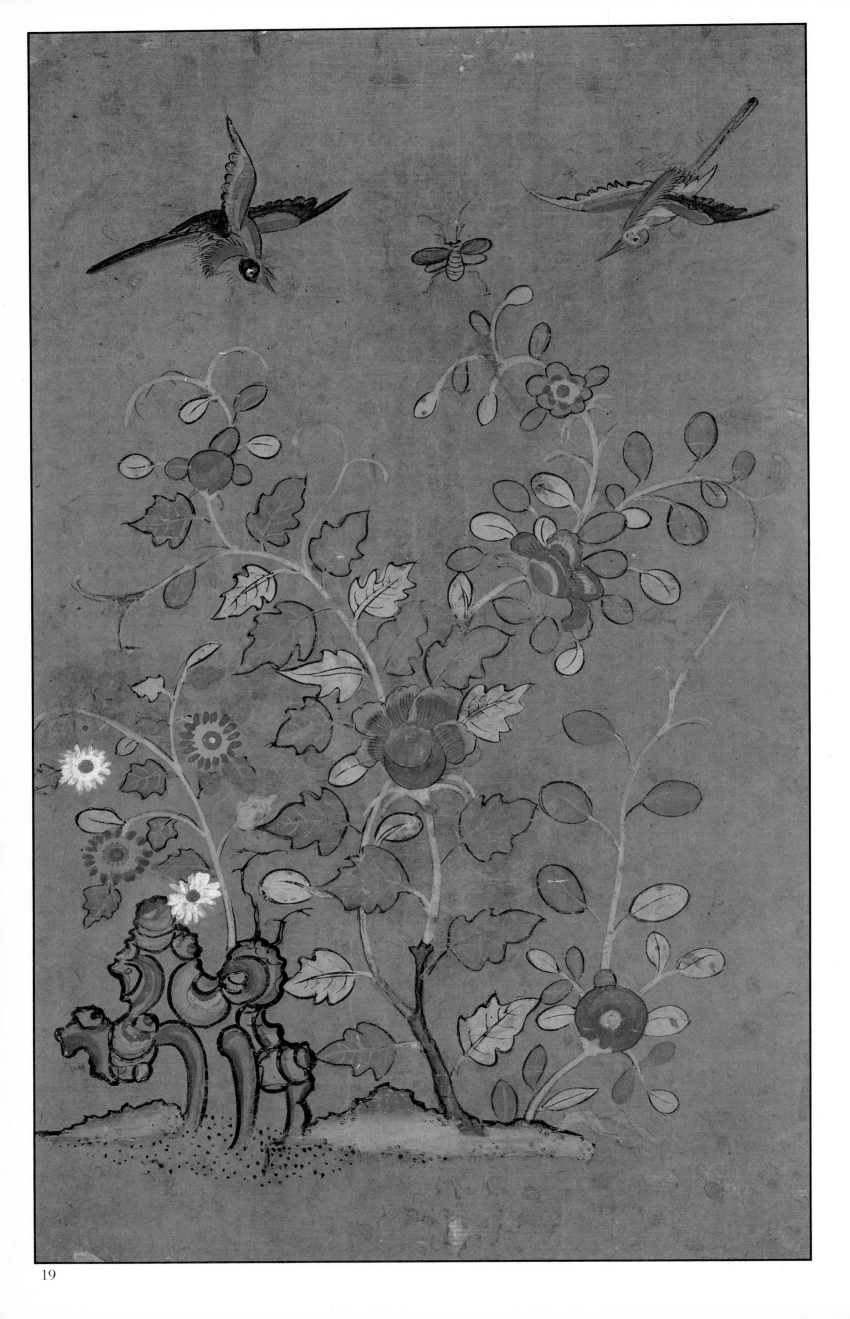

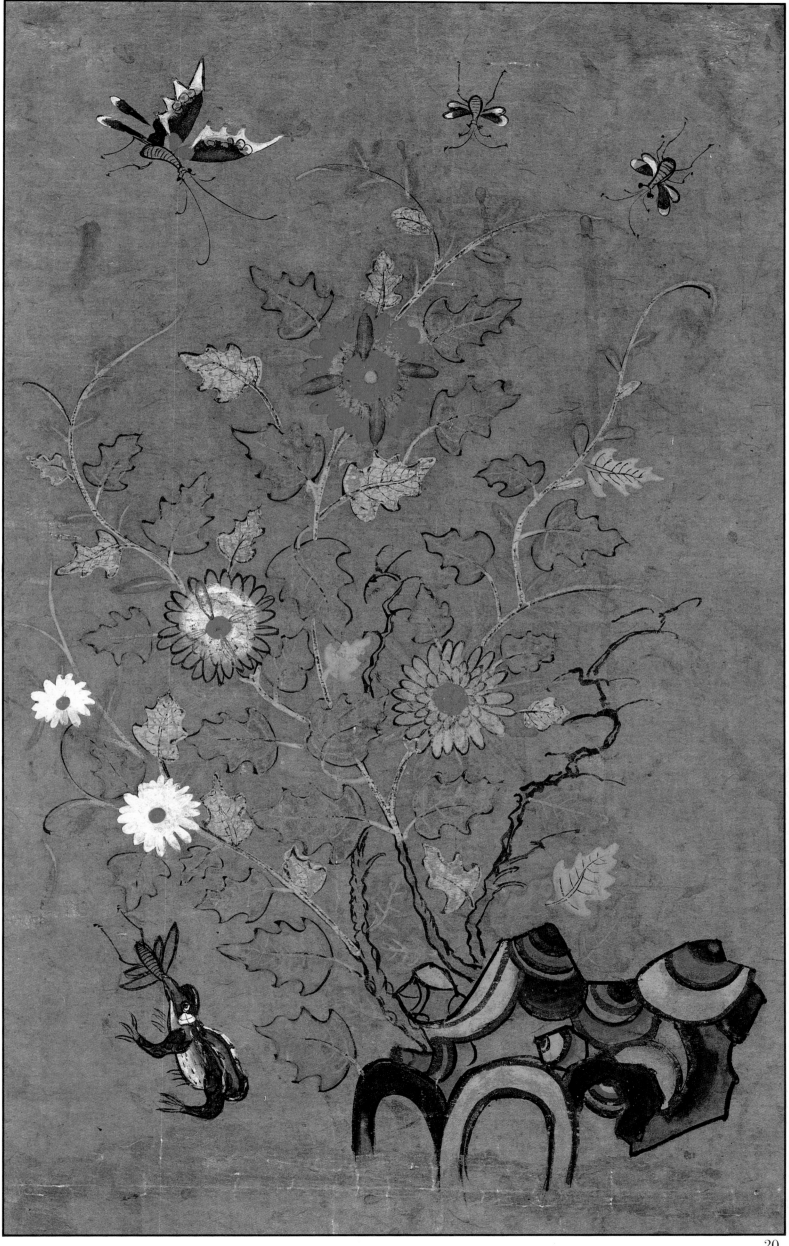

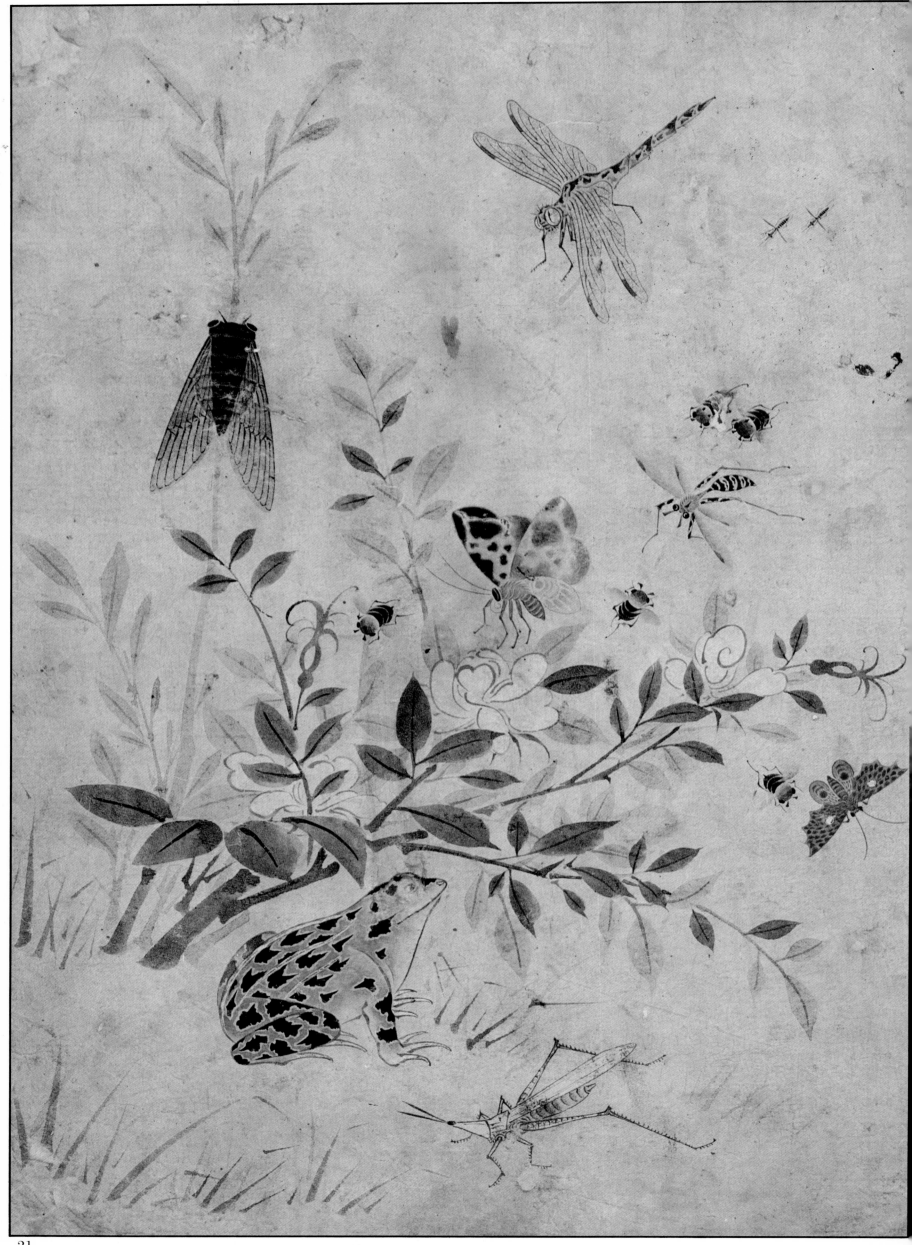

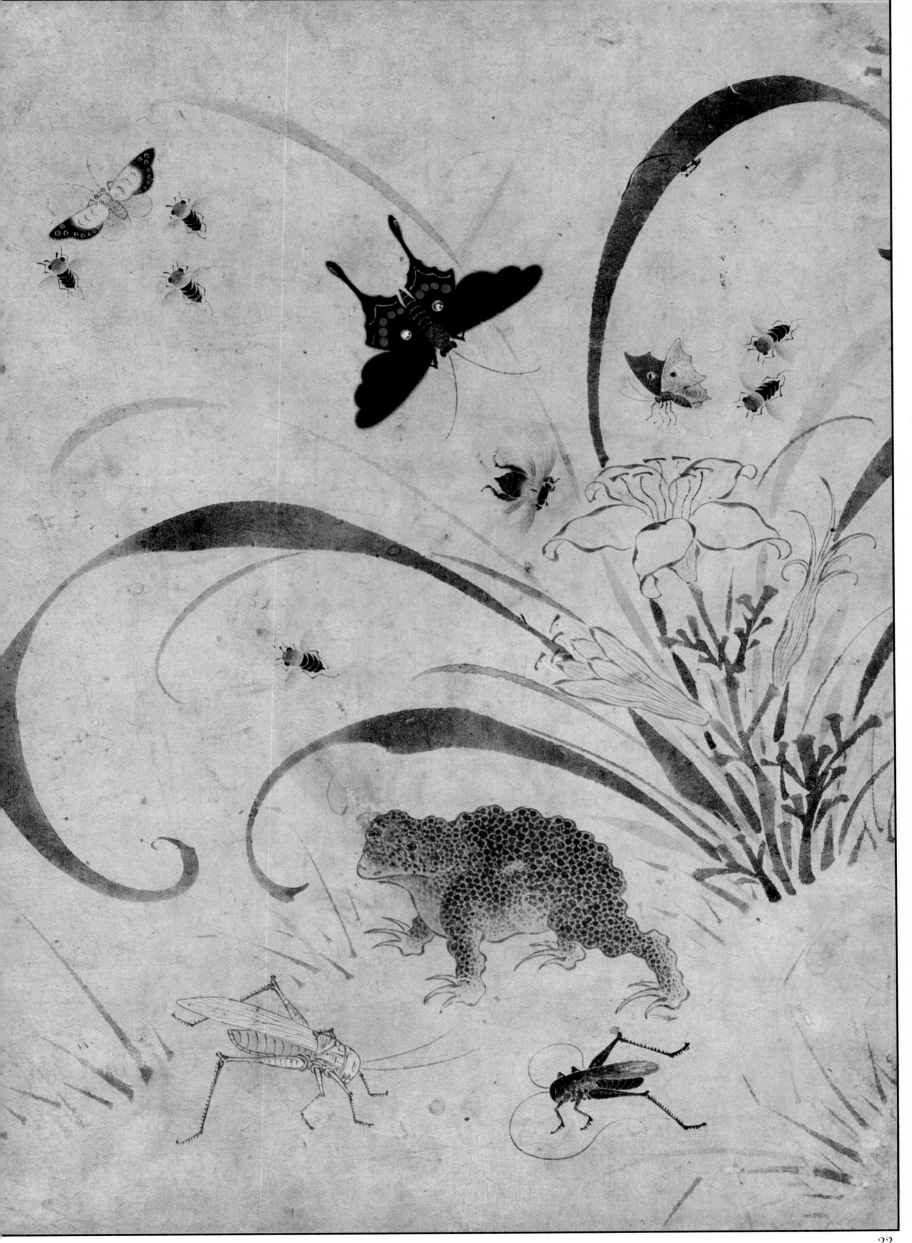

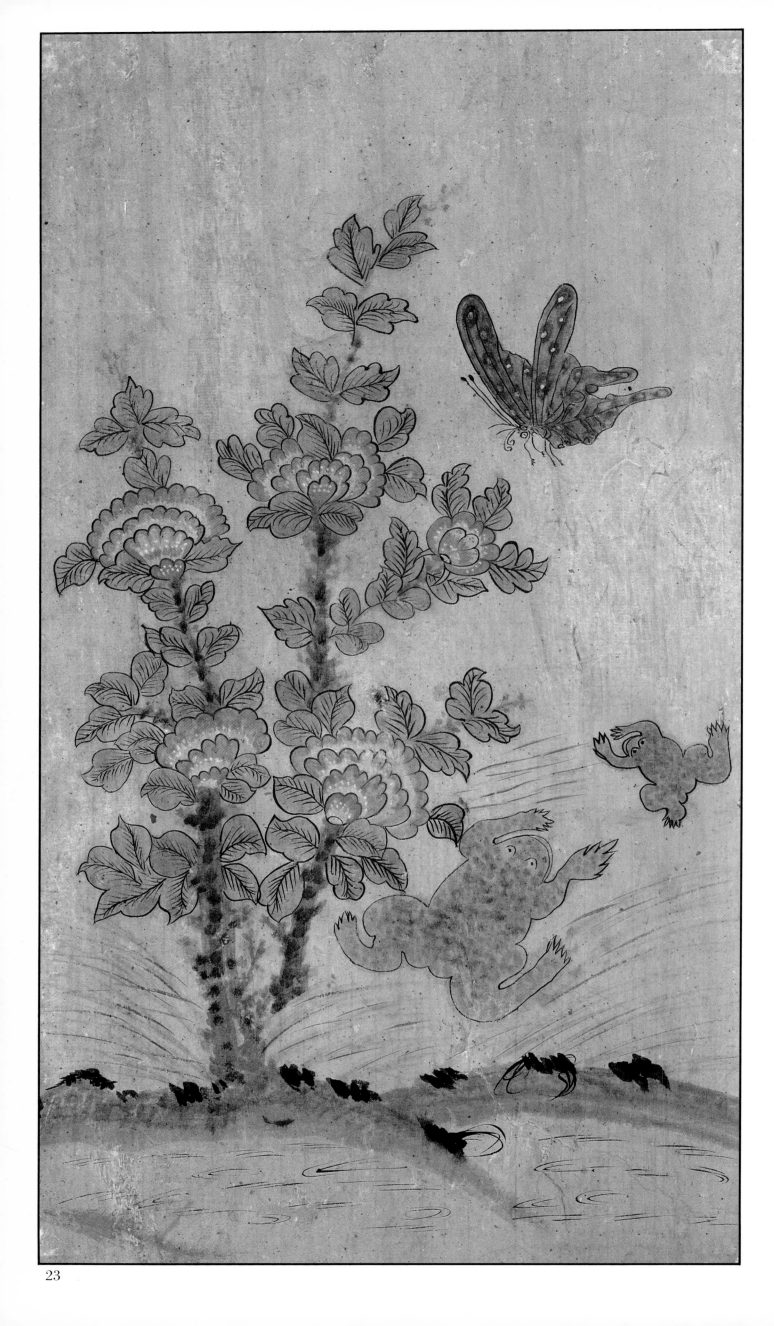

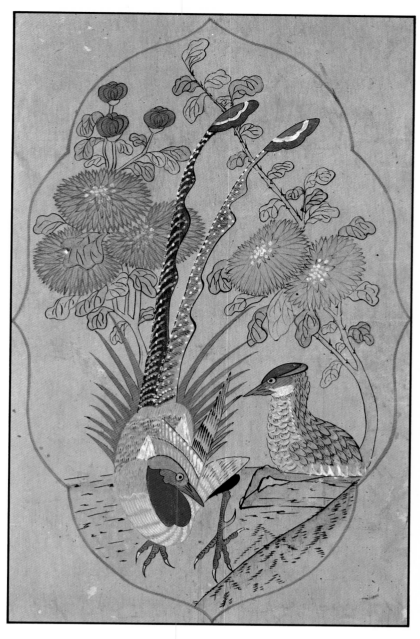

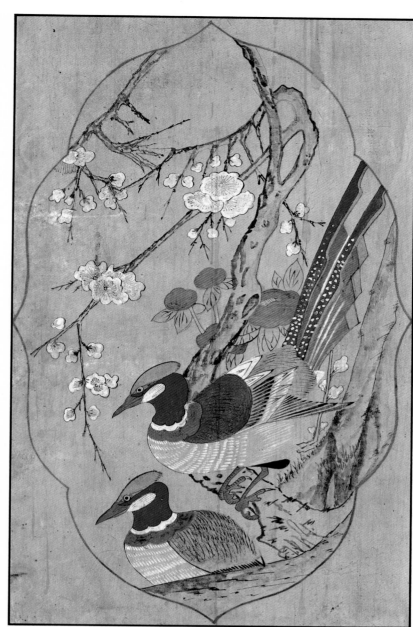

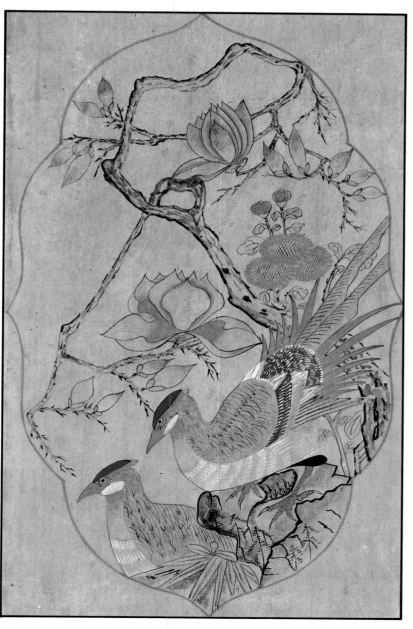

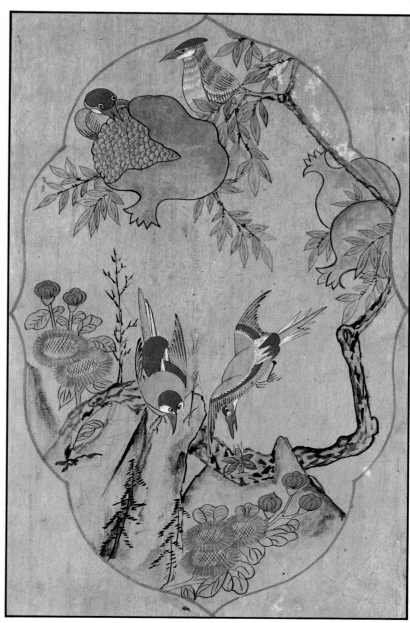

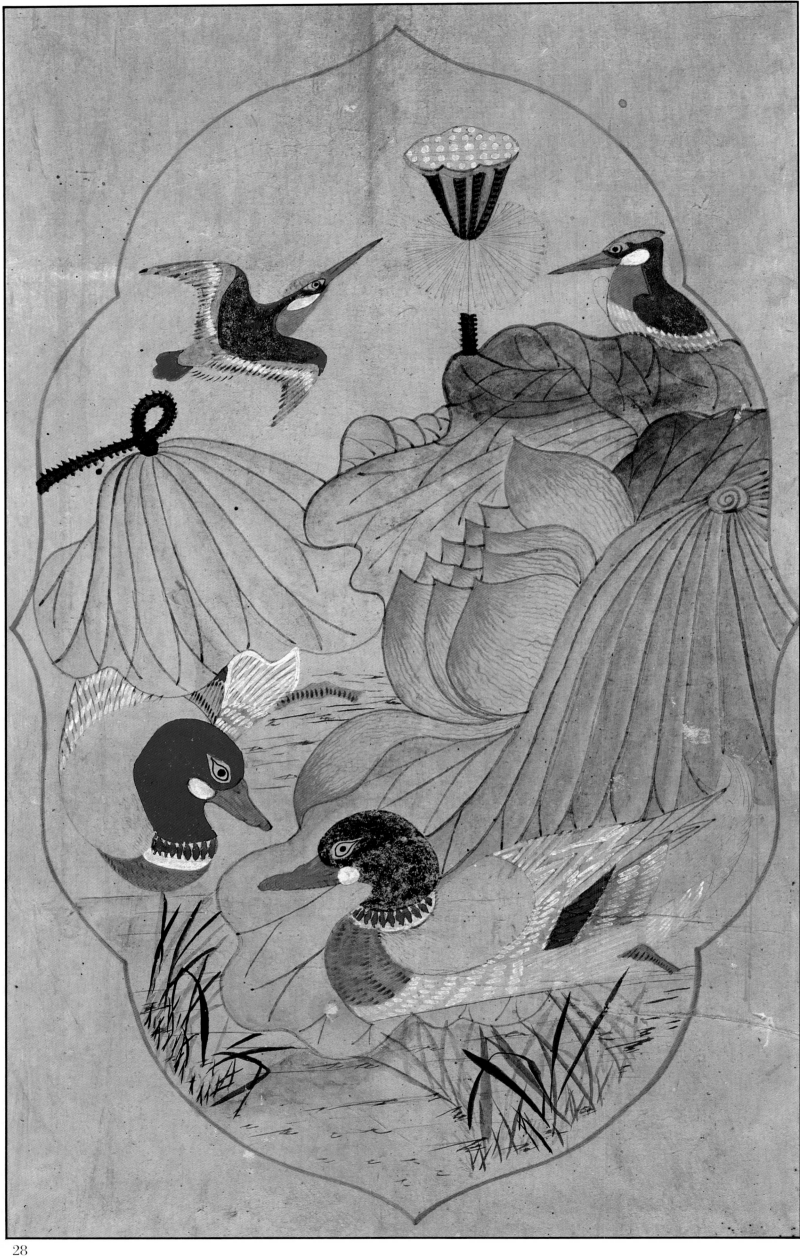

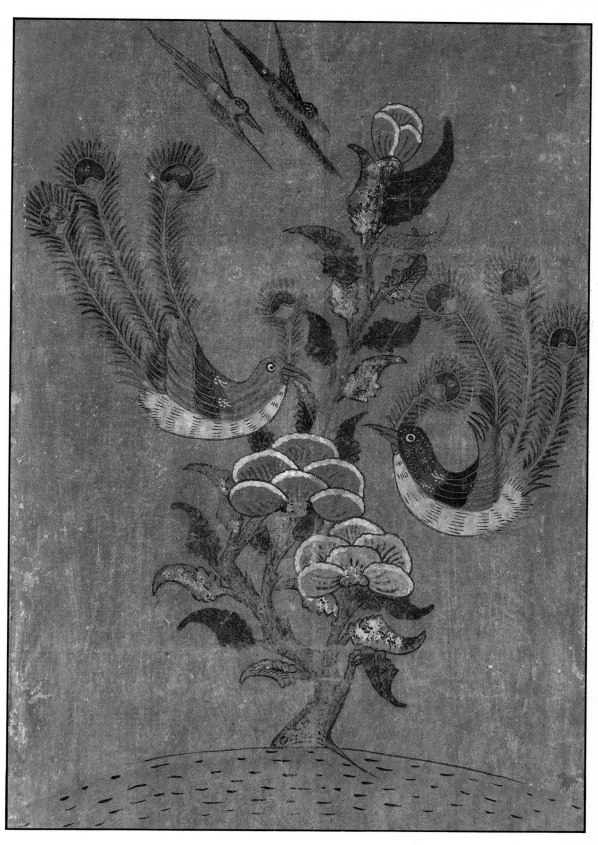

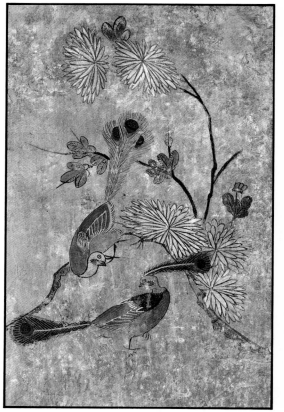

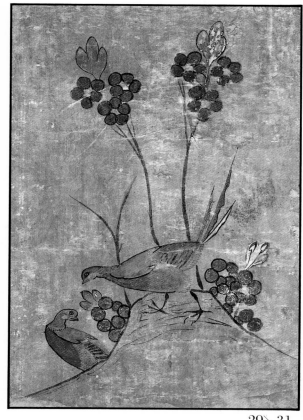

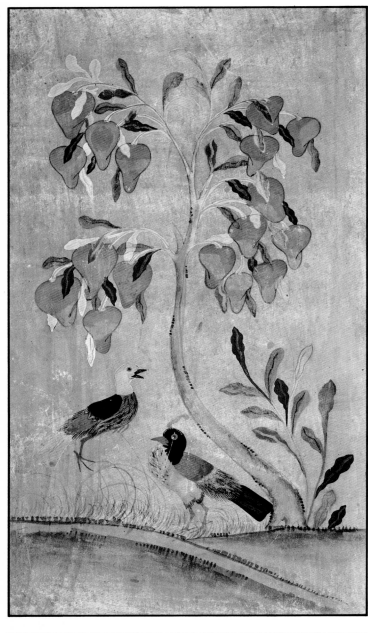

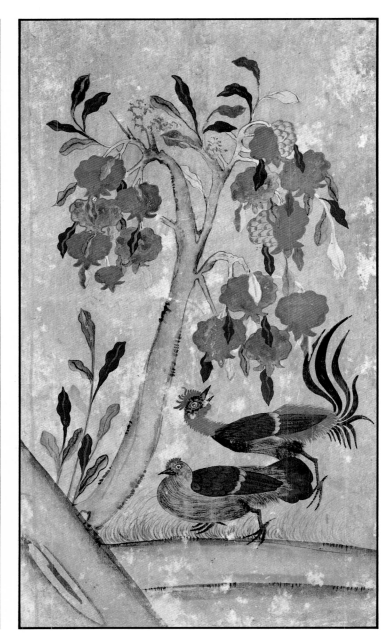

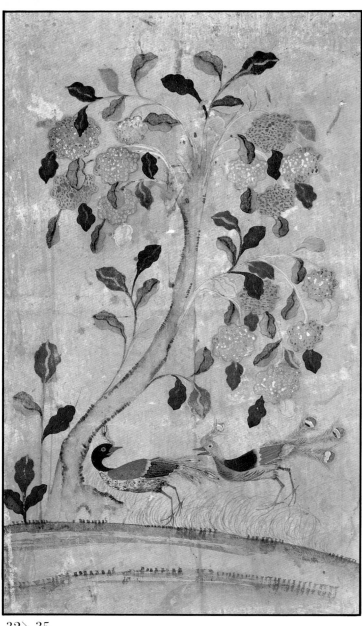

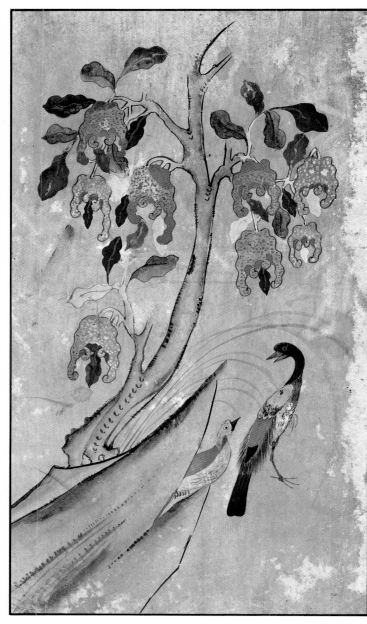

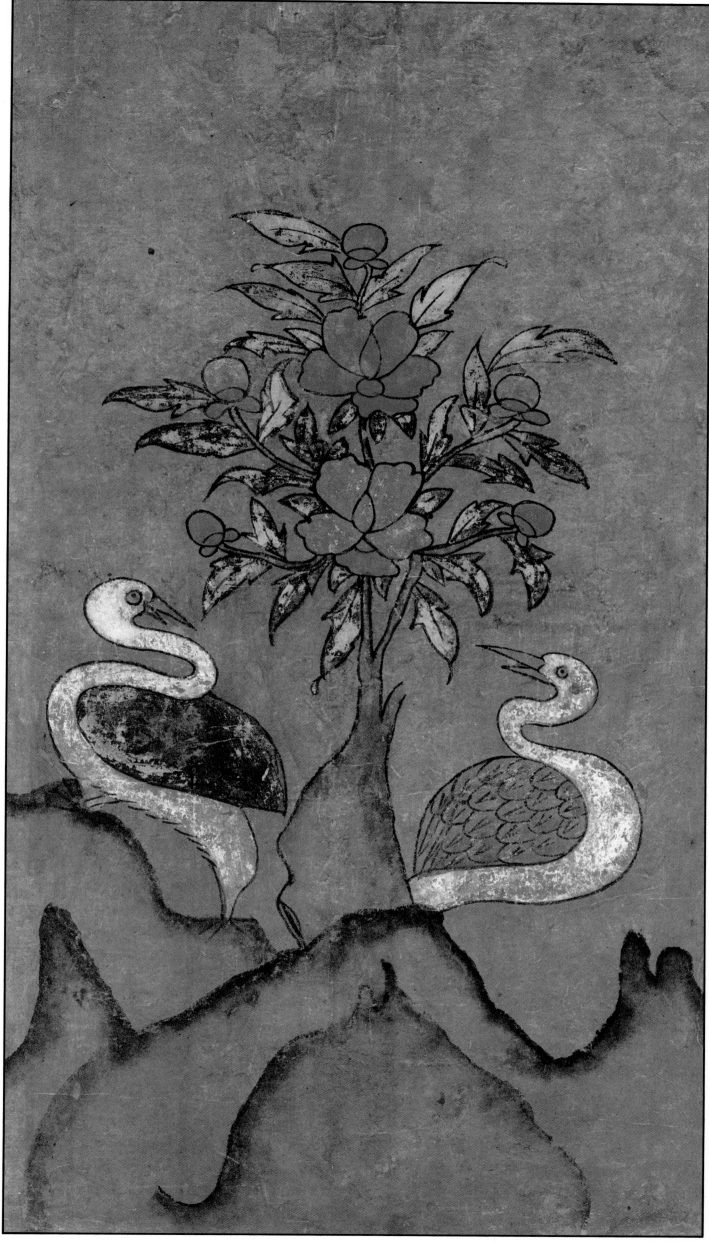

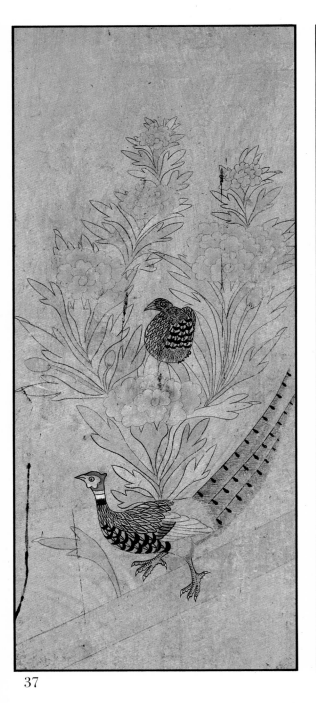

37

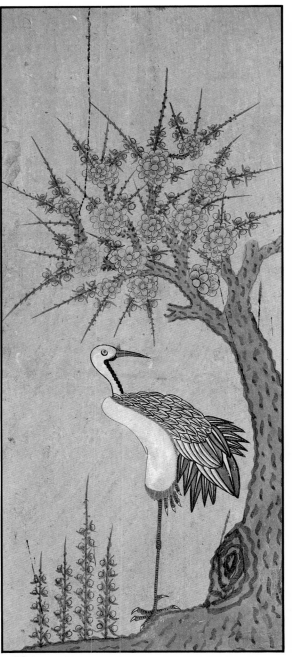

38

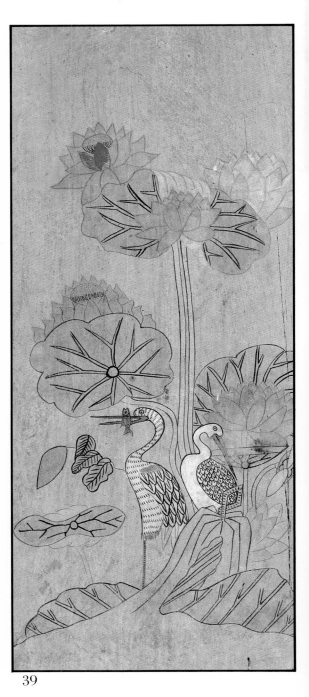

39

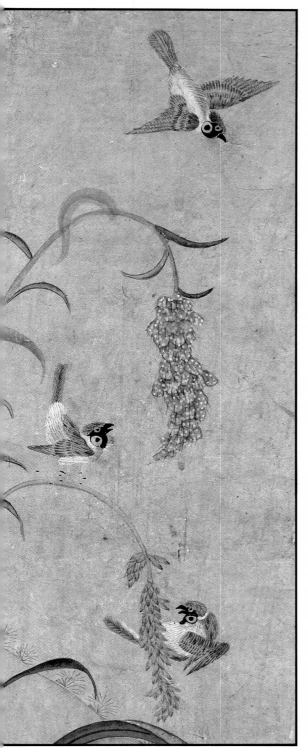

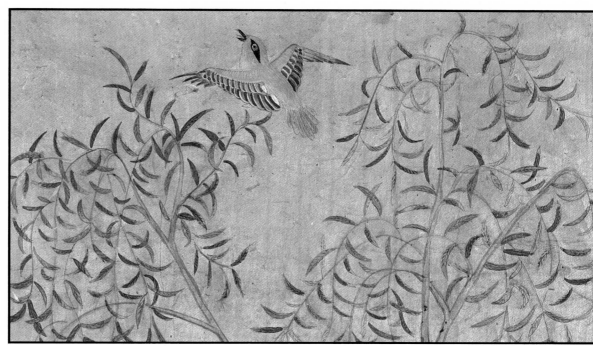

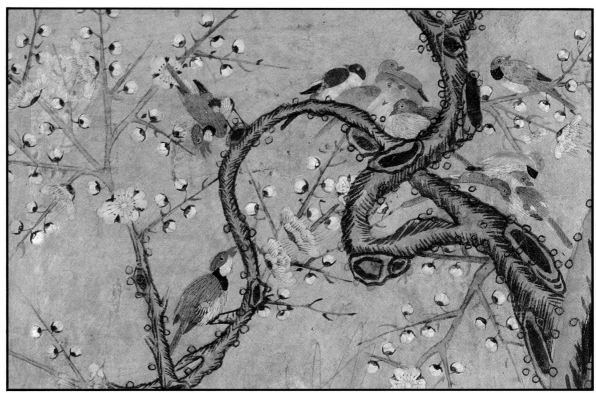

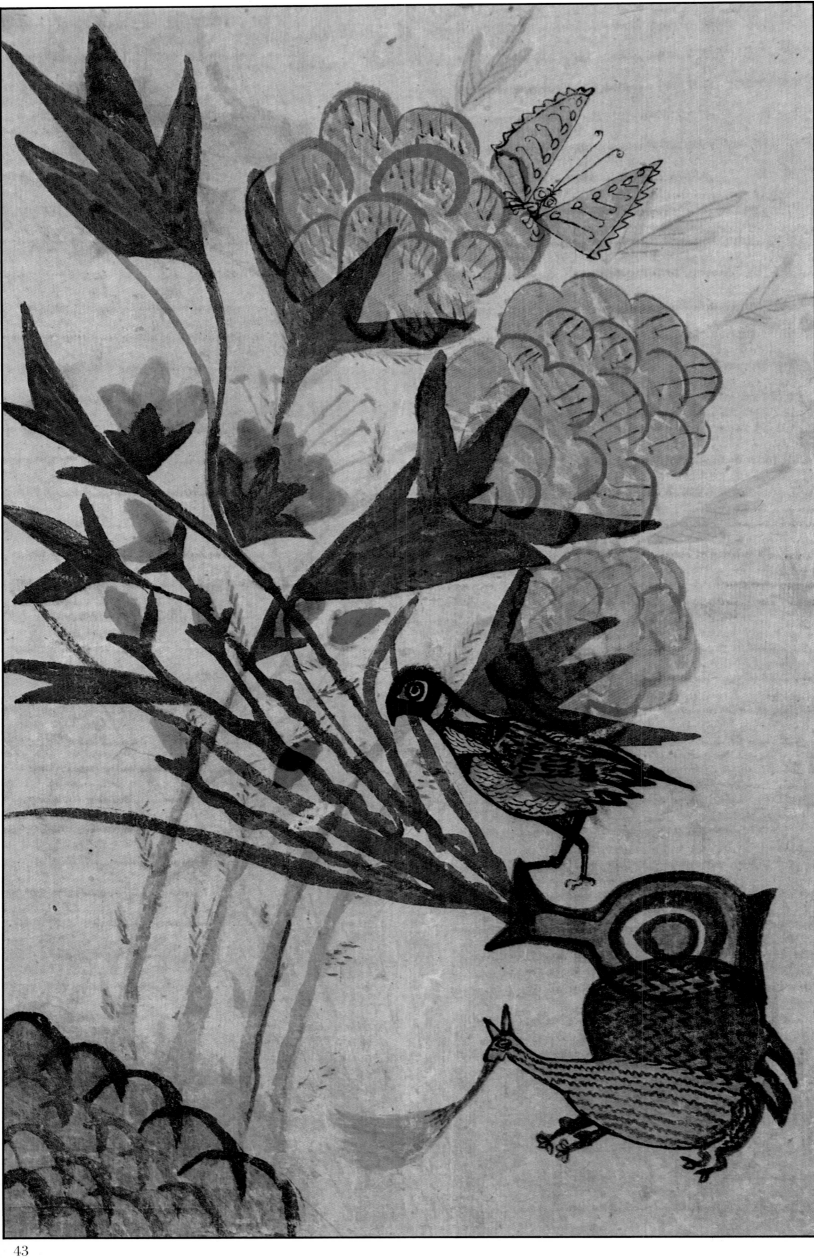

43

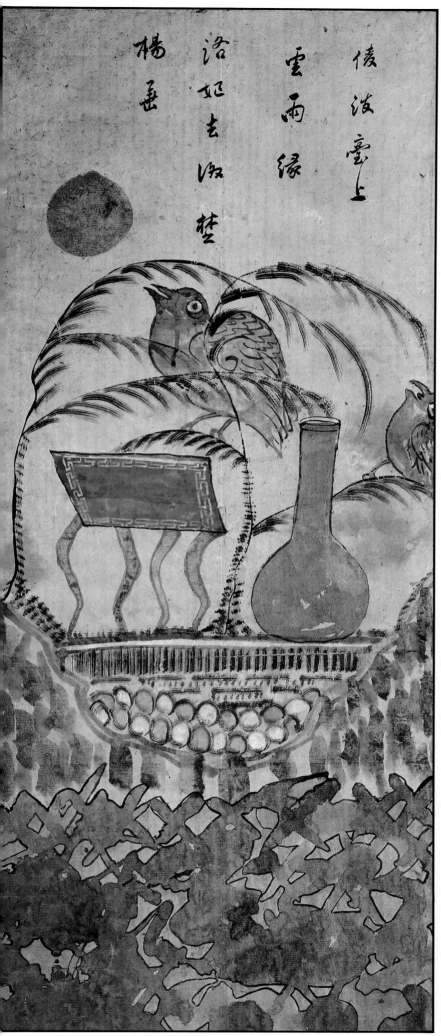

倭波臺上
雲雨緣
洛妃去洳埜
楊垂

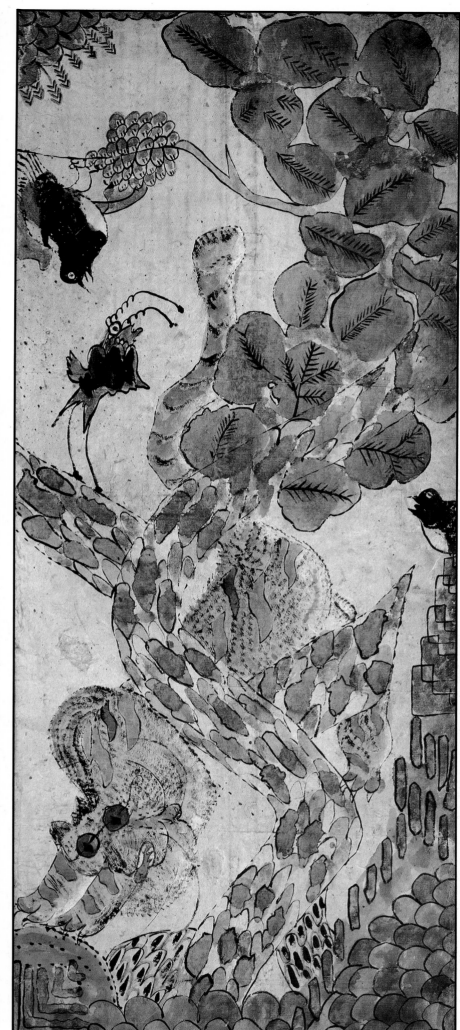

44

45

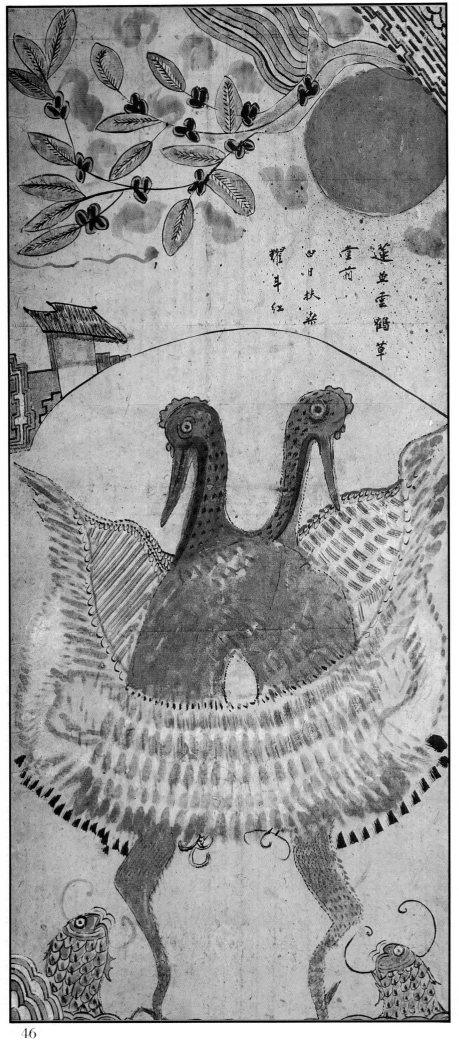

蓬萊靈鶴草
雲前
山日扶桑
耀斗紅

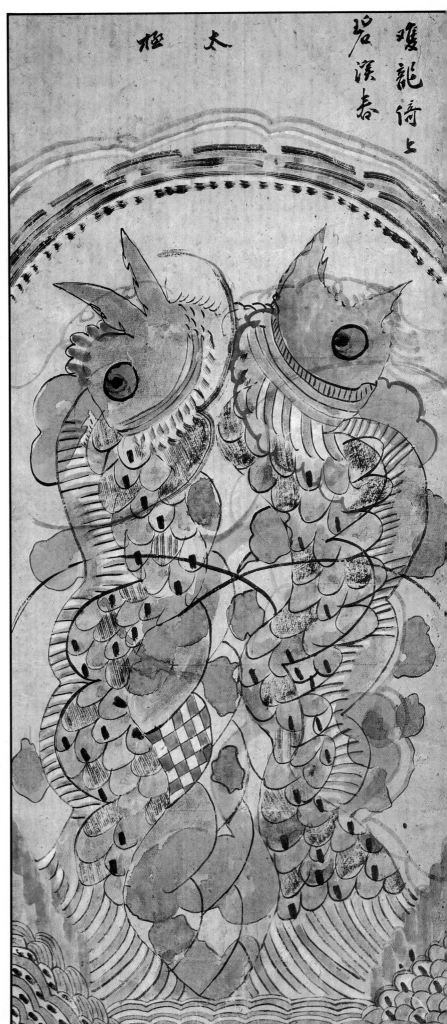

雙龍侍上
碧溪春

太極

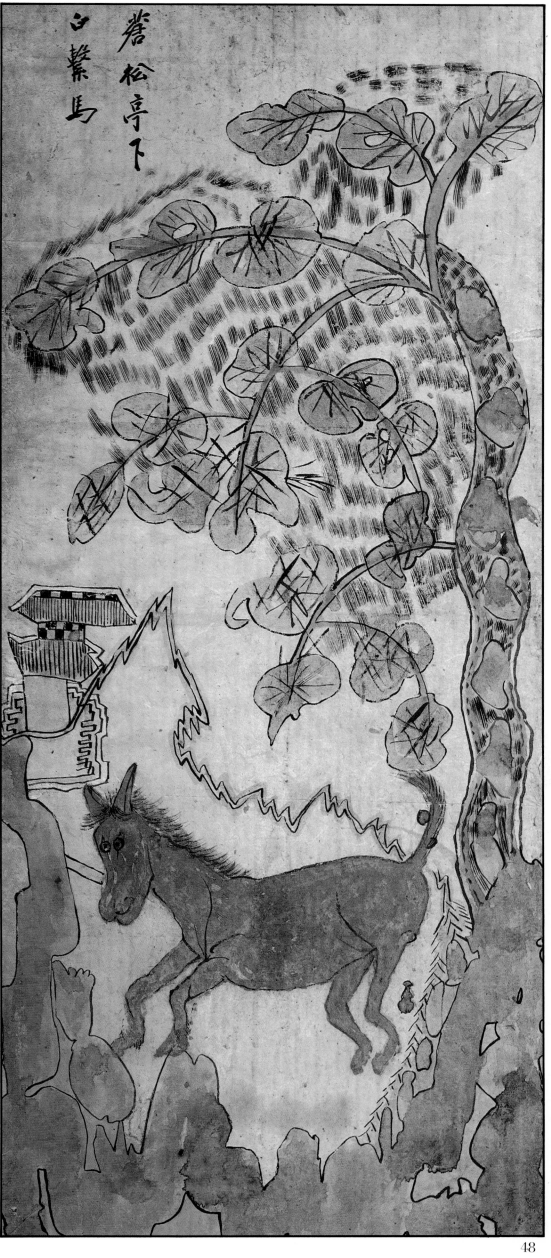

譽松亭下
己繫馬

48

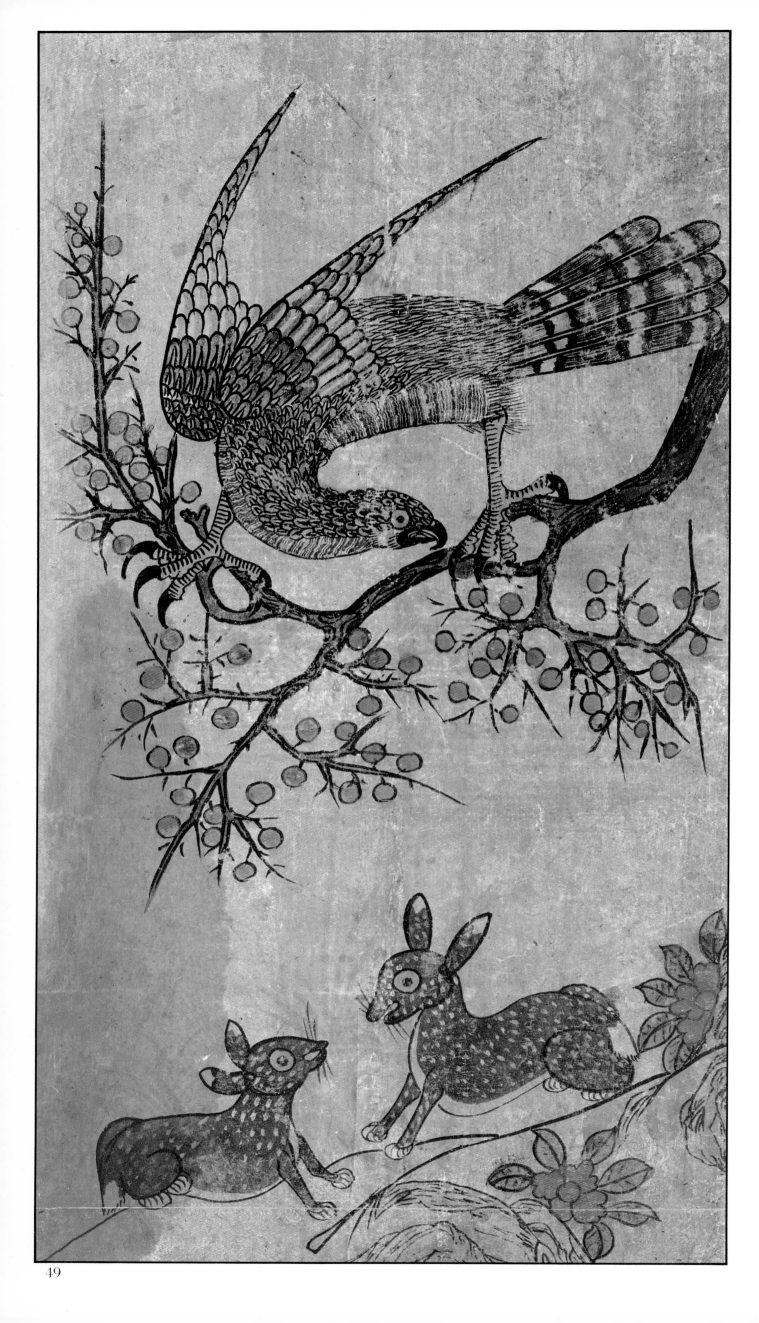

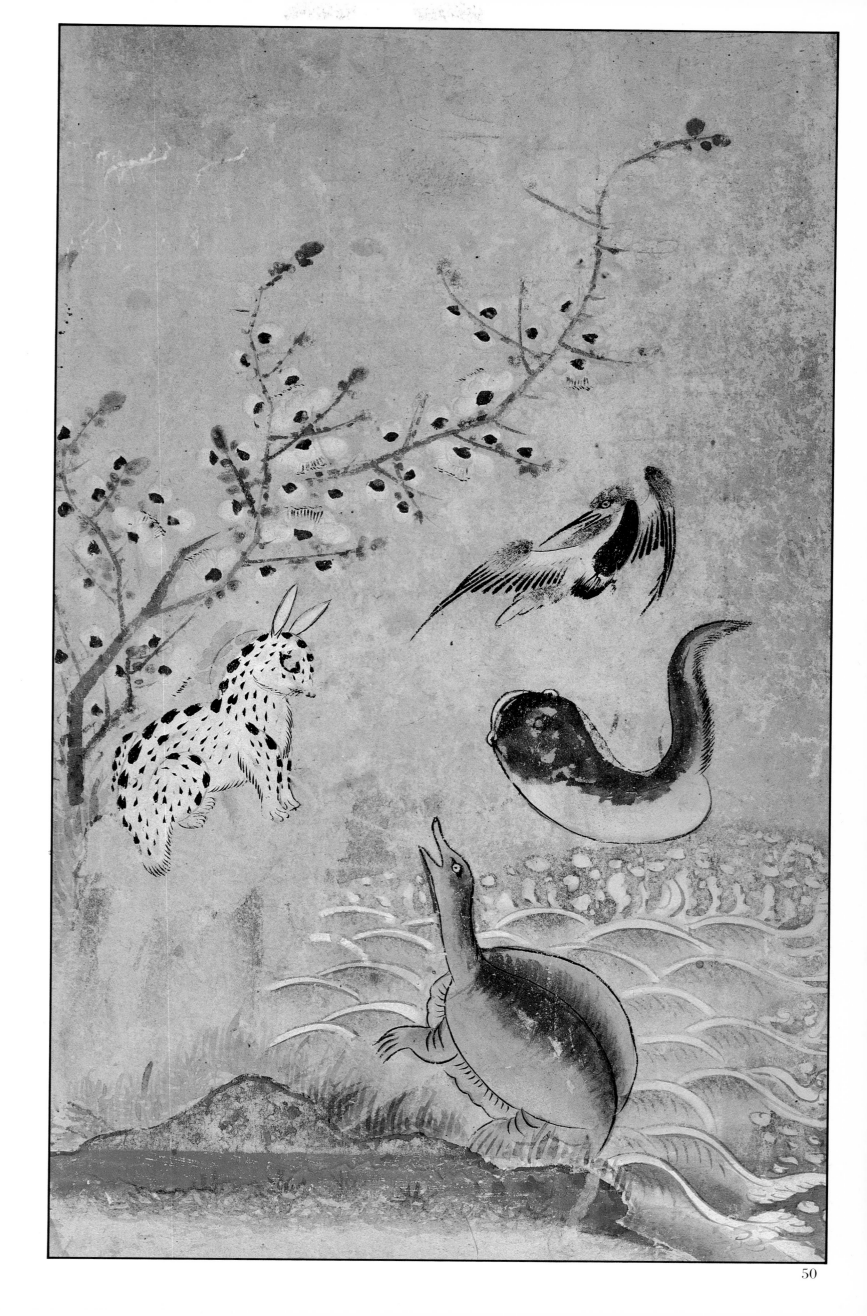

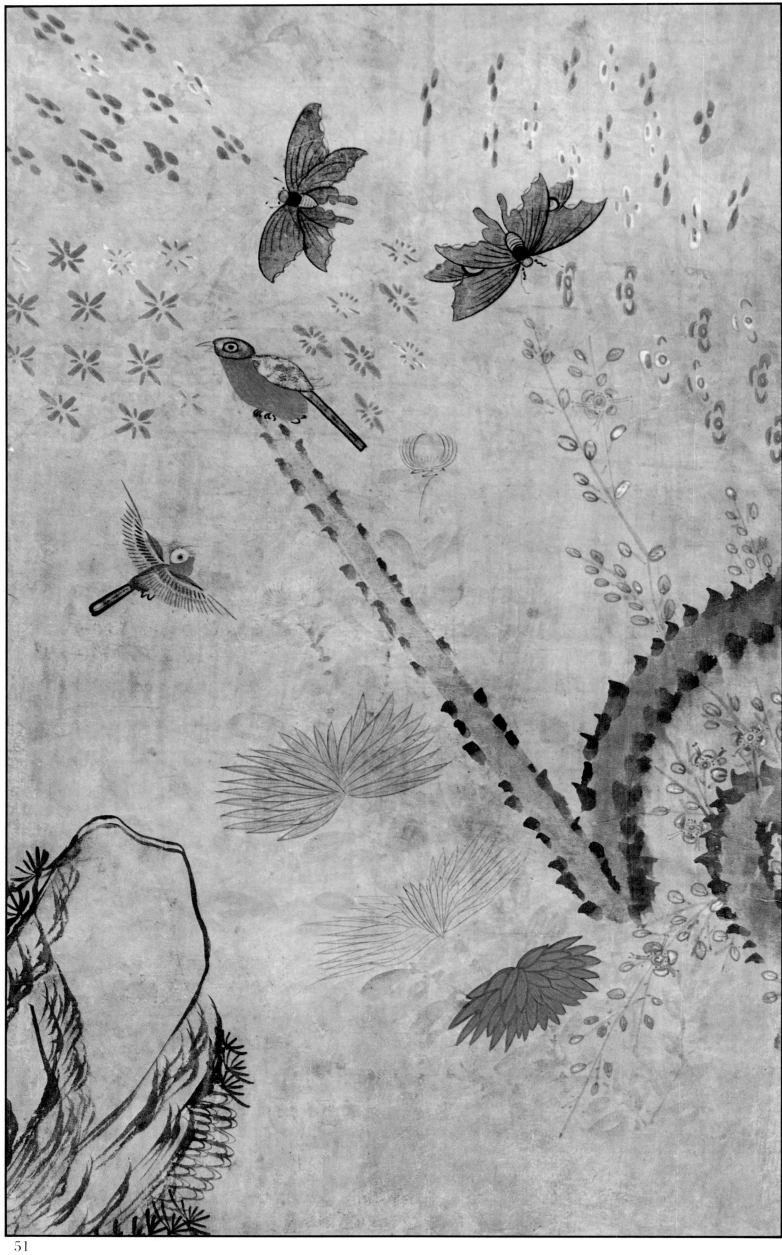

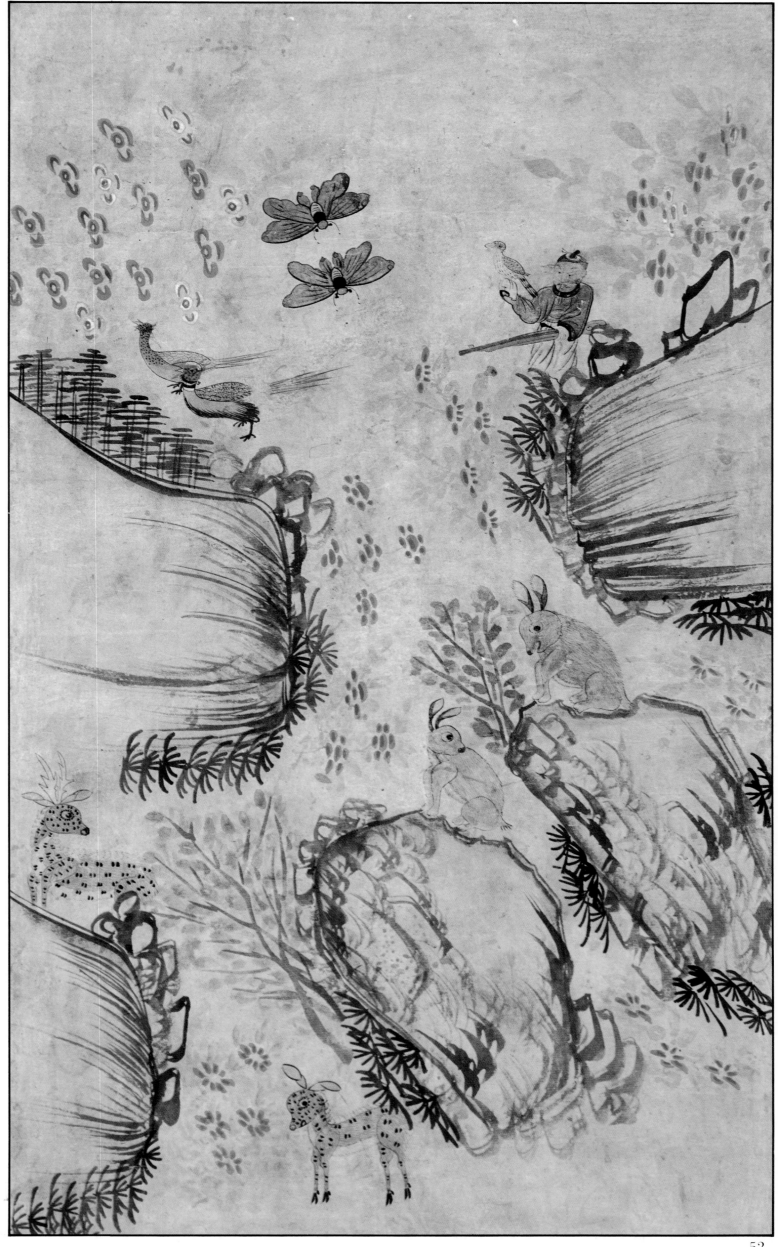

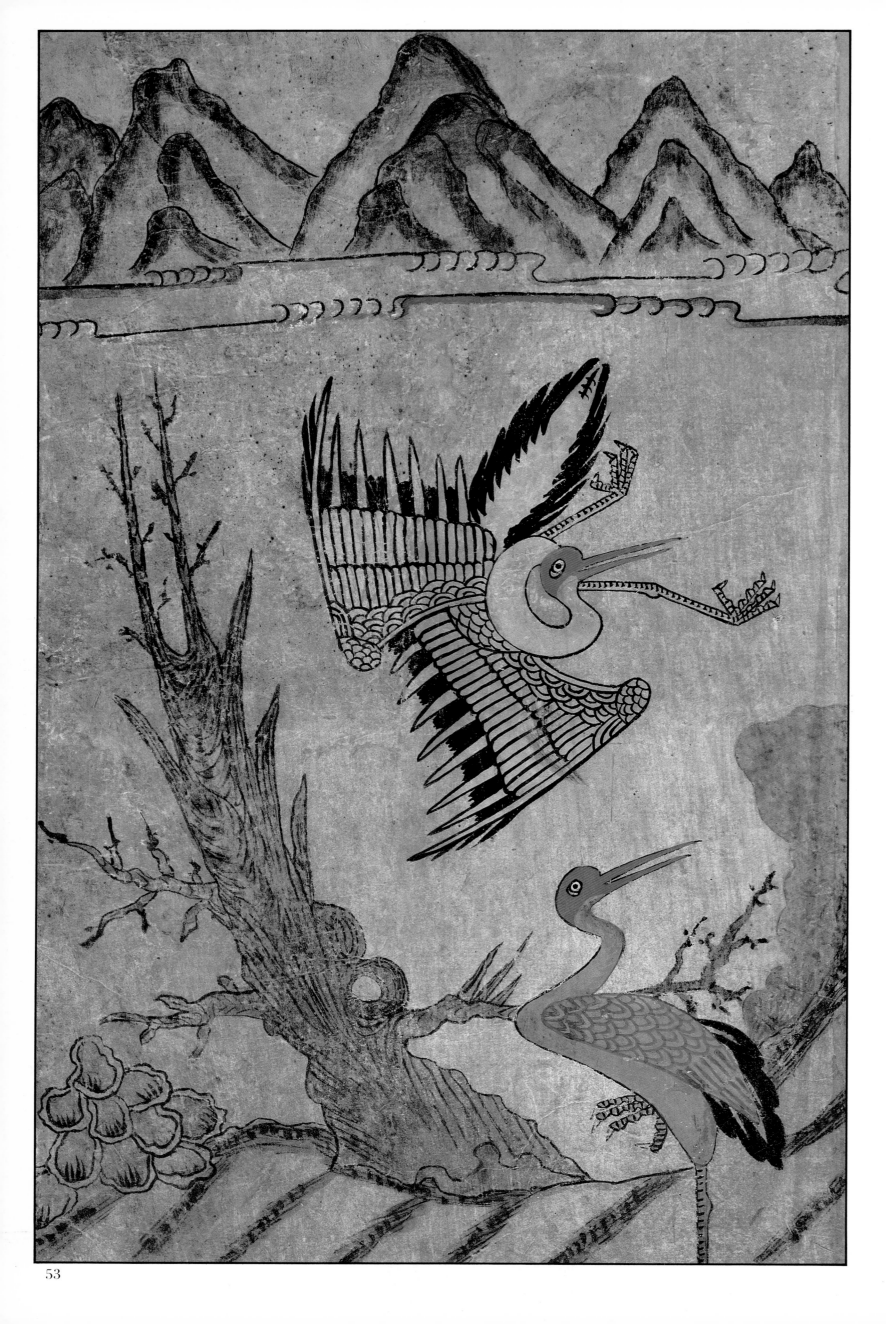

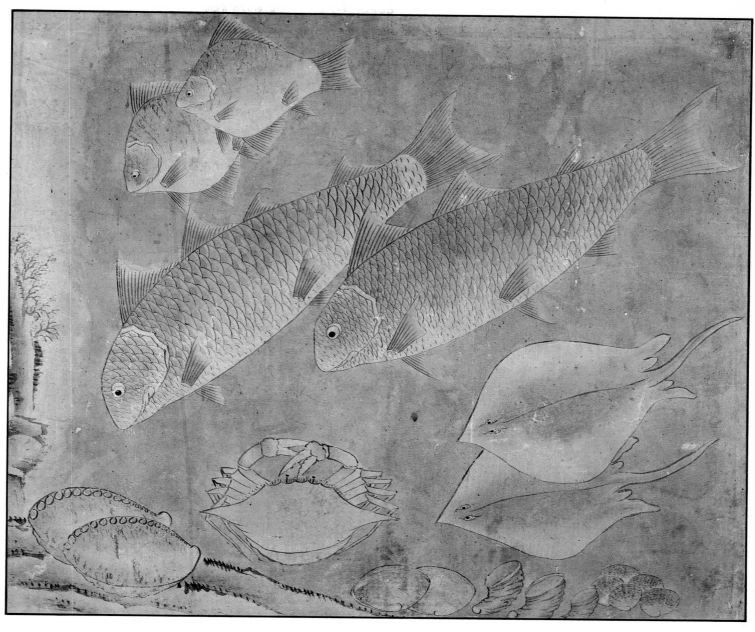

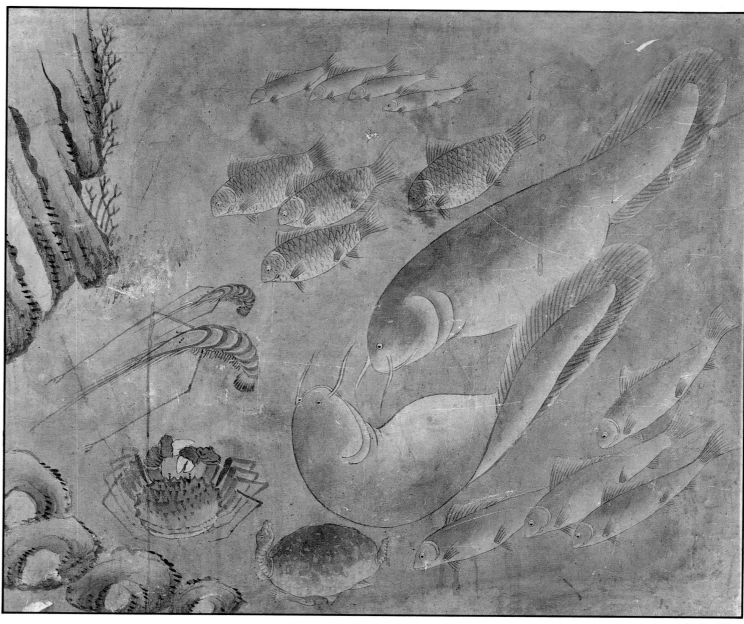

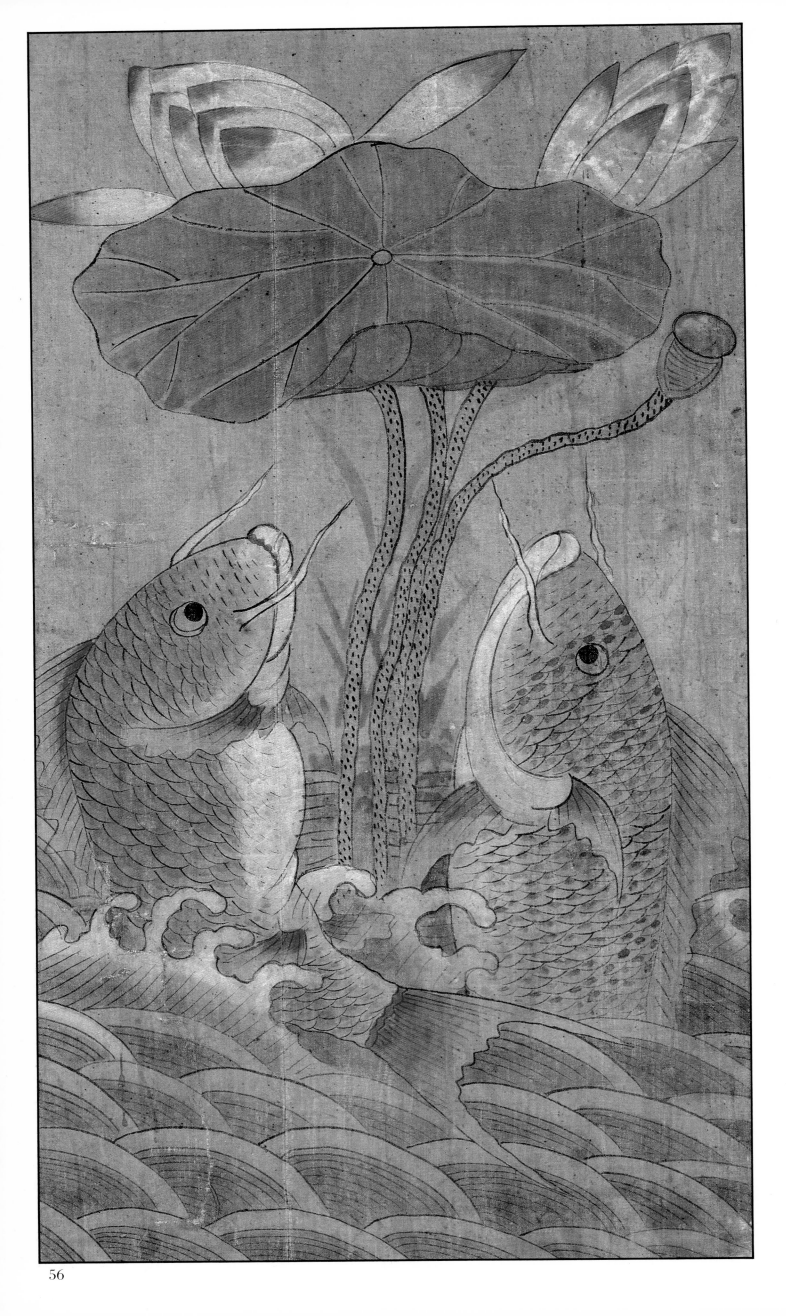

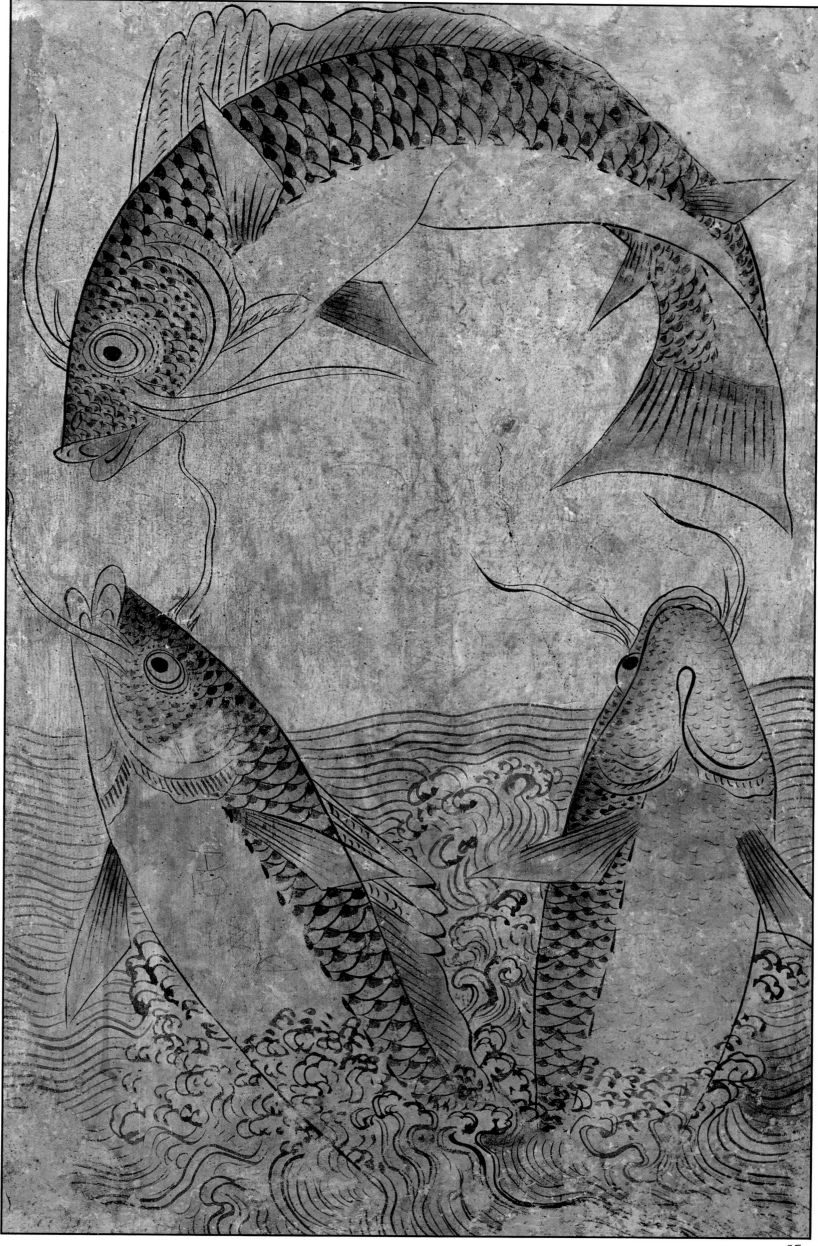

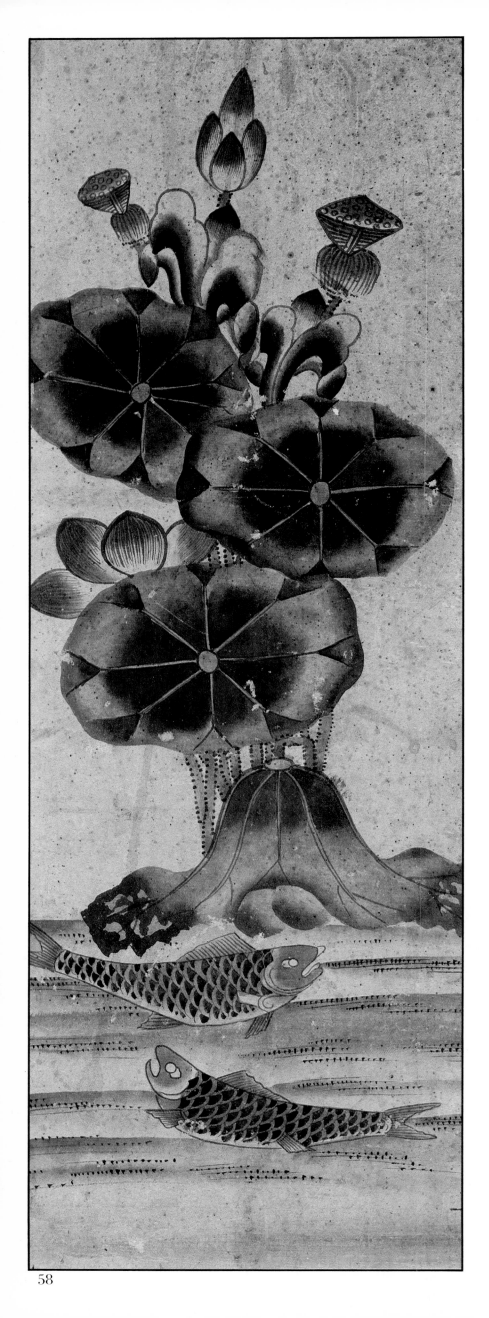

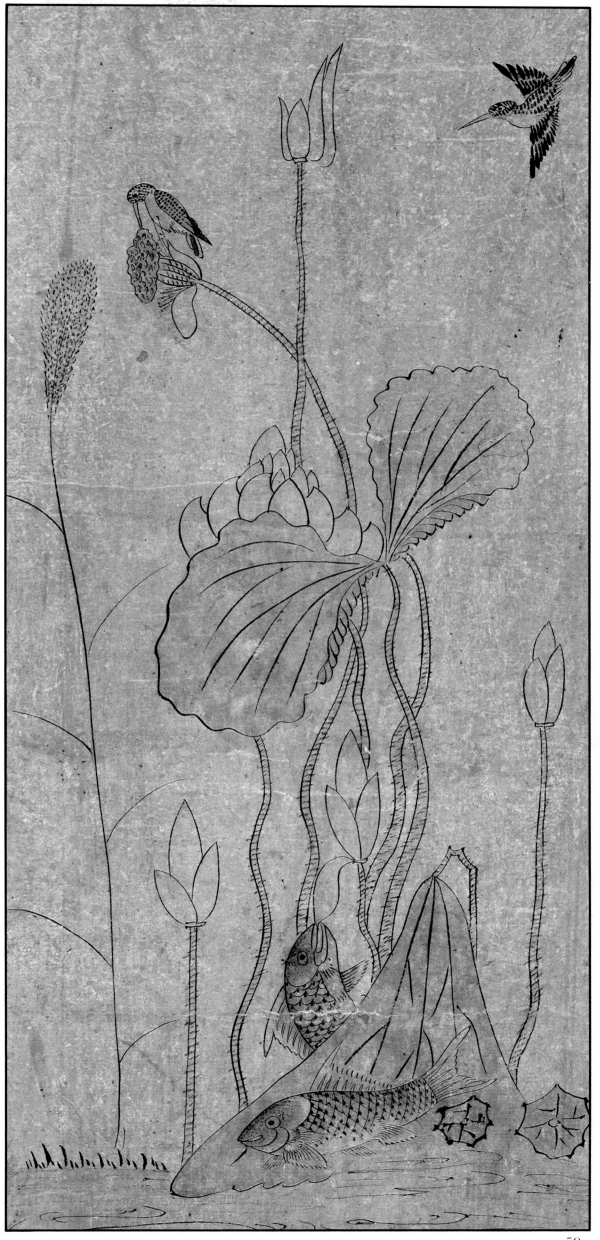

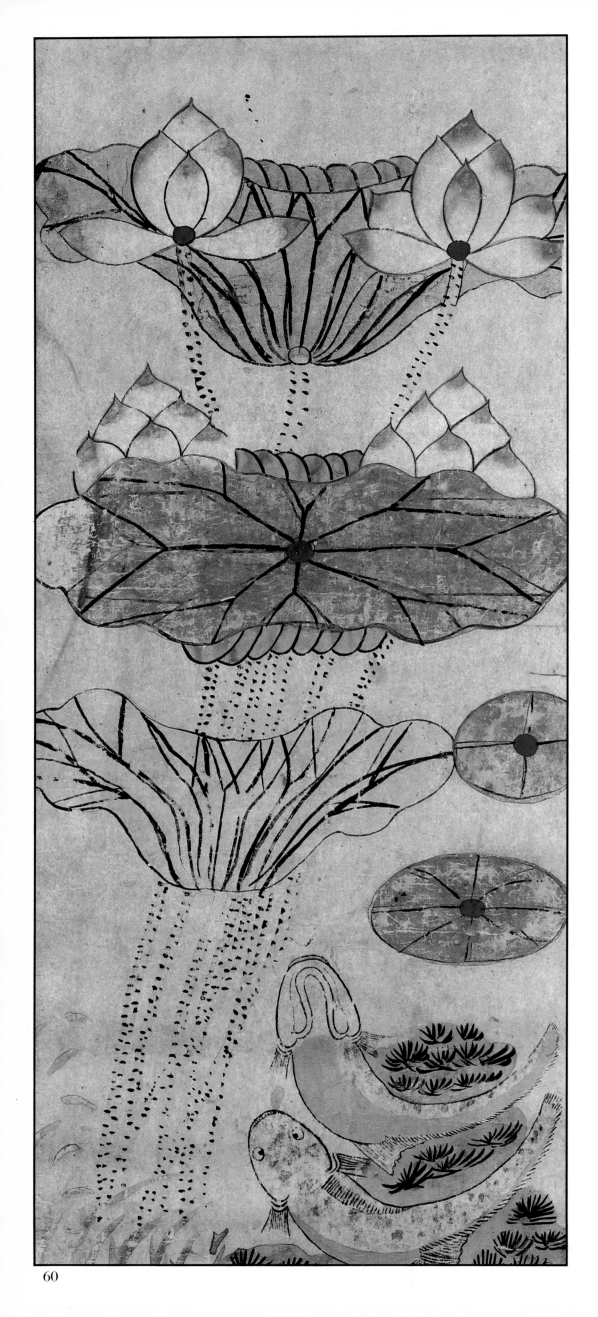

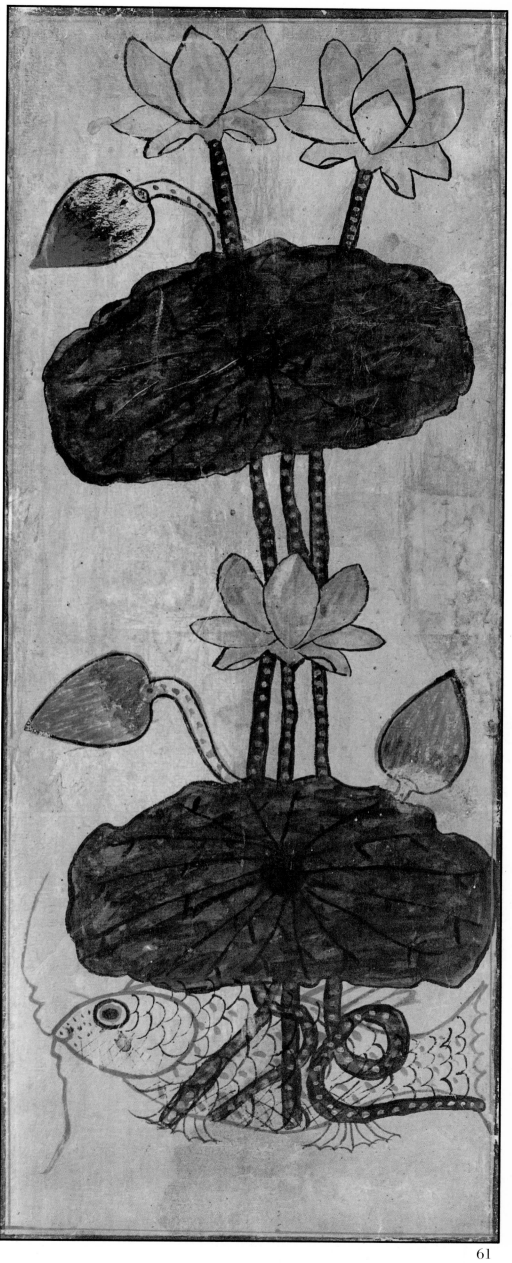

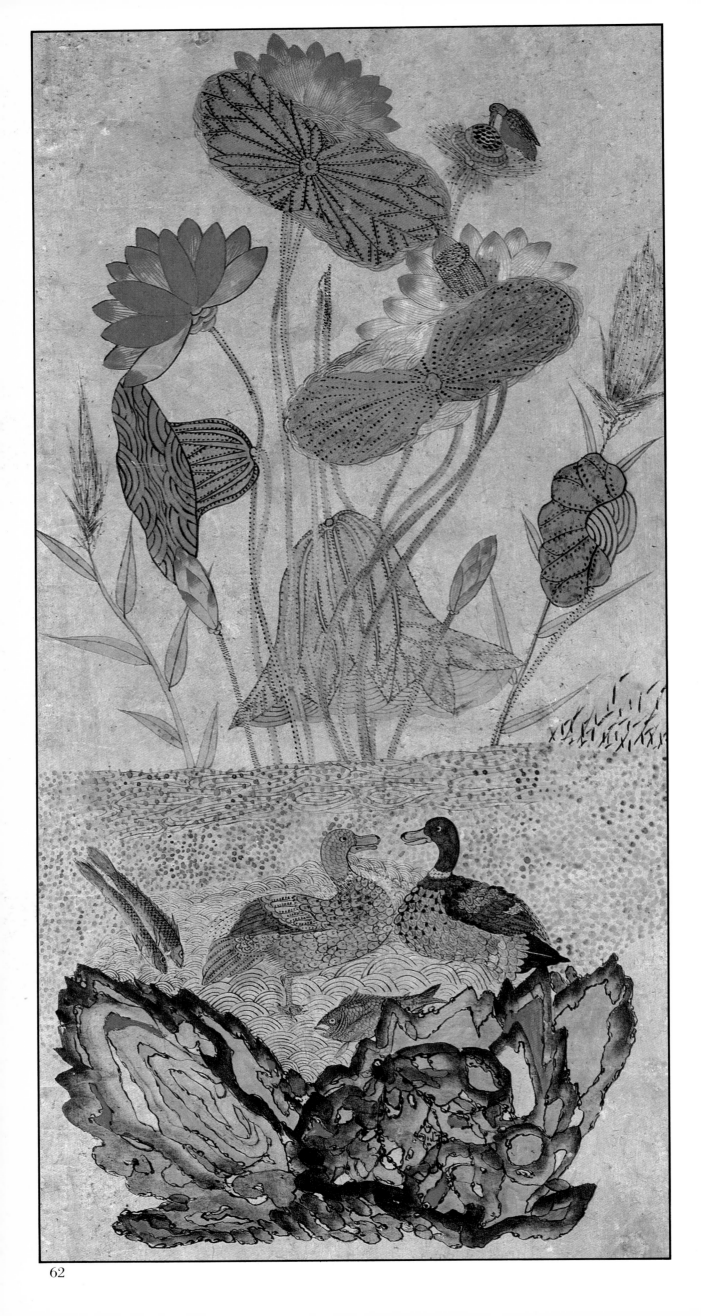

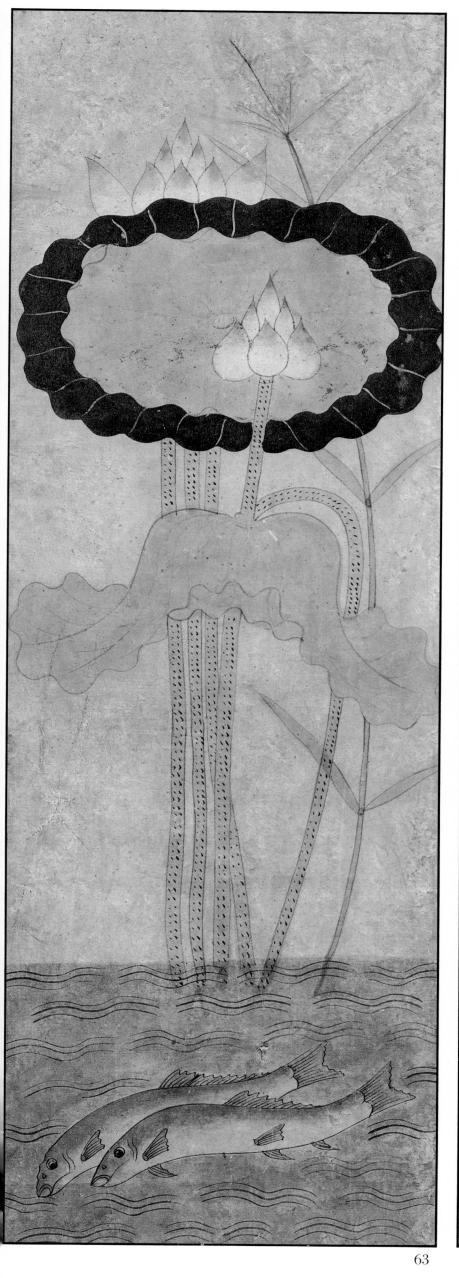

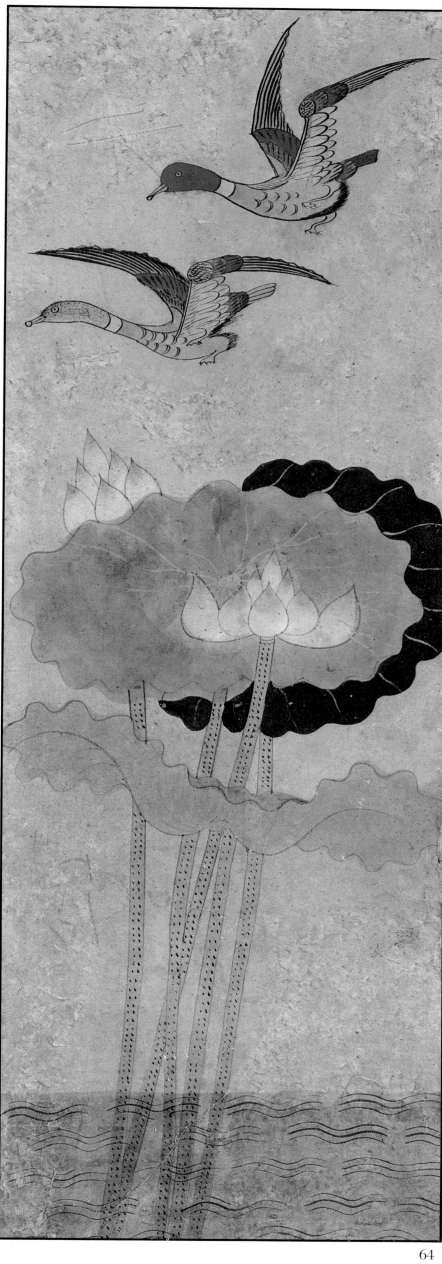

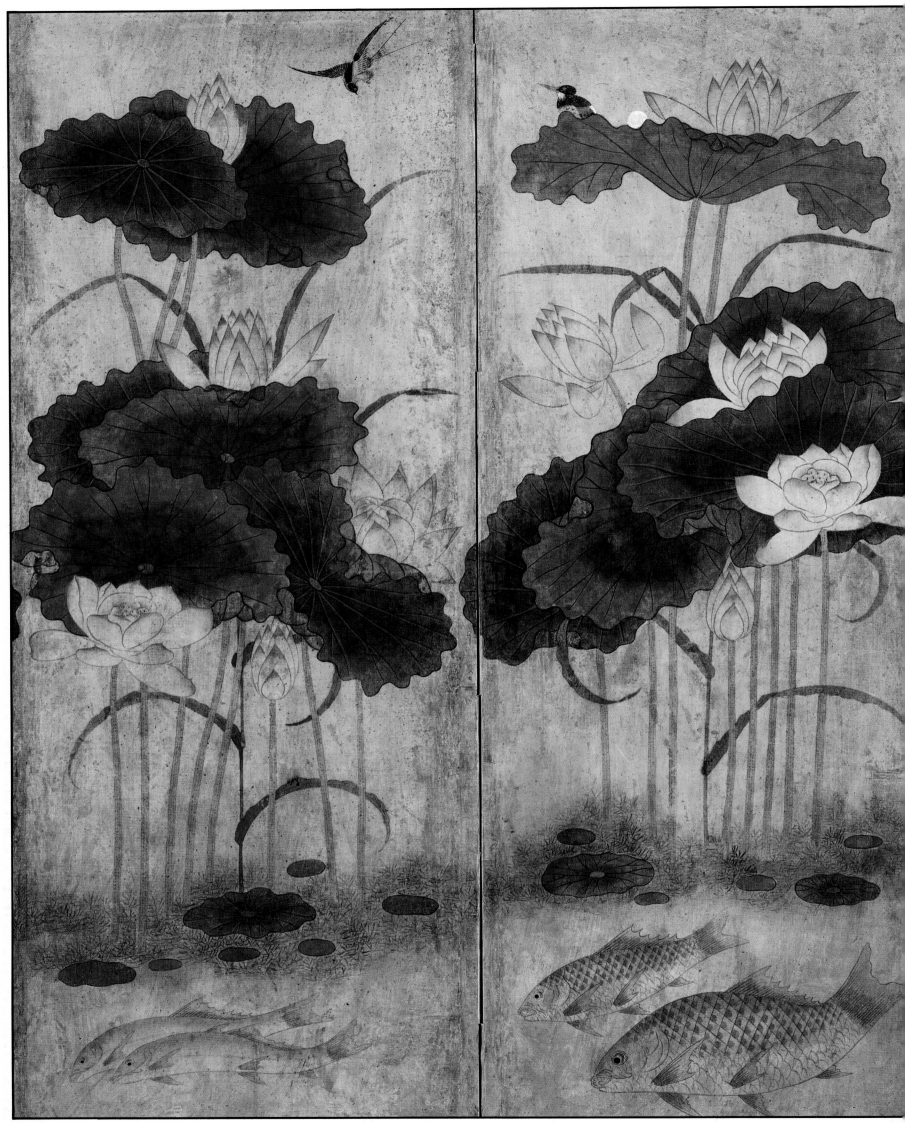

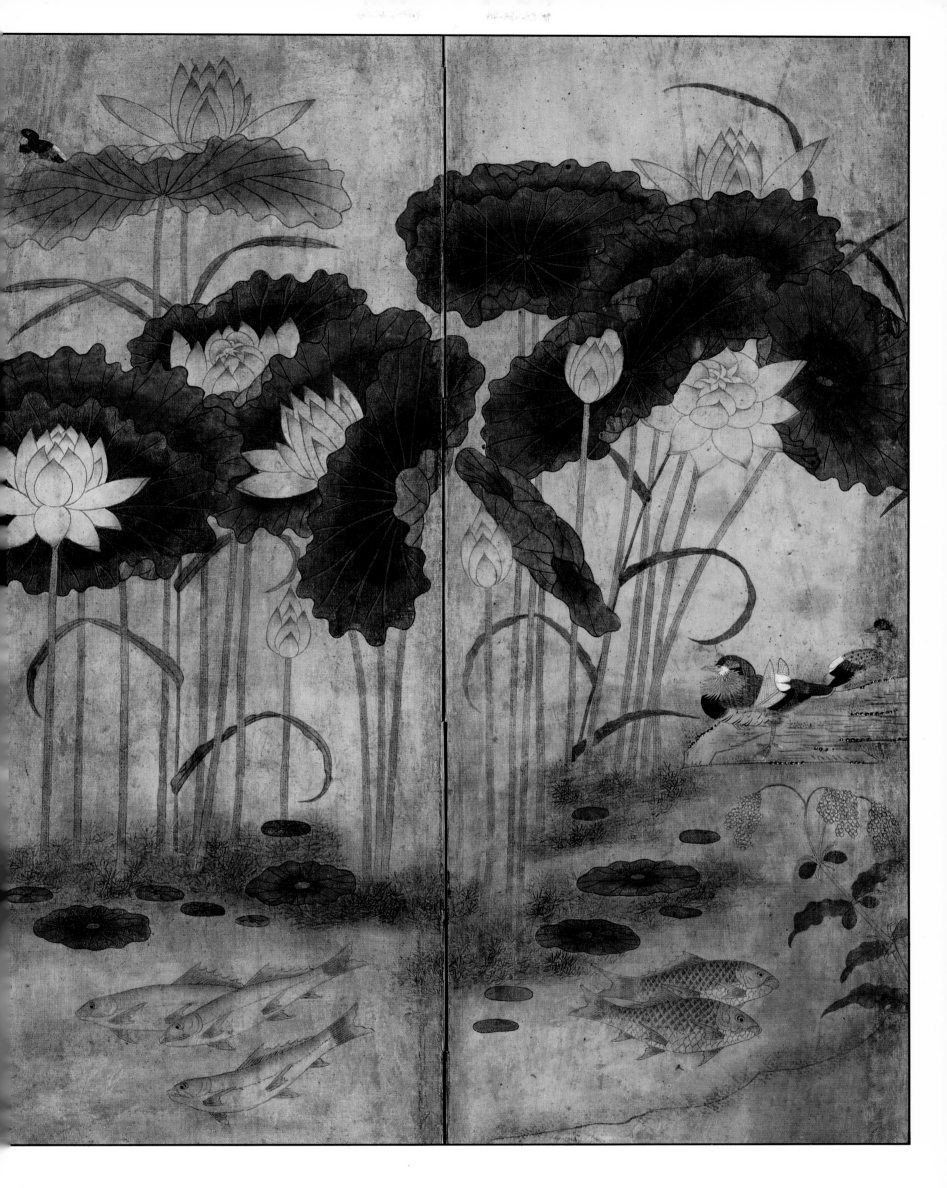

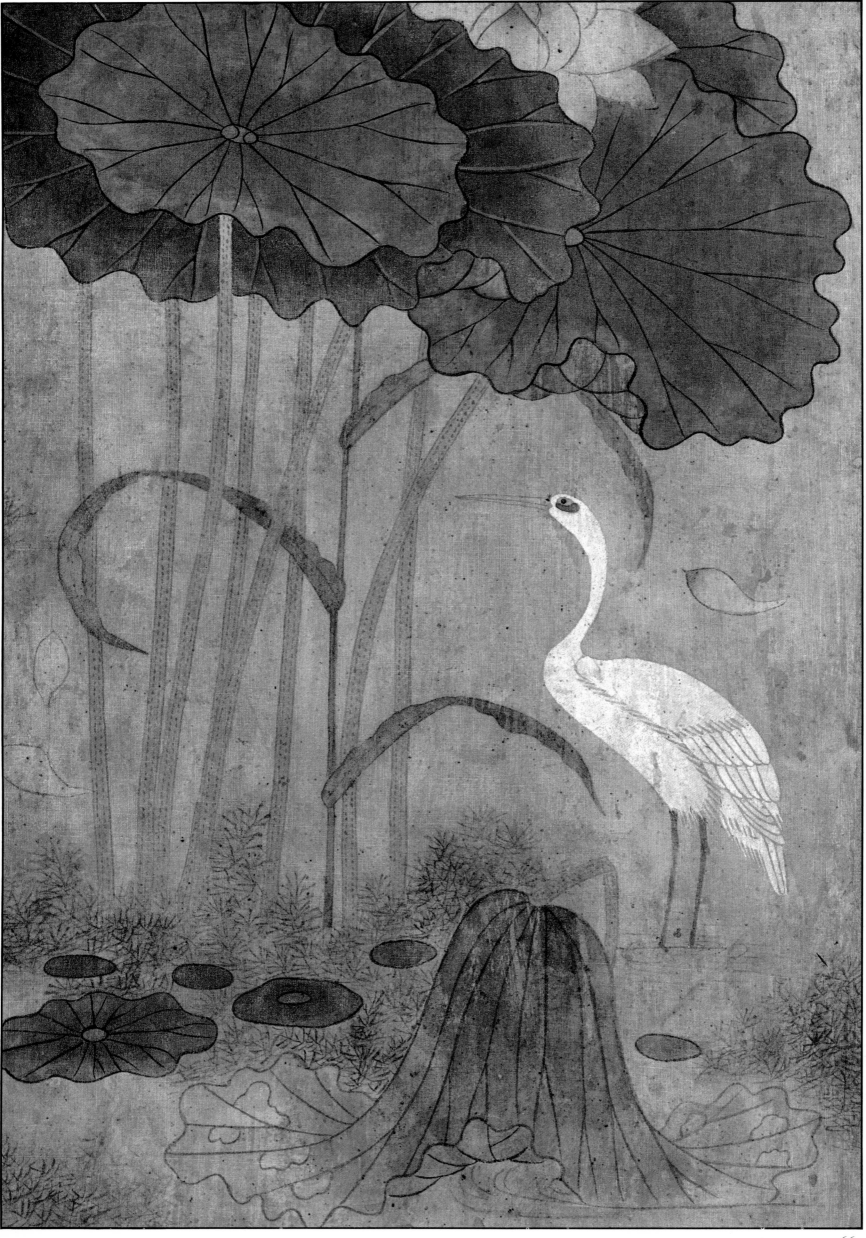

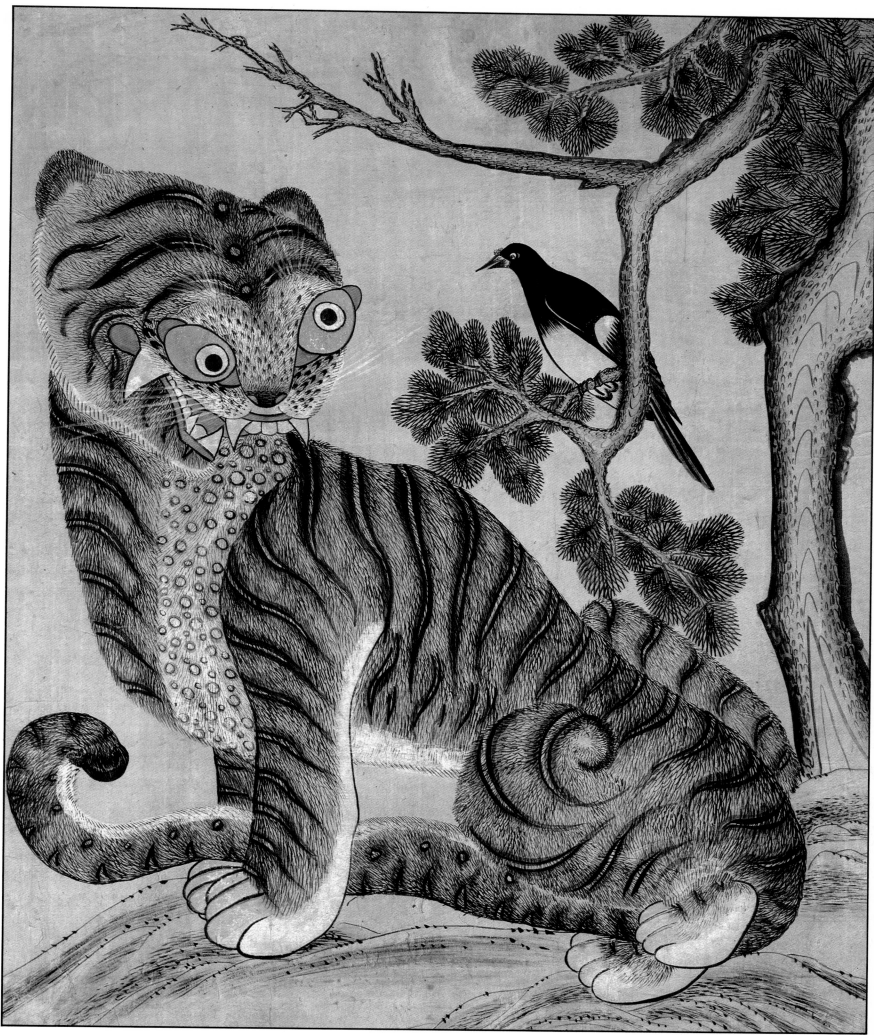

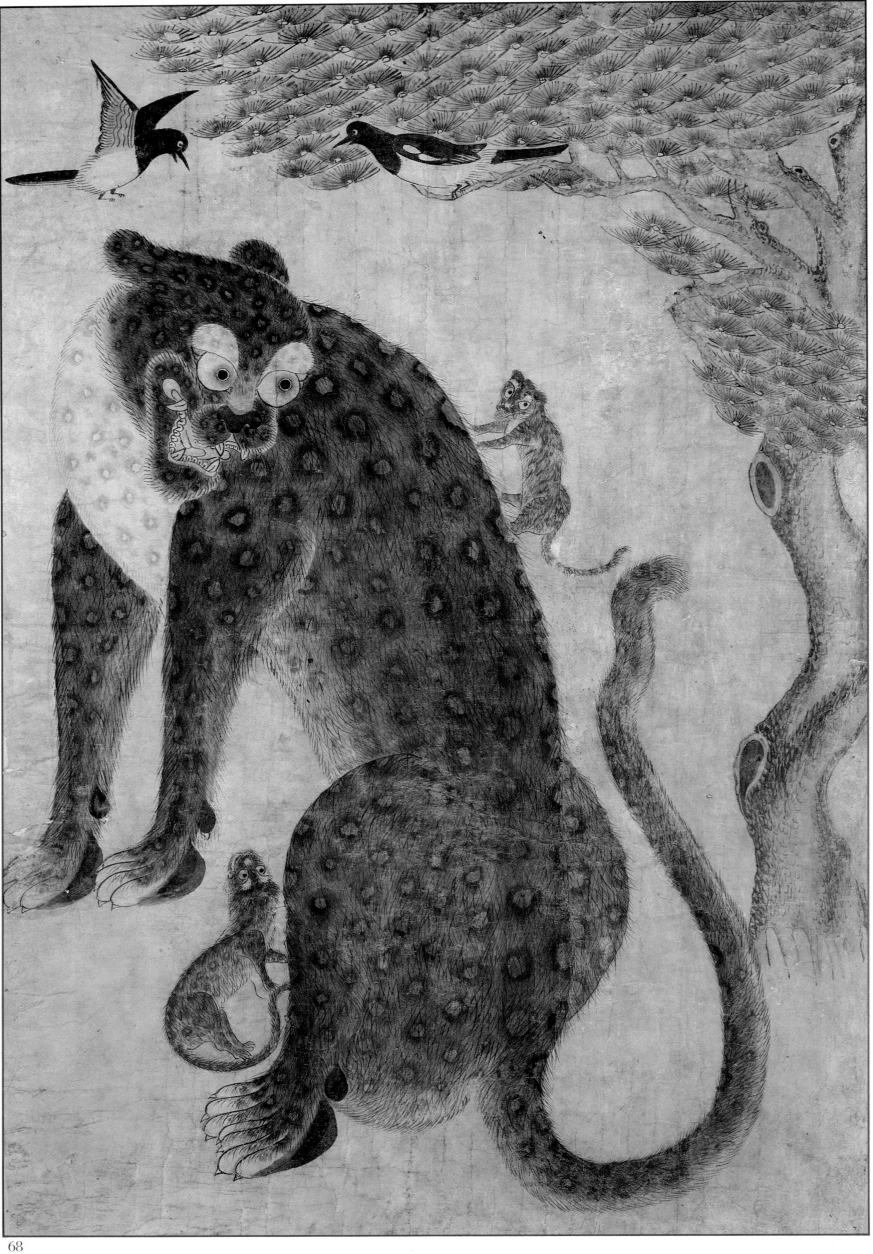

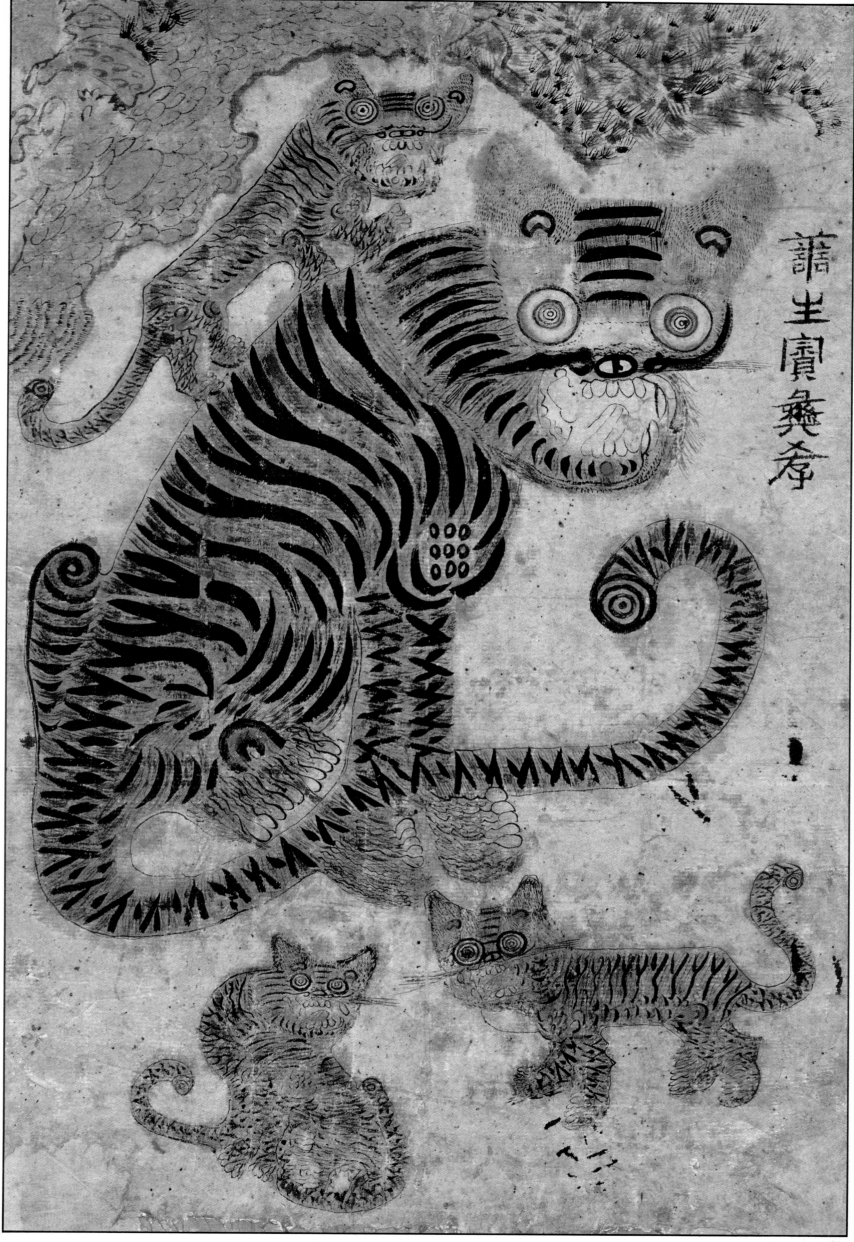

蘦生賓矗夆

69

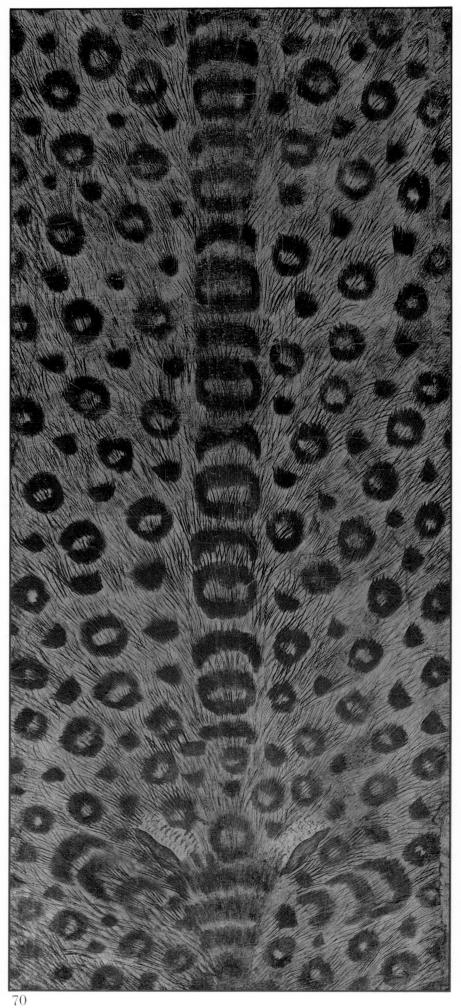

70

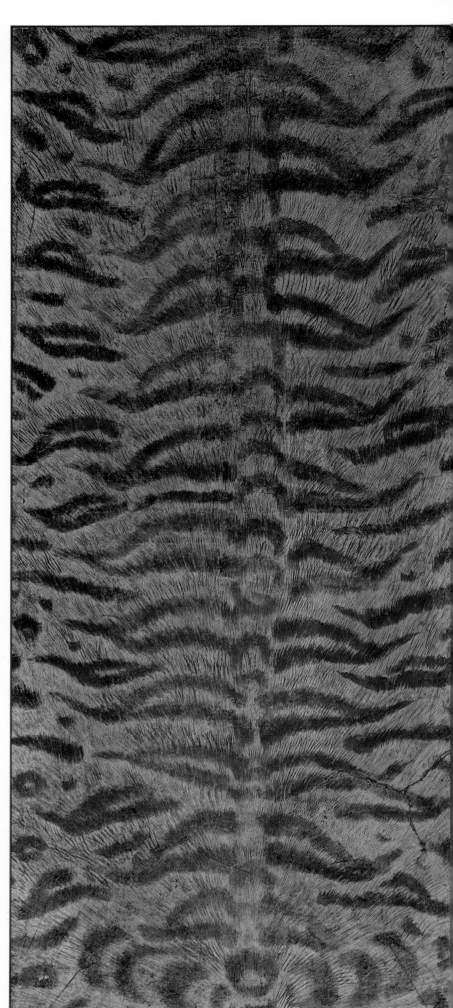

71

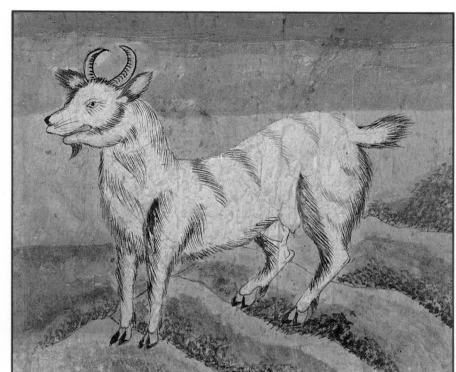

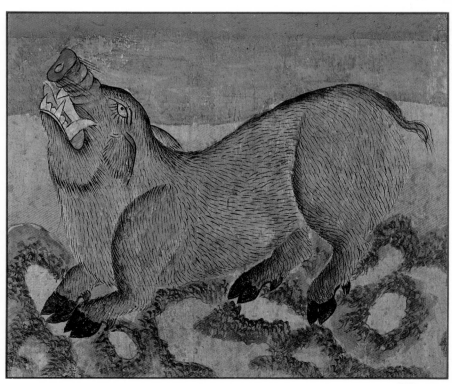

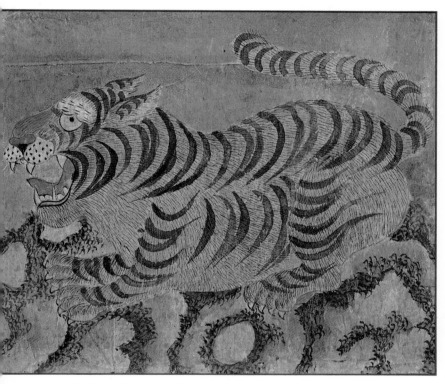

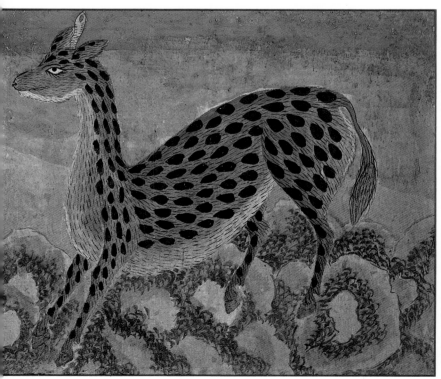

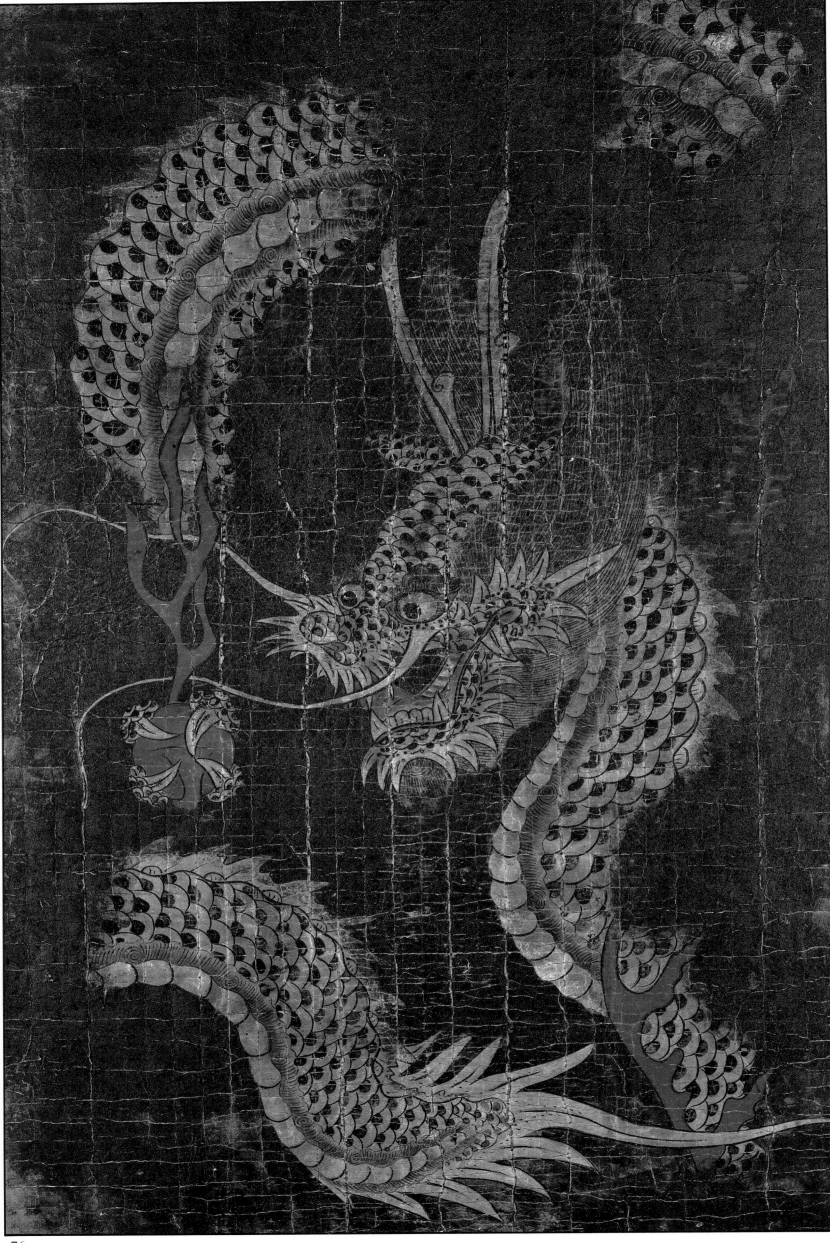

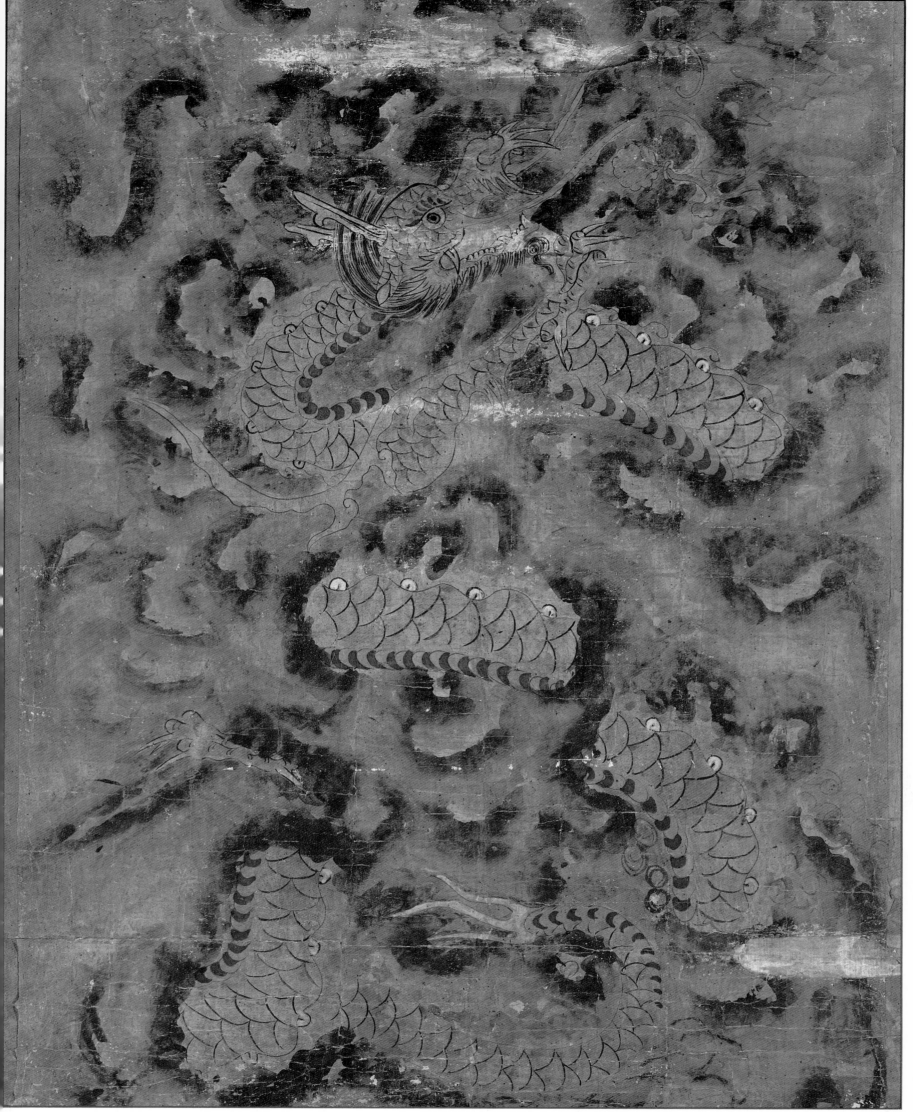

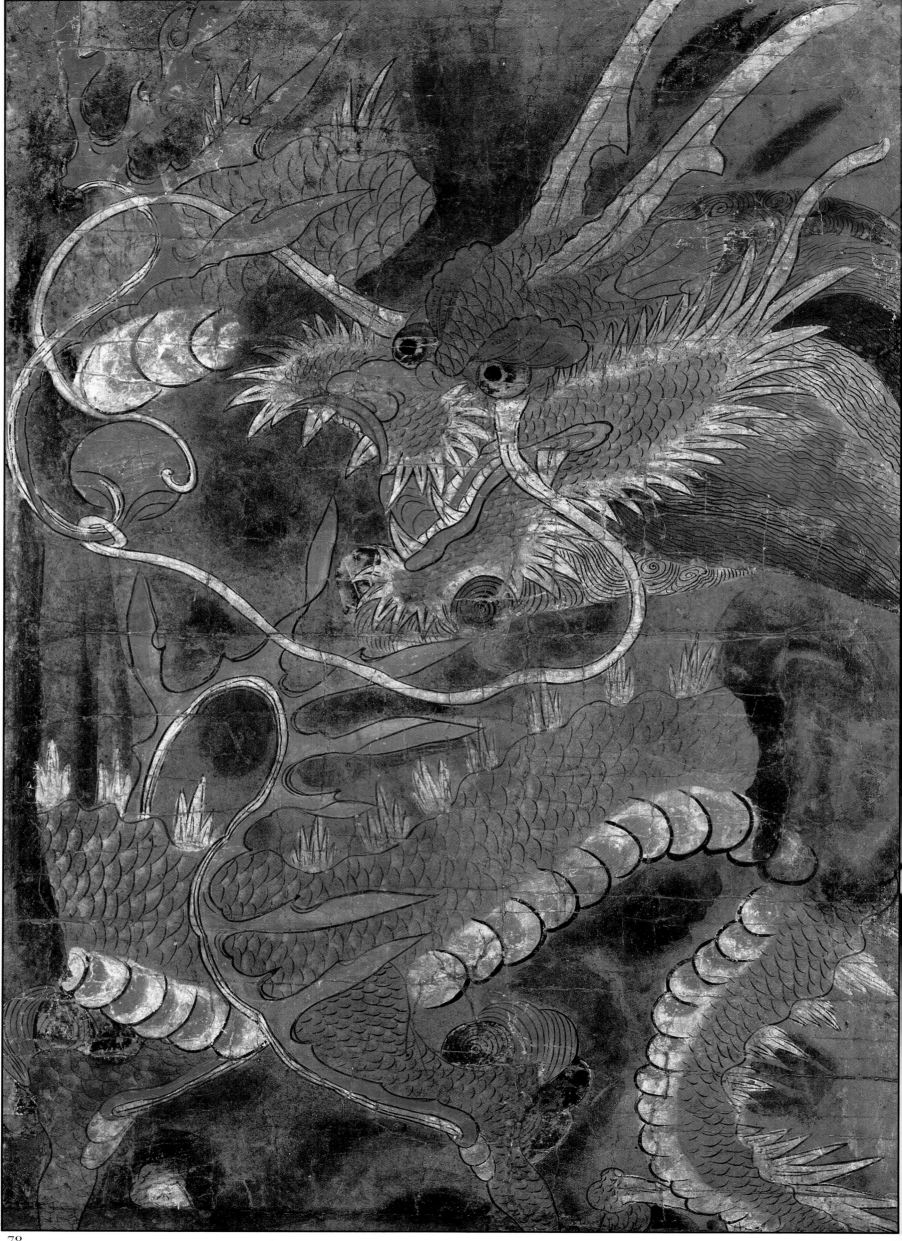

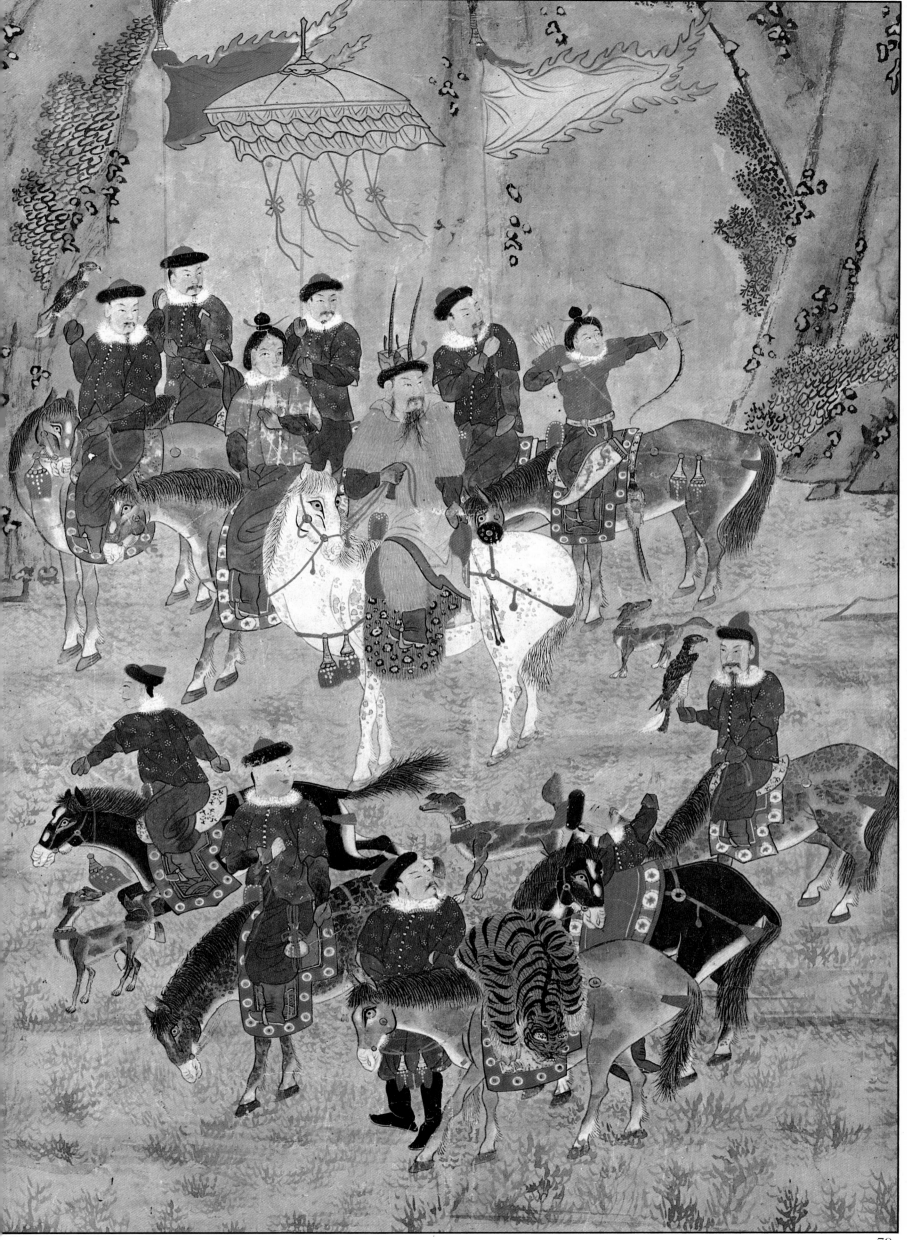

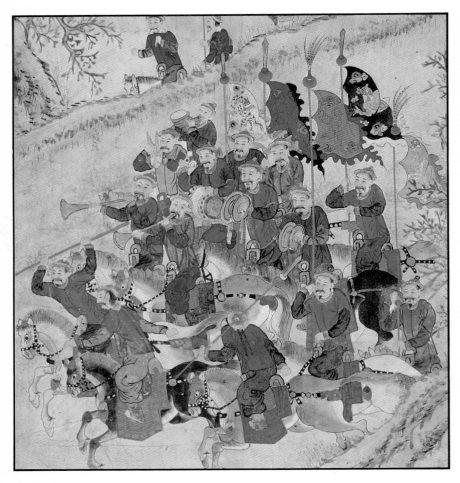

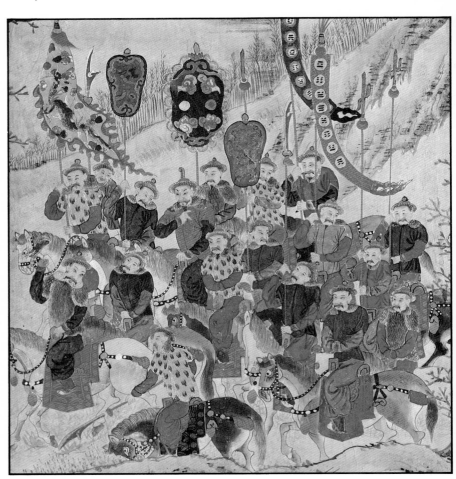

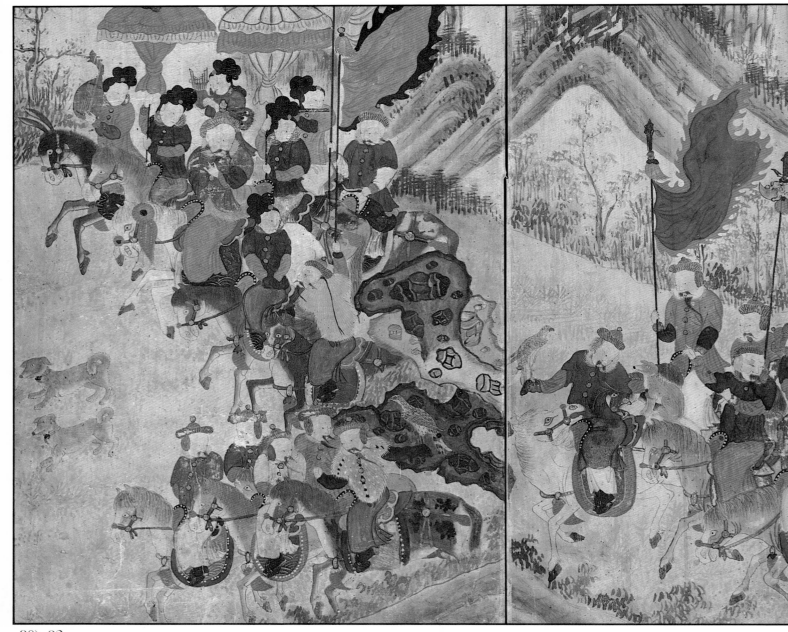

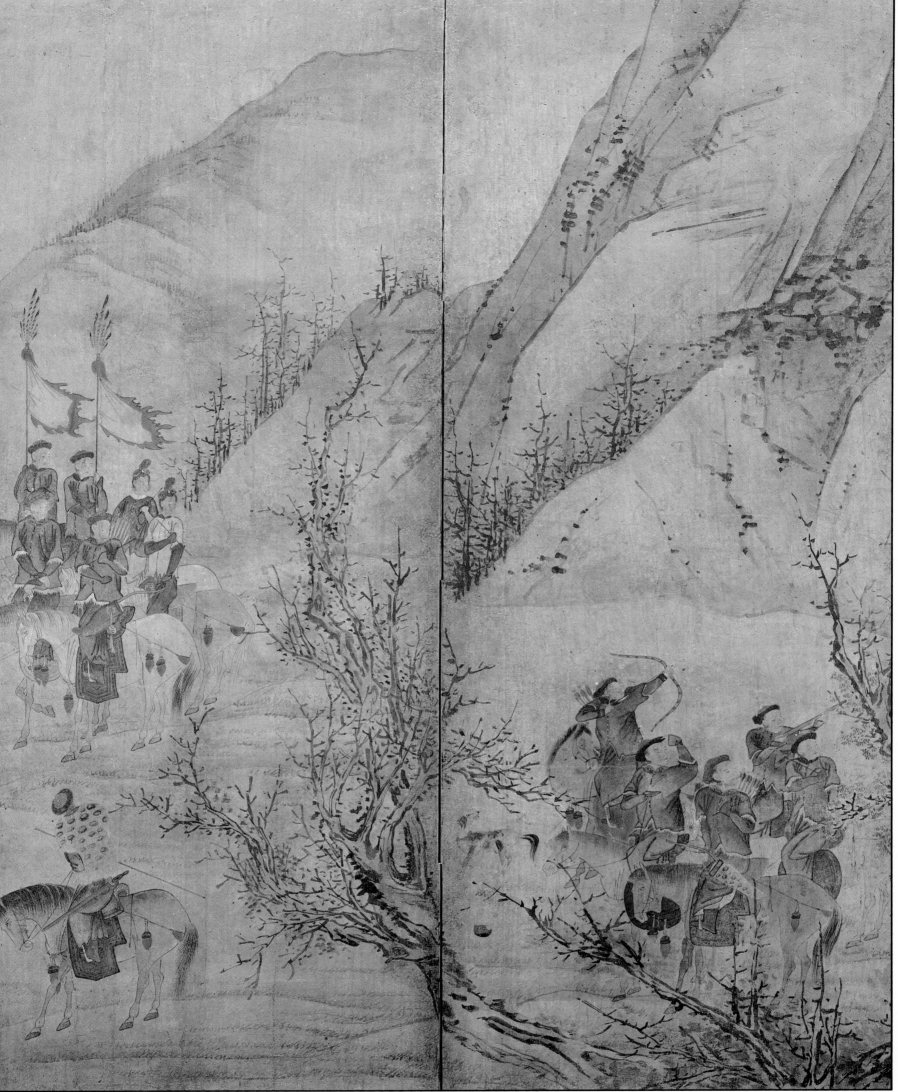

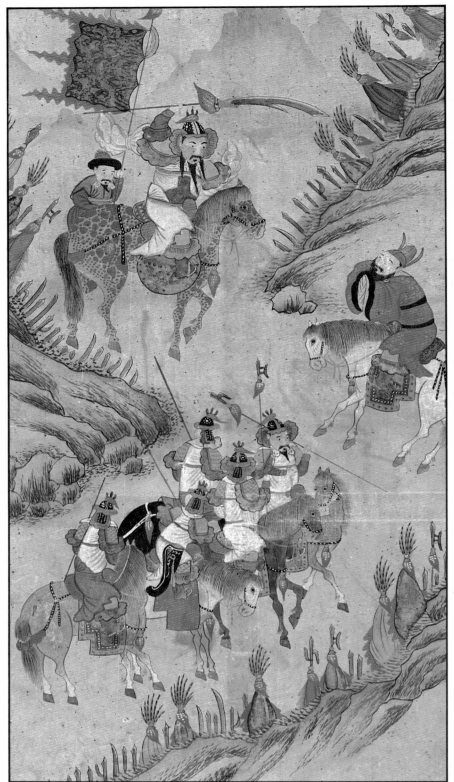

84

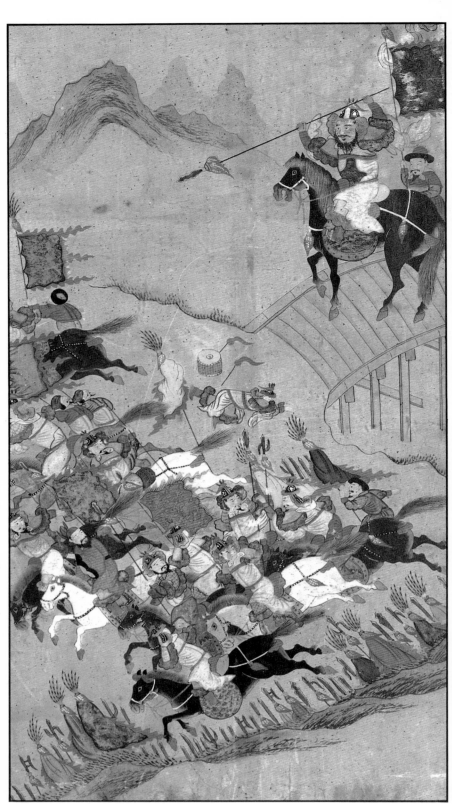

85

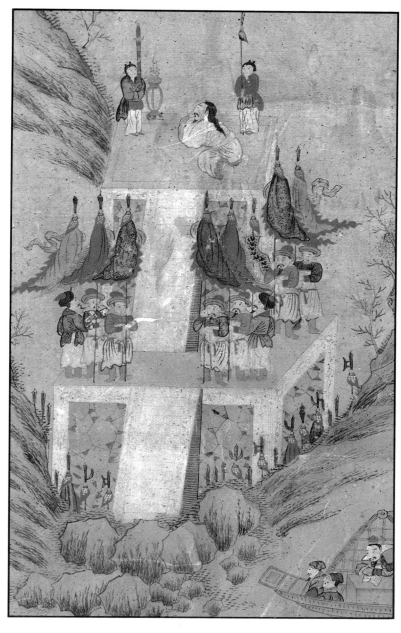

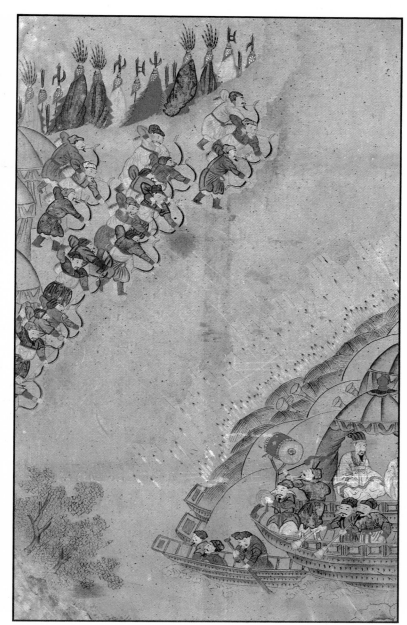

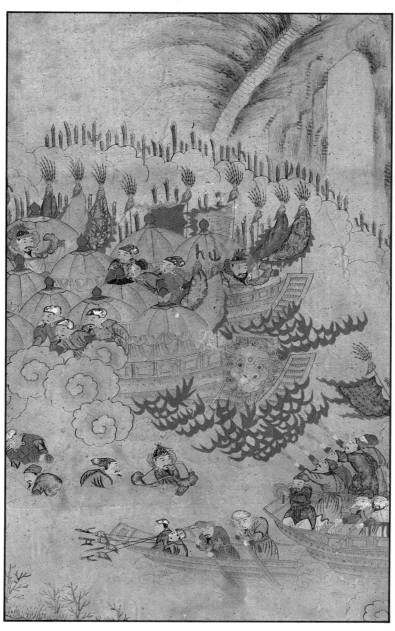

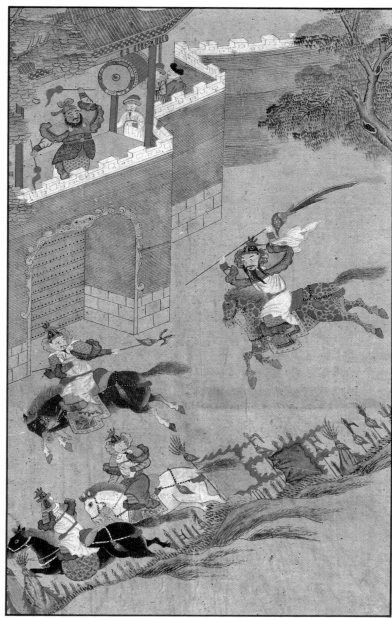

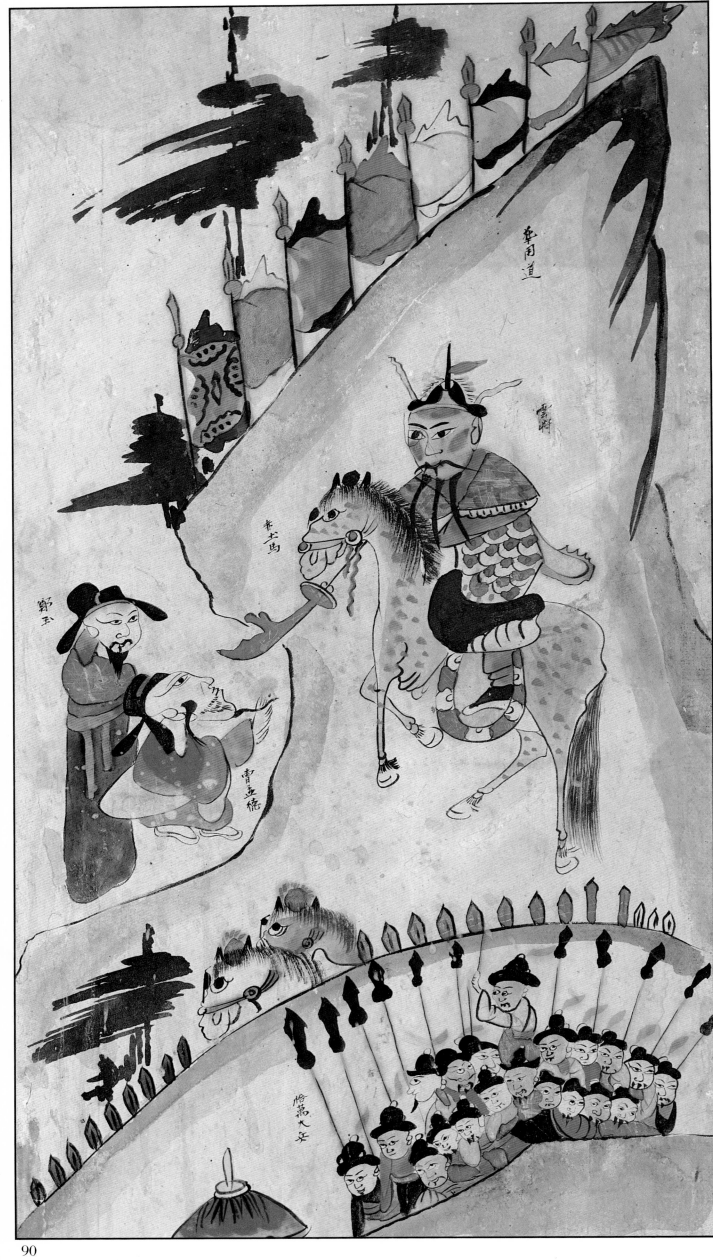

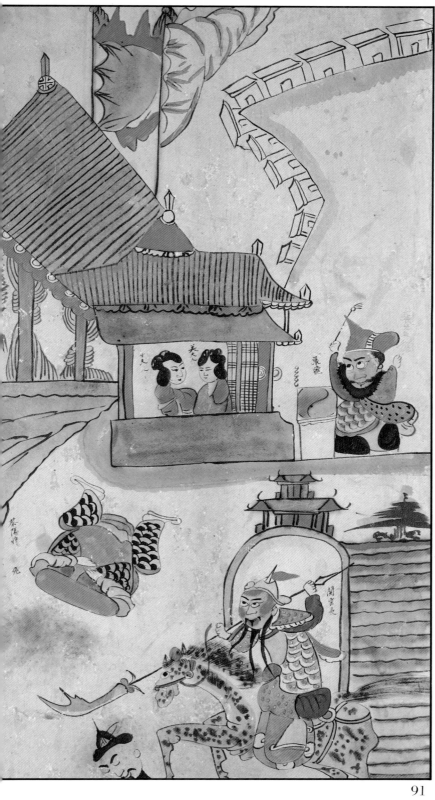

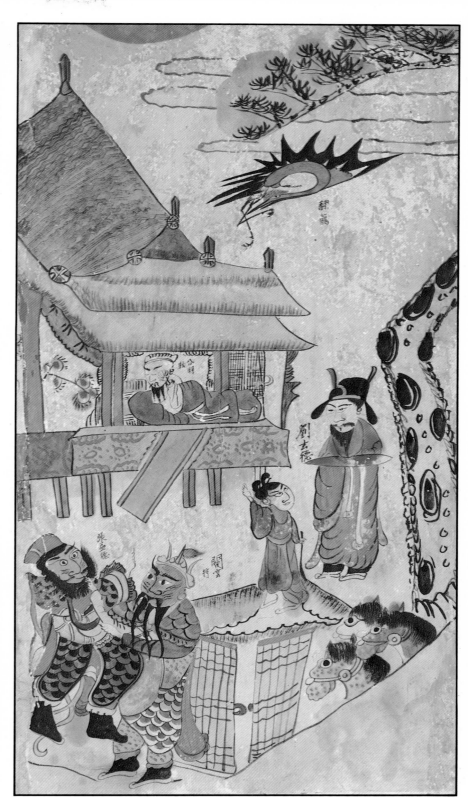

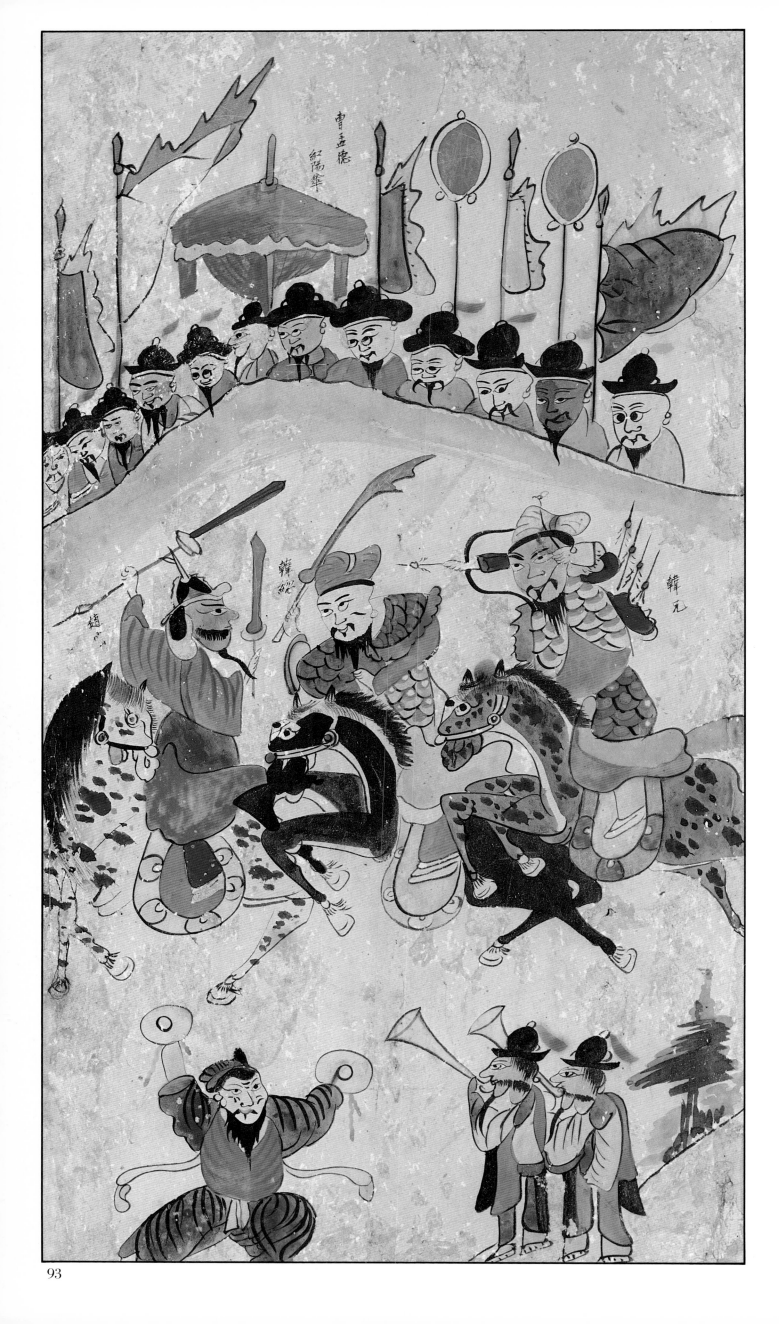

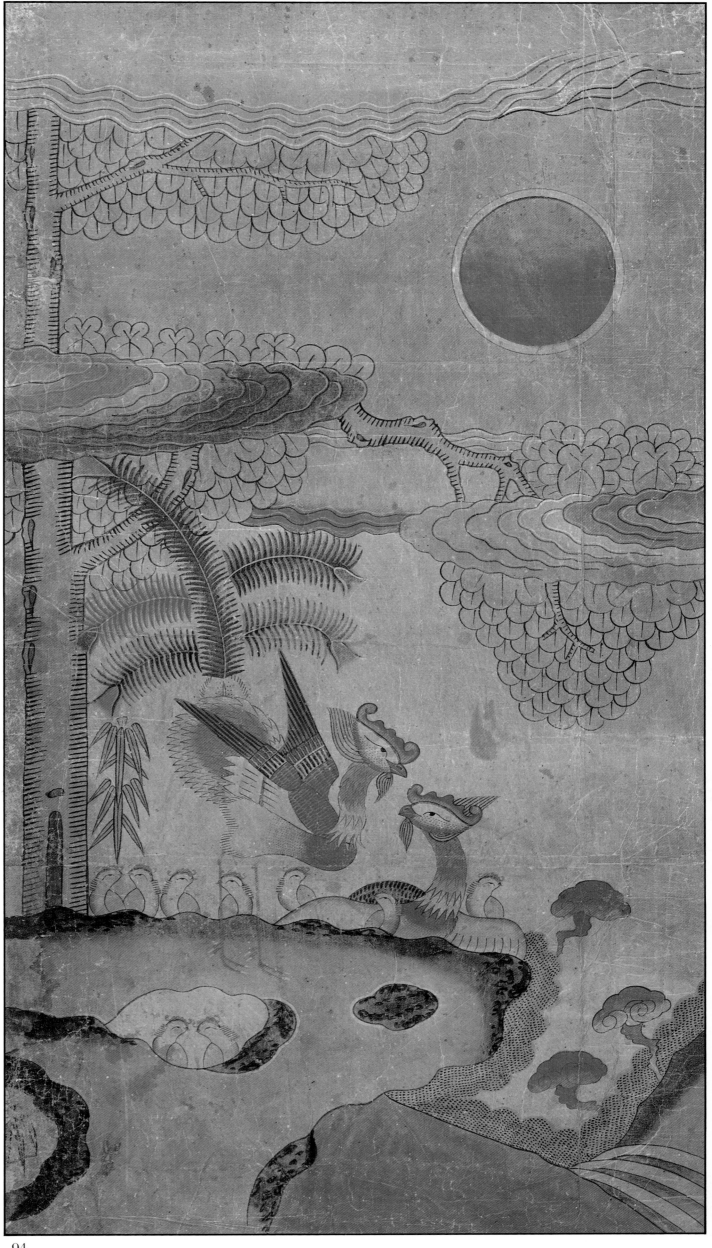

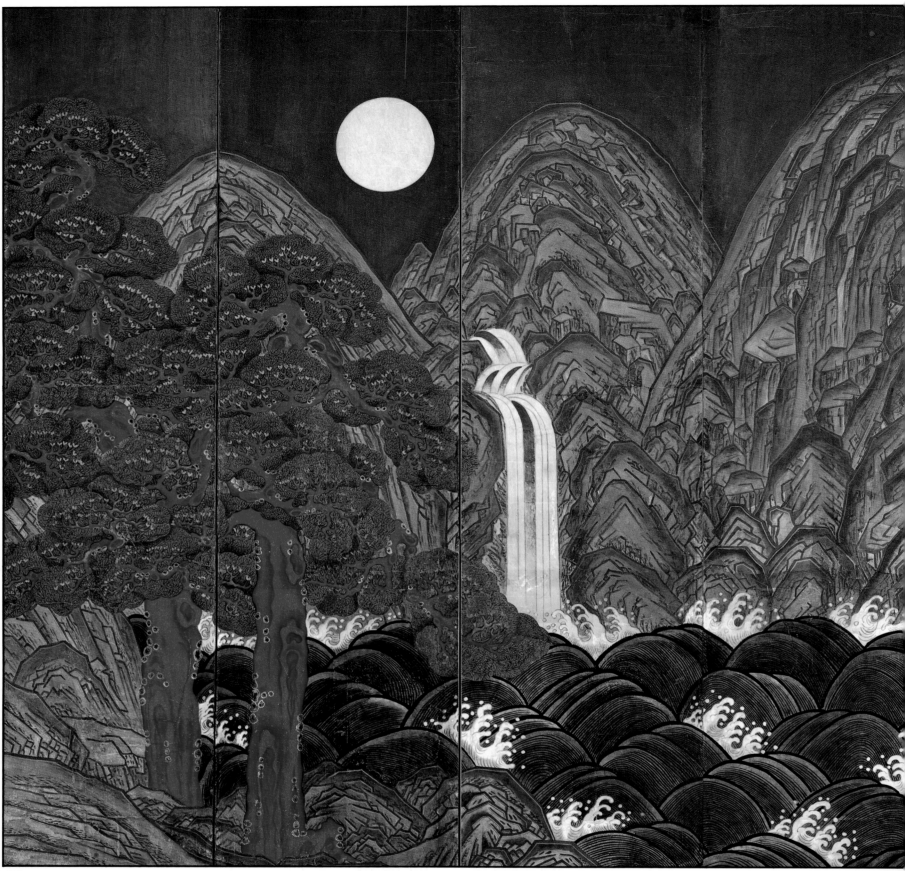

95

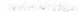

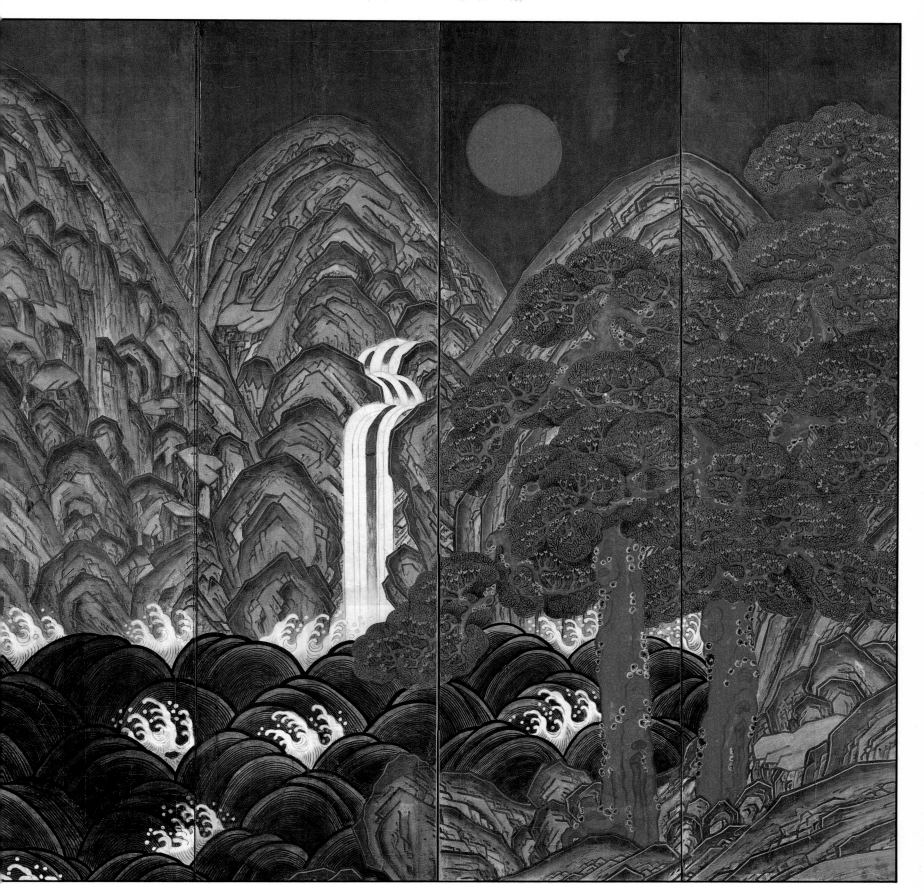

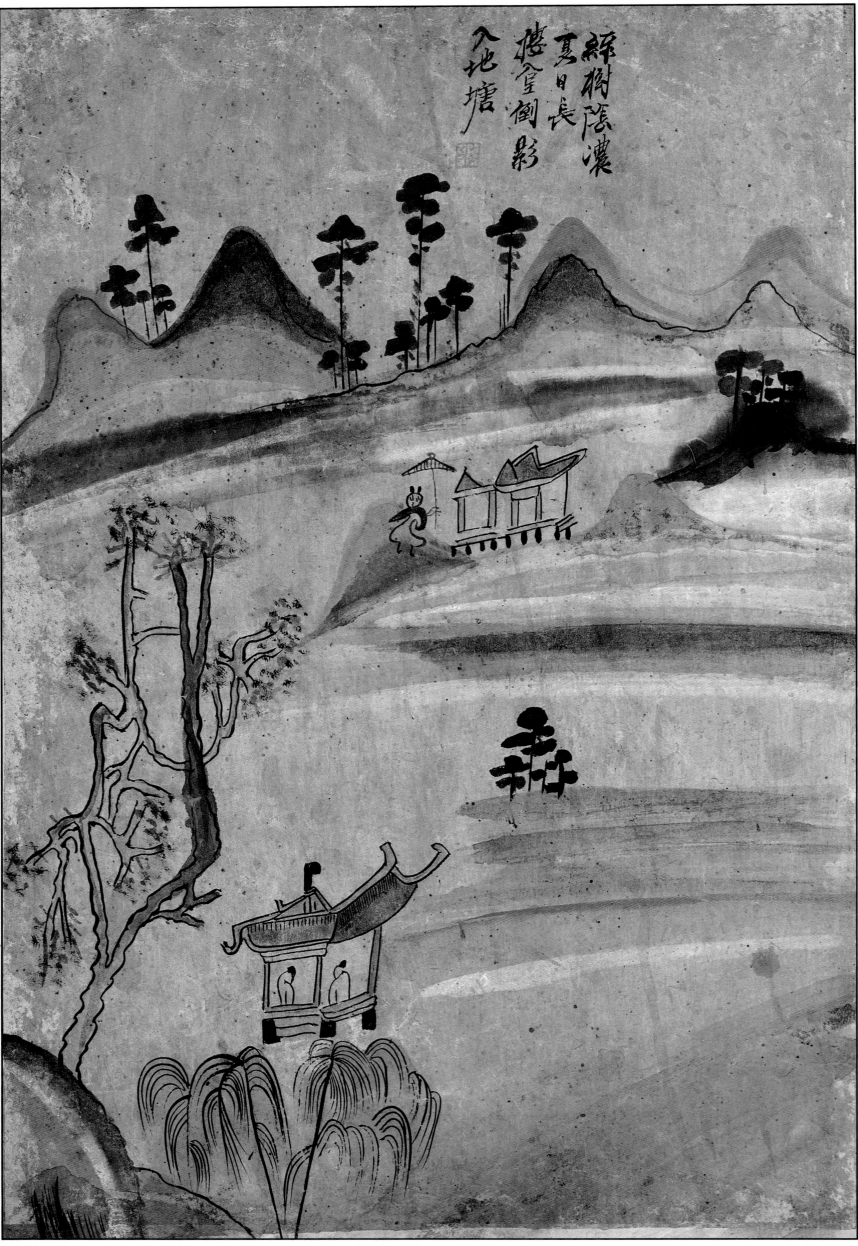

綠樹陰濃
夏日長
樓臺倒影
入池塘

只在此山中
雲深
不知處

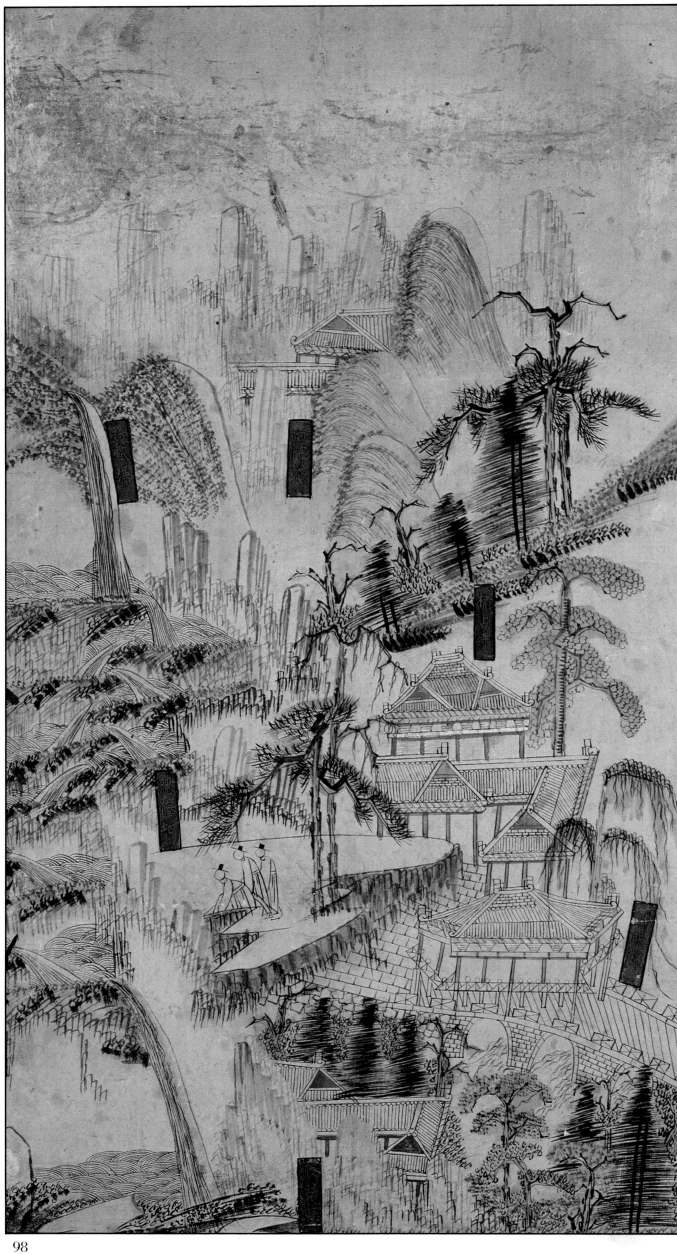

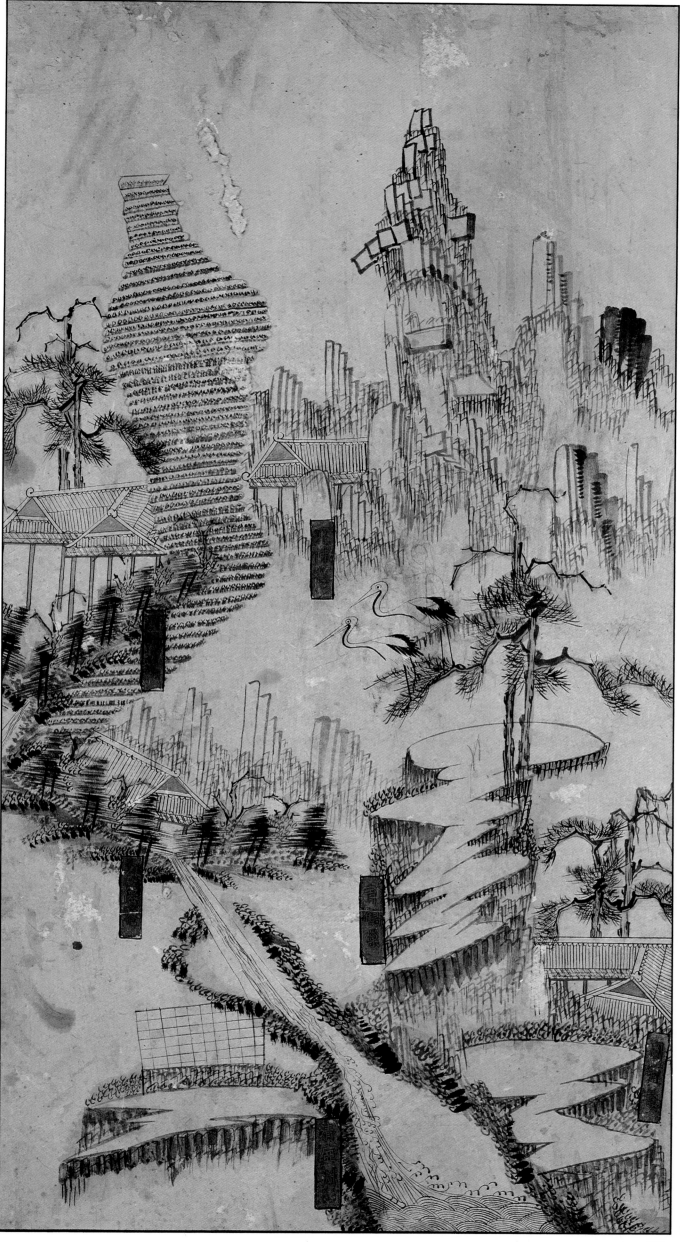

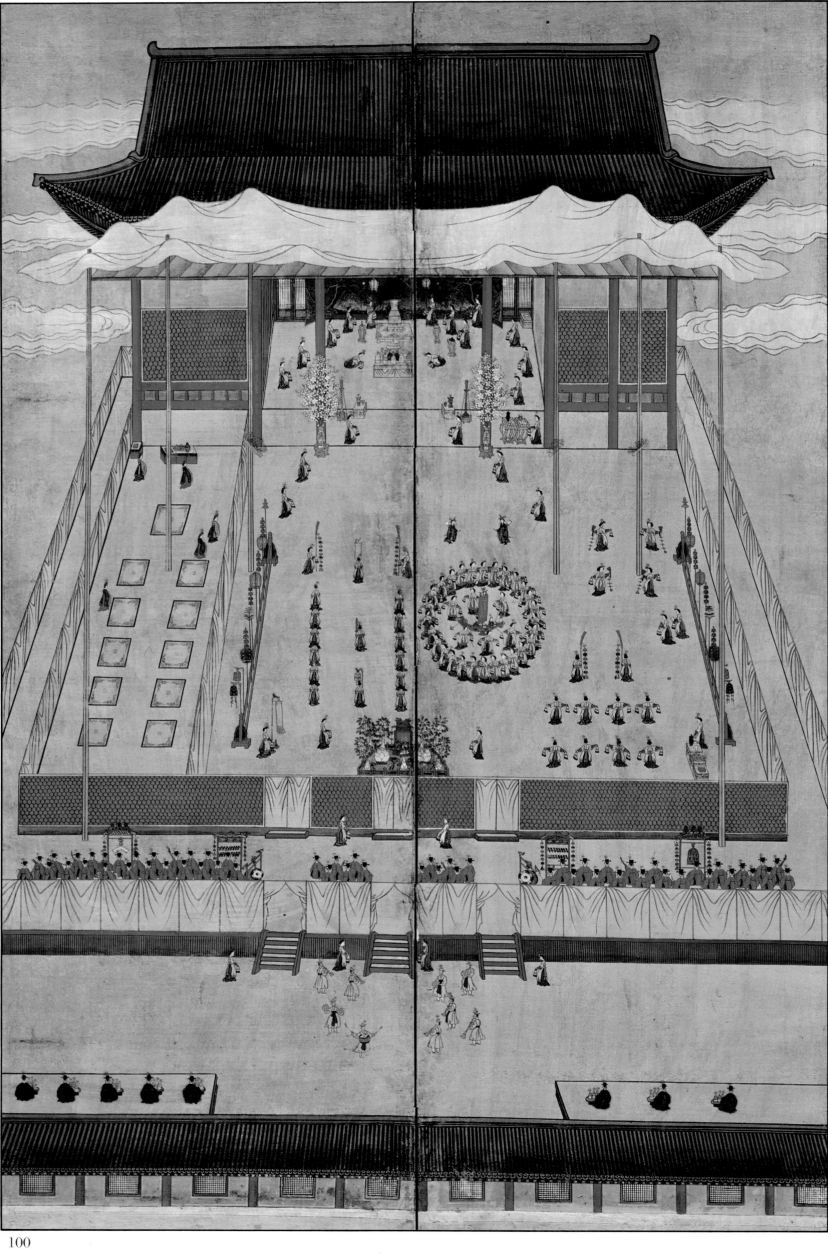

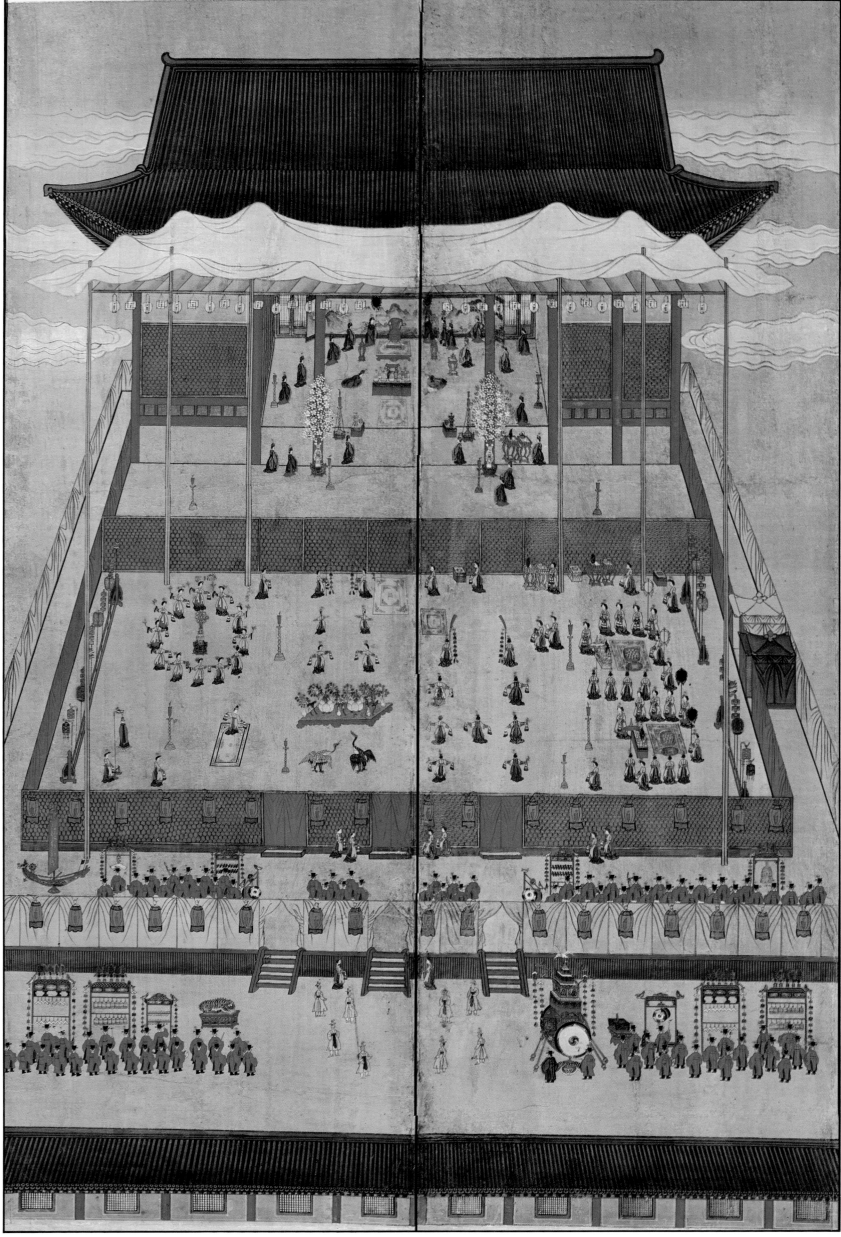

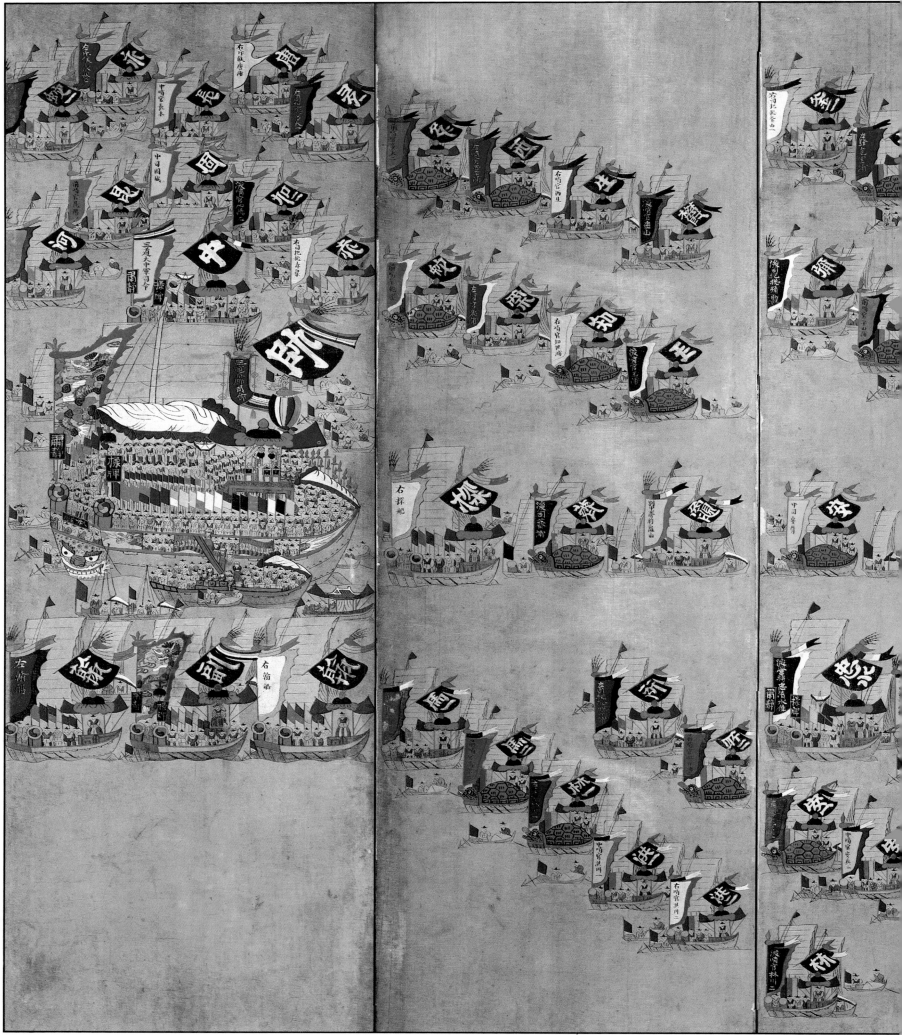

102

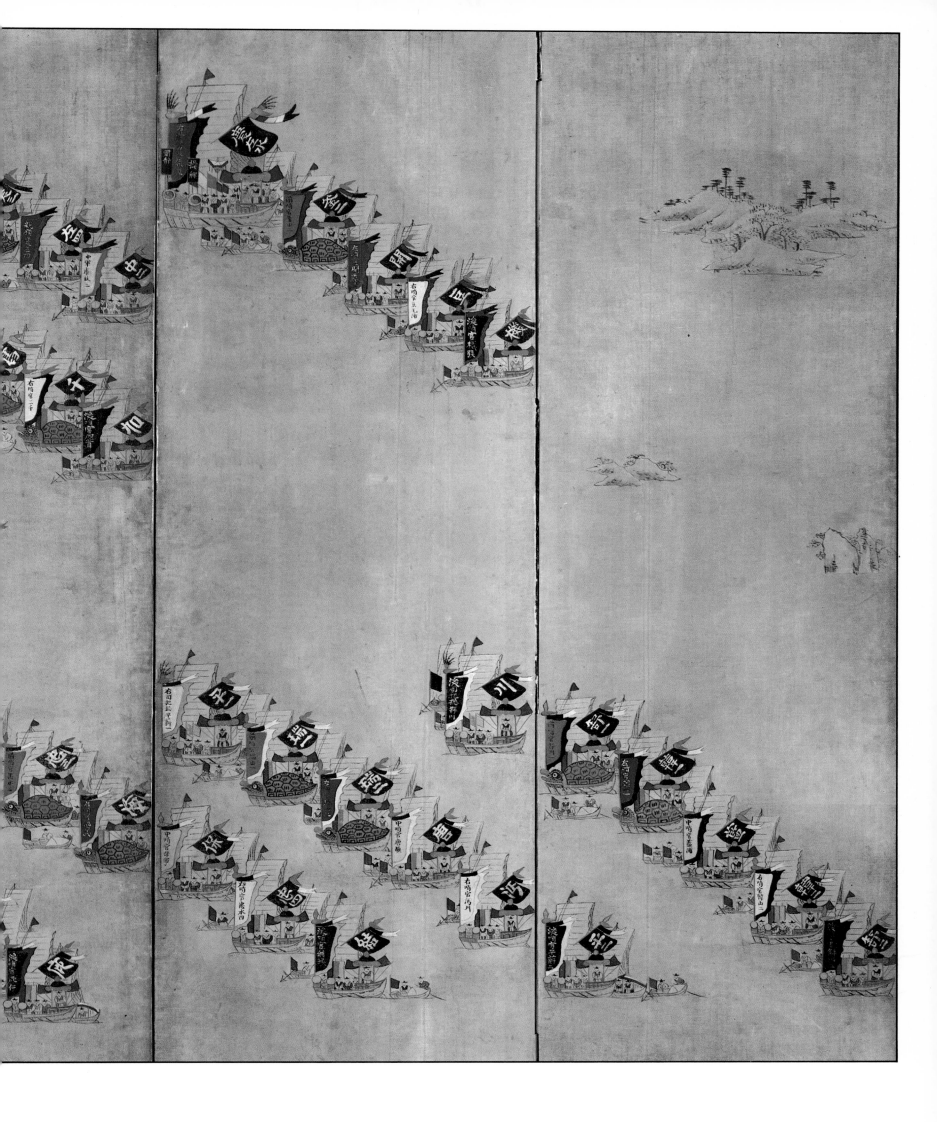

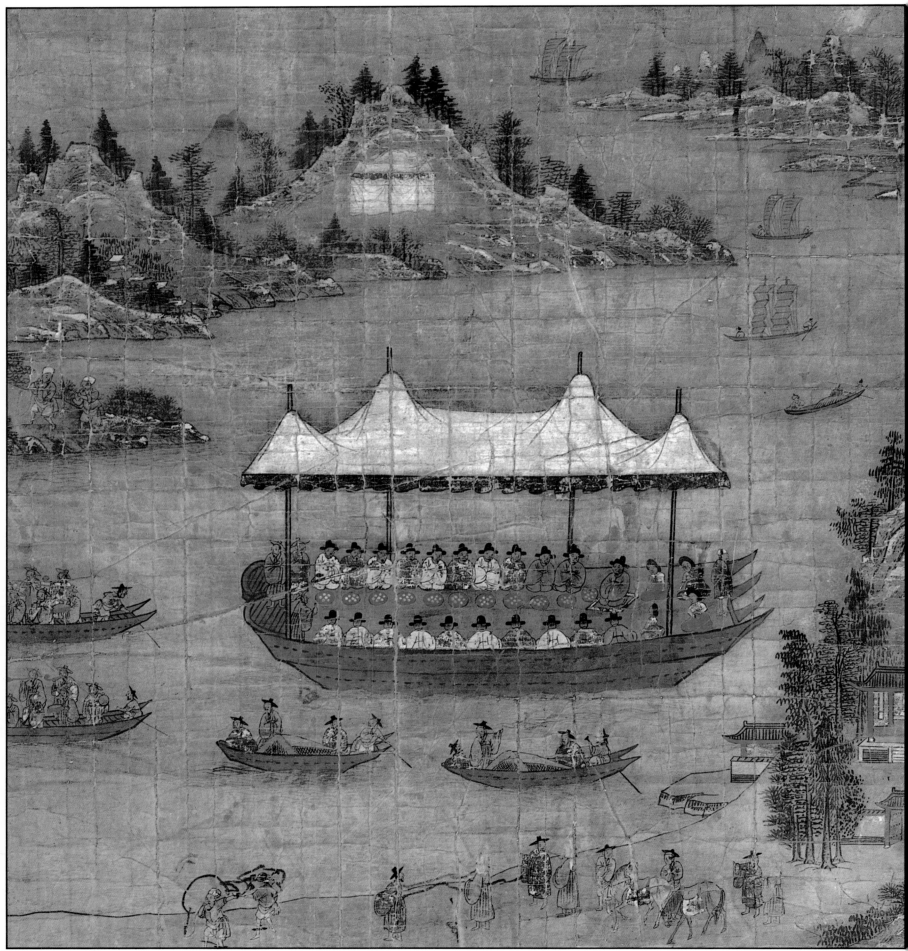

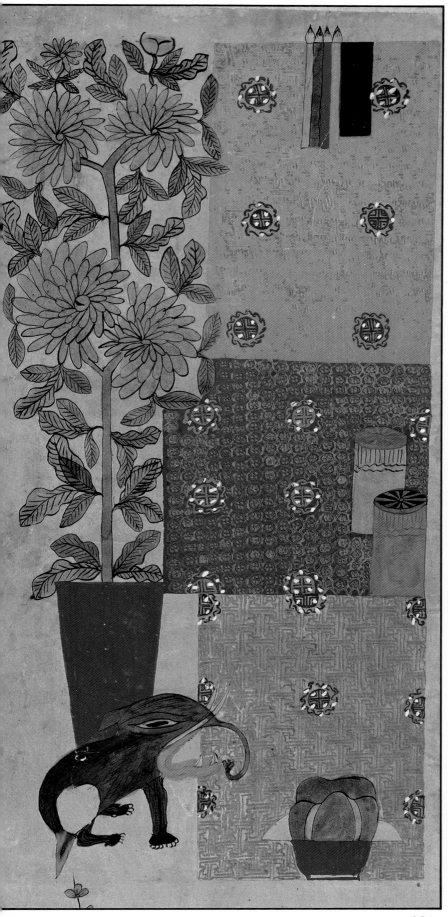

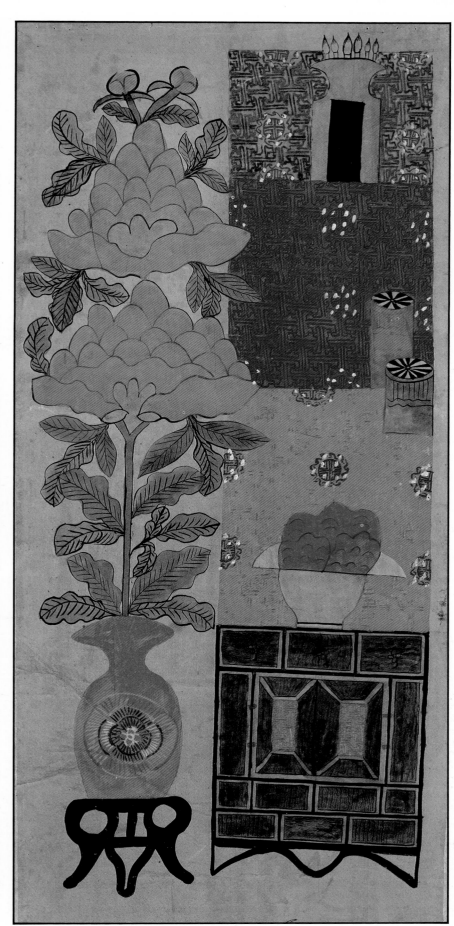

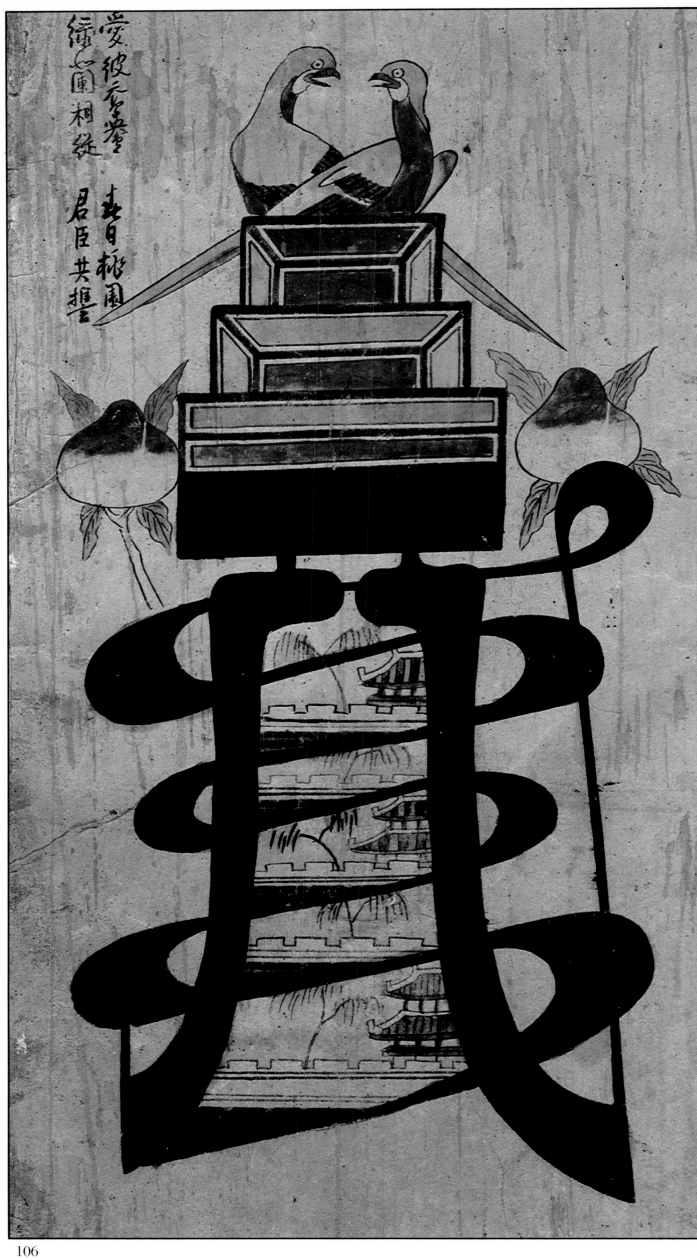

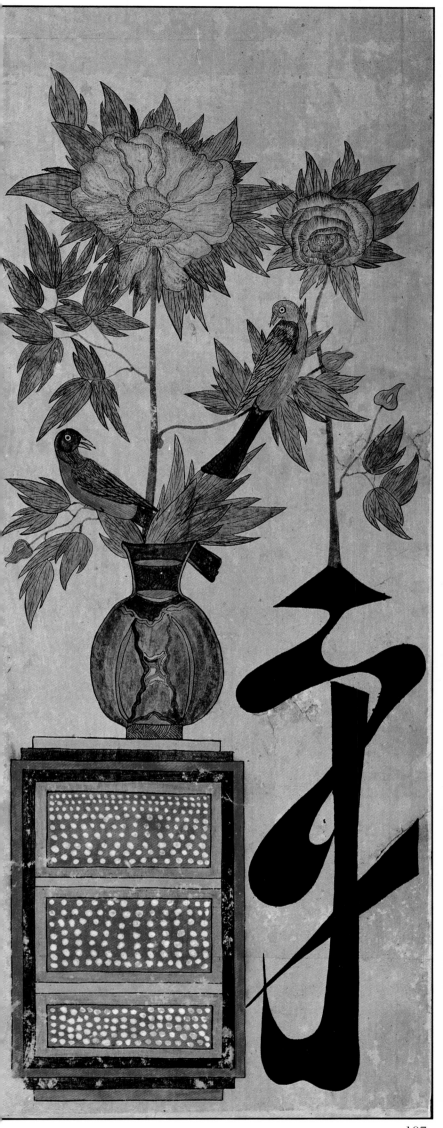

107

108

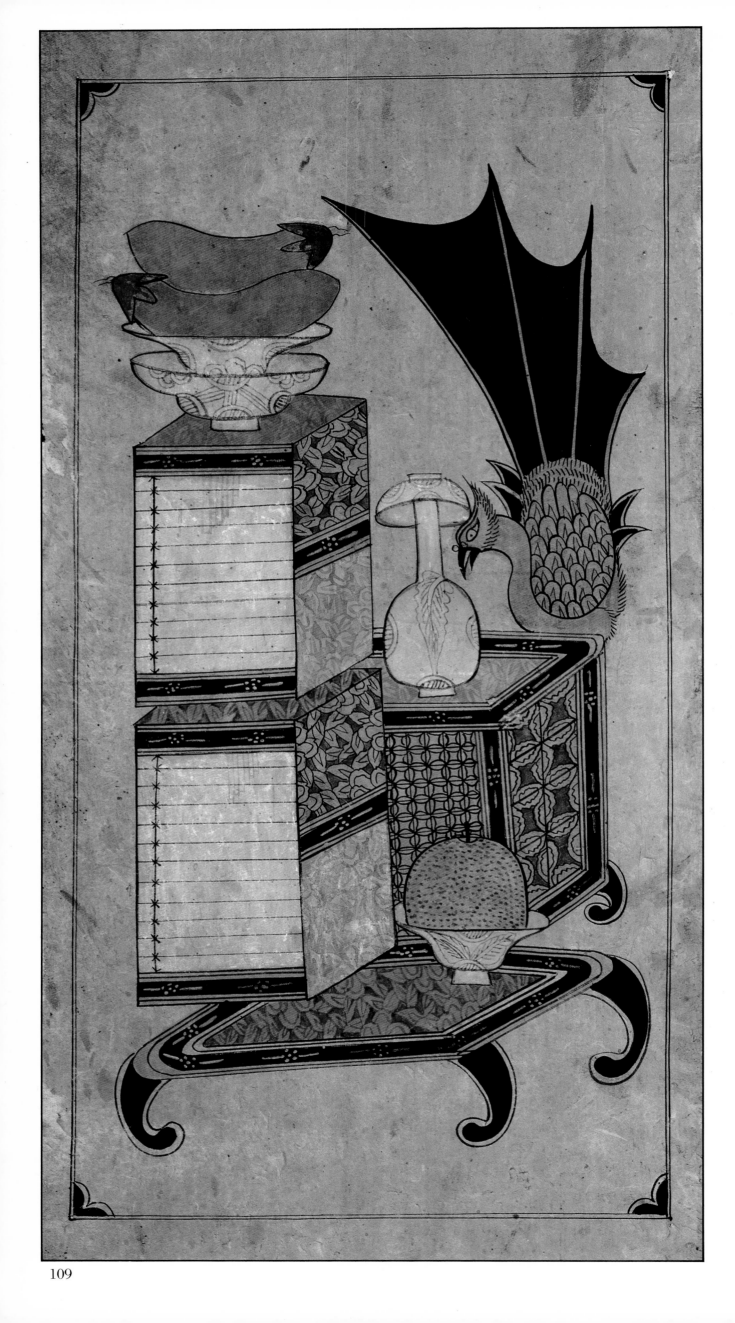

109

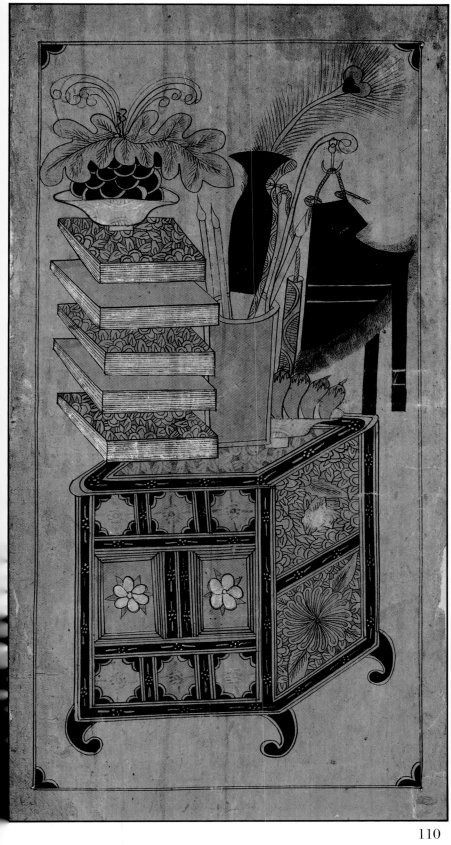

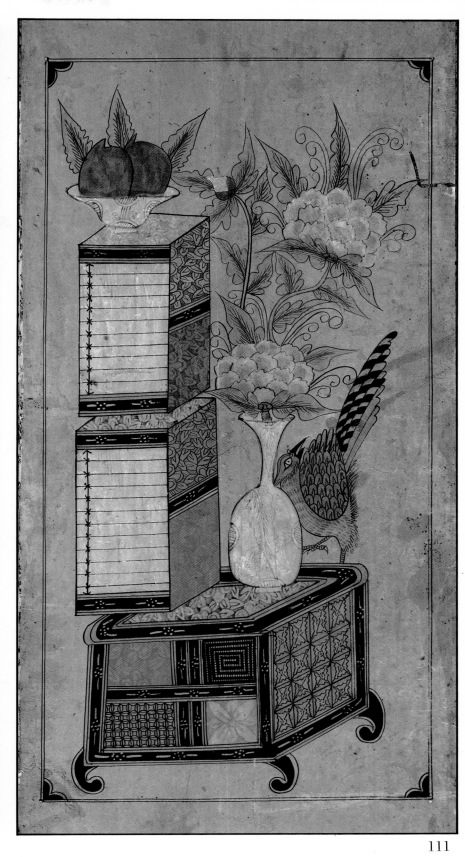

110

111

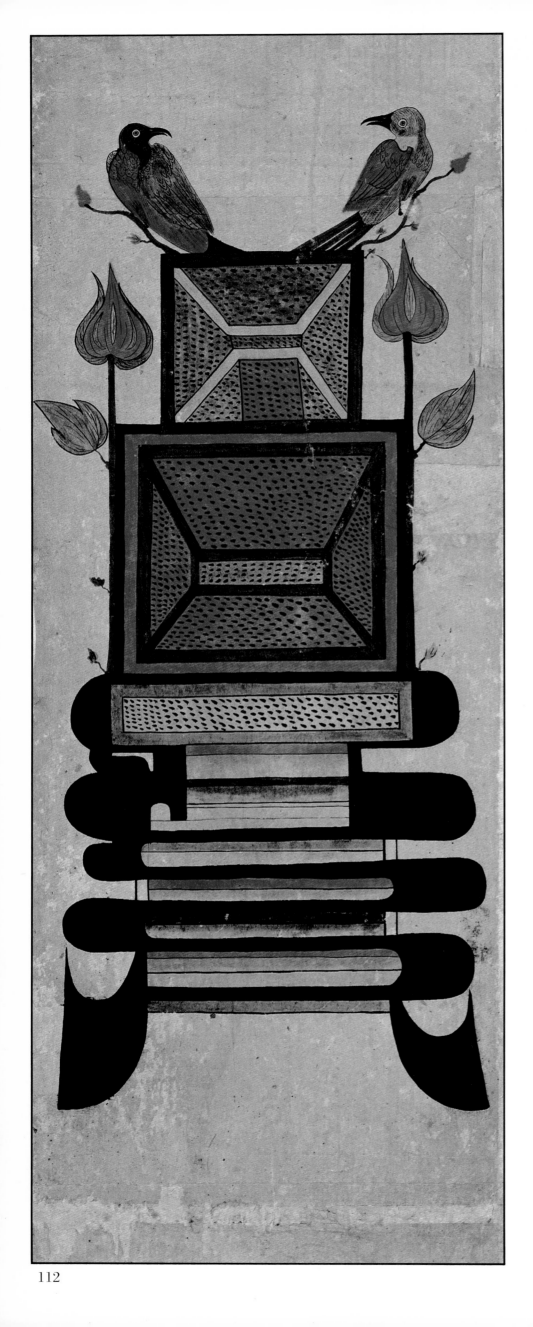

112

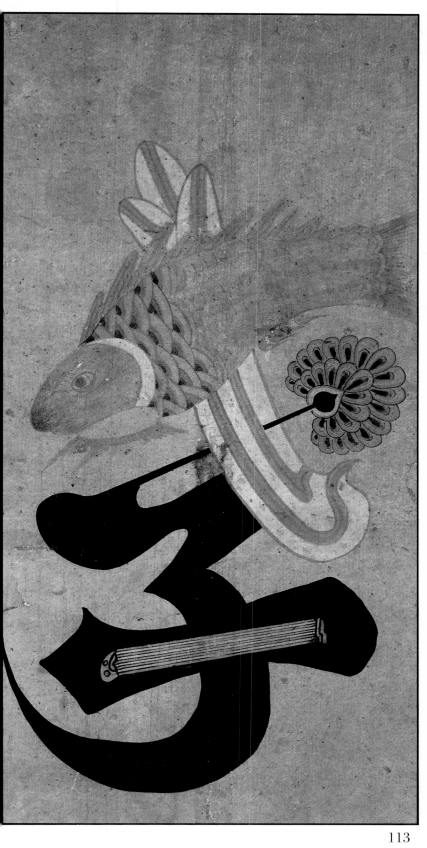

113

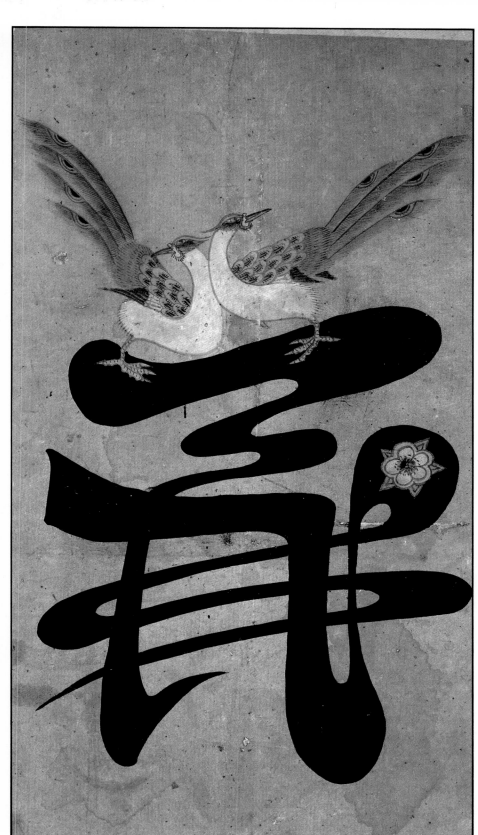

114

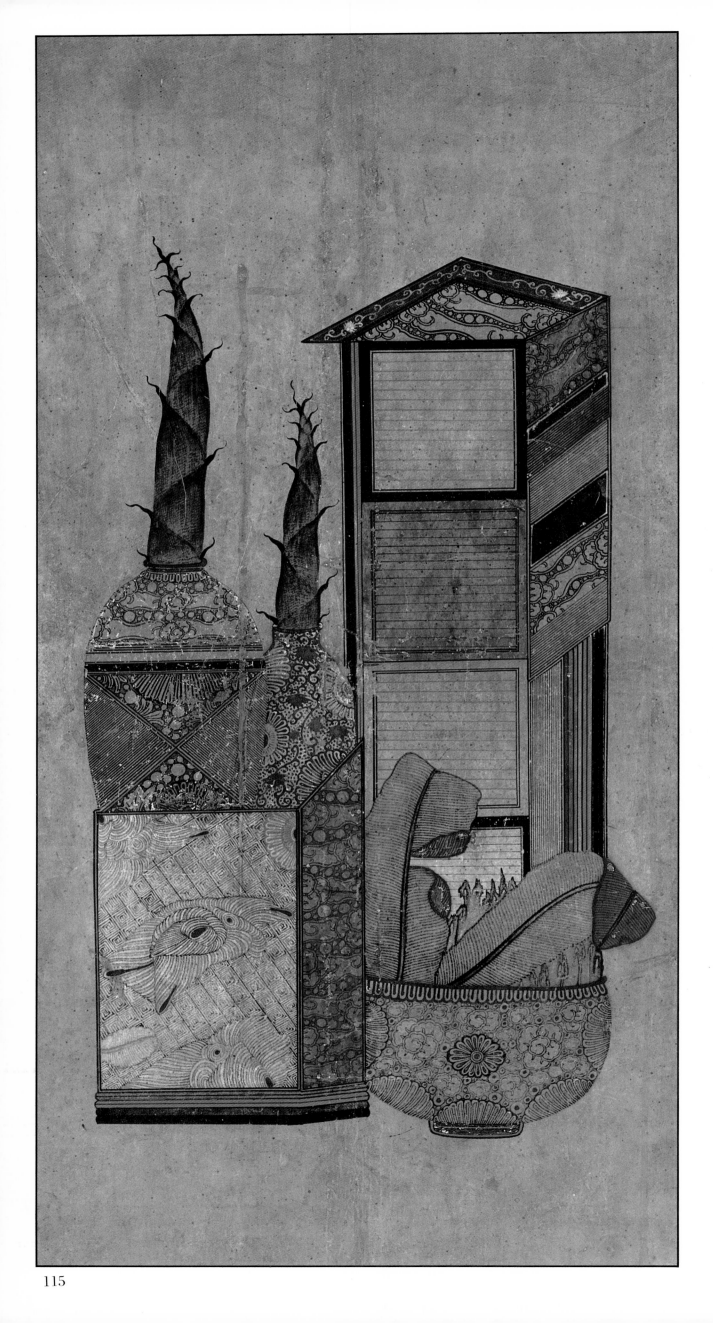

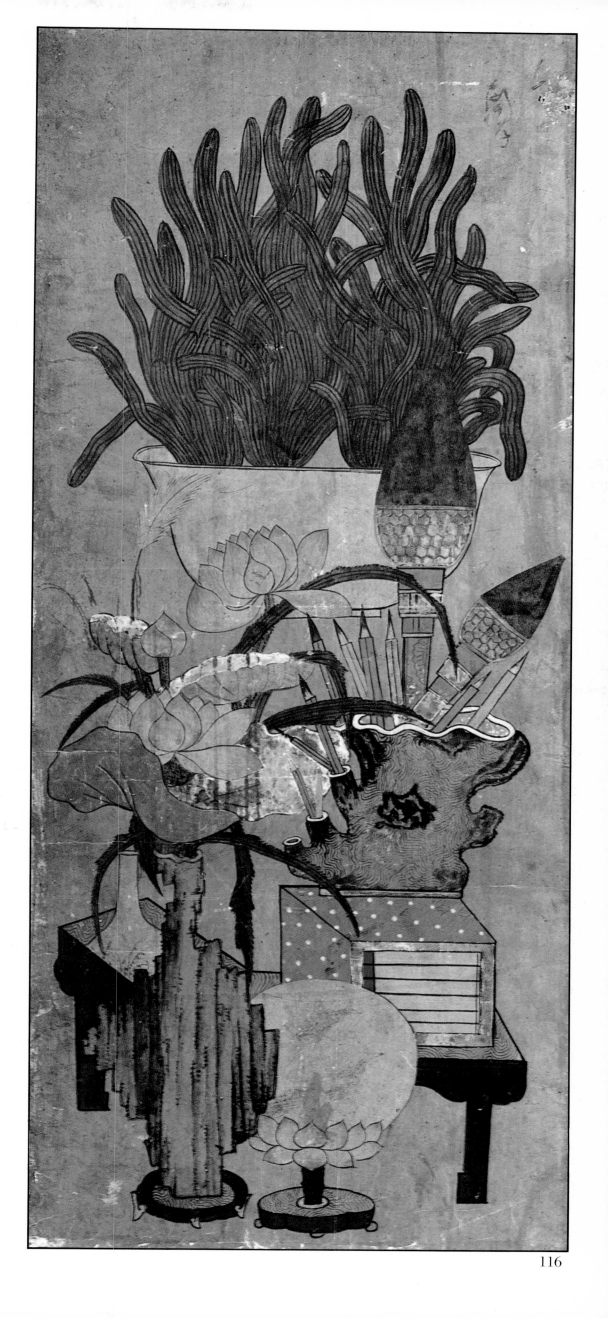

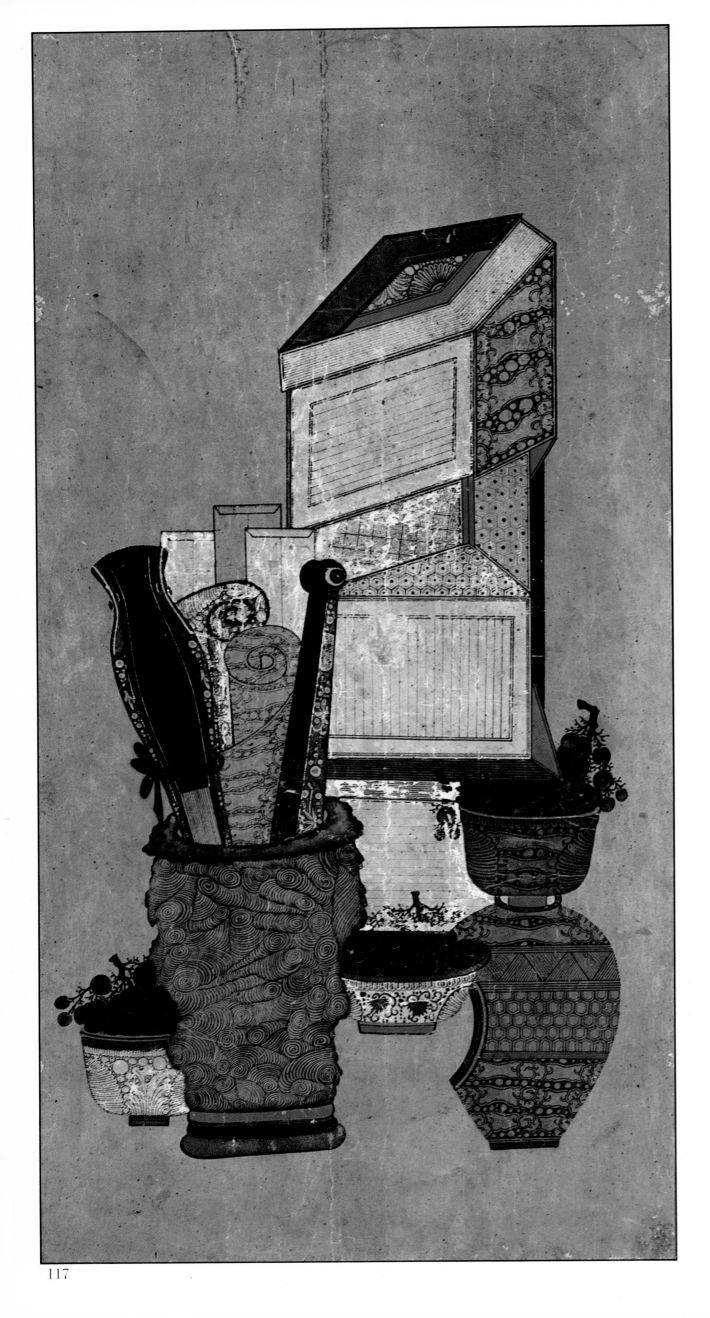

117

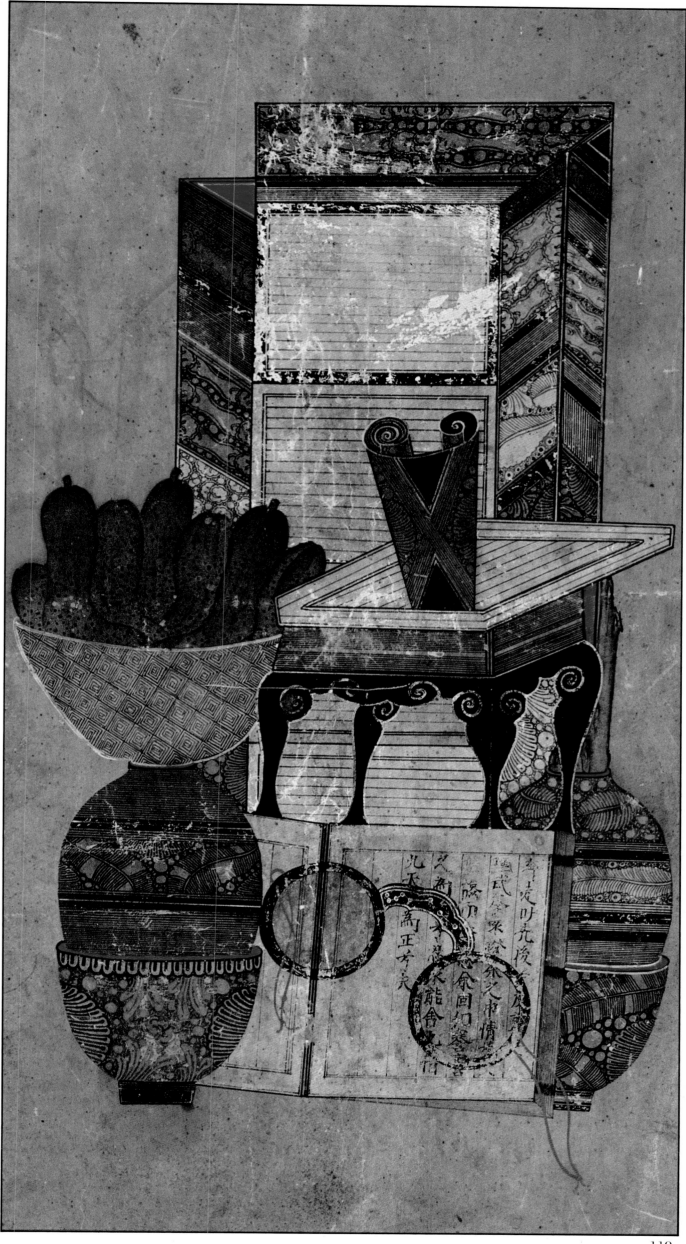

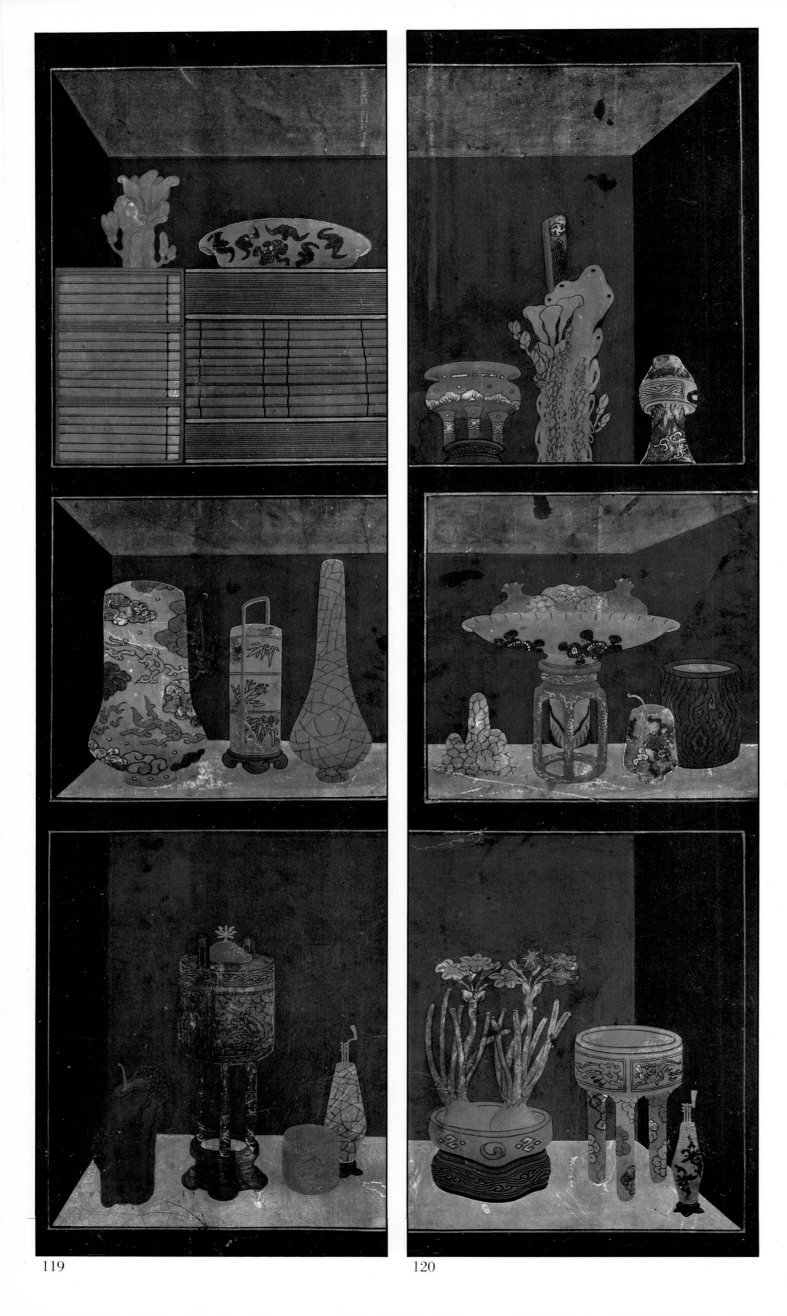

119

120

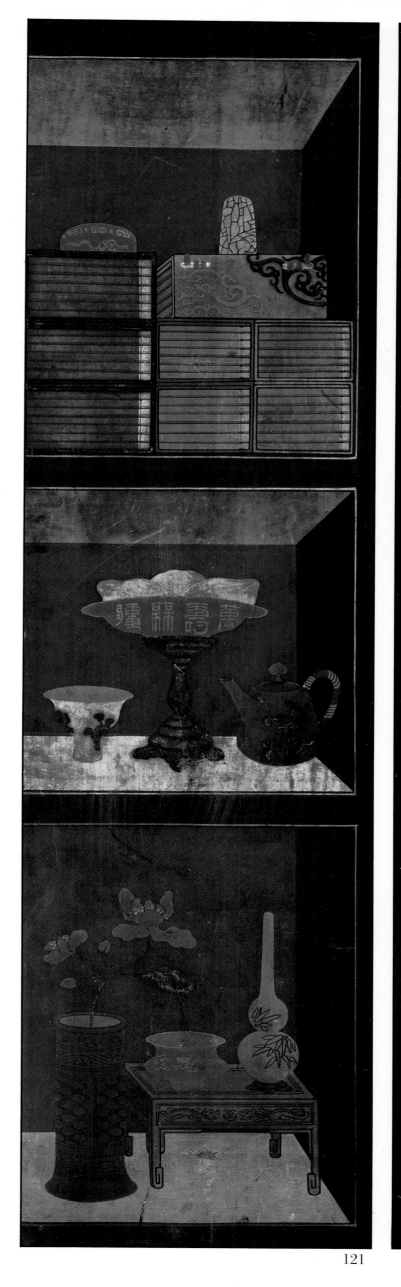

121

122

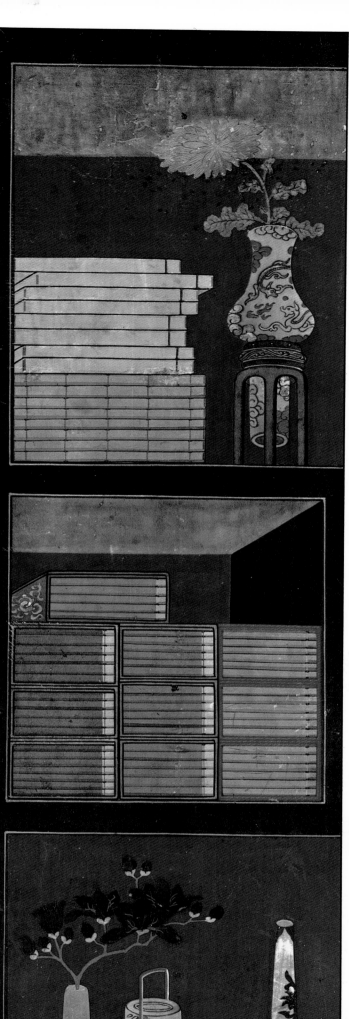

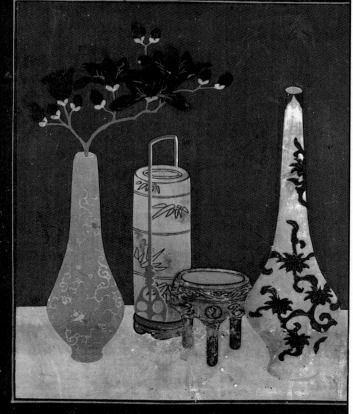

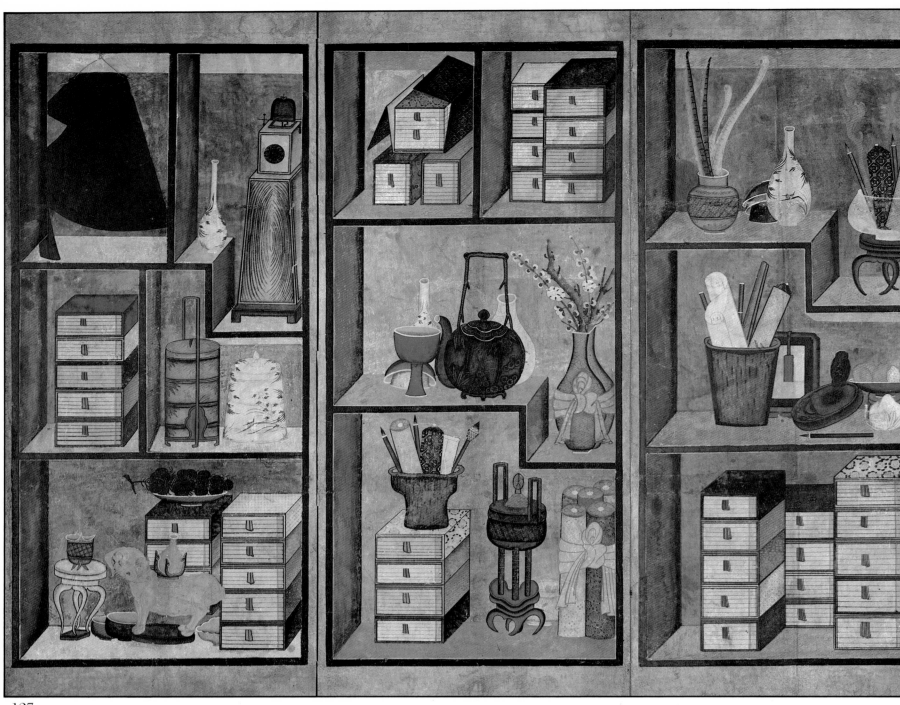

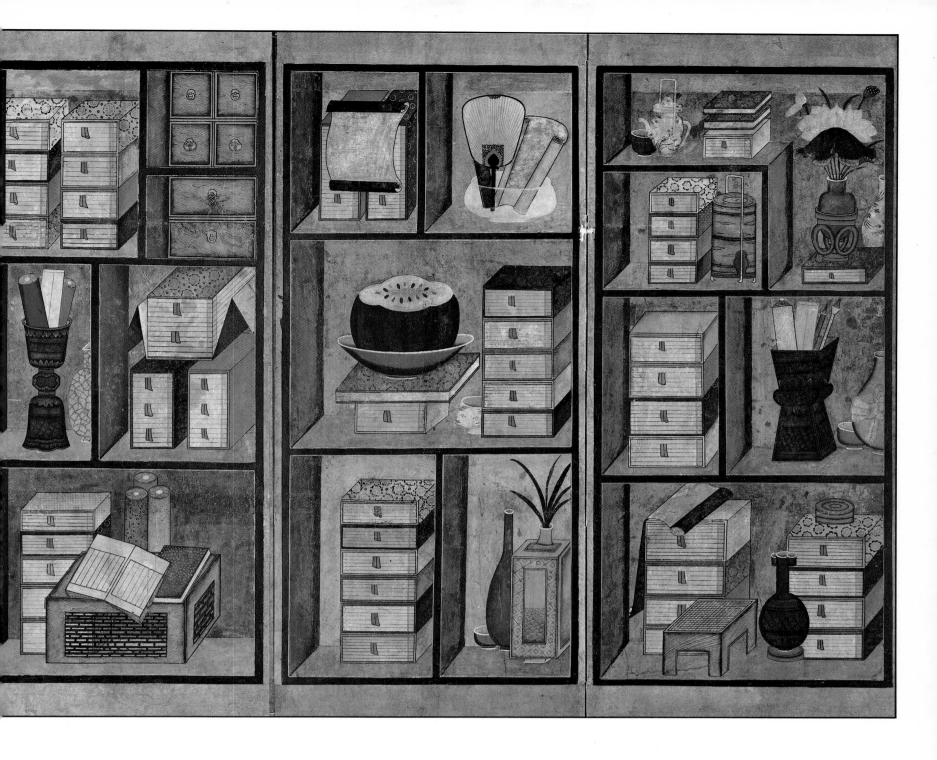

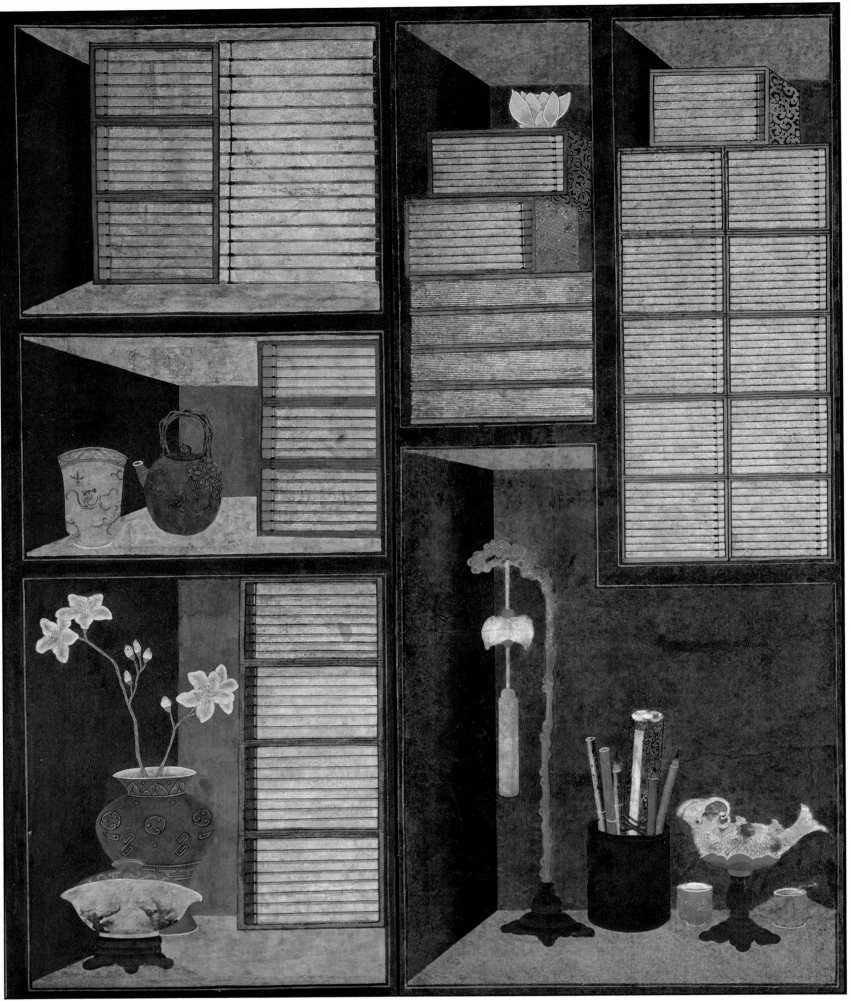

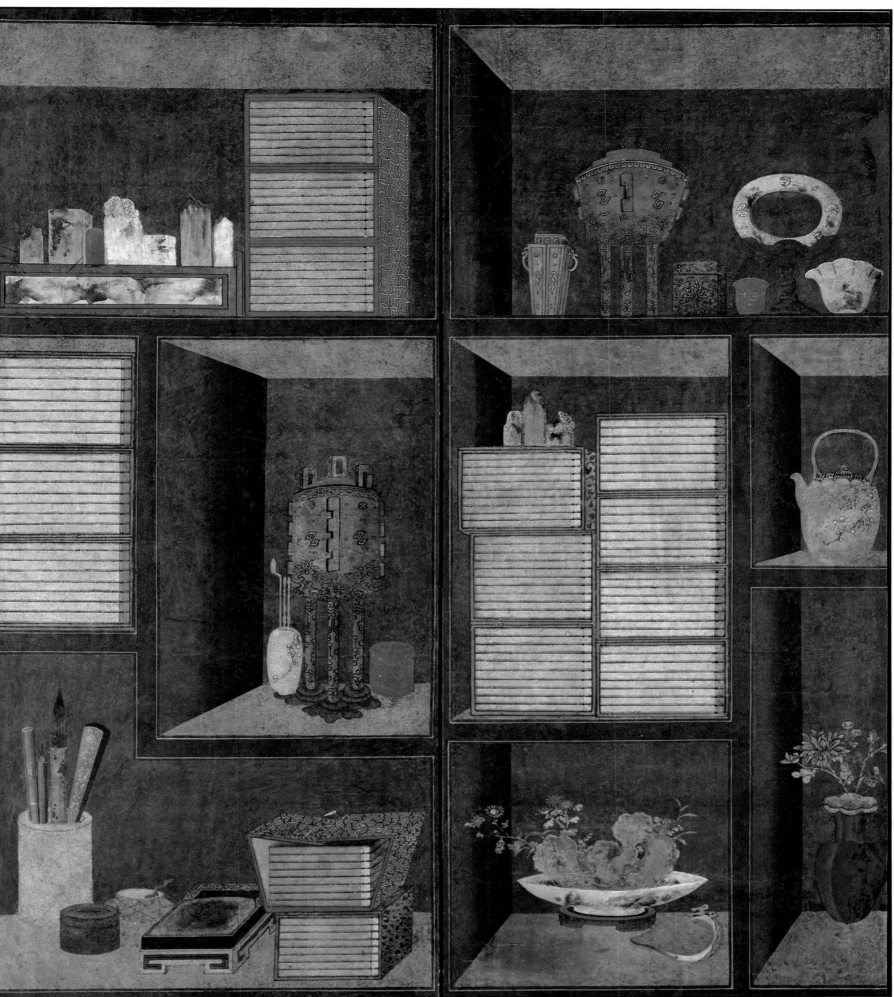

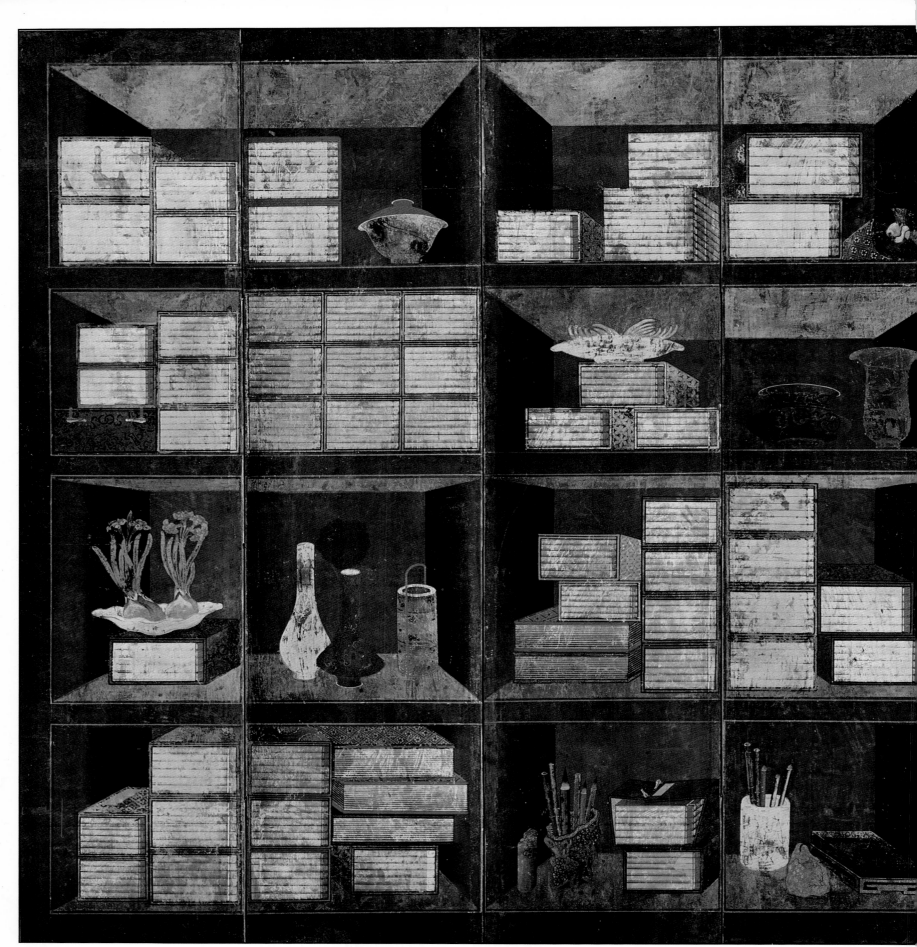

130

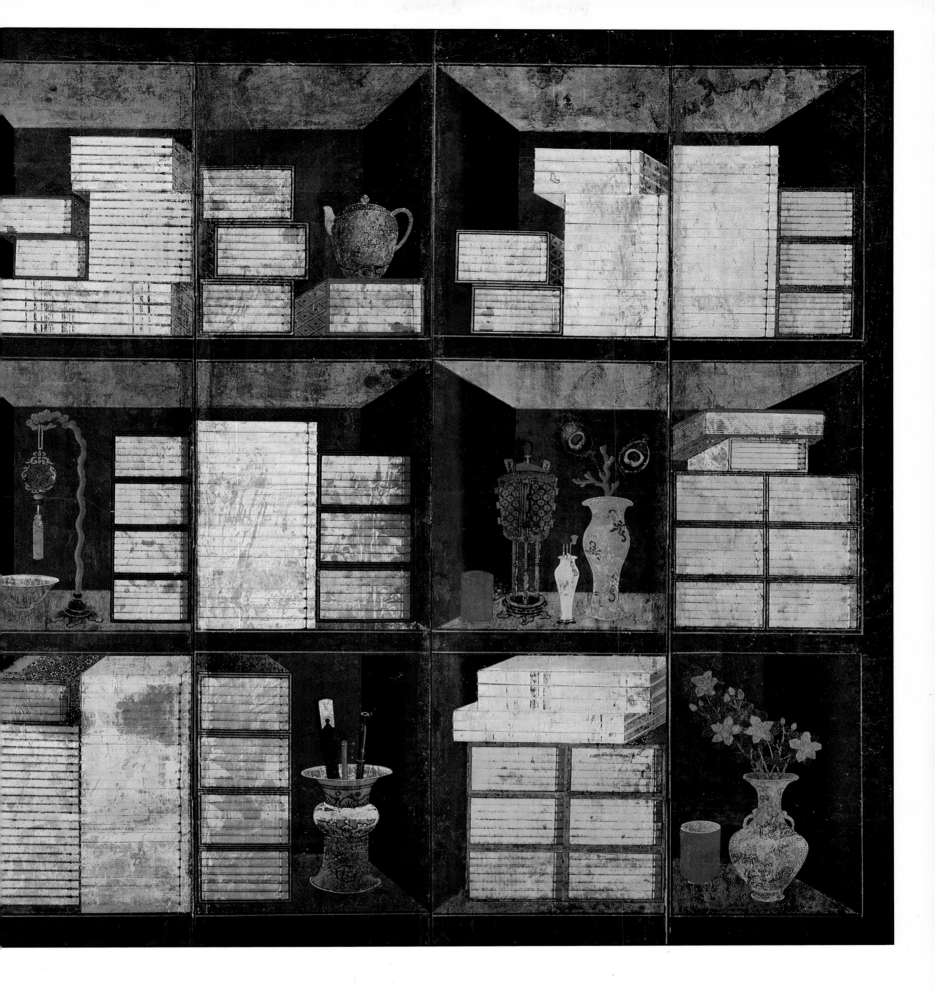

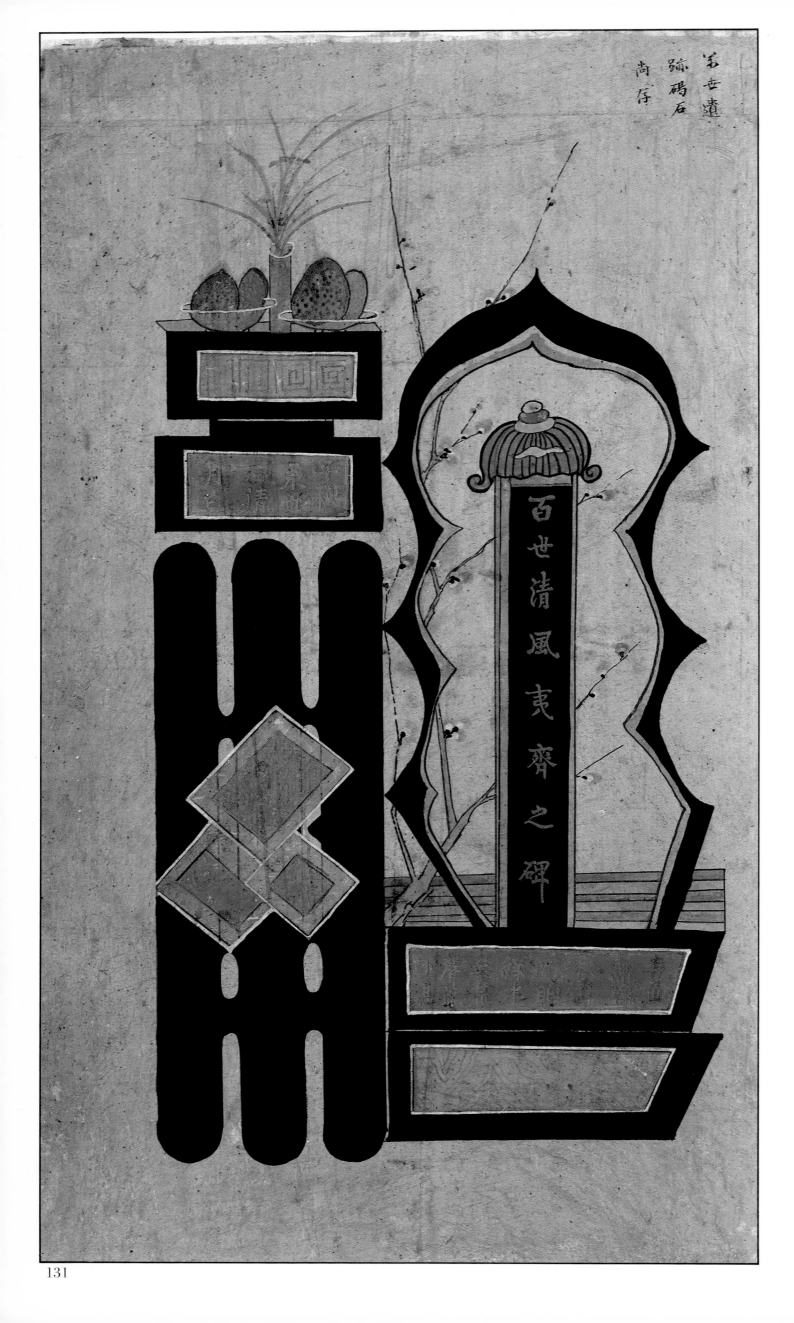

春日
桃
院

君臣

相碧

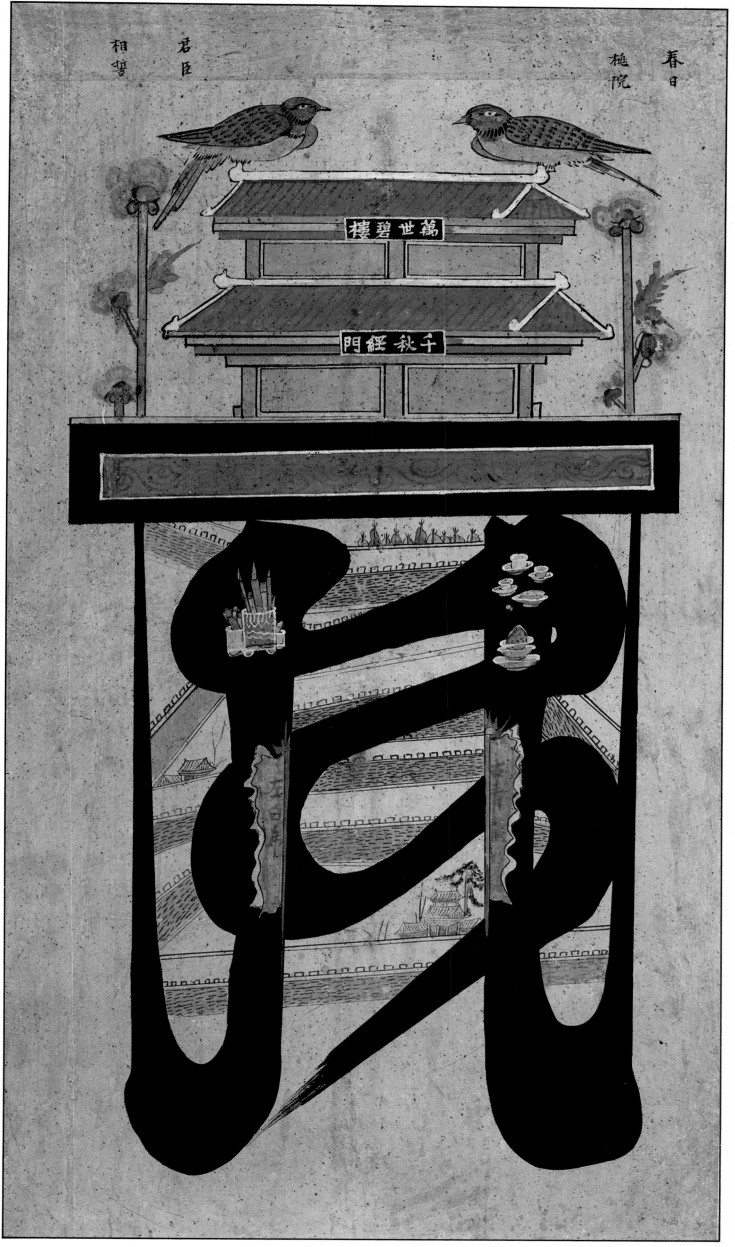

132

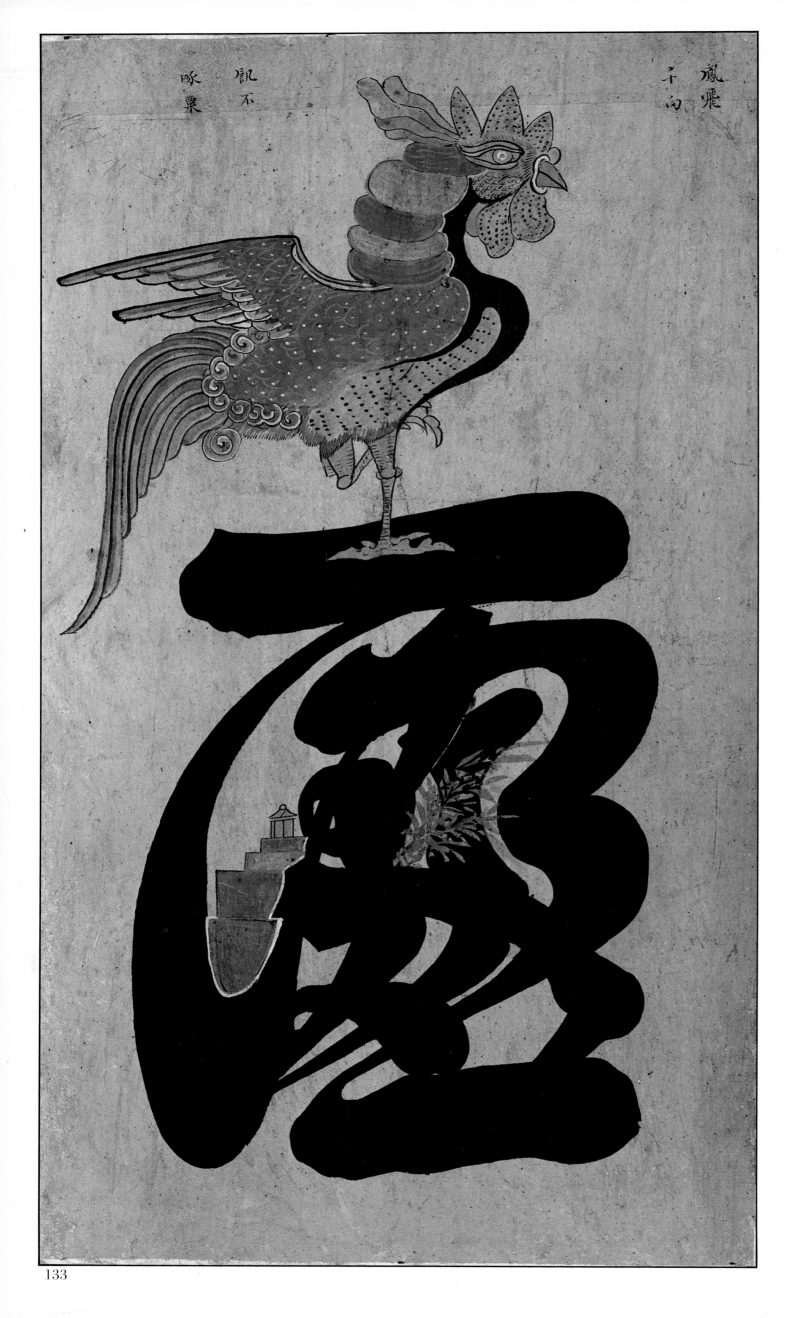

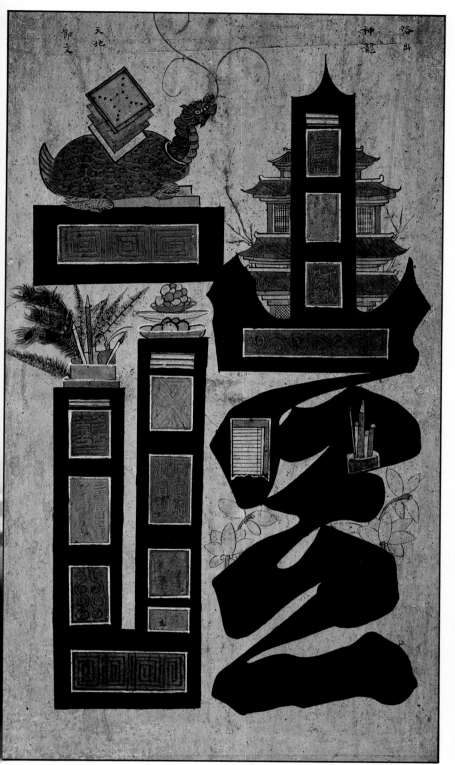

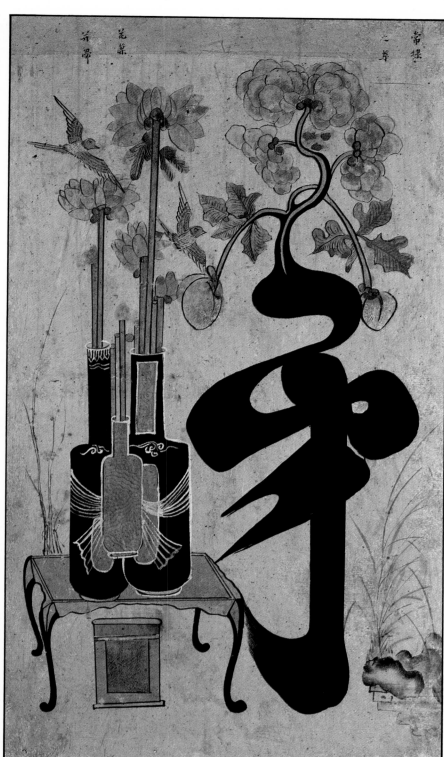

134

135

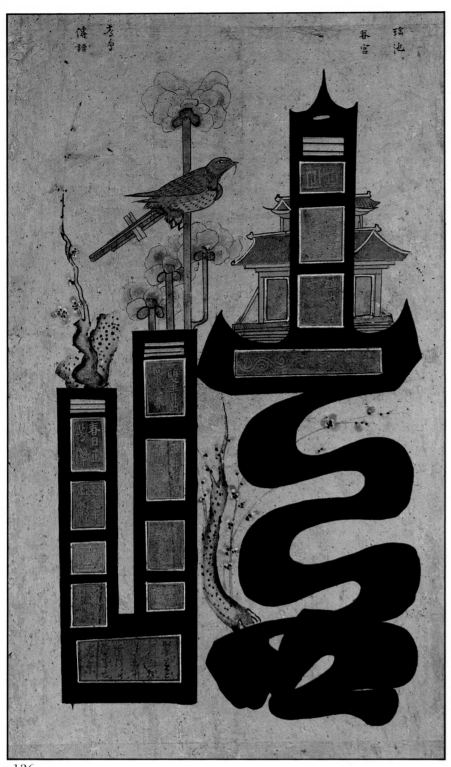

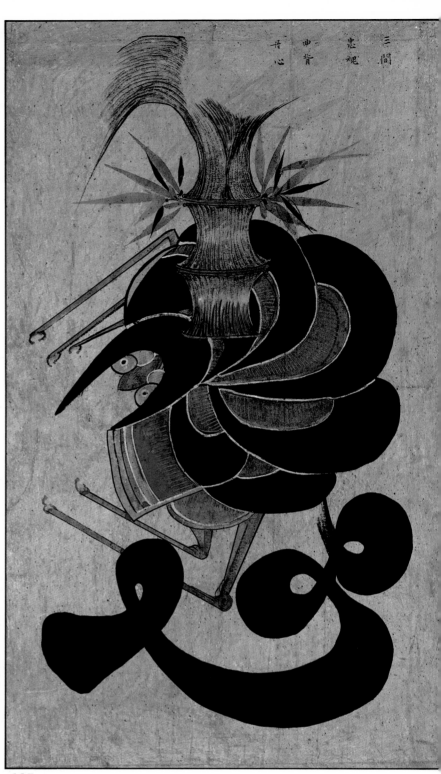

136

137

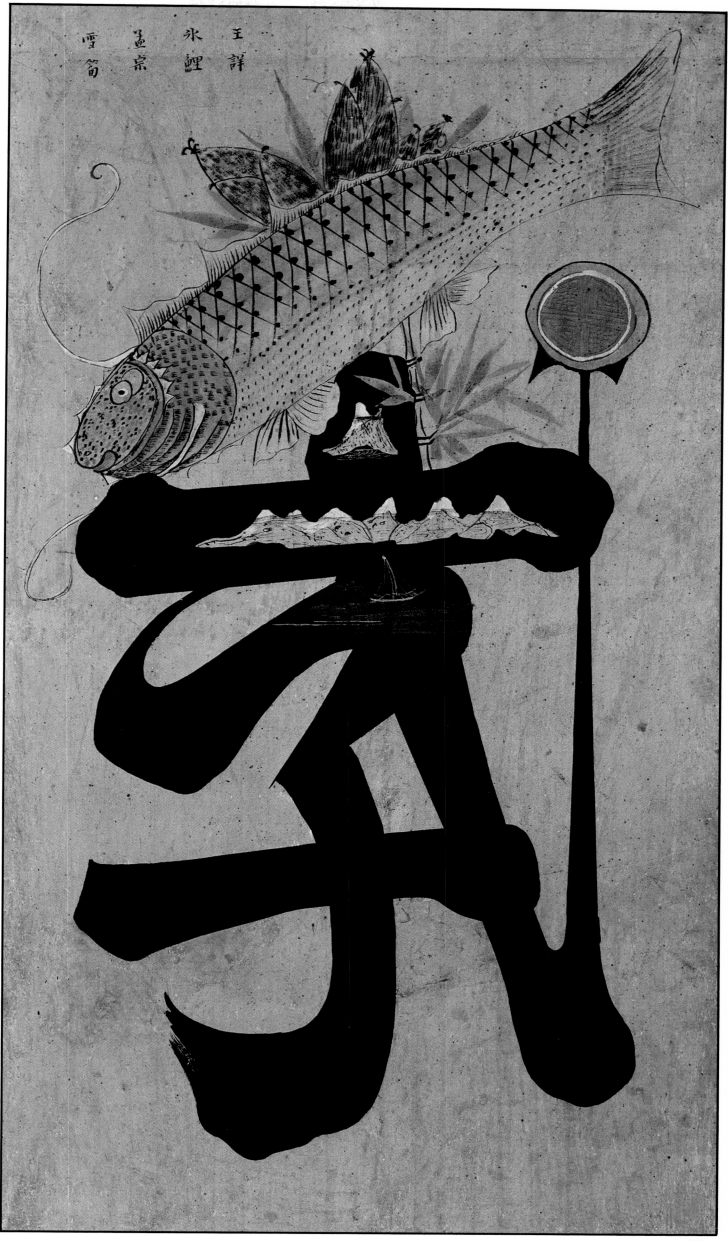

王祥 氷鯉

孟宗 雪筍

138

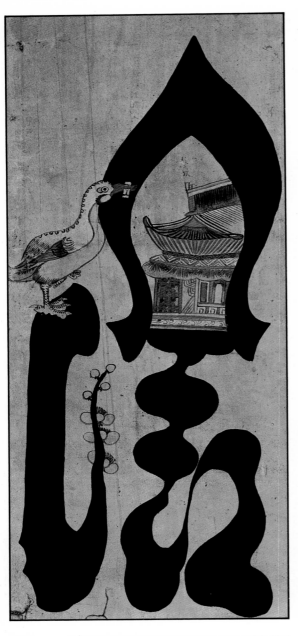
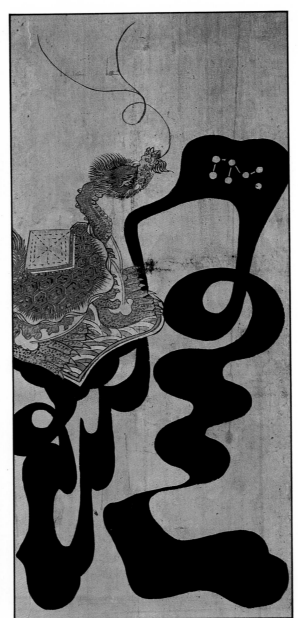
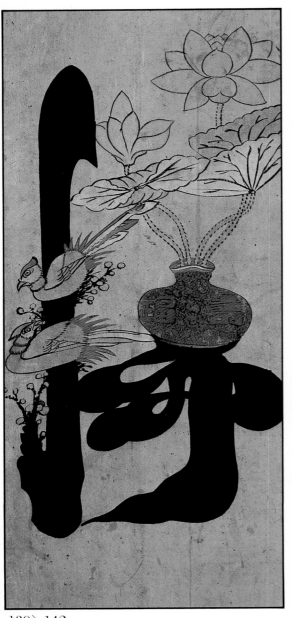
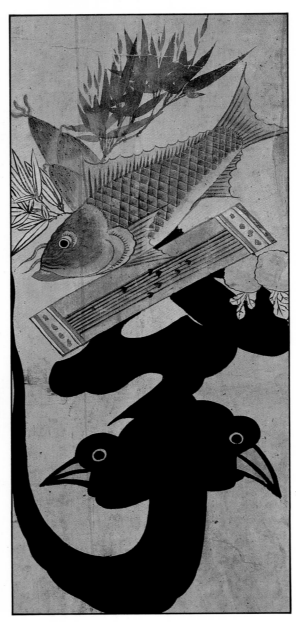

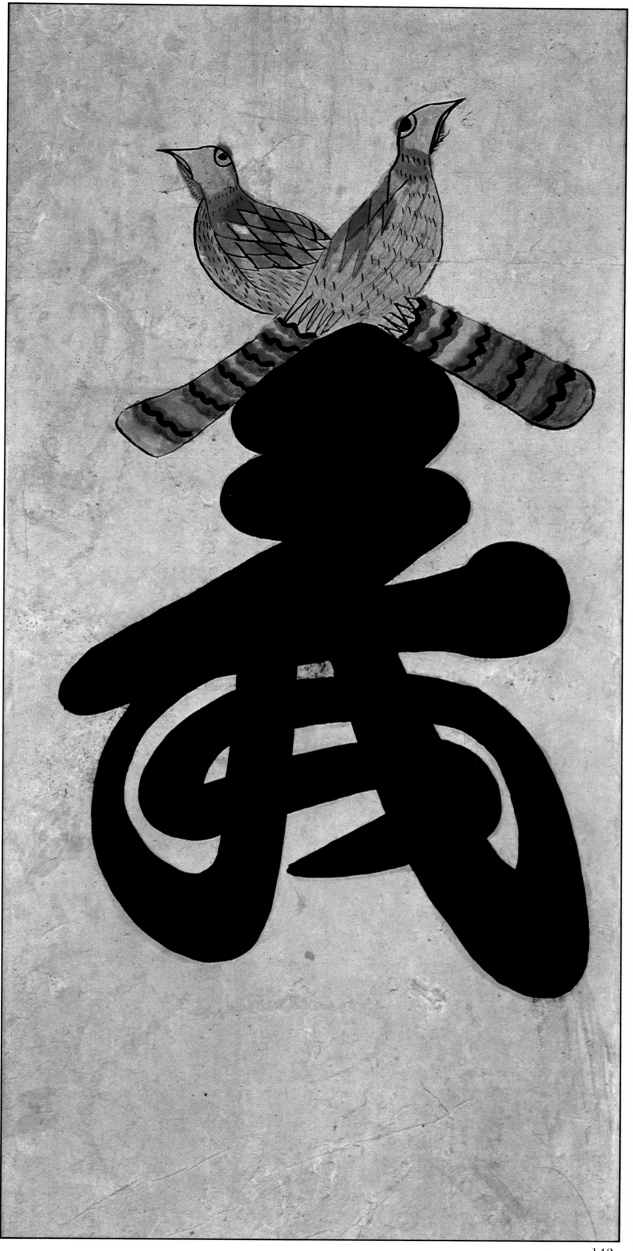

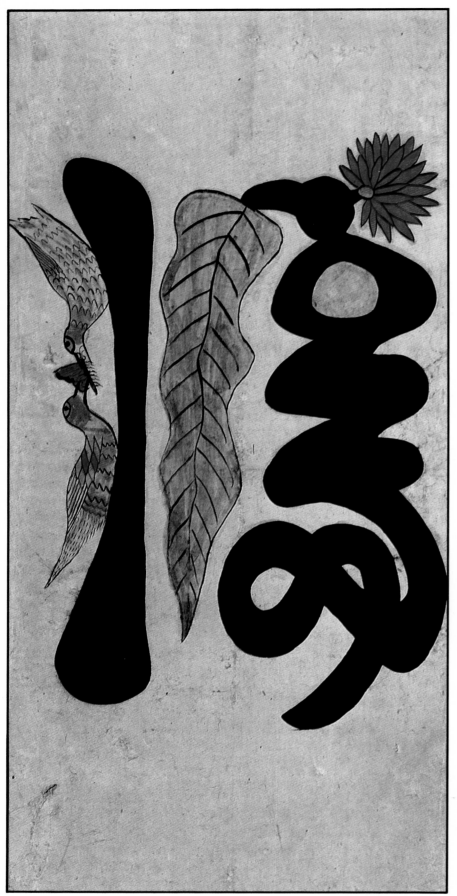

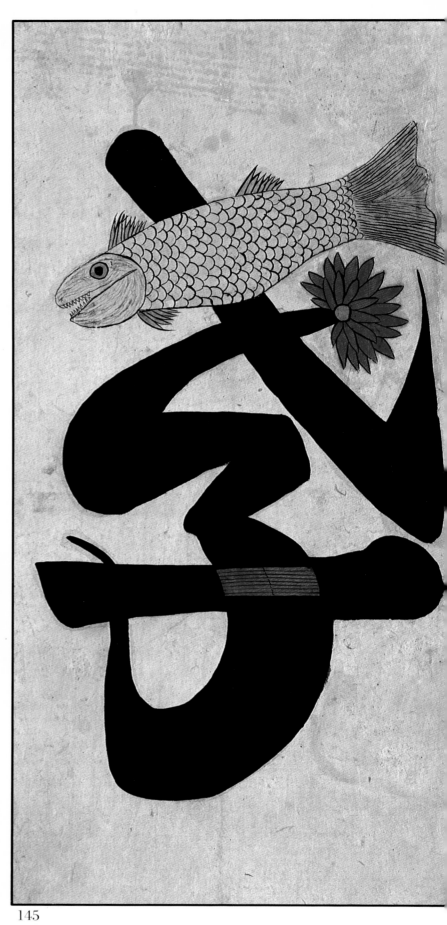

144

145

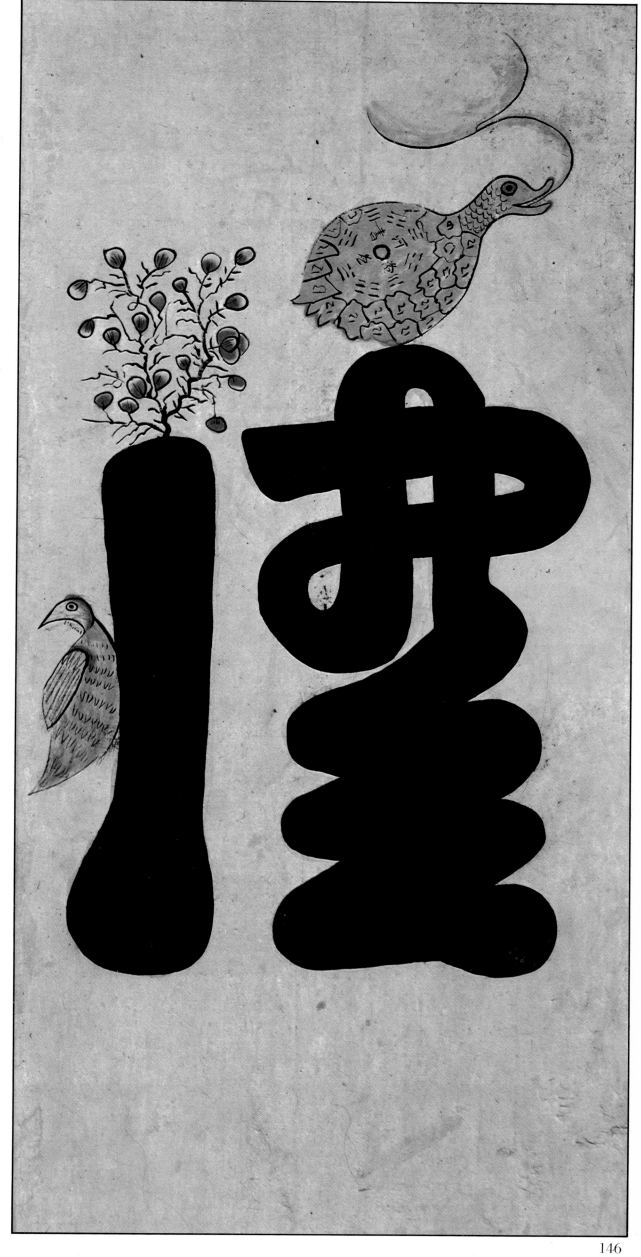

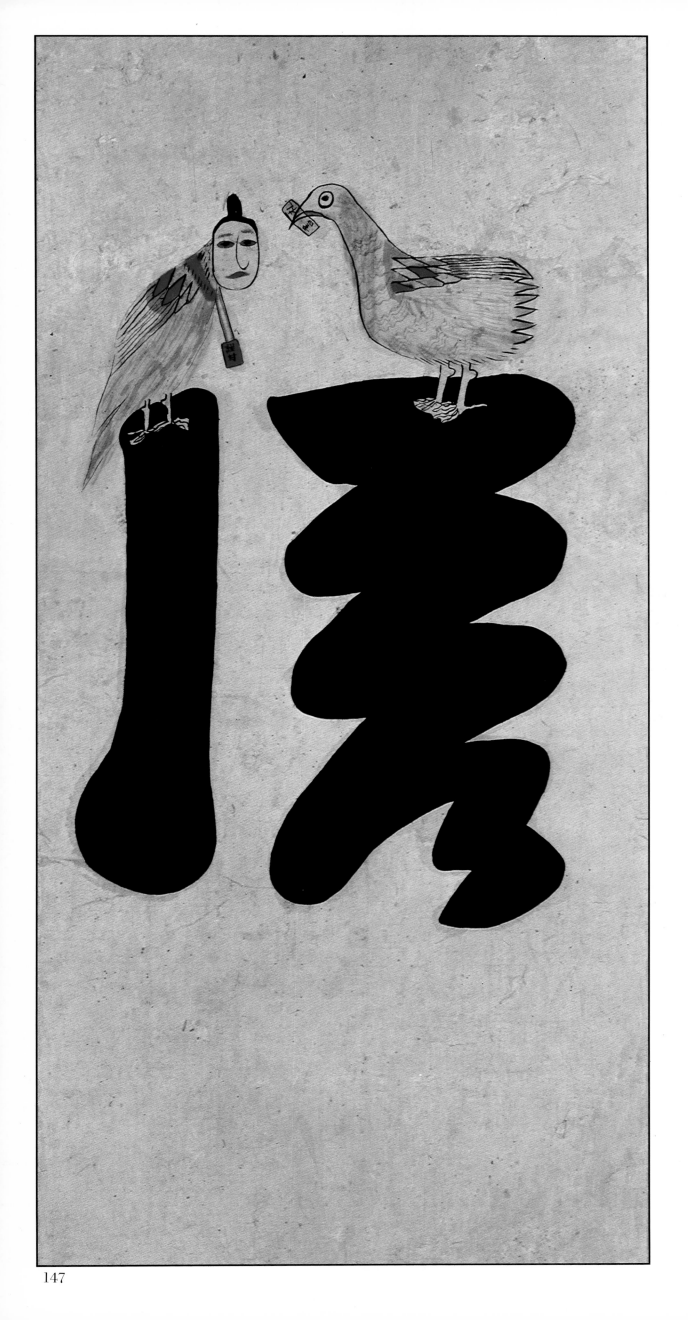

147

148

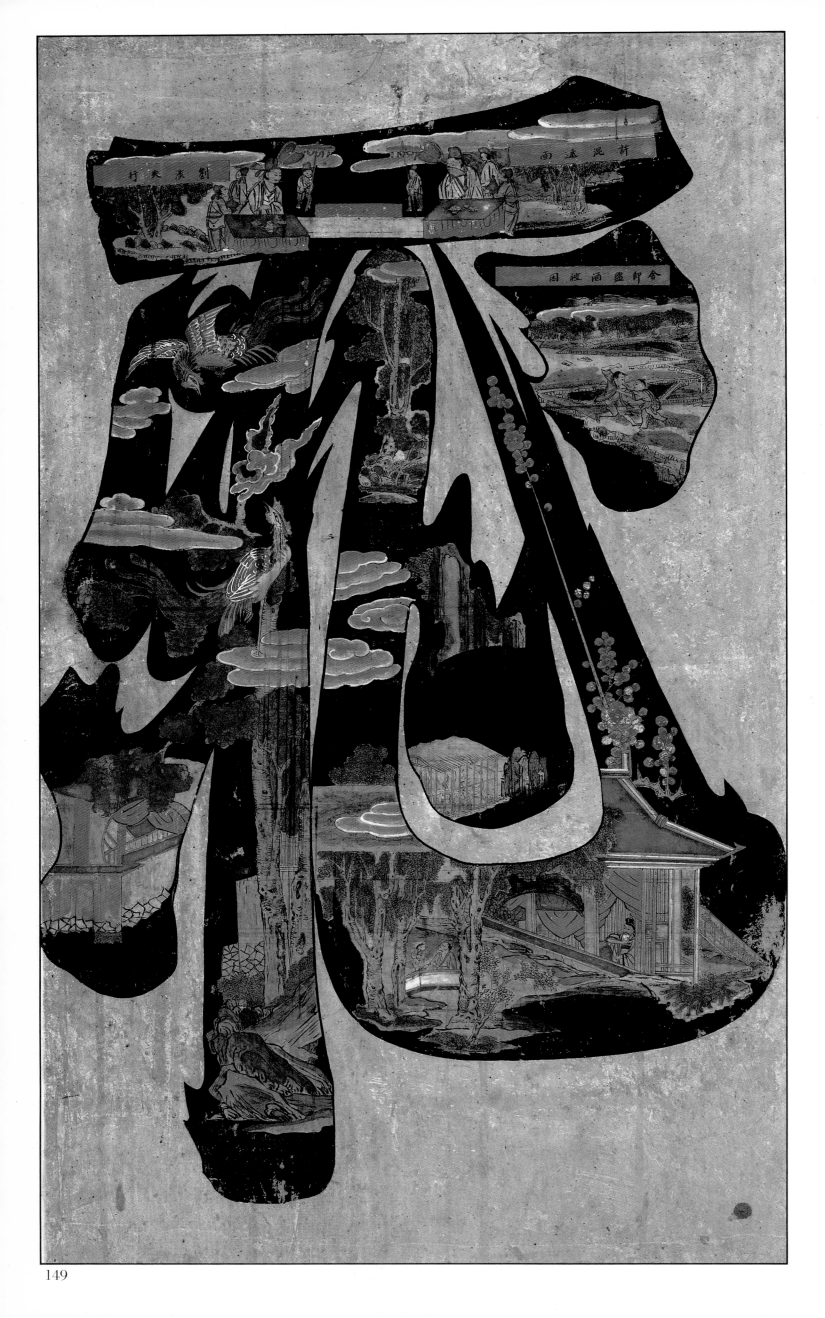

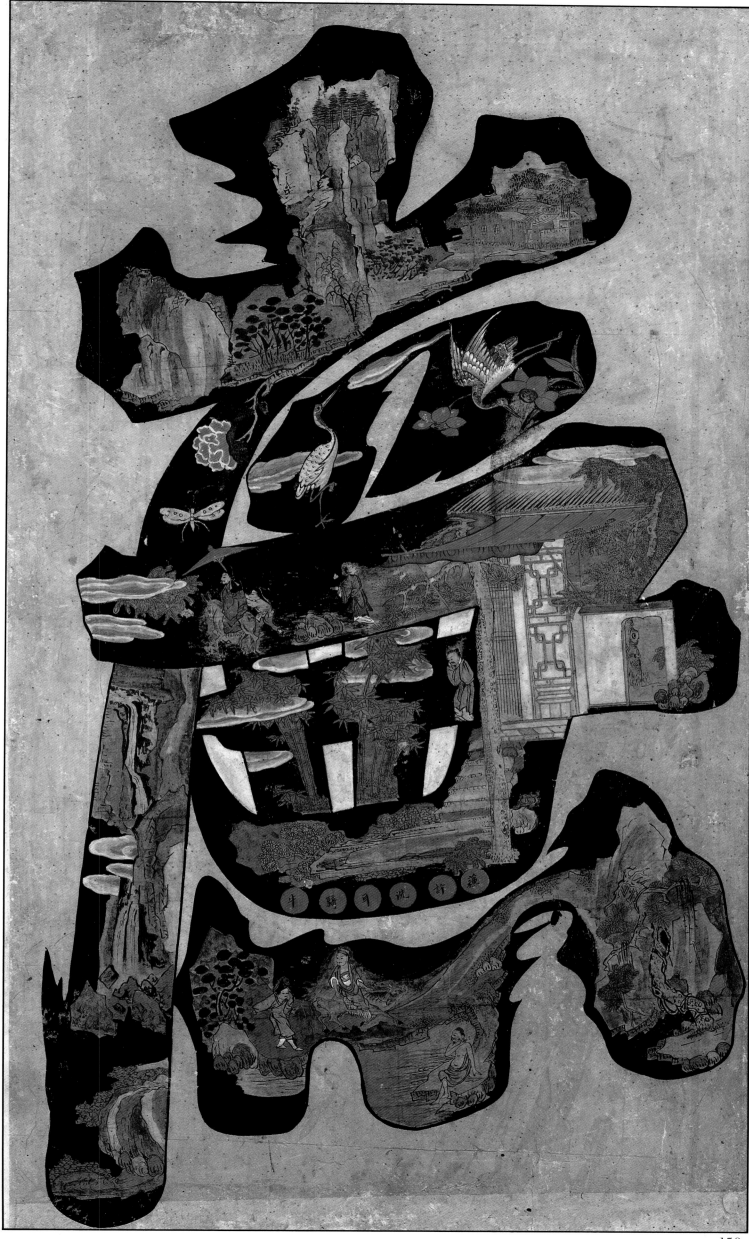

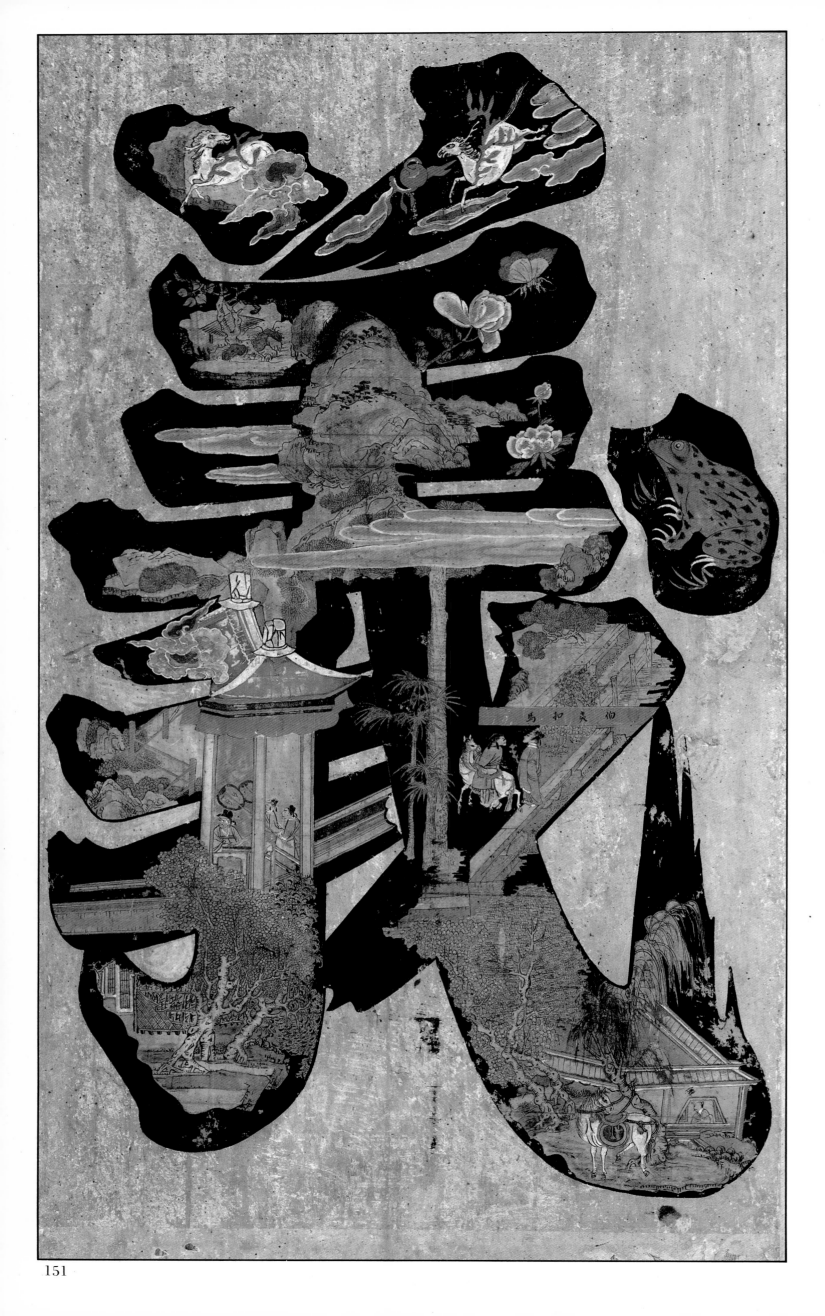

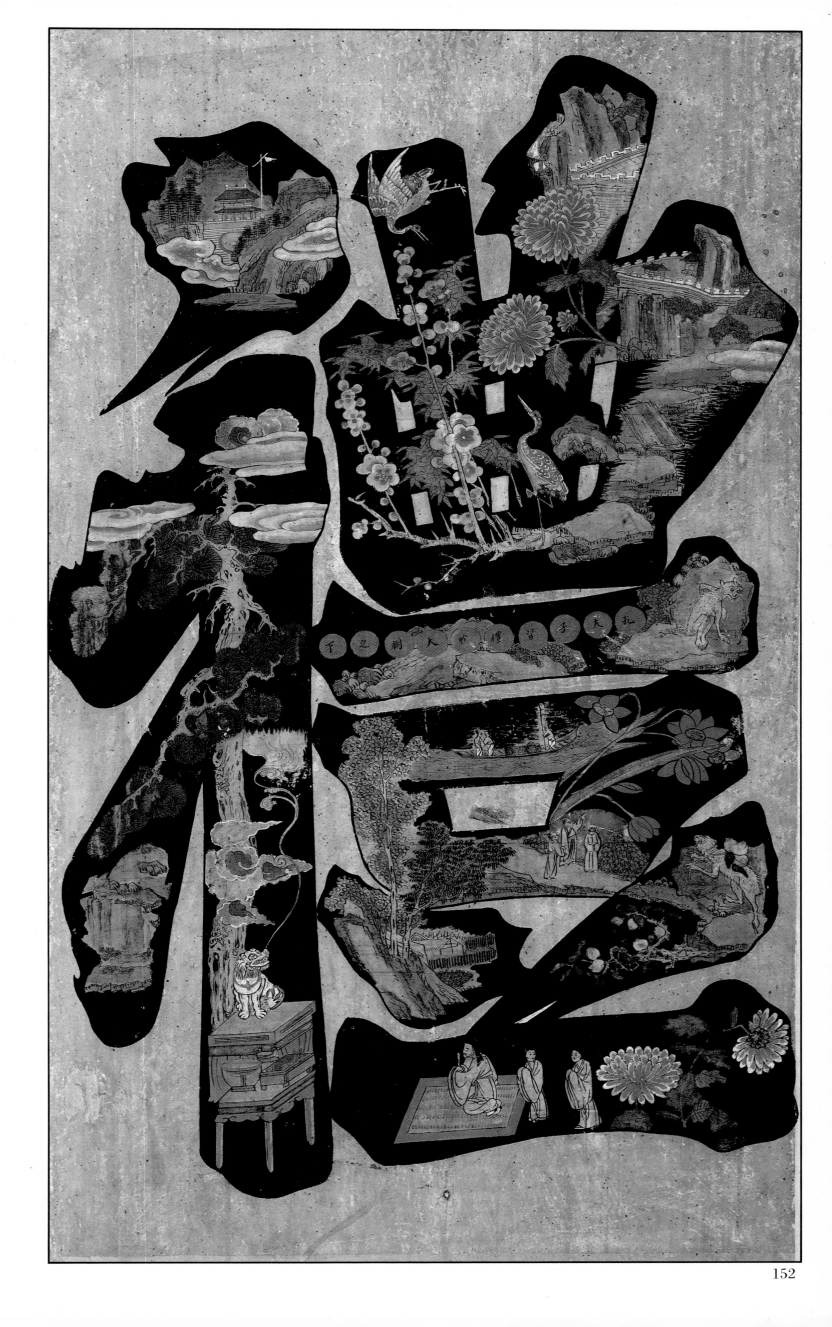

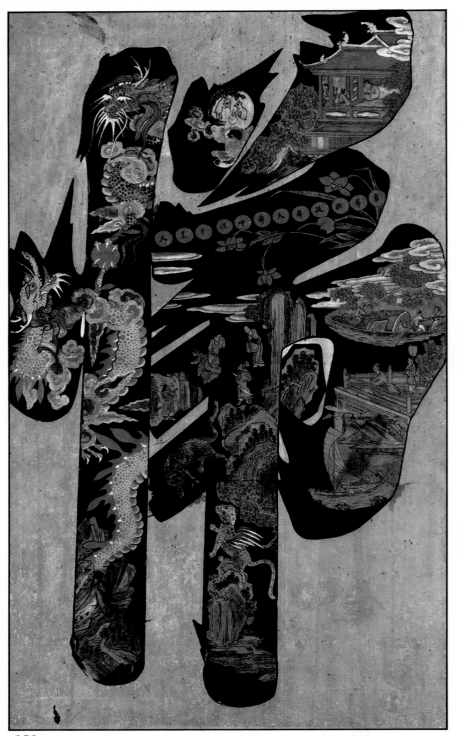

153

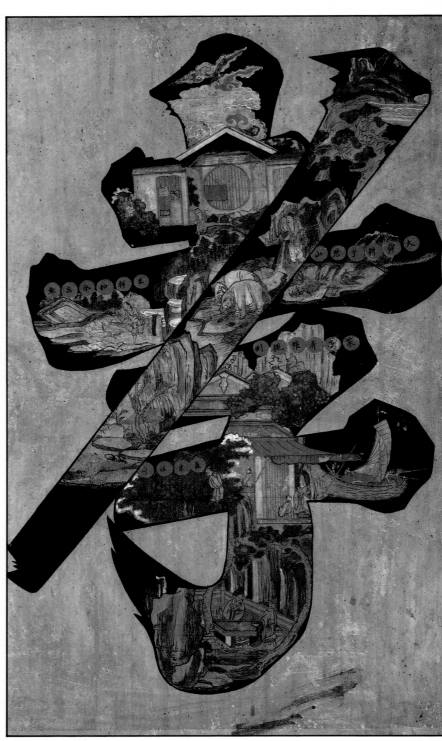

154

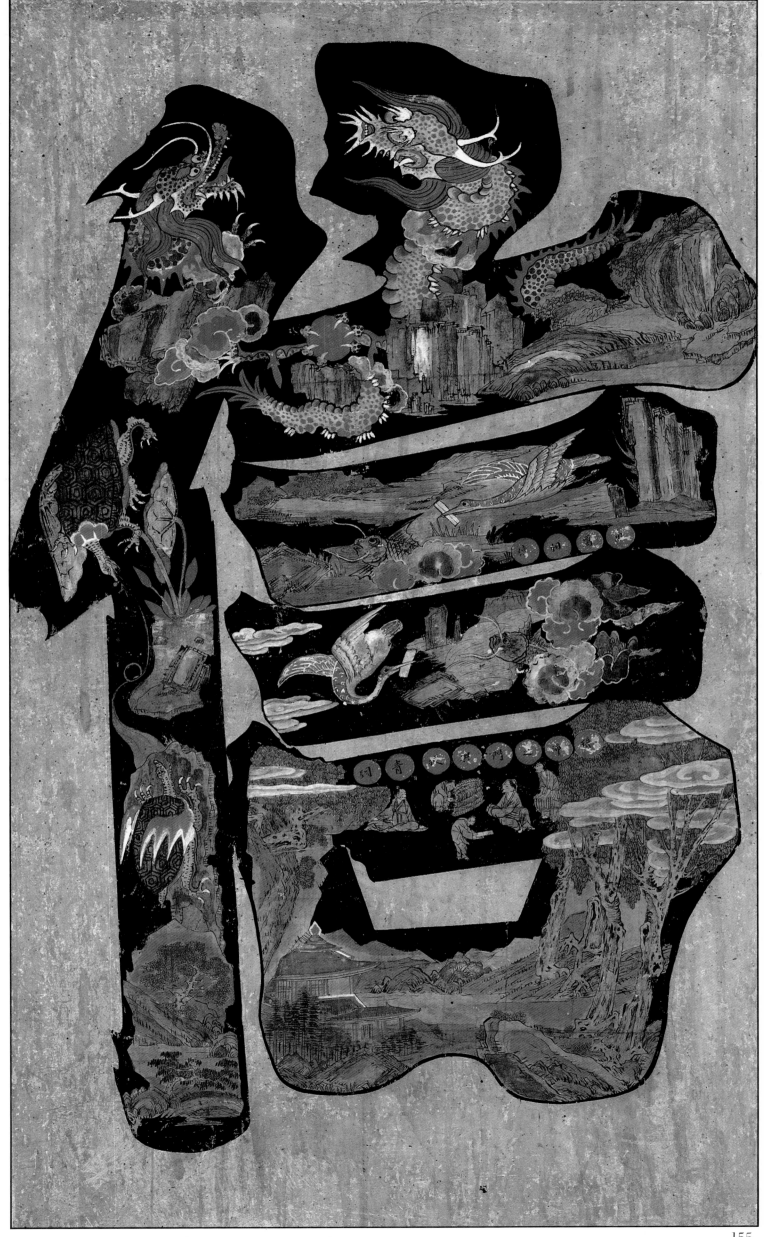

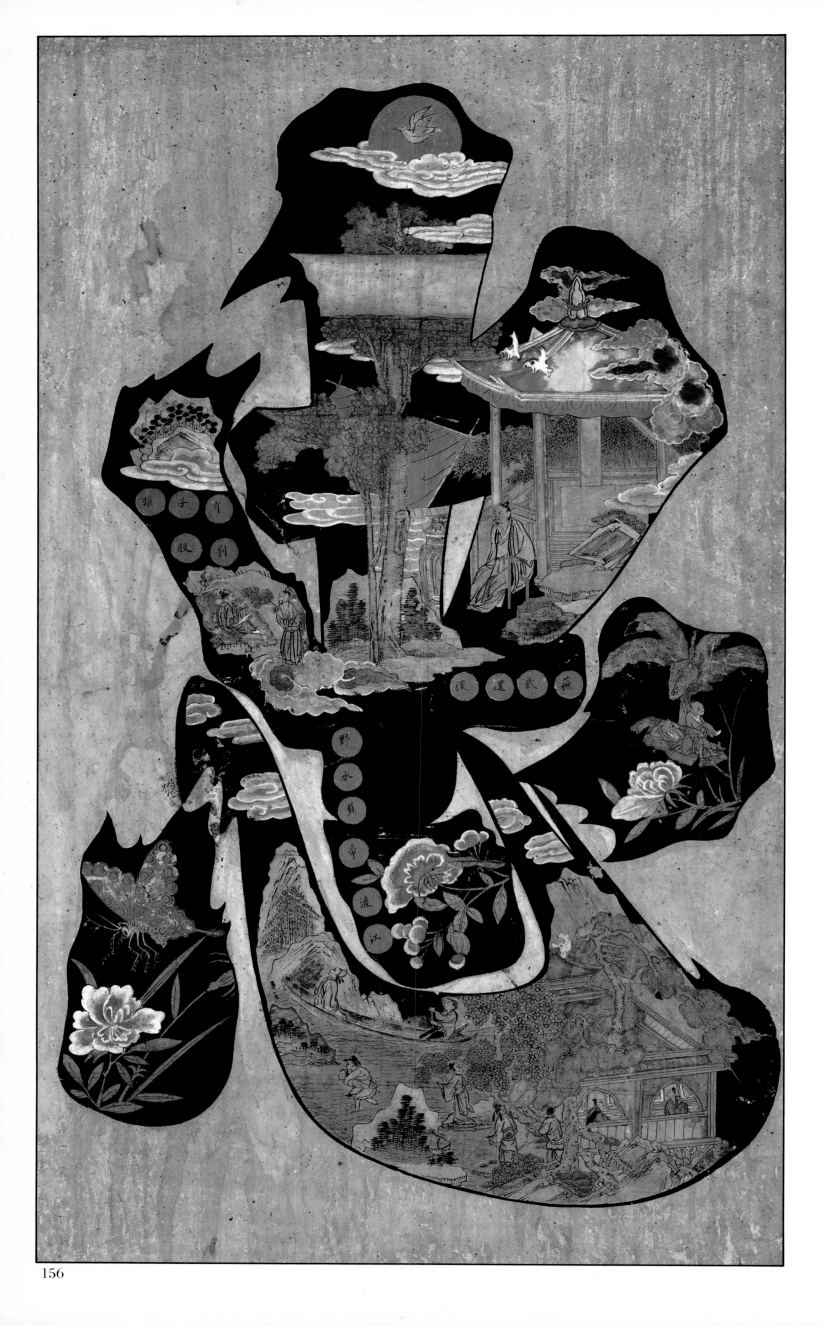

Yi-Dynasty Painting and
Its Categories

U Fan Lee
(Lee U-hwan)

What, exactly, was the significance of the "folk painting" that was an integral part of Korean life throughout the long centuries of the Yi dynasty? Alongside the "orthodox" or "academic" painting that came into being solely for purposes of aesthetic appreciation, enormous numbers of what we now call "folk paintings" were produced as a means of bringing color and variety to the interior spaces within which people led their daily lives. Very roughly speaking, the folk paintings of the Yi dynasty can be classified into those that were a part of ordinary, daily life; those that were brought out for annual festivals and other auspicious occasions, or used in various ceremonies; and those that were displayed in association with the changing seasons. Stylistically, they show a rich variety. Fundamentally, however, they all have in common the fact that they were created in order to enrich the surroundings of daily life. They were in use, moreover, throughout the whole of society, from the court to the homes of the lower classes; so that, if "folk painting" is taken to mean "painting for, or by, the common people," they far transcend the normal bounds of the term.

A fundamental feature of the folk painting of the Yi period is that the majority of the pieces are unsigned. By their very nature—their intimate connection with the daily lives of their owners—folk pictures, unlike other forms of art, called for anonymity. The everyday environment provided by the home was traditionally, for the Korean people, something sacred— a space, ideally, free and untrammeled by particular spiritual colorings or intrusions. Thus a picture should contribute to this effect, and not be a means, via the medium of a name, of asserting any one personality.

Several other reasons exist for the absence of signatures. Most of the painters were not well known and preferred not to sign their work, while the academy artists with a reputation to consider customarily preferred not to add their names to folk pictures, or even in some cases actually considered it a disgrace to do so, since there was a view in official quarters that such pictures were vulgar.

Either way, the number of extant folk paintings suggests that the number of painters must also have been very great. Most artists, moreover, were not of high *yangban* social status but belonged to the lower strata of society. They included among their ranks artists of the Bureau of Painting; artists who, having failed to get into the bureau, set off touring the provinces in order to improve their techniques and ended up earning their living there; members of the aristocracy who tried their hands at such painting as a pastime, or as a means of making a little extra money; and itinerant painters in the remote provinces who painted because they enjoyed it and were content to live out their lives far from official artistic circles. Where numbers were concerned, this last category, the wandering rural artists, was particularly numerous, but it is the works presumed to be by members—or members manqués—of the Bureau of Painting that are, as might be expected, the most outstanding in terms of quality.

One of the most important factors contributing to the birth of the folk picture was the fact that society under the Yi dynasty, of which Confucianism was the official religion, set its norms at the level of ordinary, everyday life, deriving its values from the realm of the worldly and refusing to look for salvation—as Buddhism did—to some paradise of the hereafter.

The actual lifestyles of the day were also inseparably connected with folk painting. The average home consisted generally of a number of small rooms (somewhat less than 12 square meters in size, though in the houses of the aristocracy there were some 16 to 20 square meters in size), plus one or more somewhat larger boarded-floor spaces called *maru*. The ceilings of the rooms were low, and the walls made of plaster, with small, wooden-lattice windows. The *maru*

was used for ceremonies and for entertaining regular visitors and other purposes especially in the summer months. The men's and women's living quarters were separate, the men living chiefly in a detached wing (*sarangdong*), while the women attended to the business of the house in the main building, the *naedong*. The house consisted, as it were, of a number of small rooms and *maru*, each with its own independent function.

The simple structure of dwellings as a whole was related to social conditions at the time and to the climate. There were edicts, for example, that restricted the size of ordinary homes in accordance with the Confucian insistence on frugality. Again, frequent foreign invasion and civil strife made people think twice before building houses imposing enough to invite attention. Moreover, in a natural setting that was relatively mild and free from violent changes, the urge to make a house into something special was considered in itself as flying in the face of nature. It was in accordance with such conditions, and with a mood of unforced harmony with nature, that the lifestyle of the men of the Yi dynasty developed.

This led in turn to a natural desire to make the setting of daily life something more pleasant and more varied to live in. It was precisely here that the Yi-dynasty folk painting had a major role to play—in providing diversion for eye and spirit in rooms that were otherwise small and plain. The two principal art forms appealing intrinsically to the visual faculty were painting and calligraphy. The latter was abstruse and academic in form and strongly intellectual in content, and as such was too remote from the ordinary masses to make real headway among them. Painting too—at least as far as the so-called orthodox school was concerned—was modeled after Chinese theories with their emphasis on inner power and economy of manner, and the only people, moreover, who could afford to put them in their homes were a handful of the upper class.

Yet painting is also a medium in which simple visual contact, without any particular intellectual grounding, can afford direct entry into the realm it depicts. As such, it harbors—if only it is made available in ordinary, everyday life—a possibility of being enjoyed by a broader stratum of the public. It is not without reason that most folk paintings of the Yi dynasty are, deliberately, extremely cheerful in their expression, with plenty of bright colors and amusing touches. For ordinary people of the day, painting was above all something to soothe the mind, satisfy an unsophisticated prayer, convey a message of love. It was a projection of the pragmatic, unassertive, and undemanding way of life of the ordinary Korean, who was more interested in living comfortably from moment to moment than in committing himself to lofty ideals. Since Yi folk painting functioned as part of an interior space, or as part of a wall in a building, out-of-the-way phenomena remote from the sensibilities of ordinary life were excluded in favor of themes that were familiar or that symbolized generally cherished aspirations. The artists responsible were at one with the people who displayed the pictures in their rooms, with no special need for assertive brushwork or realistic arrangement in space; distortion is in fact freely used.

In all Yi-dynasty painting, and not just its folk painting, paintings done on folding screens of many panels, or on walls (not, however, in the sense of covering entire walls; series of paintings each the size of a screen panel would be pasted on walls around the room) were far more common than paintings done on hanging scrolls, or framed. Oriental painting as a whole would seem to have evolved from the murals of ancient times, through the wall and screen paintings of later ages, on to hanging scrolls and framed paintings, becoming gradually more independent of the space it was intended to decorate. The screen and wall paintings that emerged in the Yi dynasty, while maintaining their connection with the space that they enfolded, admitted of change according to the time or place or the individual's taste, and in this sense were ideally suited to the ways of life of the Yi dynasty. Screen paintings include some in which the whole screen is devoted to a single picture and others in which it forms a series, one individual picture to each panel; it is believed that the original form was the single picture, and that this developed later into a varied set of more compact pictures.

There are various possible methods of classifying the folk paintings of the Yi period, consisting as they do of an extremely large variety of types. In the present work, I have to some extent taken these existing approaches into account, but in order to give the reader a clearer grasp of Korean folk paintings as a whole I have first classified them with emphasis on their subject matter, then have taken the types that were most favored at the time—without over-nice division into smaller categories—and commented on them in more detail. If one delves into their remoter origins, the motifs used in the folk painting of the Yi dynasty are seen to harbor compound symbolic meanings—which are often, moreover, mixed together in composing a single picture—so that classification according to symbolic significance can easily create greater confusion. Moreover, one frequently comes across an unusual treatment of themes that does not fit into any stereotype, and to attempt to distinguish in detail between all of them would, I feel, be tedious and unrealistic. Thus in what follows I have chosen a method of classification that makes it possible to discuss the subject in the broad terms while admitting

the obvious existence of exceptions. I will first give a chart showing the headlines of my classification, then proceed to discuss each category in turn.

THE CLASSIFICATION OF CATEGORIES OF KOREAN FOLK PAINTING

Flowers and birds: 1. Flowers and birds, 2. Plants and insects, 3. Peonies, 4. Lotuses, 5. Other flower-and-bird pictures (plantains, ornamental plants and trees, grapes, flowers in vases).

Animals: 6. The Four Sacred Beasts (dragon; tiger; *chujak*, a mythical bird somewhat like a phoenix; *hyŏnmu*, a snake-turtle–like creature), alone or in various combinations, 7. Tigers and tiger-skin designs, 8. Other animal pictures.

Fish: 9. "Piscine pleasures" (carp and other fish scenes).

Landscapes: 10. Landscapes (Diamond Mountains, "Eight Views" series, other landscapes).

Hunting: 11. Hunting pictures.

Genre: 12. "Hundred Boys" pictures, 13. "Ideal life" pictures, 14. Other genre pictures, 15. Historical episodes, 16. Other pictures illustrating popular tales (*Kuug mong*, literally, "Nine Cloud Dream" and *Ch'un-hyang chŏn*, "The Tale of Ch'un-hyang").

Authority: 17. "Sun and moon" pictures.

Yearly Rituals: 18. "Longevity" pictures, 19. Festival pictures.

Regional: 20. "Map" pictures.

Scholarship: 21. "Bookshelf" pictures.

Chinese characters: 22. "Letter" pictures.

Others: 23. Shamanistic pictures.

Note: The present work includes no portrait paintings or Buddhist paintings. These are all, as paintings, alien to the essential characteristics of Korean folk painting and as such, though mostly unsigned, have been omitted as exceptional cases. As for categories 13 and 16 in the above list, I have commented on them although no actual examples are included in this book.

1. Flower-and-Bird Pictures *Plates 24–43, 51, 52*

An overwhelming proportion of the folk painting of the Yi dynasty is accounted for by "flower-and-bird" pictures. A subject familiar in East Asia as one of the main themes of "pure" art, the name refers, literally, to a combination of flowers or plants and birds. The flowers are extremely varied; they may be either wild or cultivated, either large and extravagantly blooming or dainty and humble. Particularly common are peonies, plum blossom, Chinese bellflower, camellias, pine trees, bamboo, paulownia, pomegranates, and pear blossom. Birds are equally numerous, including pheasants, cranes, wild ducks, mandarin ducks, herons, cuckoos, quails, and phoenixes, pictures of ducks being particularly common.

Flowers have been cherished in Korea since ancient times as symbols of human life—its beauty and its evanescence—while ducks have been equally popular as symbols of close and eternally binding ties. Ducks—which live together amicably in pairs, refuse to find another mate should one or the other die, and look after their offspring with loving attention—have always been favorite symbols of domestic accord and affection. It is significant that most birds in Yi folk painting, and not just ducks, are depicted in pairs, or as parents and offspring. These scenes of birds living together on the closest terms constitute, one might say, a kind of hymn in color to familial and conjugal love, an embodiment of the ideals of those who painted them and those who placed them in their rooms.

The term "flower-and-bird picture," of course, covers a wide range of treatment, and individual motifs each have their symbolic significance, yet by and large they can be seen as expressions in pictorial terms of the desire to live life enjoyably and to the full, united with one's family in ties of deep affection. In this sense it is quite appropriate that flower-and-bird pictures should have been displayed chiefly in the women's rooms and in the rooms of the newly married. They are outstanding among the folk paintings of the period for the large number of colors—though not usually over-heavy or over-bright—that they use, creating a cheerful atmosphere eminently expressive of marital bliss.

The screens usually have around eight panels, each panel showing a separate scene. In the old days, there was a custom known as "first-night peeping" in Korea, according to which the relatives or friends of a newly married couple would wait until they retired for the night (the

first few days following the ceremony were spent at the bride's home), then make small holes in the paper of the door or window of the room in order to spy on the proceedings. Though this was intended in part as a way of keeping evil influences at bay, the newlyweds would in practice often stand screens with flower-and-bird pictures about the room in order to ensure their privacy.

In some cases, flower-and-bird paintings were displayed in places other than those just described—for example, in the *sarangbang* (the room that served variously as study, room of the head of the family, and room for receiving guests). Here, a different kind of atmosphere was required from the women's rooms: something more loftily spiritual, something suggestive of the cultivated tastes of the master. Thus there was a tendency to avoid anything too brilliantly colored or vulgar in them—to choose, for example, a monochrome flower-and-bird picture with a dignity reminiscent of Literati painting.

The treatment of the subject in flower-and-bird painting is free and varied, and cannot be summed up easily. It would seem, however, that in the early days realistic depictions of the subject, strongly influenced by orthodox art, were most common, and that in later times the tendency to distort shapes became stronger, developing at times into frank abstraction. Yi-period flower-and-bird pictures, among others, quite often have poems inscribed within the picture. These were obviously inspired by the type of contemporary artwork that brought painting, calligraphy, and poetry together. Even so, the men responsible for the paintings in question, however good as artists, were unlikely to have an equal understanding of the meaning and

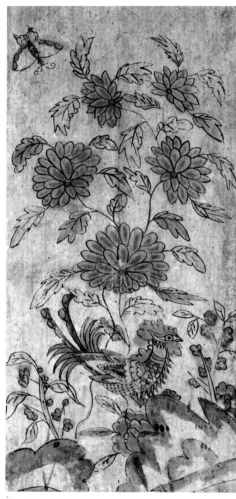

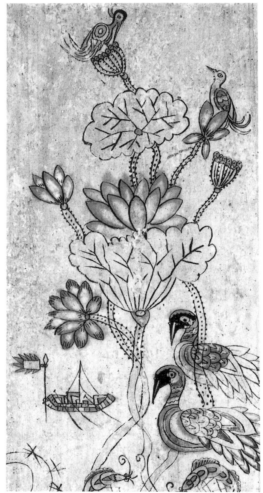

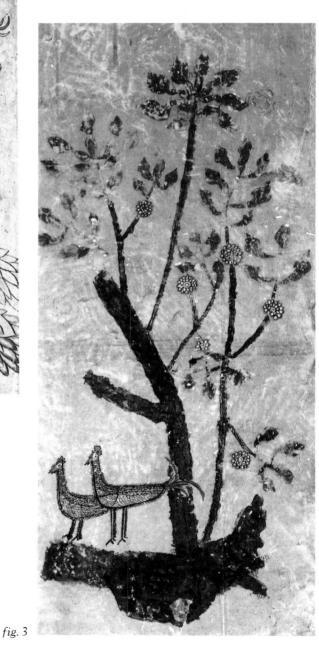

fig. 1 fig. 2

fig. 3

aesthetic value of poetry and calligraphy; in many cases, in fact, they simply imitated the form, the selection of the poetry or calligraphy being quite random. The number of artists with sufficient schooling to understand poetry or produce good calligraphy was very limited, nor, since the pictures were destined to be displayed in places where people lived, was it necessary (unless the master of the house happened himself to be a man of letters) to give the picture any highflown literary overtones.

Some flower-and-bird paintings incorporate depictions of, for example, cranes, deer, lotuses, rocks, and peonies, motifs that are usually treated separately in longevity pictures, lotus pictures, and peony pictures. Folk painting felt free from the outset to draw its themes from a variety of different categories, extracting from materials embodying a whole range of symbolic significances those that seemed most suitable for the place where the picture was to be displayed, then combining them into compositions that, in time, became stereotypes. This presumably is why flower-and-bird painting shows in practice such an abundant variety.

The brilliance of coloring in this genre is such that it embraces virtually all the rich color schemes employed over the whole field of folk painting. The colors, which were mostly obtained from the juices of plant roots and leaves (very occasionally from metallic ores or clay) include indigo, vermilion, crimson, yellow, green, blue, black, and white. The earlier the period the more common is the use of indigo, vermilion, and yellow; it seems likely that bright blue came into general use only in the eighteenth century.

fig. 4

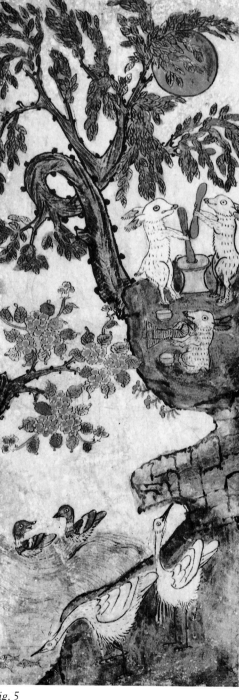

fig. 5

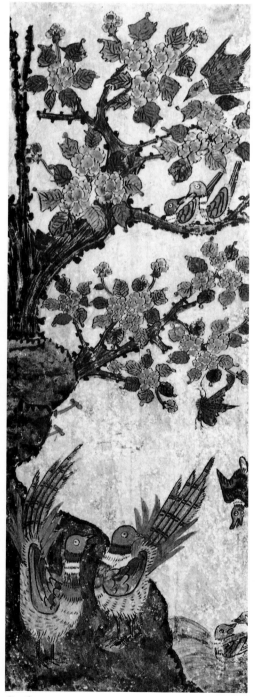

fig. 6

2. Plant-and-Insect Pictures *Plates 6–15, 19–22*

In the same way that flower-and-bird pictures combine birds with flowers or other plants, "plant-and-insect" pictures show bees, butterflies and other insects together with flowers and grasses. Bees, for example, may be shown flying busily among autumn grasses, or butterflies and grasshoppers disporting themselves among peonies or daisies. The presence of insects, of course, is not in itself enough to place a picture in this category; there are many cases where they form a relatively insignificant element in some other picture. To avoid confusion in this work, pictures in which a much greater emphasis as a whole is laid on the flowers have been placed in the flower-and-bird or the peony category.

A flock of butterflies signifies lasting prosperity. Bees are associated with prosperity and the achievement of high status. These insect motifs are only infrequently subjected to the distortion that often occurs in other folk paintings, the style tending to the realistic in the manner of orthodox painting. The treatment, too, is often delicate and detailed, with light colors; the bright colors and gay atmosphere found in flower-and-bird pictures are relatively rare.

Plant-and-insect pictures were displayed mainly in the women's rooms—especially in a lady's study, if there should be one in the house. The treatment thus is usually such as to suggest feminine grace and intelligence, or to go well with an elegant costume; the setting did not call for the distortion or brilliance of manner seen in other folk paintings. Judging from the relatively small number of plant-and-insect pictures surviving today, it seems possible that they were considered rather insubstantial for display in rooms where the ordinary life of the family was going on. It seems that they were favored chiefly by ladies of relatively high station, and thus perpetuated a style of composition, close to the academic school, that would not have appealed to the common people. The failure of a particular category of folk painting to permeate the more plebeian level of society is usually related to the fact that it preserved the original, academic style more or less as it stood, without any freely inventive interpretation.

A celebrated Yi-dynasty artist of the orthodox school who specialized in plant-and-insect paintings was, of course, Lady Shin, or Saimdang (1512–59). She started painting landscapes at the age of seven in imitation of the work of the master painter An Kyŏn (15th century). She is said also to have written a good prose style, but her speciality was pictures on such subjects as plants-and-insects, "fur and feathers," and grapes. Her pictures are refined in style, delicate in the treatment of their subjects, and graceful in their coloring. In "Korea and its Art," published in the fourth volume of his selected works (1972, Shunju-sha), Yanagi Soetsu reproduces an Yi-dynasty folk painting entitled "Flowers and Insects" in the possession of the Japan Folk Art Museum, which he attributes, rather doubtfully, to Lady Shin. There are many other artists of the orthodox school, among them Sim Sa-jŏng, or Hyŏnje (1707–69), who specialized in flower-and-insect pictures, but such was Lady Shin's fame in later ages that the existence of other plant-and-insect painters working around the same time has tended to be obscured. The plant-and-insect paintings of the folk tradition were probably influenced considerably by these artists of the orthodox school, though the treatment of the subject was doubtless modified in time to blend in with the settings in which they were to be displayed.

Perhaps because of the nature of the subject, plant-and-insect pictures in Yi-dynasty folk painting seem often to have been the work of women artists. Some have a flock of butterflies as their main subject, the flowers appearing as relatively small and unimportant; others show a few butterflies together with some flowers, the importance of the two elements being more or less equal; while others again depict various types of insects and other creatures (frogs, crickets, grasshoppers, bees, mosquitoes, moths, butterflies, dragonflies, cicadas, and so on) together with a few sparse blades of autumn grasses. One unusual type shows a scene in which butterflies and a praying mantis are accompanied by a rat gnawing at a giant radish. There are some pictures (see Color Plates 19 and 20) that are done in bright colors with abbreviated, caricature-like brushstrokes reminiscent of cartoons; these are believed to come from the end of the period. The butterflies depicted tend to be rare species. As with flower-and-bird pictures, most plant-and-insect paintings were done on folding screens, with a different scene on each panel.

3. Peony Pictures *Plates 1–5*

Most pictures of peonies show rocks done in red, blue, green, white, or purple at the root of the plant, though there are all kinds of variations, some showing the peonies alone, others showing them in vases or with butterflies or bees hovering about them. In most cases, the petals and leaves are large and ample, the plant spreading boldly over the whole space with no particular

background shown. The leaves are usually done in green or bluish-green, the flowers mostly in scarlet, crimson, or other shades of red, or in yellow (very occasionally, in white, blue, or other colors), the picture as a whole creating an extremely brilliant and massive effect.

The reason so many peony pictures are done on eight- or ten-paneled screens, and with sumptuous mounting, is that they were commonly used for wedding ceremonies. In olden times, wedding ceremonies were very often held in the courtyard of the bride's home, where a ceremonial platform was set up with a curtain to give shelter from the sun. Valuing Confucian-style "etiquette" as it did, Yi society required a complex procedure for the rite itself. This was performed standing, with the happy couple backed by a peony screen, which meant that the screen itself had to be taller than the couple, and that the picture had to have a suitably impressive effect. Well-to-do households would have their own screens, but each village usually had a communally owned screen that was available to households that could not afford one of their own. It was also quite common for a screen to be borrowed from the bridegroom's elder brother or other relatives.

Because of its size and imposing appearance the peony, which was of course a favorite flower in China too, was used as a symbol of wealth and a life free from hardship. The shape of the rocks at the root, moreover, commonly suggests the male and female sexual organs, the picture thus coming to symbolize the union of male and female. The rocks painted in some shade or other of blue (though various other colors are used occasionally) are commonly shaped to resemble the male phallus, while the rocks in shades of red with a hole in the middle symbolize the woman. Occasionally the two rocks are depicted entwined—an oddly erotic effect when one considers that peony pictures were used at wedding ceremonies.

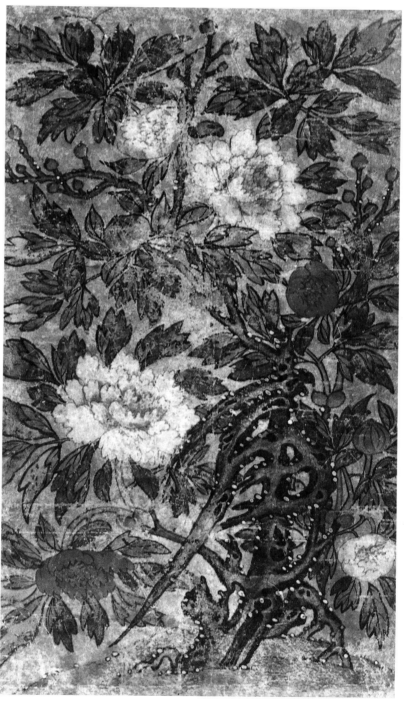

fig. 7

In China, flowers accompanied by *taihu-shi* (a type of limestone, eroded into odd shapes, that was once commonly found in Taihu, in China, and was often used for decorative purposes in gardens and flower pots) often appear in paintings and on decorated ceramic ware. Stones and rocks are another symbol of long life, and often appear as one of the motifs in the "Ten Symbols of Longevity" of Yi folk painting, as well as in independent pictures of strangely formed rocks. Some of the rocks appearing in peony pictures take the form of tigers, deer, or other animals, or are anthropomorphized—a sign, possibly, of the influence of popular beliefs attributing divine properties to natural formations, or of ideas about Taoist immortals. In every case, the rocks lose their natural shapes, being treated almost purely decoratively; in some cases, they have degenerated into a more or less unrecognizable band of color. The peony flowers themselves are quite often treated as symbols or stylized under the influence of shamanistic, Buddhist, or other beliefs, and one frequently comes across pictures in which the flowers face in four directions—forward, upward, right, and left—or in which the flower suggests a lotus.

A fairly uncommon type of peony picture shows the stalks in the form of Chinese characters. In Figure 7 here, for example, the character for "peace" (康) is incorporated in the stalk. The characters in question usually represent typical ideals of the society of the day—long life, good health, rank, wealth, and many male offspring—and were presumably intended to symbolize the aspirations of the bride and bridegroom as they embarked on their new life.

There are also smaller versions of the peony picture, which were sometimes used to decorate the room of the bridal pair, or in connection with shamanistic observances. The pictures displayed in the house of a shaman (*mudang*) or at a shrine frequently replace the rocks under the flowers with a vase, or depict flowers in isolation, painted to fill nearly the whole area of the picture; their most marked characteristic is the high degree of distortion and the flat, two-dimensional nature of the composition.

4. Lotus Pictures *Plates 58–66*

Paintings of lotuses include, besides those showing lotuses alone, others that show trout, catfish, prawns, shellfish, white cranes, herons, and so on in the lotus pond with the flowers, as well as some with kingfishers, swallows, butterflies, bees, and the like hovering in the air about them. Here, too, eight- or ten-paneled screens are more common than single paintings. The typical composition does not show, as with flower-and-bird pictures, a series of scenes differing from panel to panel as with flower-and-bird pictures, but spreads large numbers of lotuses over the whole surface of the screen. This treatment of the surface of a folding screen, normal in orthodox painting, is rather rare among folk paintings, and apart from lotus pictures is found chiefly in "longevity" and "sun-and-moon" pictures.

The first notable characteristic of lotus paintings is the almost total predominance of bright colors and the absence of Chinese ink or other monochrome media. The scenes depicted suggest a calm summer's day, with the flowers basking in a fresh, caressing breeze and spreading their leaves out at leisure over the water, while swallows dart about them, other birds peck at the lotus seeds, and cranes and herons frolic in the water. The pale colors of the flowers—white and red-ocher—make an attractive contrast with the green of the swaying leaves, and combine with the colors of the living creatures round about to give the picture as a whole a feeling of coolness and freshness.

In Japan, pictures of the lotus are inseparably associated with Buddhism, seldom occurring in any other connection. In Korea, however, lotuses have always been a favorite subject, one that evoked pleasant, spiritually refreshing associations—doubtless because the idea of such a beautiful flower rising out of the murky waters of a pond had an unconscious emotional appeal. The almost invariable inclusion of a lotus pond in Korean gardens is a good indication of this national partiality for the flower.

These pictures of lotuses served simply to provide a refreshingly cool touch during the hot summer months; the bloom's traditional associations with Buddhism—as a symbol of the Buddha's teachings or of Paradise—were largely irrelevant.

Lotus paintings done on folding screens include many relatively large pieces. In some cases they virtually hide the walls in front of which they are stood; the person viewing them does not so much appraise the pictures from a distance as feel himself surrounded by them. As a genre, lotus pictures are believed originally to have been a variant on, or development from, the flower-and-bird picture that acquired in time a kind of independent existence because of their value as a summer picture creating a feeling of coolness.

The birds, insects, fish, and the like that are depicted about the lotuses themselves always ap-

pear, as in flower-and-bird painting, in pairs of male and female. The fish, shellfish, prawns, and so on in particular seem to be enjoying themselves in the water in a way that reminds one of the "piscine pleasure" paintings; they are yet another example of the desire for affection and peaceable relations of the inhabitants of the houses they graced.

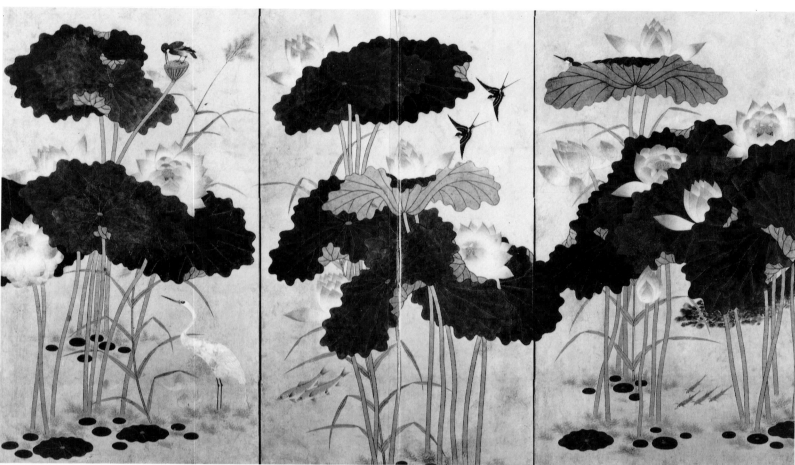

fig. 8

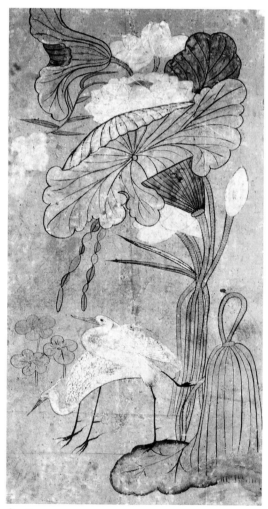

fig. 9

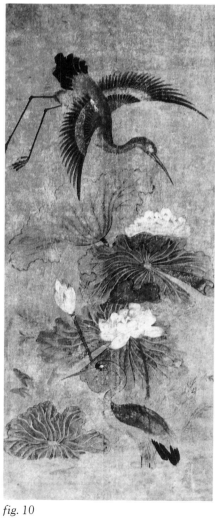

fig. 10

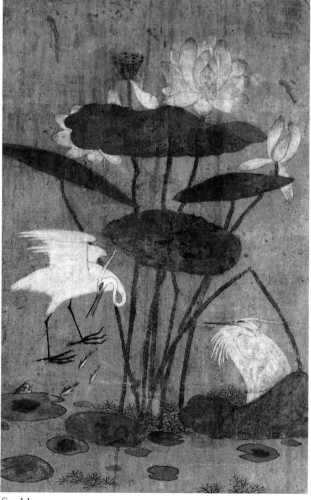

fig. 11

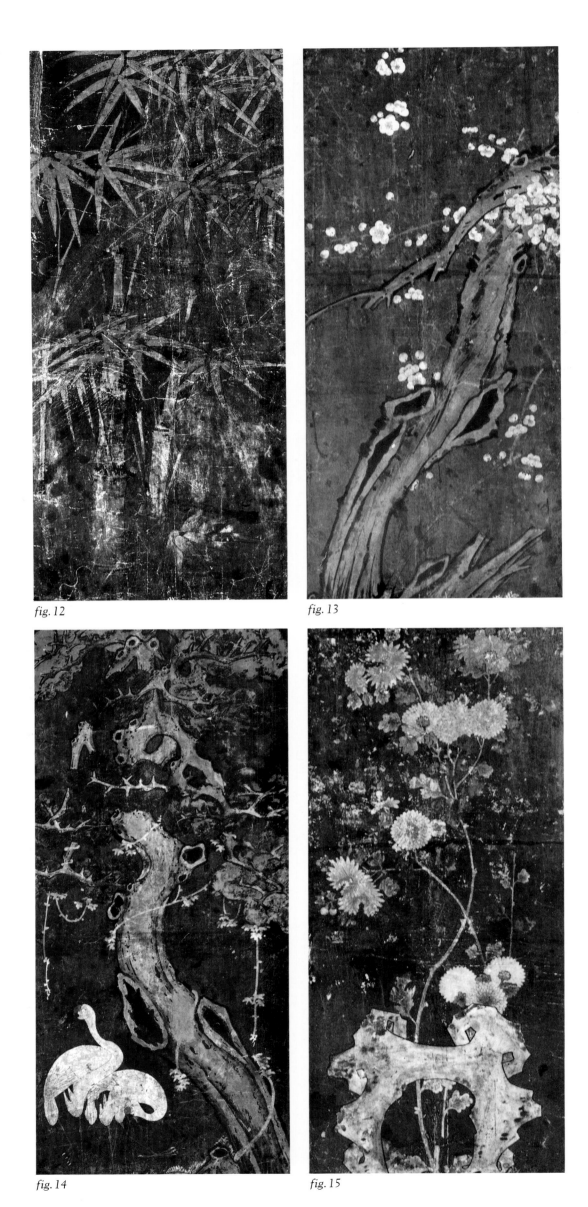

fig. 12

fig. 13

fig. 14

fig. 15

5. Other Flower-and-Bird Pictures *Plates 16–18, 23*

Below are a number of types that, while not fitting easily into any of the previous three categories, can be included in flower-and-bird painting in the broadest sense.

■ Ornamental Plants and Trees *Plates 16–18*

This includes various pictures in which flowering plants and trees are the central feature. In academic painting, the "Three Friends"—plum, pine, and bamboo—and the "Four Gentlemen"—plum, pine, orchid, and bamboo—are common subjects of both Chinese-ink and color paintings, together with other flowering plants such as the lily and the chrysanthemum. Their influence can be seen in folk painting, but the actual number of pictures is small. A typical example is seen in Figures 12 to 15.

The work is an eight-paneled screen, the central features of whose panels are plum, pine, magnolia, peony, pomegranate, chrysanthemum, bamboo, and phoenix tree respectively. The manner is refined and confident—for example, in the pomegranate tree whose branches are so slender to bear such emphatic fruit; in the huge, half-hidden rock; or the aged pine tree beyond which a male and female crane disport themselves so amicably. The pomegranate, which bears seed-filled fruit, is a symbol of fecundity, while the pine, bamboo, *pulloch'o* (an imaginary fungus shaped like a red mushroom), and cranes symbolize longevity or immortality. Here, too, the cranes appear as a pair. The dark-colored blackish texture was created by dyeing handmade Korean paper purple, then pounding the dye thoroughly into the paper.

These pictures of ornamental plants and trees are done in a style relatively close to that of academic painting, but some of them also show a semi-abstract, decorative treatment. Figures 16 to 19 are a good example; the simplified composition is reminiscent in some ways of modern design. Close inspection, moreover, reveals water birds and insects treated in a quasi-humorous fashion.

fig. 16

fig. 17

fig. 18

fig. 19

■ Plantains

This is another theme that often occurs in orthodox painting. The great rock that accompanies the tree is doubtless inherited directly from the flower-and-rock combination seen in Chinese painting. The plantain tree also makes an appearance in flower-and-bird and Hundred Boys paintings, but Figure 20 is unusual in being a single painting done on a scroll—one, moreover, that measures more than a meter in both directions. The plantain, which is indigenous to China and bears flowers in summer and autumn, reaches around five meters in height and has elongated, oval leaves that spread out to a length of nearly two meters. With its large, attractive leaves and fruit, it has always been considered a symbol of the life of plenty, while rocks and stones are of course a symbol of long life. There is an extremely stylized rock with a hole in it at the bottom of the picture just mentioned, while to one side there is a peony, the two together enhancing still further the auspicious suggestions of wealth and rank.

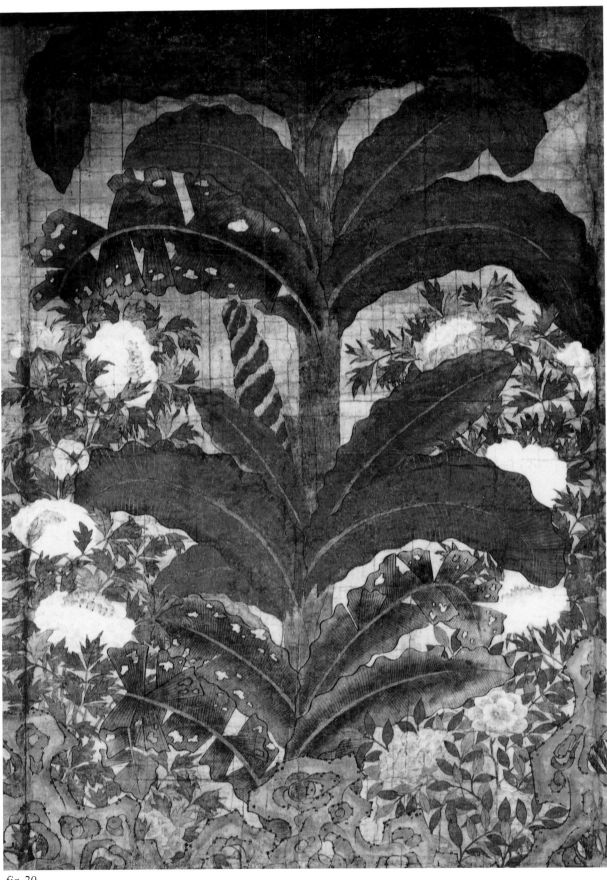

fig. 20

■ Grapes

There are various kinds of grape pictures—folding screens of eight or so panels with a continuous vine bearing abundant fruit trailing across them; single pictures of grapes and squirrels or of grapes alone; and so on. In instances where the vine is particularly long and sinuous, the pictures are referred to as "plant dragons," because of the supposed resemblance. This variation seems to have been invested with the same auspicious associations as the dragon itself. It has also been suggested that the grape, with its multitude of leaves on a single, continuous stem, and its egg-shaped fruit, was intended as a symbol of fecundity.

Grape pictures are common among paintings of the Literati and other orthodox schools and many folk paintings of grapes were doubtless done without being over scrupulous about symbolism at all. Pictures of the grapevine, which bears flowers and forms its fruit in early summer, were displayed chiefly in summer and early autumn, when they doubtless made an evocative and refreshing sight.

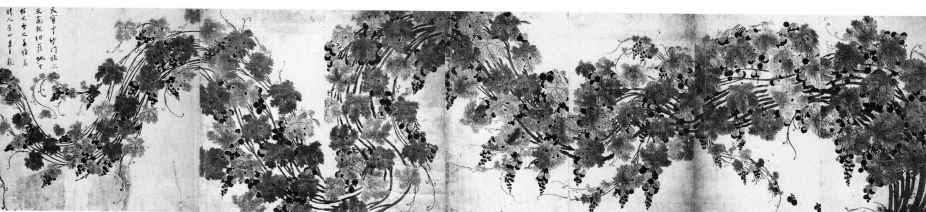

fig. 21

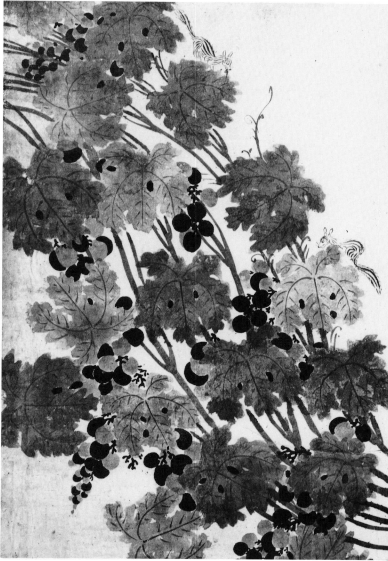

fig. 22

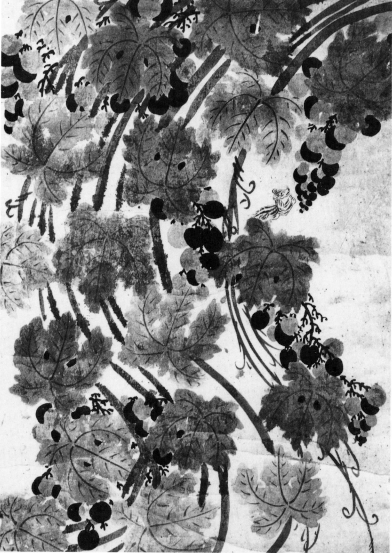

fig. 23

■ Flowers in Vases

These are pictures of flowers such as peonies, pomegranate blooms, pear blossom, lilies, and camellias arranged in pots or bowls. They often appear within pictures in the "bookshelf" category, and not only the flowers but the ceramic vessels themselves sometimes have considerable beauty of color and form. In Yi-period Korean painting, they appear on folding screens or as series of individual pictures, and there are variants such as the peonies-in-vases pictures that were produced under the influence of shamanism and displayed at shrines or in the houses of shamans.

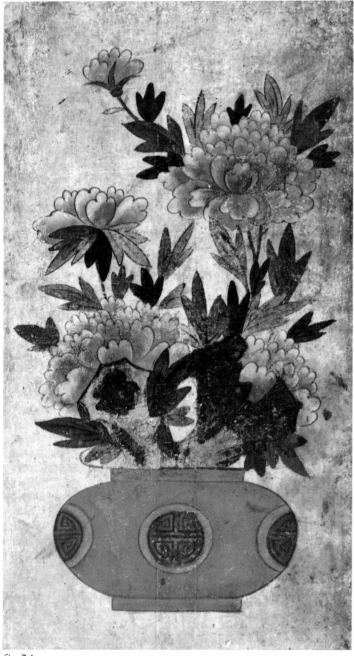

fig. 24

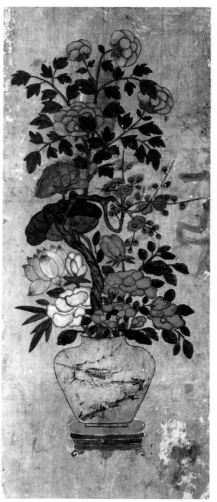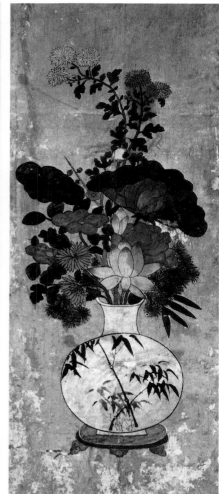

fig. 25

fig. 26

■ Flowers-and-Birds with Animals, Fish, and Plants-and-Insects *Plate 23*

The term "flowers-and-birds" covers a wide range of pictures, in some of which insects, not to mention birds and animals such as cranes, deer, tigers, wild boar, hares, horses, and fish, put in an appearance. The type of academic painting known as the "fur-and-feather" picture and incorporating birds, flowers, and animals all within the same landscape often shows a pair of hares in a natural setting. Apart from this, there are also some works, painted with great freedom of fancy, in which fish, tigers, and the like make their appearance without any particular relevance to each other. Examined in detail, their motifs might possibly reveal a rudimentary symbolism. However, with folk art of this type, to seek to explain what the picture as a whole "means" smacks of pedantry; it is safer to assume that such mixed pictures, which are particularly common among more recent works, were painted mainly to suit the fancy of the artist or the person who was to display them in his house. Changes in social conditions toward the end of the Yi period (political instability, changing lifestyles, the influx of foreign culture) had the effect of eroding the patternized modes of expression evolved by a communal imagination, and in many works the artist seems to be giving free rein to a purely personal fancy.

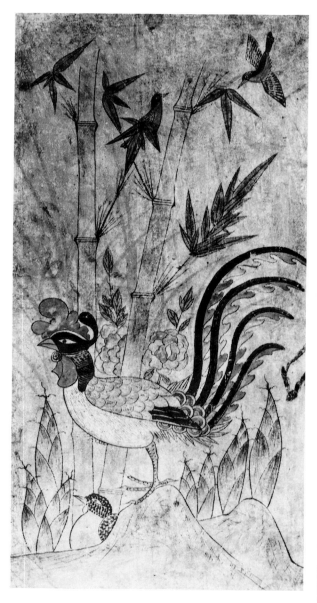

fig. 27

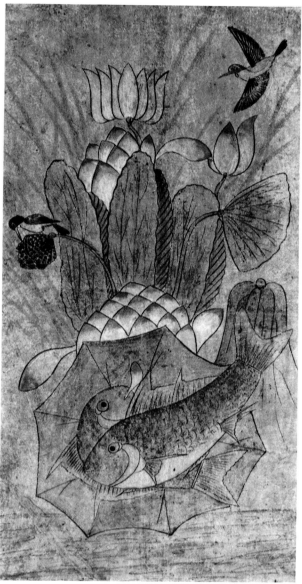

fig. 28

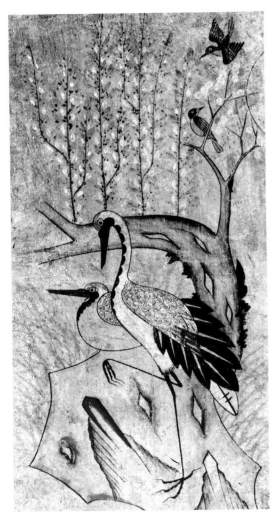
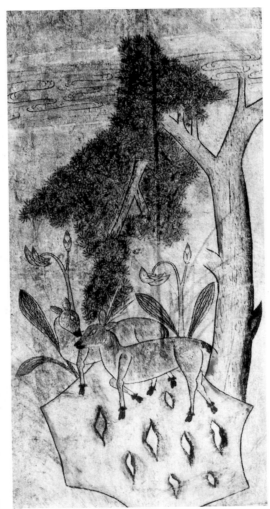

fig. 29　　　　　　　　　　fig. 30

6. Four Sacred Beasts Pictures　*Plates 76–78, 94*

Pictures of the Four Sacred Beasts (blue dragon, white tiger, black *hyŏnmu*, and red *chujak*) are representations of the four sacred animals that are believed to guard the four quarters: east, west, north, and south, respectively. They are imaginary beasts first conceived in ancient China, and traces of belief in them are to be found throughout the whole of East Asia. Murals depicting them in ancient burial mounds include, in Korea, No. 1 mound at Chinp'a-ri, which dates from the Koguryŏ period; No. 6 mound at Songsal-li, and No. 2 mound at Nŭngsal-li, both from the Paekche period; in China, Nos. 4 and 5 at Wukuai Fen and No. 1 grave at Nanli Wangcun; while a well-known example in Japan is the Takamatsu-zuka burial mound. The original inspiration for the Four Sacred Beasts is uncertain, but it seems likely that they were first conceived of as guardian gods on account of the vital importance of the four quarters in the workings of nature, and in particular the need for an agricultural people to take account of weather and the four quarters in sowing seed and gathering crops.

There are almost no folk paintings preserving the original forms of the Four Sacred Beasts as they are seen in burial mound murals; more often, the blue dragon becomes a dragon in any one of a variety of colors, the white tiger becomes a perfectly ordinary tiger, the *chujak* becomes a phoenix, an ordinary peacock, or even a chicken, and the *hyŏnmu* (a kind of mixture of turtle and snake) is shown as a tortoise or turtle. It seems likely—as might be expected with imaginary animals—that because of the lack of any unified concept of their appearance, people gradually had recourse to actual animals as models.

Pictures of the Four Sacred Beasts were displayed on walls or pillars of the house as a means of warding off evil; if there was an epidemic in the south, for example, a picture of *chujak* would be displayed in that quarter. They were almost never depicted on folding screens, but developed mainly as a subject for hanging scrolls. In some cases, the pictures are painted in a series of four, in others singly as examples of one particular genre. The tiger in particular is treated mainly as a subject for individual pictures, and is also the most common of the four, so that in what follows I have devoted a special category to it.

■ **Dragon**　*Plates 76–78*

The best expression of popular ideas about the Four Sacred Beasts is seen in the "tiger-and-dragon" pictures, which treat the two animals as a pair; these sometimes appear on folding screens, though pictures of dragons alone are more common in this form. The dragon of the

Four Sacred Beasts pictures is, properly speaking, blue, but in folk painting it may be red, yellow, white, black, or some other color.

It seems likely that these differently colored dragons were originally conceived of as having different purposes. In the Chinese classics, dragons of various colors are related to the four quarters, with various symbolic significances, and are thought of as having been born of the "spirit" that fills both heaven and earth. However, in everyday life such distinctions were almost entirely ignored, the dragons being displayed indiscriminately on walls and pillars as a means of warding off evil. The reason why dragons in folk paintings are often shown entwined with clouds is that in times of drought pictures of them in this form were frequently made up into hanging scrolls and used in rain-inducing ceremonies.

■ Chujak *Plate 94*

Chujak, the mythical red bird from the south, is frequently depicted as a phoenix or a cockerel. Representations of phoenixes are particularly common in flower-and-bird pictures and the like, and I treat them separately here since they can also be considered as constituting a category in their own right. The phoenix was traditionally considered to be a noble bird; as such, it perched always on the phoenix tree, fed on bamboo, and drank the water of a special spring that was said in China to well up in times of universal peace; however hungry it might be, it never ate such commonplace food as millet. The *chujak* of Yi folk painting is considered a symbol of good fortune, and is variously shown in the shape of a crane, a cockerel, a peacock, and so on.

7. Tiger Pictures *Plates 67–69*

The tiger has been familiar to the Korean people since ancient times as a frequent subject of stories and legends, and it is a favorite theme of folk painting too. In China prior to the introduction of knowledge of the lion—or a garbled version of the lion—from Central Asia in Han times, the tiger was king of the beasts and symbolized the averting of evil. In ancient Korea, it ranked with the bear and the wolf as an object of veneration. In addition, in a country where the tradition of mountain worship was strong, it came to be considered as the messenger of the Mountain Spirit, whom folk painting often depicts as an old man mounted on a tiger. Though the tiger was originally one of the Four Sacred Beasts, it probably became associated in time with all kinds of local beliefs and stories, thus undergoing a gradual transformation into the image found in the dragon-and-tiger picture, or the independent tiger picture, as we know it. Tiger pictures, being considered efficacious in warding off evil, are often displayed on the front gate at the New Year, and pictures of tigers, or of the Mountain Spirit mounted on a tiger, are often found in shrines also.

The design most favored shows the tiger in a dramatic posture in front of a magpie perched on a pine tree. The tiger often looks as though it is laughing—or it could, perhaps, be talking to the magpie. As to when, and for what purpose, the pine, magpie, and tiger came to be associated in one composition, the question remains puzzling. In the orthodox painting of the Yi period, tiger paintings by such artists as Kim Hong-do (1745–1818) and Yi Sang-jwa (1465–?) still survive, but none of them throws any light on this relationship. One theory holds that the tiger is the messenger of the Mountain Spirit or the tutelary deity of the village, while the magpie bears his oracle; another says that the *chujak*, originally one of the Four Sacred Beasts, was transformed into the magpie (a bird which even today inhabits Korea in large numbers). Either way, it is certain that the magpie, a migratory bird, was considered to be a bearer of good tidings. A belief still survives that to hear a magpie crying in the morning means that one will have a welcome visitor that day.

The tigers of Japanese art are usually shown with bamboo, but in Korean folk painting it is the pine that figures chiefly. The pine signifies purification and freedom from evil influences, and also appears in longevity and sun-and-moon pictures as a symbol of long life. It is, in addition, a favorite construction material much used in everyday life, so that, all in all, it seems to have been looked on as a valuable and auspicious tree.

Some of the pictures depict individual hairs on the tiger's body with an obsessive care reminiscent, almost, of the elaborate detail of a portrait painting, but the treatment as a whole is frequently ironical, not to say cute. While many of the earliest examples have a fierce dignity worthy of what was, at one stage, the king of beasts, in later ages the tiger was increasingly caricaturized—made, for example, to resemble a cat, or shown smoking—or was given spots like the leopard, or turned into more or less purely decorative designs. This does not mean that the tiger, for Koreans of the Yi period, was a friendly animal. The tiger as such was still con-

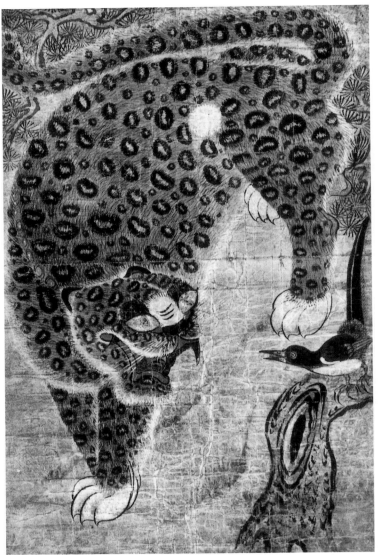

fig. 31

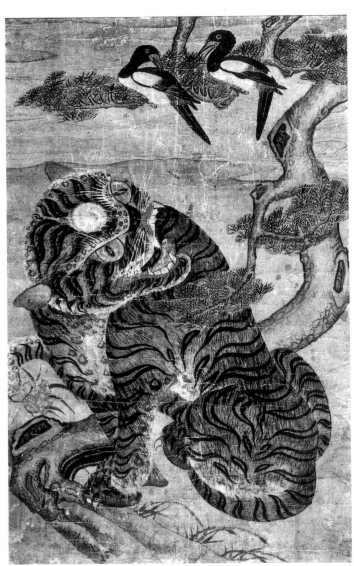

fig. 32

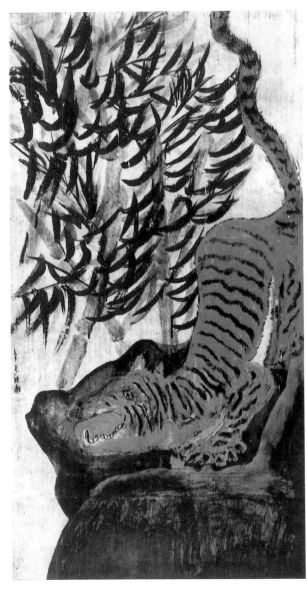

fig. 33

sidered the most ferocious of animals—strong enough, indeed, to be efficacious in warding off evil—and the early pictures of raging tigers were a frank expression of that fierceness. However, as folk painting gradually pervaded the daily lives of the ordinary people, it came—in a typical expression of the tough quirkiness of the common people—to be shown humorously and even anthropomorphized. Probably, too, the artists, rarely having the chance to see a real tiger, were more often than not obliged to imagine it with reference to cats and other, more familiar animals.

There are some tiger pictures with inscriptions showing that they were quite explicitly intended as charms to ward off evil. Sometimes these were mass-produced as prints, or even reduced to pieces of paper for sticking up on walls, pillars, and gates, with only the Chinese character for "tiger" and no picture. It is also recorded that a folk treatment for malaria and boils involved sticking pictures of tigers on the affected parts of the body.

Tiger-skin Designs *Plates 70, 71*

This refers to pictures in which a large part of the surface is occupied by patterns resembling tiger or leopard skin. Whereas the "tiger picture" was often characterized by a humorous treatment with much distortion, tiger-skin pictures are more purely pictorial—flat, two-dimensional compositions with a harmoniously decorative effect. Many of them are realistic, the tiger's hair and markings being painstakingly depicted, but there are also some eight-paneled screens of high artistic quality with a three-dimensional composition in which interiors with various writing implements are visible through spaces in the middle of a "curtain" of tiger skin.

There was formerly a custom at Korean weddings of covering the palanquin carrying the bride with a tiger-skin rug. Wedding ceremonies were held at the bride's home, where the new couple slept and ate for several days so that the bridegroom could pay his respects to the bride's parents, relatives, and neighbors; then, when this was done, the couple proceeded together to the bridegroom's home, the tiger skin being used as a means of protecting against evil on the way. Tiger skins were also favored as floor coverings within the home. It was against a background of customs such as these that the tiger-skin picture came into being. Originally, thus, it probably embodied the symbolic purpose of warding off evil in the same way as the tiger picture. Gradually, however, this significance seems to have been ignored in favor of a more pictorial approach, and the pictures came to be displayed in the guest room and elsewhere purely for their decorative qualities.

8. Other Animal Pictures *Plates 49, 53*

Pictures of cranes, deer, hares, cats, dogs, hawks, and so on are common; pictures of cows, horses, monkeys, and other favorite themes of orthodox painting are rare. The deer and the crane, which are usually depicted in pairs or together with a pine tree, are both symbols of long life, and as such occur as themes of the longevity picture. The hare, too, which is considered an auspicious animal, puts in an appearance, in the form of male-female pairs, in flower-and-bird screen paintings. Pictures of cranes frequently served as means of averting evil, being especially common in the form of woodblock prints intended as charms to fend off the "three evils." There are also rare examples of works done in fine detail with a brush, and pictures made by applying color with a brush to a preliminary sketch printed with woodblocks. Other subjects of prints intended as charms included tigers, dogs, cockerels, and the fabulous giraffelike animal known as *kirin*; these were never mounted on screens, but were pasted on walls and pillars. They are all characterized by a lack of realism and by two-dimensional forms tending to the grotesque. There are also some pictures showing the Four Divine Animals (*kirin*, dragon, phoenix, and turtle).

9. "Piscine Pleasures" Pictures *Plates 50, 54, 55*

These include pictures showing various types of fish, shellfish, prawns, crabs, etc.; pictures of these creatures together with flowers; pictures in which, for some reason unknown, rays, octopuses, clams, squid, and the like are depicted along with a landscape containing horses and deer; and others in which they are seen swimming among rocks near the shore. The fish sometimes go in pairs, sometimes in shoals with their families and friends; either way, the intention is never to represent their appearance and habits faithfully, but to create scenes in which they are shown enjoying life together. No distinction is made between salt- and fresh-water fish, all kinds of species being depicted swimming happily together in a kind of peaceful, watery paradise.

Such pictures—since fish go about in shoals and have large numbers of offspring—were prized as symbols of fecundity, family unity, domestic tranquillity, and the like. They were

displayed chiefly in the women's rooms, rooms used for parturition, and in the rooms of young married couples. The "parturition room" was created by setting aside a woman's room temporarily for the purpose of childbirth and even husbands were not allowed inside the women's rooms without special permission.

The "piscine pleasures" pictures generally avoid heavy, showy colors, being painted in a limited range of subdued hues. Since, however, it was important to create a happy scene that would symbolize family accord, the fish, crabs, prawns, and shellfish were often shown with human faces or other anthropomorphic features. The fishes with artfully innocent expressions, the crabs and prawns that seem to be dancing, the shellfish with wide-open mouths—all are humorous and amusing. Some fish even have hair growing on their heads, and there are others that look like phalluses. There are some works showing a shoal of fish coupling in pairs that create the effect of an abstract design and show an excellent sense of composition.

Popular tradition often presents the catfish and carp as symbols of female and male children, respectively; the carp is a vigorous fish that leaps about on the surface of the water and is even known to climb waterfalls, whereas the catfish usually swims quietly, keeping to the bed of the river. Thus a pregnant woman who dreamt of one or the other was thought to be able to tell the sex of her unborn child.

In a sense, though they form a stereotyped male-female contrast, it would be wrong to see them strictly as male and female symbols, since folk painting often shows pairs of fish in which both male and female are carp or catfish. Prawns and shellfish, again, are thought to symbolize compatibility and good relations. A type of picture that fits in well with this kind of popular belief is seen in the prawns and shellfish accompanying the character *ch'ung* in the "letter" pictures.

However, it would be wrong to interpret all the motifs occurring in piscine pleasures pictures in the same way. It seems more likely that the genre represents a kind of aquatic flower-and-bird painting, in which a large number of motifs derived originally from a variety of popular beliefs have been freely adopted and regrouped to fit in with the themes of conjugal and family

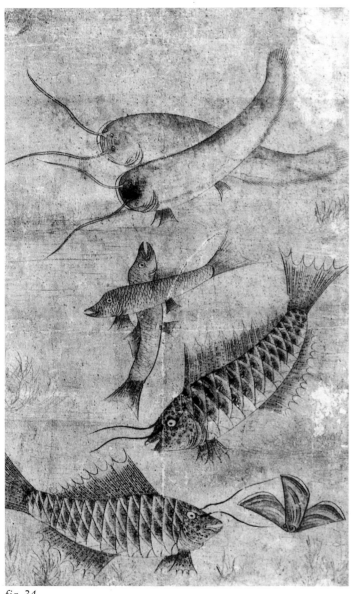

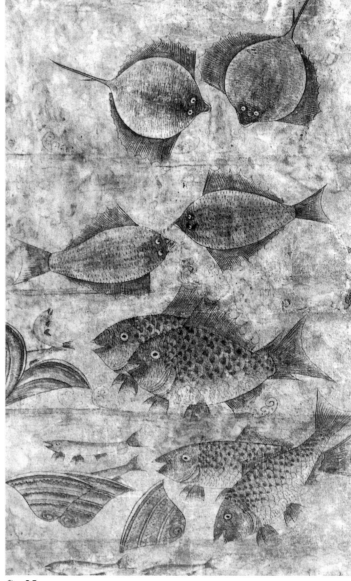

fig. 34

fig. 35

love; it is unlikely that they were composed with an eye to the symbolic significance of each and every detail.

■ **Carp** *Plates 56, 57*

The carp, familiar in East Asia as the king of fish, has always been a popular subject for painting, and it is common in folk pictures too. Pictures of carp signify the birth of a male child or success in society, and were displayed on occasions such as the day before a young man took the official examinations, or the birthday of a boy, as well as just before an expected birth. Whereas piscine pleasures pictures are often painted on folding screens, carp pictures are usually independent works. The pictures showing, typically, an early morning scene just as the sun is rising, with a carp leaping vigorously above the surface of the water, are an expression of the desire that a healthy boy-baby will be born, will grow in time to adulthood, and will make his vigorous mark in the world.

It was also generally believed, incidentally, that to eat carp was good for the health; it is said that they were particularly prized in the remote mountain areas where no other really edible fish were available.

The best known of the many popular tales about carp is the legend of *denglongmen*, or Dragon Gate, recorded in a biography in the Book of Latter Han. This is the name of a swiftly flowing section of the Yellow River; carp gather downstream from it and try to climb upstream against the current. A large number of them are carried away by the water, but those that succeed are transformed, according to the story, into dragons; it is from this that the use of the phrase *denglongmen* to refer to worldly success and advancement derives. Some of the carp paintings that occur in folk painting clearly reflect this popular tale, and there are even some that show a creature with the top half of a dragon and the bottom half of a carp leaping above a stream.

There are, of course, other carp pictures too—showing, for example, a male and female carp disporting themselves beneath lotuses, and other scenes unrelated to the symbolic significances described above.

10. Landscape Pictures *Plates 96–99*

The landscape has occupied a unique and central position in Oriental art as a whole, and it makes a predictably frequent appearance in the folk painting of the Yi dynasty. There are many different types: depictions of actual places, such as the Diamond Mountains pictures and the Eight Views of Xiaoxiang; combinations of actual scenes with landscapes of the imagination; purely imaginary landscapes; extremely abbreviated representations of landscapes in the manner of Literati painting; and so on.

Distortion of actual shapes is common; even where the subject is an actually existing scene, realism is often sacrificed to the demands of a highly imaginative freedom, since mountains and rivers, in the landscapes of Chinese and other Oriental art, are normally presented, rather, as awesome *symbols* of nature. Most folk pictures of the Yi dynasty, however, eschew lofty idealism, rapid brushwork, and emphasis on composition in favor of an approach that, while still freely imaginative, has an amiable optimism that does not depend so much on the artist's individual vision. Moreover, the landscapes of Yi folk art are more frequently than not done in light color or monochrome, with few brilliant hues. They were displayed, in the form of folding screens or hanging scrolls, in the master's room or study, and were replaced from time to time as the season or individual fancy required.

■ **Diamond Mountains Pictures** *Plates 98, 99*

This category includes panoramic, two-dimensional views of the "Twelve Thousand Peaks of the Diamond Mountains"; "Eight Views" series of natural beauty spots or historic sites; scenes of the "Sea and the Diamond Mountains," with mountains ranged along a seashore; bird's-eye views; and so on, as well as many others in which peaks and waterfalls, temples and caves are marked in as on a tourist map.

In many cases the peaks in a Diamond Mountains picture are made to suggest human beings or Buddhist deities, horses, oxen, or other creatures. In Buddhism, Taoism, and shamanism alike the Diamond Mountains were considered to be sacred. One reason was the special associations of the term "diamond" in Buddhist belief; temples such as Changan-sa and P'yohun-sa were founded in the Diamond Mountains, and temples and caves housing Buddhist figures are shown in the folk pictures. Secondly, the Diamond Mountains were formerly a great center of Taoism, and were also known as Pongnae-san (one of the legendary homes of the Immortals). The ancient Chinese considered Pongnae-san one of three holy mountains, im-

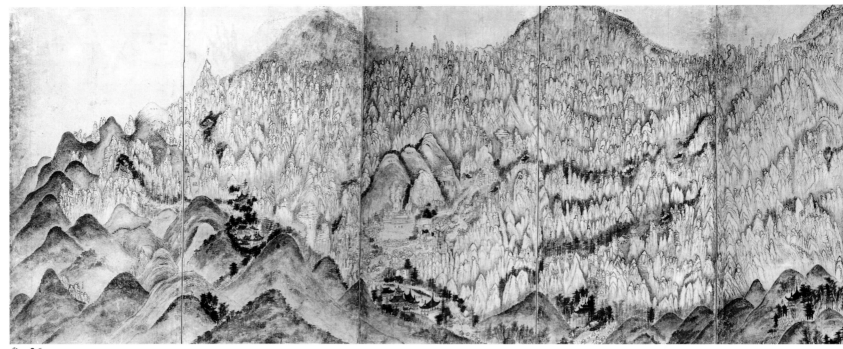

fig. 36

fig. 37

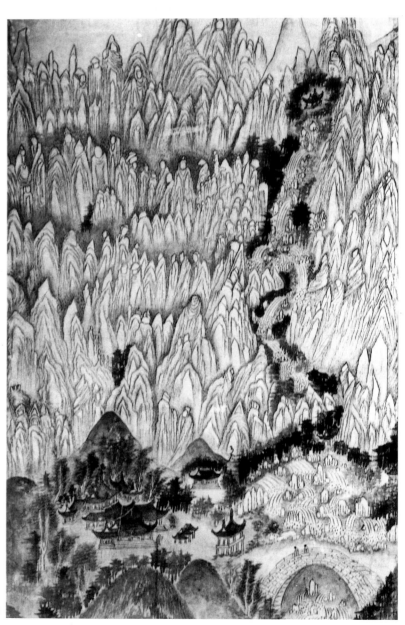

fig. 38

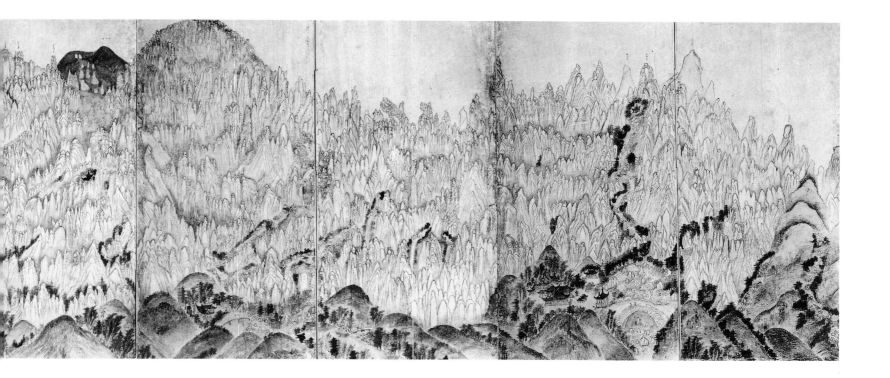

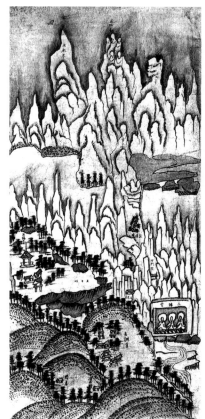

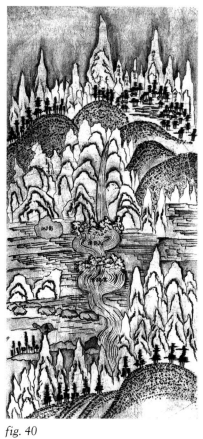

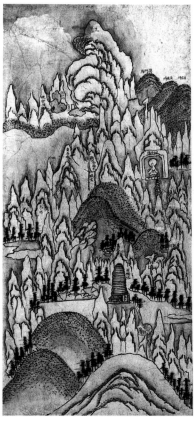

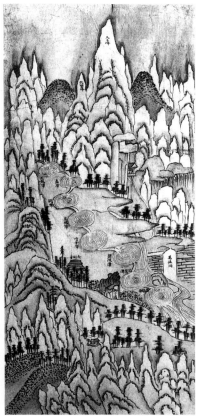

fig. 39 fig. 40 fig. 41 fig. 42

agined as rising out of the eastern seas; Koreans have always treated the whole Diamond Mountain area as sacred. Such ideas about incorporated with popular animistic ideas about spirits residing in the mountains themselves, further encouraging the worship of mountains and linking up, in turn, with shamanism, so that peaks and even oddly shaped rocks came to be anthropomorphized. Thus the pictures of the Diamond Mountains that have always been so popular in folk painting are, as it were, a reflection of man's most basic longings expressed via a mingling of elements from the three religions of Buddhism, Taoism, and shamanism. One often finds in them, in fact, temples, caves, rocks, and so on that are associated with all three.

A direct expression of this kind of popular religious belief is seen in the Diamond Mountains screen shown in Figures 36 to 38. A panoramic view of the whole complex of peaks is contained within the ten panels of a folding screen; many of the peaks take the form of worshiping humans (or Buddhas), or of horses and oxen, while place-names associated with one or the other of the three religions are inscribed in minute detail. Figure 43, on the other hand, is an example of a picture showing a mountainous area facing the sea. The "Sea and the Diamond

Mountains" are represented by a collection of oddly shaped crags and rocks, the scene having the rich variety typical of the idealized landscapes of Oriental art. Of the eight panels of this screen, the first five from the left present the scene extending from a fortified town as far as the Diamond Mountains in the manner of a map, but once the latter are reached the style changes to a bizarre, fanciful semi-abstraction reminiscent of modern art in order to depict a scene of a minister of the late Yi dynasty visiting the mountains with his entourage. Whereas the right side of the screen depicts a large area shown, bird's-eye–fashion, from a considerable height, the lefthand side depicts its subject in greater closeup and from a lower level.

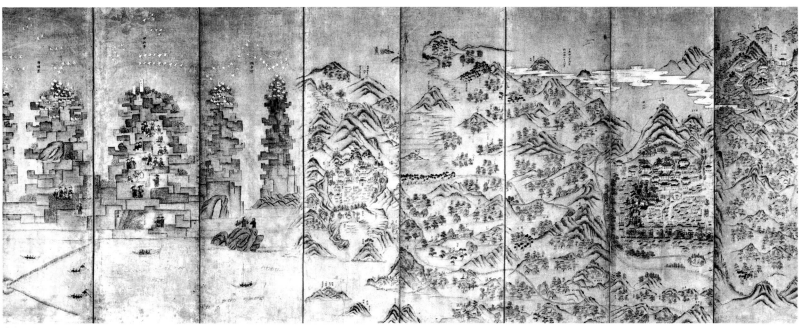

fig. 43

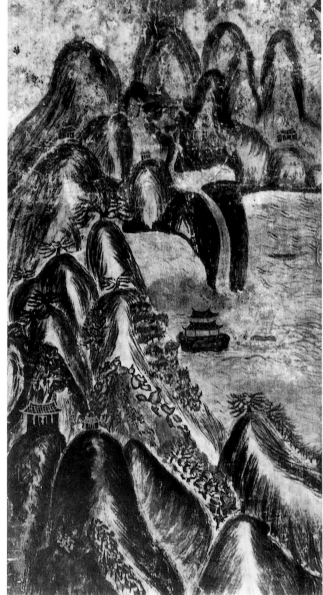

fig. 44

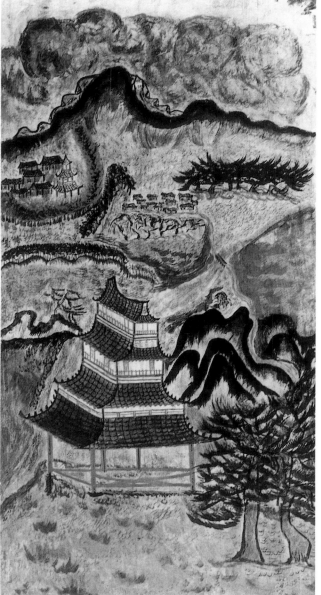

fig. 45

■ "Eight Views" Series

The "Eight Views of Xiaoxiang" that became formalized in Sung China are conjectured to have been imported into Korea by the Koryŏ period, and provided a subject for folk painting also. The original eight views show eight scenic spots in the neighborhood of Xiaoshui and Xiangshui to the south of Lake Dongting, the individual titles being Geese Descending on Sandbanks; Returning Sails from a Distant Shore; Mountain Village in Clearing Rain; Evening Snow over the River; Autumn Moon over Lake Dongting; Night Rain over Xiao and Xiang; Evening Bell from a Misty Temple; and Sunset Glow over a Fishing Village. These sets of essentially Chinese landscapes provided a much-loved theme for academic painting in Korea, but series of actual Korean landscapes also became increasingly popular; they include the "Eight Views of Kwandong," the "Eight Views of Cheju Island," and the "Eight Views of Chinyang," among others.

The "Eight Views of Kwandong" are eight views on the eastern coast in Kangwŏn Province, done on an eight-paneled screen. Like the pictures of the Diamond Mountains, these "Eight Views" sets include a wide variety of treatment: some, though depictions of actual places, treat nature with a freedom of imagination that would make it difficult to identify the location; some abandon the attempt at realism in favor of a more purely artistic interest; some distort natural scenery to make highly geometrical shapes; and some—this is often seen in the "Eight Views of Cheju Island" series—employ a cartoonlike, caricatured manner.

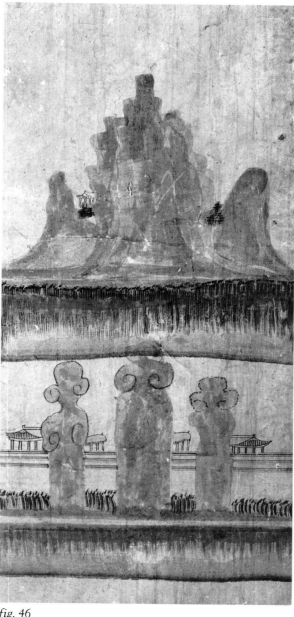 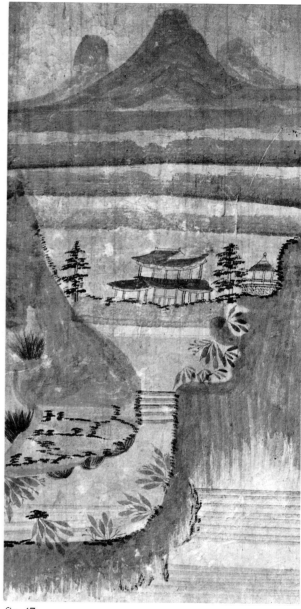

fig. 46 fig. 47

■ Other Landscapes *Plates 96, 97*

These include pictures that seem to depict particular places taken from life, imaginary scenes, and scenes in which human figures or houses are prominent. There is a wide range of treatment, ranging from the highly abstract, through an emphasis on bizarre crags and rocks, to Literati-style scenes in monochrome. A majority of them are relaxed and serene in effect, with little use of bright colors.

11. Hunting Pictures *Plates 79–83*

These usually show men mounted on horses hunting tigers, bears, deer, and other prey in the countryside. There are many human figures, usually clad in colorful Mongolian costumes (though occasionally in Korean dress of the Yi dynasty) that make a vivid contrast with the weak colors or ink monochrome in which the natural scene is depicted. Many of these pictures are on a large scale; around eight panels is usual, the whole space commonly being devoted to a single scene seen from a bird's-eye view. There are two types, showing hunting in the hills and in the open country; the earlier the picture the more realistic, generally speaking, is the treatment, works of the later period tending to minimize the natural scene while showing human and animal figures large, almost in the manner of modern "action" comics.

In China, too, one finds pictures of men hunting on horses from the late Qin dynasty, but the hunting pictures found among Yi folk painting go back to the burial mound murals of Koguryŏ. For example, a picture of a white tiger and men hunting deer from the fourth or fifth century survives in P'yŏngan Province, and a picture of a horseman chasing a tiger and deer from around the sixth century in Jian Xian, China. Fragments of a hunting picture said to be the work of King Kongmin of Koryŏ (1330–74) and traditionally known as the "Great Hunt at Ŭmsan," or "Great Hunt at Ch'ŏnsan," are separately held in the Seoul National University Library, the National Museum in Seoul, and the collection of the former Yi royal family. It is a detailed, brightly colored picture in the style of the Sung academy, and the clothing of the figures is not Korean. The hunting picture as a genre would seem originally to have come from Mongolia and to refer back to the origins of the equestrian peoples of northern Asia. Originally a record of how the horse-riding men came from afar via the northern route over the mountains of Ch'ŏnsan, it was developed as a genre in its own right on the Korean peninsula until, in the Yi dynasty, it produced a highly original offshoot in the folk picture.

Hunting pictures invariably show a noble or nobles attended by retainers; eulogizing as they did the fearlessness of the hunters, they were much favored among the warrior class. In some cases they were bestowed by the king on personal retainers to mark a promotion or, conversely, were presented to the king by his retainers; either way, they were displayed chiefly in the homes of warriors, and saw little development for use in ordinary homes. There is a theory that, since Mongolians engaged in hunting were considered the epitome of the fearsome, pic-

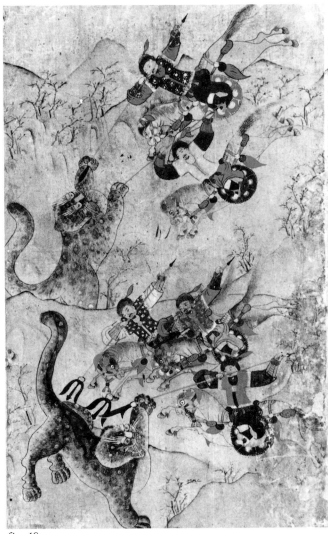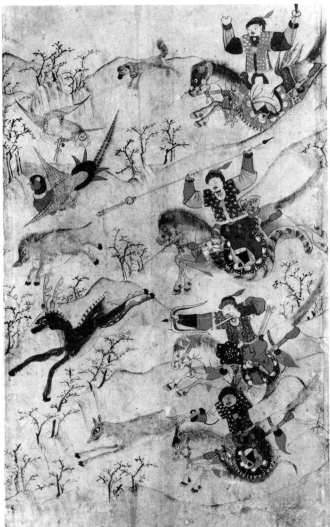

fig. 48 *fig. 49*

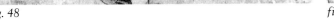

tures of them were displayed as charms to ward off evil, but in fact it seems that the other uses already mentioned predominated.

The composition and coloring of such pictures became fixed, and was carried on for years with little change. The tigers or deer, monkeys, birds, wild boar, or the like are often, if one looks at them carefully, depicted rather humorously, with semi-human features. Sometimes, in fact, they look more human than the figures chasing them. Despite the nature of the theme, there is little bloodthirstiness, nor is there anything sensational in the treatment or coloring, the whole being composed in such a way as to create a pleasant, enjoyable mood. This is a reflection partly of the desire of the men of the Yi dynasty to live out their daily lives without being disturbed by uncomfortable thoughts, and partly of the practical desire to make the interiors of their hones as pleasant as possible. The tigers are often said to represent incompetent rulers, and some scholars see the pictures as satirical—as implying that however such rulers may preen themselves, they will eventually be attacked by invaders (represented by the Mongolian huntsmen), with the result that the ordinary people (the other animals represented) will be made to suffer.

12. "Hundred Boys" Pictures

These show small boys engaged in various games and pastimes. The boys climb trees, play with pet monkeys, ride on horses, wrestle, bathe in the river, watch cockfights, chase dragonflies, and so on. The scenes are depicted as though from above and at a distance. Almost always, their clothing and the houses shown in the background are Chinese-style; it seems that this type of picture originally came from China and was preserved thereafter without any particular distortion. Such pictures were more commonly displayed in the homes of the aristocracy than in the homes of the ordinary people. The treatment is often correspondingly detailed and painstaking, though it might also be said that the failure of such pictures to become popular among the masses deprived them of the characteristic plebeian energy and freedom of other folk paintings.

Hundred Boys pictures are usually done on folding screens, each game or pastime regularly being allotted its own panel. They were placed in the rooms of children or women—sometimes of pregnant women—where they symbolized the desire for children, or the desire that children should grow up strong and healthy.

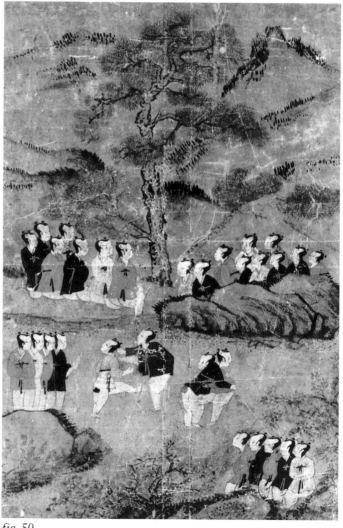

fig. 50

13. "Ideal Life" Pictures

These depict the stages of an idealized human life, usually that of a man, and were intended as a prayer that a son should succeed in the world and become a valued member of society. The scenes start with the child's first birthday, then go on to show how, after diligent study, he goes to the capital to take the official examinations, passes them, and becomes a government official; marries; and is promoted to successively higher posts till he reaches his sixtieth birthday and, after a mellow old age, dies a peaceful death. They afford valuable evidence of the customs and annual rites of the day; unlike the "Hundred Boys" pictures, the genre is peculiar to Yi Korea, and all the figures are shown wearing Korean dress.

Most take the form of folding screens with eight to ten panels, and are done in light colors. Few other genre pictures show human beings engaged in so many different activities. Besides those pictures depicting an idealized human life, there are others that are retrospective of actual lives of individuals, the latter type including some painted to mark the individual's attainment of high rank and others painted after his demise and displayed on the anniversary of his death as a means of recalling his life. Those that trace the course of an actual life are usually realistic in their treatment, while those that represent an idealized life employ a high degree of distortion. Presumably, free rein was given to the imagination in the depiction of ambitious fantasies, whereas the record of an actual life required a higher degree of faithfulness to reality.

14. Other Genre Pictures *Plates 100, 101, 103*

These include pictures of customs of the four seasons, pictures illustrating ethical tales, and pictures of court rituals, processions, and scenes of boating trips and visits to the country. The scenes of the four seasons include ordinary people at work in the fields and paddies, people weaving at home, girls playing on swings, and other activities associated with particular times of the year; they were displayed chiefly at festival times and in the *sŏdang* (village schools or academies). The ethical pictures were pictorial representations of Confucian ideals, similar in nature to the letter pictures, with which they share many of the old tales they illustrate. Illustrated books such as the *Samgang haengsil*, or "Conduct of the Three Bonds" (i.e., loyalty, filial piety, and fidelity), published in 1432, as well as other later versions, and the *Oryun haengsil* ("Conduct of the Five Virtues"; end of the eighteenth century), appeared by royal

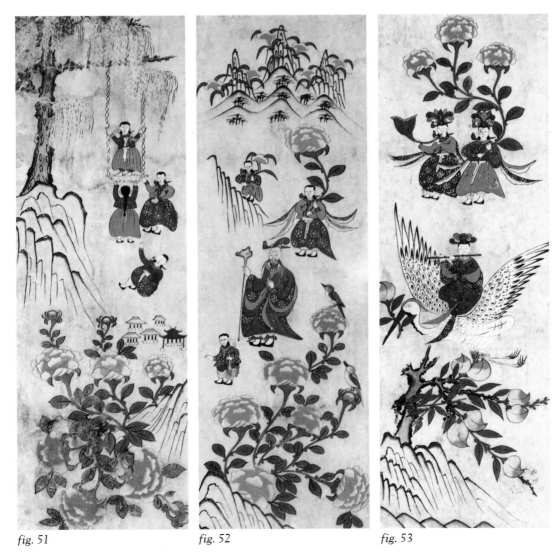

fig. 51　　　　　*fig. 52*　　　　　*fig. 53*

command, being first executed by an academy painter then made generally available in the form of woodblock prints. In folk painting, one often comes across screen paintings known as "filial devotion pictures," based on the tales of filial piety that, along with tales of loyal followers and faithful wives, form the subject of these ethical works. There are, for example, the story of Minsun (a disciple of Confucius), who stopped his father from turning out his ill-natured stepmother, and the story of Shizhen, son of a poor farmer, who, being told by a doctor that his critically ill father might be restored to health by drinking fresh human blood, cut off his finger and let his father drink his own. Whereas the letter pictures gradually became abstract, these ethical pictures avoid extreme distortion and abstraction, preferring to stick to the relation of the tale in question.

The pictures of court rituals allow one to see, from a bird's-eye view, the arrangement of the interior of the court and the way officials were stationed at various points within it according to their rank. They are a valuable guide to the customs and dress of the court at the time; the composition usually emphasizes symmetry, and the pictures are mostly on a large scale, eight- to ten-paneled screens being common. The "procession pictures" are pictorial records of journeys made by the king and processions of official envoys; some show actual scenes, while others indicate the rules of precedence in the procession. They are done on handscrolls and screens and as woodblock prints, and the procession itself is usually shown in detail, without unnecessary background details.

Other genre pictures include those showing aristocrats or officials enjoying themselves boating, and a type of picture based on the Chinese tale of the elderly Guo Ziyi. He built a house deep in the hills, where he had lots of children and lived happily amidst nature; he is well known as a type of the fortunate man, and it is said that he founded a happy and prosperous village, and that King Xiaozong was delighted when he heard of it. Some of the pictures show a row of splendid Chinese dwellings together with a large number of children, while others, such as Figures 51 to 53, show, with a great deal of distortion, a girl on a swing or holding a spray of peach blossom or a peony flower.

15. Pictures of Historical Episodes *Plates 84–93, 102*

These are representations of stories, based on historical fact, taken from such sources as the *Sanguozhi* ("History of the Three Kingdoms"), the *Shuihu juan* ("The Water Margin"), and the story of Yi Sun-shin's battle at sea. Popular versions of the first two, including the *Sanguozhi yanyi* ("Romance of the Three Kingdoms"), which newly came into favor and were having a marked effect on the literary world toward the end of the Ming dynasty, were brought to Korea following the Japanese invasion of 1592 and enjoyed a wide vogue, especially among men of letters. They subsequently achieved wide currency via recitations and began to make an appearance in folk painting too. They were displayed in children's rooms or in the *sŏdang* schools, mostly as a means of inculcating the desire for knowledge and the virtues of courage and benevolence. Without exception, the screens form a series of individual scenes, and since the stories as such were widely known already the treatment was usually less realistic than caricature-like and amusing.

The "Romance of the Three Kingdoms" is a novel written in late Yüan or early Ming on the basis of historical facts of the Three Kingdoms period of Chinese history. Toward the end of the Latter Han dynasty, three states—Wei, Wu, and Shu—vied for hegemony; the novel takes the emperor of Wei, Caocao, as its villain and centers on the activities of three figures from Shu—Guan Yu, the prototype of the heroic warrior, Zhang Fei, an out-and-out bumpkin, and the cautious and dependable Kong Ming. The scene in which Liu Bei, who has come into prominence at the time of the Huang Zhong uprising, swears a pledge of brotherhood in a peach garden with the three heroes and fights alongside them, always appears with the peach motif in letter pictures.

"The Water Margin," by Xuan Naiyan of the late Yüan and early Ming periods in China, is a novel based on an episode in the *History of Sung* describing the great power wielded by a band of robbers at the end of the Sung dynasty. The story tells how a large number of heroes who have become robbers through quirks of fate join forces in Liangshan-po but are defeated by the wiles of the court and go to their several ends in various parts of the country.

The aforementioned are all Chinese sources, but the pictures concerned with Yi Sun-shin are records of the invasion of Korea by Japanese forces under Toyotomi Hideyoshi which occurred in 1592. The Japanese forces, 158,000 strong, with Kato Kiyomasa, Konishi Yukinaga, and Nabeshima Naoshige at their head, landed at Pusan. After a few hours' battle they overwhelmed the garrisons there, and within twenty days of the landing the capital of Seoul had

been occupied. The Japanese army had taken Korea unawares, and as the government was divided, an effective counter-offensive proved difficult. The king, therefore, sought reinforcements from Ming China and appealed to the peasants to raise their own resistance force. However, while the government was thus desperately clinging to existence, Yi, commander of the Chŏlla navy, destroyed the Japanese fleet and secured control of the seas. On this occasion, Yi had invented a type of ironclad vessel—known as a "turtle ship" because of the resemblance of its protective superstructure to the shell of a turtle—which gave him outstanding powers of attack. For the Japanese fleet, defeat in this sea battle put supply lines in danger and threatened the army in turn. Yi was rewarded by being promoted to overall command of naval forces, and is still revered as a national hero to this day.

The battle appears in folk painting in the form of eight- to ten-paneled screens, known as "turtle-ship pictures," in which the turtle-ship fleet is shown in blue. The pictures as a whole are done in brilliant colors, with a pleasingly decorative effect; they were put on show as a means of inculcating the virtues of patriotism and courage in children.

16. Other Pictures Illustrating Popular Tales

These include pictorial representations of episodes from literature popular at the time, works such as *Ch'un-hyang chŏn* and *Kuun mong*. Most are folding screens with eight or so panels, the pictures corresponding with important episodes in the novel. The former is the story of a virtuous woman, while the latter is a story preaching, essentially, the Buddhist doctrine of impermanence by showing how worldly fame and riches are no more than a passing dream. I sum up the stories briefly below.

"The Tale of Ch'un-hyang" (*Ch'un-hyang chŏn*; author unknown): Sŏng Ch'un-hyang, daughter of a *kisaeng* in Namwŏn, Chŏlla Province, pledges enduring love with Yi Mong-nyong, son of the newly appointed provincial governor, but when Mong-nyong's father is appointed to a post in the capital of Seoul, he goes with him, passes the official government examinations, and embarks on an official career. Following this, Ch'un-hyang is obliged to become a serving woman to Pyŏn, a villainous man who has succeeded Mong-nyong's father as governor. Despite his advances, she remains faithful to Mong-nyong; her refusal to yield herself lands her in prison, where she comes close to being killed. She is rescued, however, by Mong-nyong himself, who is touring the provinces as a secret emissary traveling incognito for the king, and the two are finally united in marriage. A companion work, *Oktan ch'un chŏn*, is the story of a *kisaeng* who saves the beggar Yi Hyŏl-yong, who has been betrayed by a friend, and has him finally appointed secret emissary to the king.

"Nine Cloud Dream" (*Kuun mong*; by Kim Man-jung, 1637–92): Sŏngjin, a Buddhist monk engaged in ascetic practices, encounters eight Taoist nymphs. He becomes friendly with them, and gives them each one of the eight beads that he is wearing on his person. This leads them, however, to sin, as a result of which he and the eight women are condemned by Yŏlla, god of the Buddhist underworld, and blown away by a great storm. They are all subsequently reborn into this world, each according to his or her karma. Sŏngjin is born as the child of an elderly couple who have hitherto had no children, and given the name of Soyu. He grows up both handsome and talented; he passes the official examinations at an early age and is barely thirty when he becomes prime minister. He subsequently encounters eight beautiful women and swears his love for them. Each of them carries a bead on her person—these being the identical beads that he had originally given to the nymphs.

Other popular literature of the day that makes its appearance includes the tales of Sim Ch'ŏng and Hong Kiltong and many others. Particularly after the official adoption of the *han'gul* syllabary, first devised in the reign of the fourth Yi king, Sejong (1419–50), literature made astonishing strides, and works on national themes began to flourish in opposition to the predominantly Chinese-flavored works of the past.

Pictures illustrating these works serve not so much to clarify the content as to add to the pleasure of hearing them read in a congenial setting. There is, for example, a type of performance called *p'ansori* in which a single person plays all the characters who appear in a particular work of literature; such performances, accompanied by a drum, were sometimes given in front of a screen of this nature.

17. Sun and Moon Pictures Plate 95

"Sun and moon" pictures were mostly intended to form a backdrop to the king's throne in the royal palace, and are thus almost all large, folding-screen pictures of eight or so panels. They

played a more or less fixed role, similar to that of murals or sliding-door paintings. Sun-and-moon court paintings surviving today include those in Injŏng Hall of Ch'angdŏk Palace, Myŏngjŏng Hall of Ch'anggyŏng Palace, and Kŭnjŏng Hall of Kyŏngbok Palace. They were all painted by members of the official Bureau of Painting, and have a strictly regulated organization, with little variation. A red sun and white moon are placed to left and right, respectively, with a rocky mountain done in green and blue towering in the center and, cascading from the mountains to either side of it, waterfalls that unite to form a rippling, rushing river. At the two extremities are aged pine trees, their trunks done in red. The whole is symmetrical, and the prevailing tone is the blue of the sky and the rivers, with patches of red here and there. The deserted, peaceful scene without a single living creature creates a peculiar effect of fantasy, and the simplified organization of space, with its lack of perspective, the linked semicircles of the waves, and the decorative treatment of the crags, is striking.

The sun and the moon, on the right and left, have always been seen as guardian gods of the heavens, principal deities of the solar and lunar realms that represent day and night respectively. In the suggestion of a belief in an unlimited life-force of nature, one can see the influence of popular nature-worship and the Taoist ideas of China. According to Kim Sa-yŏp's "The Natural Setting and Culture in Korea", which deals in detail with worship of the sun and moon gods in Korean shamanism, the sun and moon were anthropomorphic deities and both male, and each had a consort. On the other hand, a folk tale of the Hamhŭng district of Korea makes the sun a female god and the moon a male god. There were once a brother and sister—it says—who were on bad terms and quarreled constantly. One day, the brother stuck a needle into his sister's eye and killed her, so the mother imprisoned him and he died of starvation. The sister was subsequently reborn as the sun and the brother as the moon; the sister, having been stabbed in the eye, still gives off a strong light on that account, a light which dazzles people if they try to look at it.

Shamans, again, have a sacred mirror that symbolizes the sun and moon gods. Many of these have representations of the sun, moon, and the seven stars of the Dipper cast on their back, while some also have the Chinese characters "il-wŏl tae-myŏng" (literally, "sun-moon, great-brightness"). The mirrors are round and have a convex surface, the back being concave; the front symbolizes the refulgence of the sun and moon and also, it is believed, reveals within itself the faces of the gods.

The motifs of sun, moon, mountain, pine trees, and water seen in the sun-and-moon pictures resemble those of the "longevity" pictures. In Korea, with its strong tradition of mountain worship, mountains are frequently revered as gods and are also seen as symbols of long life. The mountain in these pictures could be any of the craggy mountains that are common in Korea, but one theory says that it represents Kunlun, the imaginary sacred mountain of ancient Chinese popular belief. Water gushing from mountains is believed to have special power as the source of life and also, as is shown by the length of rivers, to possess an enduring vitality. The pine is accounted a symbol of long life because of its own longevity; its needles in particular were used in ritual purification. Thus the sun-and-moon picture can be seen as a projection of a view of the nation as an entity drawing eternal life from the realms of heaven, earth, and living creatures and existing under the protection of the gods, and also as an expression of the authority of the king.

It was necessary that the Yi sun-and-moon picture should emphasize the dignity of king and state, and for this reason the pictures avoided any extreme distortion or caricaturization, concentrating instead on a stable symmetry of composition. Their style was seldom taken up among the ordinary people, but there are a few examples that developed under the influence of shamanism; thus there exist specimens, intended for display in shrines, in which the solemn atmosphere has given way to a simplified, two-dimensional arrangement.

18. Longevity Pictures

These are pictures composed of a number of motifs taken from the realms of heaven (sun, moon, clouds), earth (mountains, rocks, water), animals (cranes, tortoises, deer), and plants (pines, bamboo, pulloch'o, peaches). All these motifs are symbols of long life; in many cases, ten of them are selected to form what is known as a "Ten Symbols of Longevity" picture, though sometimes a smaller group is chosen: for example, deer, crane, pine, and bamboo.

The longevity picture appears not only in folk painting but in the designs on papered walls and as decorations on inkstone boxes, chests-of-drawers, boxes, and other articles used about the house. A chest-of-drawers with mother-of-pearl inlay used by the Yi royal family, with the longevity motifs arranged in a symmetrical design, still survives.

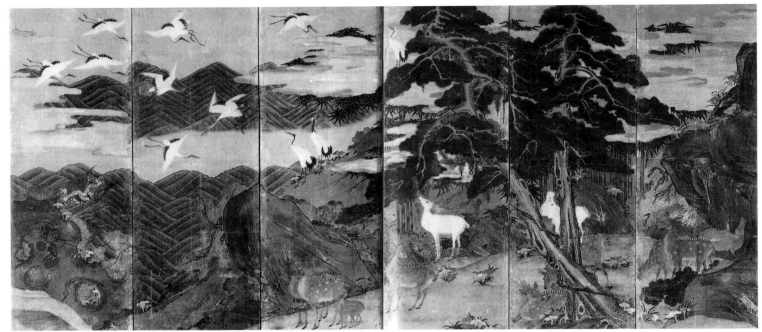

fig. 54

Some of the motifs are, as we have seen, also used in sun-and-moon pictures, but whereas treatment in the latter is consistently designed to suggest authority, with a stately arrangement of its components, the longevity paintings have brilliant colors and a decorative manner, creating cheerful, peaceful scenes—fanciful paradises, as it were, of nature and living creatures.

They were used chiefly as auspicious pictures for display on New Year's Day, but they were also brought out quite frequently at sixtieth-birthday celebrations, other birthdays of the elderly, and so on. Very occasionally they were also displayed, in the form of a small folding screen, in the rooms of women of the aristocracy. The pictures of court rituals seen in Plates 100 and 101 show a sun-and-moon picture behind the royal throne and a longevity picture behind the throne of the royal consort, though the relationship between the consort and such pictures is unclear. It may be interesting to note here—even though it has nothing to do with the Yi period—that at the 1972 talks between Red Cross representatives from North and South Korea, intended as a first step toward reunification, a longevity screen was placed against the wall to the right of the table where the delegates sat—a case of a folk painting used, presumably, to suggest enduring peace.

Spiritually, the longevity picture would seem to be inspired basically by traditional Korean nature worship as seen in ideas about the sun-god, the spirits of sun and moon, mountain spirits, and so on, and to use symbols or objects adopted from Chinese ideas about the Immortals. These ideas held that, provided men lived a life transcending worldly considerations and engaged in various special practices, they could attain physical immortality and eventually be received into the world of the Immortals; such beliefs were eventually to form the nucleus of Taoism. The Taoist view of the universe, attributing eternal life to nature and living creatures as it did, was obviously related at a deep level to animism. And as ideas of the Immortals, and Taoism as a religion, spread to various parts of Asia, they combined with animism there to create new and unique developments.

The earlier the date of a longevity picture, the stricter the composition and the more marked the lack of spontaneity; in later periods, the elements of decoration and distortion increase, and the pictures become more relaxed and enjoyable. Relatively large screens with from eight to twelve panels are general; they were used principally among the upper classes, being beyond the reach of most ordinary people. Some of them were given by the king to his ministers at the New Year. The air of luxury, suggestive of an aristocratic taste, that invests longevity pictures probably indicates that many of then were produced by members or former members of the Bureau of Painting.

19. Festival Pictures

"Festival" pictures, which are put on display at the New Year, at the Ch'usŏk Festival, on birthdays and on other festive occasions, include the longevity pictures just dealt with, "golden fowl" pictures, and "magic peach" pictures. They were used as a background against which people sang, danced, fraternized, and generally enjoyed the particular festive day. With those

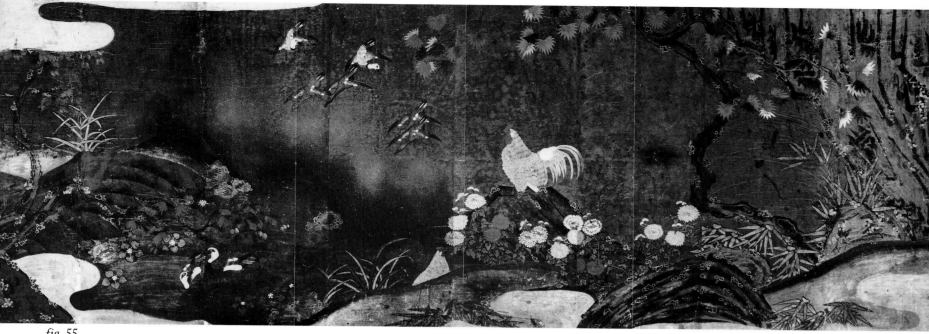

fig. 55

fig. 56

that are painted on folding screens, the more recent examples tend to fill the whole space with color, leaving no white background. Compared with, say, the "letter" and "bookshelf" pictures, which show the principal motifs standing out against an empty background, these works have a far more decorative effect, one calculated to enhance the festive air of any room they are placed in.

The golden fowl picture shown in Figure 55 shows male and female birds (one partially hidden) in the center against a background of maples and bamboo, chrysanthemums and other plants, and a pond in which waterfowl are disporting themselves. The Korean verse form known as *sijo* includes some on the subject of the golden fowl, and there are many stories about it too—one saying, for example, that it lays golden eggs which have medicinal properties. It is considered to be a bird of good omen, and this type of picture was in fact used at the New Year to create a festive, auspicious atmosphere. It was also believed that whoever displayed it would be blessed with good friends. Thus it was often used at gatherings of male acquaintances, sometimes as the backdrop to a drinking party. It was favored chiefly by the aristocracy.

There is a theory that golden-fowl pictures were considered to be effective in averting evil, but this is believed to refer to variations on the *chujak* (see Figure 56) of the Four Sacred Beasts, whereas with true golden-fowl pictures the decorative and fanciful qualities of the scene as a whole suggest that it was aimed less at such practical results than at pure enjoyment. In Korea, incidentally, it was the custom to place a rooster, or a picture of a rooster, outside the

front gate, and there are various popular tales about the chicken as a symbol of protection from evil. For example, it is said that to drink a chicken's egg mixed with sweet liquor on the first day of the year is good for warding off evil, and that if a sick man offers a chicken up to the gods and prays, his sickness will be cured.

Magic peach pictures depict either peaches alone or peaches and Immortals together. There is a popular belief that whoever eats peaches will live long, and peaches traditionally were treated as symbols of longevity and happiness. On the peaches is painted a red spot; this usually signifies the warding off of evil, and presumably became associated with long life symbols because of its usefulness in averting sickness and the like. Popular beliefs associated with the peach are found in China, Korea, and Japan, and are influenced by the mountain worship and the ideas about the Immortals that are found spread across Central Asia. There are some longevity pictures too that center around a large number of peach trees (and their fruit); these are closer in significance to the pictures of magic peaches and Immortals, and are rather different in purport from the longevity picture as such.

20. "Map" Pictures

Works that serve as maps of a kind can be classified roughly into those focusing on fortified towns and on natural beauty spots. They frequently depict their subjects from all kinds of angles, in defiance of the rules of perspective, or employ a flat, two-dimensional treatment—though this absence of a sense of direction and of spatial depth is of course a characteristic of Yi folk painting as a whole. The fortified towns shown include P'yŏngyang, Chinyang, and Hansŏng; typical pictures of beauty spots are the "Kosan-gugok-do," "Mui-gugok-do," and "Hwayang-gugok-do." Almost all the pictures showing walled towns present a bird's-eye view of the subject, and are interesting as a kind of map showing the organization of cities of the day. Quite a lot of these pictures take the form of woodblock prints. The picture of the walled city of P'yŏngyang seen in Figure 57 presents a detailed view of the central part of the city, which was a center of politics and culture from early times. They show almost no variation in treatment, and all have large numbers of trading and fishing vessels going to and fro on the Taedong River, with a ferry on this side of Taedong Gate.

As for the pictures showing beauty spots with mountains and rivers, a majority of them represent scenes based partly on reality, partly on the imagination. The "Mui-gugok-do" and the "Kosan-gugok-do" are landscapes, partly imaginary, based on scenes in China and in Kangwŏn Province in Korea, respectively.

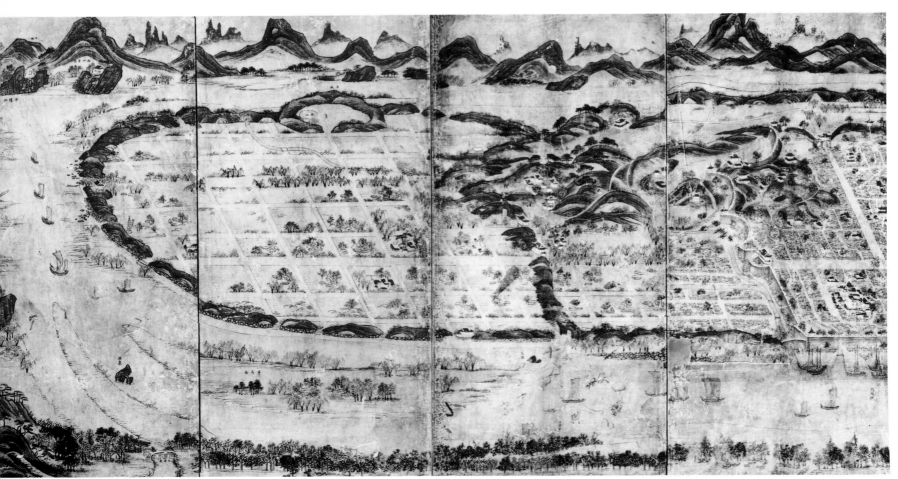

fig. 57

21. Bookshelf Pictures *Plates 104, 105, 109–111, 115–130*

This type of picture is usually known in Korea as *ch'aekkŏri* (literally, "books and associated things"). Thus pictures in this category generally focus on paper, Chinese ink, writing brushes, and inkstones—the "Four Companions"—and also show, surrounding them, other things that the scholar requires in his everyday tasks, together with fruit, unusual imported objects, and the like, the whole combining to form a composition that is at once picturesque and intellectual in its overtones. Common motifs in addition to the "Four Companions" are colorfully bound books, tea ware, fans, fruit, flowers, vases, miniature trees, spectacles, clocks, chess (*paduk*) boards, ornaments, boxes, seals, pipes, clothes, swords, stuffed birds, and so on, a startling effect occasionally being achieved by the inclusion of human figures or live birds. Such pictures give a good idea of the lifestyles of literary men and the upper classes of the day, while the imported spectacles and clocks afford valuable material for folkway studies.

The "bookshelf" picture genre is unique among folk paintings, and includes a large number of outstanding works. No background is shown, the objects themselves forming a kind of still-life. They are piled up, or arranged neatly on shelves, to form an organized pattern, a large number of the pictures employing reversed perspective and brilliant coloring. Originally, this type of picture probably derived from Chinese painting, but Chinese paintings of the same kind normally show the objects concerned lined up horizontally, without any more ambitious organization.

In the main, two types of composition are employed by the Yi version of this type of picture: the "bookshelf" type and the "book pile" type. The former usually takes the form of a folding screen of some eight panels, and the effect is more realistic than distinctive. The large, broad bookshelf is the kind in use at the time; the things on show inside it have a feeling of reality and are arranged in an orderly way; there is no unexpected intrusion of, for example, human figures. It seems likely that all "bookshelf" pictures were originally of this type—which is, in fact, more common the further back one goes. The "pile" type of picture tends to come from a later period; in time, moreover, elements of distortion creep in, and a stronger originality comes to be shown in the choice of objects displayed.

These bookshelf pictures were originally an expression of a generalized respect for learning, reflecting the view that to devote oneself to study is a privilege. They were displayed chiefly in children's rooms or studies, and also sometimes in the small village schools and at home on children's birthdays. When no such picture was available for a birthday, it was sometimes borrowed. The frequent use of reverse perspective—with the more distant objects shown larger than those in the foreground—was intended to suggest that the picture, as an object of reverence, was looking at the human being rather than the opposite; the portrait painting of the Yi period employs a similar type of composition. The student does not look at the picture but sits facing his desk, with the picture watchful at his back.

In later ages, nevertheless, didactic significances were gradually discarded, and the genre developed more as a pleasing form of interior decoration pure and simple, the concern being not so much with iconography as with producing a *picture* of original composition and brilliant coloring. In doing so, it helped create a characteristic type of still-life. One even finds some examples that depict disintegrating books and broken desks—thus seeming to reject, or at least to caricature, scholarship itself.

22. Letter Pictures *Plates 106–108, 112–114, 131–156*

Along with the bookshelf pictures, "letter" pictures are one of the most characteristic products of Yi folk painting. There are many variations, but the most common type, of which most specimens survive, is that known sometimes as *hyoje-do*, "pictures of filial and fraternal devotion" in which the eight Chinese characters *hyo, che, ch'ung, shin, ye, ŭi, yŏm,* and *ch'i* (孝, 悌, 忠, 信, 禮, 義, 廉, and 恥) are painted on the eight panels of a folding screen. The ethical outlook they represent is essentially Confucian, the respective messages of the eight characters being that one should show filial piety toward one's parents; that siblings should live on amicable terms; that one should be loyal to king and country; that one should maintain trust; that one should observe Confucian propriety; that one should observe one's commitments; that one should live frugally and honestly; and that one should have a proper sense of shame.

The nation at the time was ruled in accordance with Confucian principles, and this type of picture naturally reflected them, especially the theories of "three bonds, five virtues" that were a basic summing-up of their import: that the vassal should obey his king, the child its parent, and the wife her husband; and that the child should revere its parents, the vassal be loyal to his

fig. 58

fig. 59

fig. 60

fig. 61

king, the wife be faithful to her husband, inferior give support to superior, and friends have faith in each other. These teachings were widely disseminated at the time; at the command of the king, collections were made of Chinese tales of devotion, and various pictures of ethical import were published in the form of picture books and prints. The collection of pictures known as "Conduct of the Three Bonds," first compiled in the reign of Sejong (r. 1419–50), gained particularly wide currency and became, along with the "Illustrated Twin Virtues," a kind of educational charter of the Yi dynasty. The *hyoje-do* would seem to have come into being and developed within this tradition.

The pictorial motifs (in **bold type** below) associated with the eight characters draw on a number of the same old Chinese tales as the ethical pictures just mentioned. A few examples follow.

■ **Filial Devotion** (孝, *hyo*)

Carp, ice. Wang Xiang, a Jin-period scholar, was badly treated by his stepmother, yet when she fell ill and expressed a desire to eat carp, he broke the thick ice on a pond and caught a carp for her.

Bamboo shoot, bamboo grove. Mengzong, a government official of Wu, had a mother who was old and sick, but could not afford to buy medicine for her. He was standing weeping in a snow-covered bamboo grove when, suddenly, bamboo shoots poked their heads up through the ground where his tears had melted the snow. He gave them to his mother to eat, and she promptly recovered.

Zither. Shun's father remarries and has a child, called Xiang, by his new wife. The father shows undue affection for Xiang, who has an evil nature, and he, his second wife and Xiang plot together to kill Shun. Yao, impressed by the loyalty with which Shun serves the other three, finds a wife for him, and gives him a zither, but the three finally succeed in killing him. Xiang appropriates Shun's wife and the zither to himself, and is playing the zither with great self-satisfaction when Shun is brought back to life by the sound. He does not blame the other three, however, but serves them even more loyally than before, and eventually becomes king himself.

Folding fan, round fan. The story of Huangxiang, who fans his father to cool him in hot weather and warms him with his own body when it is cold.

■ **Fraternal Devotion** (悌, *che*)

Flowering Almond. The flowering almond has particularly profuse and attractive blossoms. The harmony of blossom and leaves is especially beautiful—and so is the relationship of mutual trust and help between siblings and friends.

Wagtail. The wagtail is always in busy motion—singing when it flies, wagging its tail delicately when it walks; the human being, too, should be swift and sensitive in his response whenever a brother is in distress.

■ **Loyalty** (忠, ch'ung)

The Tale of Guan Longfeng. King Jie of Xia, who spent his days in dissipation, neglecting affairs of state, was advised to mend his ways by his vassal Guan Longfeng. The king promptly flew into a rage and threatened to kill Guan. Guan persisted; he was quite ready to die, he said, but unless the king awakened to the error of his ways the country would be ruined. The king, moved by the steadfastness of Guan's loyalty, repented.

■ **Trust** (信, shin)

A bird with a letter in its beak. Weisheng and Xiaoyi, long separated, were concerned about each other's welfare, but one spring day a bird that was flying close to a lotus pond brought a letter in its beak for one of them, and thereafter flew to and fro between the two with news of each other. Where there is trust, feeling will find a way to express itself.

■ **Propriety** (禮, ye)

Turtle. When Yu quelled the floods of the Yellow River, a turtle appeared from the receding waters of the Lo River, a tributary of the Yellow River, with nine designs on its back. From these, all kinds of rules for life were developed, and Confucius in turn worked them into a coherent system. He imparted his teachings to Wei Yan, who took them to heart and eventually became a wise and beloved ruler.

■ **Commitment** (義, ŭi)

Peach. Liu Bei, a descendant of the royal family of Han, swore an oath of mutual obligation with Guan Yu and Zhang Fei in a peach garden. Thereafter they fought for each other without fear for their lives.

■ **Frugal Honesty** (廉, yŏm)

Phoenix. The phoenix is a noble bird living high in the heavens that refuses to eat an inferior grain such as millet, however hungry it may be. Human beings should emulate it by living pure lives however poor they may be.

■ **Shame** (恥, ch'i)

The Story of Boye and Shuqi; Mt. Shouyang. Boye and Shuqi of Zhou were ashamed to receive their stipends from King Wu of Zhou on account of his misrule, and went into retreat on Mt. Shouyang, where they subsisted on ferns until they finally died of starvation. King Wu finally realized how honorable the two men had been, and felt ashamed of his own behavior.

Hyoje-do also include tales with little connection with Confucianism—such as those of the Dragon Gate or the Reconciliation of the Prawn and the Shellfish—and these too are sometimes combined with letter pictures, bookshelf pictures, and landscapes.

The earliest examples of letter pictures usually reproduce the forms of the Chinese characters faithfully, with pictures illustrating old tales, or a text, within them. In later periods, however, the pictorial element comes to predominate over the meaning. The forms of the characters break down and character and picture separate, or are fragmented in relation to each other, the character becoming one of various other pictorial elements. As pictures, this means, the later examples are the more interesting, animals or plants being shown in brilliant colors on top of characters done in Chinese ink.

The "letter" pictures aimed at instilling filial and fraternal devotion were chiefly displayed, in the form of folding screens, in children's rooms, where the child sat with his back to the picture as he did his lessons. They were not, of course, intended to teach the child characters as such, but embodied some moral message deriving from Confucianism—for example, that one should, however hard one's life, revere learning and the way of life associated with it. Although they stemmed from a strictly Chinese, Confucianist ethical outlook, as their relationship with society and the home developed in Yi Korea they were gradually molded by popular attitudes to everyday life—to the point where the eight characters came to be something more than a program for life and sought to embody more universal truths.

There are other letter pictures besides the *hyoje-do*, but their total number is few, and they can be dealt with simply here. Next in frequency to the *hyoje-do* are the *subok* ("long life, and happiness") pictures. These include some that incorporate the characters *su* and *bok*, or simply *bok*, written in a large number of different styles, and others that combine them with other

characters—for example in the phrase *subok kangnyŏng* ("a long, prosperous, and peaceful life"), or with the pair *kwinam* ("wealth and male offspring"). These folding screens embodying auspicious characters were commonly displayed on children's birthdays, at wedding ceremonies, and at ceremonies to celebrate a sixtieth birthday. Pictures incorporating the characters "Hail to the Amida Buddha" were displayed in Buddhist temples. In the same way as Buddhist paintings, they were done principally for use on walls and doors; the larger ones were stuck on temple walls or used on sliding screens, while small ones were used as hanging scrolls. There are also letter pictures intended for use by, for example, shamans as charms to bring good fortune or avert evil. They are usually done in vermilion—a color believed to have evil-averting properties—and in many cases it is impossible to tell whether something is a picture or a character. They can be considered as a type of letter picture embodying the supposed magical properties of the Chinese character involved.

Such letter pictures are to be found not just in Korea but elsewhere as well; however, despite various shared features, those of Yi-period Korea have rarely been surpassed in their vigorous development as an integral part of everyday life. While keeping in touch with the characters themselves as units of meaning and as designs, they create a rich variety in the works seen purely as pictures.

23. Shamanistic Pictures

These include portraits of the shaman, depictions of various shamanistic customs or offerings placed on the altar or in the shrine, and pictures centering on Chinese characters and intended as charms. Most of them are independent, single-sheet pictures, intended for display in shrines, the homes of shamans, at ceremonies, and so on. Pictures of altars or shrines were also used in ordinary homes when religious services were held there; they were stuck on the wall as objects of worship, and offerings were placed before them; in homes that could not afford to make offerings, pictures were chosen that showed a large amount of fruit or flowers. It seems likely that the pictures originally showed only altars and shrines as such, the depiction of offerings being a later development.

Most shamanastic pictures employ extreme distortion and a flat treatment that avoids any three-dimensional effects. A good example is the pictures of shamans, whose characteristics distinguish them sharply from the ordinary Yi-period portrait (of, for example, a king or an ancestor). Emphasis is placed on odd clothing, the implements and decorations used in ceremonies, the shaman's face and so on—the balance of the body as a whole being completely ignored.

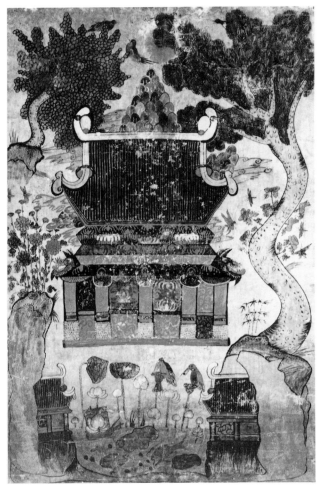

fig. 62

Yi-Dynasty Painting and the Concept of Folk Art

Za-yong Zo
(Cho Cha-yong)

Introduction

The present work provides a comprehensive survey of the unsigned Korean painting of the Yi dynasty. It includes works of the highest value, works cherished almost as family heirlooms and as such kept from general view. A special emphasis is placed on pictures painted for use in ordinary homes, which are outstanding among the folk painting of the period. This latter appropriated for its own use every one of the generally recognized themes of "serious" Oriental painting, transforming them into pictures for everyday use and adding other themes characteristic of the folk painting proper, thus giving birth to a body of work of a vast variety and volume. Its styles, too, show a similar range, refusing to be restricted by the theories and techniques of official painting; by treating its subjects with a new freedom and vigor it created, as it were, a "nonofficial" school of painting able, in quality and quantity, to stand comparison with the academic schools of painting that extend over the whole of East Asia.

This work is based on two volumes which were published in Japanese following an exhibition of the folk painting of the Yi dynasty which toured five major cities of Japan from November 1979 until July of the following year. The works displayed at the time provided, in the same way as the present work, a broad survey of the whole field of folk painting, from simple pictures intended as charms and found in peasant homes, to splendidly mounted screens used at the royal court. The wide range of the styles undoubtedly came as a shock to those who held the traditional view of folk painting, which centered on peasant works such as the "letter" pictures of Cheju Island. The choice, in fact, represented a new view of folk painting based on a far wider interpretation than before.

The folk paintings of the Yi period were not painted in accordance with any particular aesthetic or theory of painting, nor, on the other hand, were they undertaken mainly by untrained, itinerant artists. They are unsigned pictures intended for practical use, painted in terms of a basic, shared humanity, with the free participation of the whole nation yet including first-rate artists, and with a folk, or national, flavor that made them readily acceptable to ordinary people. For this reason, they possess an essentially Korean flavor yet at the same time embody states of mind that have universal appeal.

All kinds of cultural organizations in both Japan and South Korea cooperated in the exhibition, but this does not mean of course that they all saw folk painting in identical terms. Some, in fact, were of the opinion that the restrictive title "Folk Paintings of the Yi Dynasty" should be abandoned in favor of a less confining title such as "An Exhibition of Korean Screens," or simply "An Exhibition of Korean Painting." As to why they finally agreed to the term "folk painting," this should become apparent in the course of my examination of the concept as such.

To make a comprehensive collection of folk paintings in all their different forms at a time when the new view of folk painting has yet to be universally accepted may in a sense be dangerous. Nevertheless, insofar as it is necessary to substitute a broader and deeper view of folk art for the old view that focused exclusively on the work of peasants, to do so is surely of the greatest value.

The projects in question—the exhibition of Yi-dynasty folk paintings in Japan, the publication of the volumes in Japanese, and the present volume—are valuable as a means of making known recent activities in unearthing folk pictures, and as the most effective means of making them known abroad; but there was also a more historical, universal significance, which has become apparent to me in the course of actually moving about the international scene.

On a recent trip to the United States, I visited Mingei International, a museum in San Diego, California. An exhibition of Korean folk art was in progress. I was astonished to discover that, as the name of the museum itself suggests, the Japanese term *mingei* has been accepted internationally. It brought home to me the fact that even after the breakdown of the world folkcraft movement, the folk art movement in Japan has continued to develop independently and to have international repercussions.

I was surprised, too, to find that those responsible for the museum were all admirers of Yanagi Soetsu, and at the same time well versed in Korean matters. It is clear that the presence of many traditional Korean objects among the works that spurred the folk art movement in Japan has been responsible for spreading knowledge of Korean folk art among experts in the West. There is a close relationship between the Japanese folk art movement and Korean folk art objects, and the inevitability of the relationship was brought home to me afresh by this overseas exhibition. It made me realize one other thing too: that since, in exhibitions of Korean folk art and folk painting in Japan and America, the selection of works has been made, not in accordance with Western aesthetic criteria or the particular concepts of certain organizations, but on the basis of a broader concept of folk art, the number of people who are supporting a wider interpretation has been increasing. This implies more than a simple change of concept; it has happened because of the discovery, in all kinds of places in Korea, of a succession of major works too fine to be understood without a change in basic ideas, works that cannot be judged in terms of aesthetic criteria such as unsophistication and primitiveness.

It may well be that the shift in views of folk painting of which the international scene is beginning to make us aware represents a first step toward a revolution in approaches to pictorial art that Yanagi Soetsu forecast half a century ago. Yanagi made the sweeping prediction that future ideals of art would shift from adulation of genius to emphasis on a more cooperative approach to creation. Provided the old view of folk painting is rectified and the search for actual specimens based on the new, broader view is carried on still more vigorously, there is no reason why this vision should not be realized.

The Concepts of Folk, Folk Art, and Folk Painting

One tends to imagine vaguely that, just as music has its folk song, literature its folk tales and dance its folk dances, so painting has its folk pictures. Whenever a picture by an anonymous artist obviously intended for some practical purpose is discovered, we unhesitatingly label it a "folk painting." The phrase has such a comfortable ring to it, and is so convenient, that it has come to be used as a matter of convenience; but since the term remains to be defined with precision, it has also created all kinds of confusion.

One often comes across the phrase nowadays at exhibitions and in written publications, but interpretations differ subtly depending on the sponsor or the author. Some see it as referring to pictures related to folklore in some way or other. Some define it as "national" pictures— pictures on specifically national themes. Some assert that it refers to pictures symbolizing, directly or indirectly, various popular faiths and beliefs, while others take the term to mean simply pictures in a "folk," i.e., unsophisticated, style. Yet others see the term as indicating "popular" or "plebeian" pictures, or certain forms of decorative or applied art.

Since this confusing variety of approach still persists today, I feel I should start by making clear what concept I myself apply to the term. To do this requires, I feel, that I first make clear my idea of "folk art" and, even before that, of the word "folk" as such.

Fundamentally, it would seem, differences in the interpretation of "folk painting" or "folk art" stem from differences in the concept of "folk." The narrow concept of folk painting sees folk as referring to the political or social structure and explains it in terms of the common or non-aristocratic people—the ordinary people, the lower classes, or, perhaps, the "nonofficial" world of the masses as opposed to the "official" world. If one takes this to mean, essentially, the ruled classes, then in terms of the class system of Yi Korea, with its king and nobles, warriors, farmers, artisans, merchants, and priests and shamans, "folk" corresponds to all but kings and nobles.

Seen in such terms, then, folk art and folk painting can be summed up as applied art and pictures that are non-aristocratic in nature. The term "folk" as used by the Japanese folk art movement would seem to refer in this way to the social structure. The Japanese word *mingei* is an abbreviation for *minshuteki kogei*, i.e., the applied arts of the masses, and *minga* likewise means the pictures—one kind of applied art—of the masses. They are produced by artisans or professional painters for practical, everyday purposes; and they are such that they can be produced in large quantities and bought and sold cheaply. Unfortunately, however, to define *mingei* and

minga thus as crafts too often means that the works chosen to represent them are of a vulgar, debased nature.

A good example is the ceramic wine bottle considered as an object of applied art. The green celadon of the Koryŏ period and the white porcelain of the Yi dynasty include any number of outstanding unsigned bottles. However, the conventional view of folk arts excludes those that are too aristocratic by nature; too much sophistication, in short, disqualifies a piece as folk art. Similarly, the *ukiyo-e* woodblock print, which was "born of the masses, produced for the masses, and purchased by the masses" (Yanagi Soetsu), is not classified as folk painting, for the simple reason that it breaks the rule of anonymity. Much the same set of standards prevails in the folk art movements of Europe and America.

Does this mean then that—to accept provisionally the distinction between "pure" art and "applied" art—folk art and painting as generally conceived of do not comprise all applied art, but refer only to objects that have a strongly unsophisticated or primitive character and were produced with a particular kind of innocence and lack of self-awareness?

The aesthetic ideal of the Japanese folk art movement seems to be a total absorption in the beauty of folk art that is akin to the ideal of the tea adept or the spiritual enlightenment of Zen, and is achieved via the medium of applied art objects embodying this unsophisticated quality to a high degree. In this respect, it differs from the Western approach to folk art and folk craft; the ideals of the folk art movement are, indeed, sometimes placed on an equal footing with those of the tea ceremony and Zen, and it occasionally happens that a perfectly ordinary piece of Yi pottery intended for everyday use is transformed into a Koryŏ teabowl with a price tag of one million dollars. This naturally invites cynicism; but it is necessary here to go a step further, and to ask whether, in the first place, this kind of Korean teabowl really *was* produced and used as the kind of utensil that one might, say, put the cat's food in. In this connection, a story relating to the old Korean tradition of *chudo* (literally, "the way of wine") may throw some light on the question.

Until quite recently, Kwangju in Chŏlla Province was a place where one could still enjoy the tradition of Yi *chudo*. It is said that one night twenty years ago a group of prominent tipplers gathered in a well-known place for a party with *kisaeng* in attendance. The conversation turned to drinking cups, and those present decided to compare views on what constituted a good cup. They first sent a messenger to an antique shop to fetch specimens of various types of old drinking cups. Then, as they gradually grew merrier, they set about making their selection.

The first cups to be ruled out were the expensive silver ones provided by the drinking place itself. Next to go was a dainty Japanese-style cup. Opinion was divided until the very end concerning specimens in Koryŏ celadon and Yi porcelain, but these too were eventually dismissed, leaving only a crudely made cup for everyday use dating from the early Yi period.

As this story shows, the ideals of the tea ceremony adept and the Korean connoisseurs of drinking have much in common. It suggests too that even the "million-dollar" Koryŏ teabowl may not have been the product of a "simple potter" but an object that, though unsigned, is of genuine artistic worth, discovered originally by discriminating tea drinkers of the past and cherished accordingly ever since. To say this is more than mere rhetoric: one tends to forget that, paradoxically, no object whatsoever can truly exist in its own right without the attendant appreciation of those who are close to it and recognize its qualities.

May not the same be true, then, of folk paintings too? Are the unsigned folk paintings of the Yi dynasty *really* nothing but a collection of works created, artlessly, by country painters innocent of any higher artistic aspirations? Might it not be truer to see them as joint products born out of the participation—in the broadest sense—of all kinds of people, irrespective of whether they were known or unknown as individuals and of their social positions? If this should be so, then the meaning of folk art and folk painting is clearly distinct from social structure in the sense described above.

Painters, writers, musicians, dancers—all, individually, have a rarity value as "artists," yet their art is not made in a vacuum. It cannot exist without the numberless anonymous admirers who experience and applaud the artist's work, lending, directly and indirectly, support to the artist's efforts. However energetically a Christian minister, a Buddhist priest, or a Confucian master may preach, religion itself cannot exist without a body of followers. The Christian missionary tells the masses to achieve salvation by putting their faith in Christ. The aged Buddhist monk exhorts his simpler believers: "Recite the Hail Amida and you will attain happiness." Even in the Confucian classics, one finds constant references to the satisfaction of secular, selfish wishes. In short, it is impossible to understand religion solely in terms of religious philosophy, without examining the relationship between the sacred on the one hand and the

more selfish interests of the individual on the other.

Human culture constitutes, as it were, an enormous theater with both actors and audience. In the audience, presidents, ministers, millionaires, and ordinary people all sit together, indistinguishable as ants in an anthill. The overall nature of their relationships as a whole is such that it is not possible to say who is really taking the lead—the "actors" or the masses who applaud them. In fact, one could say that it is both.

It is from considerations such as this that the concept of "folk" in the broader sense and, in turn, the concepts of "folk art" and "folk pictures," also in the broader sense, derive. All human beings are a combination of intellect and instinct; for society's benefit, they wear differing "uniforms" depending on their rank or occupation, but back in their own homes they don once more their common, plain humanity. As kings, ministers, religious leaders, generals, and the like they may cut splendid figures, but once they have reverted to their simple status as husbands, brothers, and friends, they become their true selves again, stripped of their temporary finery. This is what the Korean *Sirhak* thinkers of the eighteenth century meant when they said that "when a man reverts to being a commoner, he shows his true self." If one interprets the reversion here not simply in terms of the social hierarchy but as signifying a return to the original, instinctive human being, then the meaning of "folk" in the broader sense should become quite apparent.

"Folk," in other words, can be seen as relating to the instinctual, human nature inherent in all individuals, as opposed to the more "superficial" intellect. Men are all essentially equal; just as the enjoyment of, say, annual rituals is not confined to the peasant, so it is a mistake to make value judgments derived from the exclusive viewpoint of a particular class. Thus the term "folk painting," for example, should be rethought on the basis of a broader concept, rather than seeking to apply it to the pictures of one particular social stratum.

It is important here to remember that every art has two sides, one aimed at aesthetic appreciation, the other at fulfilling a practical need. Even what has traditionally been seen in the East as "orthodox" painting, as "pure" art, always contains certain elements of the popular. In particular, it is naive to label a picture as "pure art" just because, say, it is in the Literati style and deals with a traditional theme such as the "Four Gentlemen," for such a picture may well be one of many similar fan-paintings mass-produced with almost machinelike speed by a fan painter in some isolated country village. On the other hand, I once examined a body of congratulatory pictures presented to a certain illustrious personage on his sixtieth birthday. It was full of folding screens and hanging scrolls executed by famous artists of the day. Every piece was in the academic style, quite different from that of folk painting, yet the subjects of the paintings were all secular in feeling insofar as they celebrated the personage's long life and good fortune. It is doubtful whether such congratulatory pictures can really be treated as "pure" art; and one is constantly encountering other, similar cases.

On another occasion, I came across a splendid preliminary sketch for a picture of a Taoist immortal, which prompted the thought that there were probably similar preliminary sketches for other pictures of the kind that we are familiar with today as works of the "old masters," and that they were sometimes in fact reproduced in great quantities. Thus three works have been discovered that are identical with a large screen painting of a golden cockerel long prized as a court decorative painting. I have had similar experiences with "Diamond Mountains" and "Ten Symbols of Longevity" pictures.

This being so, the view held in some quarters that court decorative paintings should not be included in the category of folk painting would seem to require careful rethinking.

It seems that the aesthetic theories of painters of the Yi dynasty particularly scorned the intrusion into pictures of anything "vulgar." The term "popular pictures" as used in the Yi dynasty was a pejorative term applied to pictures with a strong popular—i.e., nonacademic—element. It includes, for example, shamanistic pictures of various deities, the hanging pictures of Buddhist temples, and decorative paintings on folding screens, as well as pictures used as charms and possessing strong folk characteristics and other pictures on secular themes. The popular picture as it was conceived in the Yi dynasty has something in common with folk painting in the broader sense, insofar as both take account of the "vulgarity" inherent in all human beings and deal with a similar range of subjects. However, the new, broader concept of folk painting sets aside the negative view of such art, stressing instead that there is in the popular a major element of beauty that has been overlooked until now.

As I have said already, a broader concept of folk painting is necessary to replace the older, narrower concept. In this broader sense, folk painting signifies a decorative painting which, irrespective of the social status of the artist or the owner and of its commercial value as a picture,

was painted for use in the home, in a religious or other ceremony, in praying for the souls of the dead, or for some other practical purpose, and which has symbolic associations of a folk or religious nature. It embraces all kinds of unsigned pictures intended for everyday use and executed in a free style unfettered by the restrictions of orthodox painting.

The repercussions of the radically new view of painting proposed by Yanagi Soetsu seem to have gone no further than the activities of a small number of sympathizers. The chief reason here lay, I suspect, in the restrictive nature of views of folk art and folk painting at the time. How can one assemble works, in quantities and of a quality sufficient to make the general public change its ideas about painting, on the basis of a set of values that recognizes as folk paintings only the naive products of painters with no grounding in art? The first thing then is to change our concepts of folk art and folk pictures.

The Concept of "Korean Painting"

Before discussing the folk painting of the Yi dynasty as such, let us first glance at the nature of Korean painting and its special qualities as a whole and try to define folk art in relation to it.

In recent years the term *hanhwa*, or Korean painting, has become popular in South Korea itself, but in Japan it was already in common use in the past, along with the expression *chosŏnhwa*; the artistic sense that was so quick to discover the beauty of the Korean teabowls undoubtedly detected a similarly unique quality in Korean painting too. In Korea itself, unfortunately, this convenient word was slow to come into general use. The blame lay, if anywhere, in the failure of the art historians to define clearly the special qualities of Korean painting.

Any simple classification that would enable one to say with confidence "this is a typical Korean painting" is indeed impossible; but it can perhaps be clarified to some extent by referring to actual examples.

One tends to assume vaguely that just as there is "Korean dress" and "Korean food" there must be something called "Korean painting," but the latter is not so readily identified. To examine the more superficially "Korean" aspects first, the dearth in ancient painting of depictions of people wearing Korean dress or of typically Korean houses is one barrier, perhaps, to the formation of a clear sense of Korean-ness; where clothes and buildings are in the Chinese style, one tends to assume that the pictures also are Chinese. In practice, though, there are a surprising number that show specifically Korean characteristics.

Among the so-called orthodox, or serious, paintings that are always mentioned in histories of Korean art, those that reveal traits specifically characteristic of Korea are, for example, pictures of manners and customs, portraits, and landscapes showing actual scenery. However, artistic circles during the Yi dynasty dismissed these more often than not as "popular" art. For example, the works of Hyewŏn and Tanwŏn, two of the leading genre painters of the eighteenth century, include a large number of pornographic, or at least erotic, pictures. Today, these are considered as genre paintings within an orthodox tradition, but at the time they were treated with utter contempt. And yet, provided one gets rid of the idea that they are popular art, it is precisely such genre paintings that show the dress of the Korean people and the Korean scene in the most natural manner. Since, moreover, they include many outstanding works by first-class artists, it would be a great loss to exclude them from consideration as Korean painting. Portrait paintings, also, consist almost entirely of pictures of Korean nationals, and can be seen as typical Korean paintings employing a characteristic treatment of their own.

Pictures of specifically Korean landscapes, which fall under the general heading of landscape painting, are one of the leading types of Oriental painting as a whole. They are typified by the work of eighteenth-century landscape painter Kyŏmjae (Chŏng Sŏn) showing the Diamond Mountains. They break away from the general Oriental convention in both subject and style, demonstrating what can be truly called a Korean originality. The same theme was taken up in turn by folk painting, and pictures of the Diamond Mountains, together with other paintings inspired by actual landscapes such as the "Eight Views of Kwandong," "The Chinyang Fortress," "The Fortified City of P'yŏngyang," and the "Ten Views of Cheju Island" (done, moreover, on the large surfaces provided by folding screens), came to attract much attention. It was the rediscovery of folk paintings such as these, unfettered by the traditional techniques of the orthodox school, that helped to create a new respect for Korean painting as an independent body of art.

The vast numbers of pictures admitted by the broader view of what constitutes folk painting have shown that the history of Korean painting up to and including the Yi dynasty consisted almost entirely of pictures with some practical, extra-artistic purpose. What is more, such folk painting is not merely decorative but also, as I shall point out later, represents a whole under-

lying complex of popular beliefs, so that in some cases it is possible to trace its artistic lineage back to the magical pictures of prehistoric times. Its sources, thus, run far deeper, and provide more convincing evidence of true "Korean-ness," than Korean painting of the "orthodox" school, which came into being under a constant influence from Chinese painting. This extremely important point can be made clearer by examining a number of actual examples.

It is difficult to be sure with the materials available at present whether it is possible to discover genuine elements of Korean art in the bone-and-tortoiseshell pictures and rock drawings of the Paleolithic era discovered by archaeologists in recent years, but the lineage can probably be traced at least as far back as the murals in the Koguryŏ burial mounds. The Koguryŏ murals, even admitting a heavy influence from Chinese art, do, I believe, exhibit various elements that later contributed to the Korean picture as such. For example, the picture of the Four Sacred Beasts that is one of the best known of the many surviving pictures associated with burial rites surely represents a tradition aimed at averting evil that runs through the rock engravings of the Koguryŏ burial mounds to the dragon-and-tiger pictures (munbae-do, gate-guarding picture charms) of the Yi dynasty. The dragon-and-tiger theme is, admittedly, common to all Oriental painting, but in no other case did it become so deeply intertwined with everyday life and undergo such a long development as among the Korean people. It is rash, at the very least, to exaggerate the importance of the Chinese element in the whole of its subsequent development simply because it is found among surviving Chinese works.

The sources of the flower-and-bird pictures that form the largest group among Yi folk paintings would similarly seem to have distant origins, but there is still insufficient material to document exactly how this influence was felt. Fortunately, the exhibition of Buddhist paintings from the Koryŏ dynasty held some years ago at the Yamato Bunkakan, in Japan, served to reveal useful background information on this genre. Similar hints are also to be found in the murals of the Koguryŏ burial mounds. The fact remains that the flower-and-bird picture in Korean painting is seen at its most original in the folding screens of Yi-dynasty folk art. The flower-and-bird paintings of China, Japan, and Korea are admittedly similar in some respects, yet even the Chinese version, if one tries to trace its ultimate origins, proves to have been influenced by the West; the uniqueness of each country, in short, is manifested within any number of such interacting influences.

Pictures of tigers are among the most characteristically Korean of the folk pictures of the Yi dynasty. The pictures of this period are, strictly speaking, derived from the white tiger of the "blue dragon–white tiger" pair in the traditional Four Sacred Beasts genre. In short, the tiger was only incorporated into the history of Korean painting because of its role as an averter of evil—a fact that becomes clear from the information provided by folk art. The history of pictures to ward off evil dates back far in Korea, and the practice continued on into the Yi period in the form of gate-guardian pictures, such as those of Ch'iu and of Ch'ŏyong who fought the Yellow Emperor. Apart from these, the tiger also appears in hanging pictures as the messenger of the Mountain Spirit. Unfortunately, few old specimens survive, probably because it was the custom to burn the old picture when a new one was hung in its place, but it remains clear that the tiger pictures were a product of mountain spirit worship—of a national mode of belief— reaching right back to the earliest days of the nation. The uniqueness of Korean painting does not depend solely on the visible characteristics of the picture; the way it reflects such beliefs as this is another, and most important, element.

The concept of Korean painting can, of course, be expanded to include orthodox painting as well, but it is the pictures for practical use, closely bound up with everyday life, that, in view of the position they occupy in the history of painting and the sheer quantity of material available, should be considered as constituting the mainstream. They are what would be described in Korean as *salm* pictures, a word meaning "life" in the sense of the ordinary, everyday aspects of human life.

As for the essential quality of Korean painting as painting, I shall have more to say later. However, if one were to sum it up in one word, the most appropriate would be the Korean *mŏt*. (See "Folk Painting and Aesthetic Criteria" near the end of this essay for a more detailed discussion of these terms.) A picture without *mŏt* does not give expression to the sense of enjoyment, or *joie de vivre*, of the Korean people, and as such cannot be called "Korean." In Korean art, artistic value depends on how *mŏt* is manifested—indeed, it is a yardstick by which not only art, but all that is worthwhile in human behavior is measured. To give expression to *mŏt*, it is necessary to have humor, originality, force, and directness, and to create an appeal that is natural and simple yet at the same time refined.

Another criterion is whether it has *ŏl*: whether, that is, it is infused with soul. The Korean

people tend to reject out of hand anything, be it an art object or an individual, that lacks *ŏl*. *Ŏl* in the present case does not imply that the picture treats of some religious theme, but suggests, rather, a certain frame of mind in the artist as a human being. The question is: was the picture, irrespective of technical skill, painted with utter sincerity and purity of heart? The theme itself, of course, is an important part of a work's "Korean-ness," but in discussing its qualities as art, it is *salm*, *ŏl*, and *mŏt* that are indispensable.

Korean Painting: An Overview

We have seen that pictures painted for specific practical purposes constitute the mainstream of Korean painting, and that by and large such pictures correspond with what is meant by "folk painting" in the broader interpretation. However, the concept of Korean painting also includes of course the "official" school.

It is customary to divide Korean painting into two main categories: "pure" painting and "practical" painting, the latter signifying work done with primarily nonartistic aims. Pure painting is subdivided, by its style, into Southern, Northern, Literati, Zen, and Academic, while practical paintings can be classified according to the purpose for which they were intended. The latter include what I shall refer to as "everyday" pictures, chiefly of works intended as an integral part of domestic life; "documentary" pictures, including maps, pictures of mountains, portraits, pictures of ceremonies, and historical pictures; and "religious" pictures referring to works used in religious ceremonies. The last-named include Buddhist, Taoist, Confucian, and shamanistic works, though art histories in the past so far have dealt with Buddhist pictures almost exclusively. In addition to these there are the pictures whose purpose is to seek the repose of the spirits of the dead; they include the murals found in burial mounds, and decorative pictures showing ritual objects used at funerals or objects intended for the use of the dead. Representative of the tomb murals are those that survive from Koguryŏ.

Strictly speaking, however, this method of classification implies a number of problems. It suggests, for example, that pure pictures and practical pictures are somehow opposites, whereas the overall division—sometimes adopted—of Korean painting into pictures for appreciation and pictures for decorative purposes makes the distinction between "pure" and "practical" painting meaningless, in that *everything* can be seen as in some sense having a practical purpose.

Such an enormous number of Yi-dynasty paintings partake of folk painting qualities, and the range of types is so wide, that it is quite impossible to grasp the picture fully if one sticks to the narrow definition of folk painting. The question arises at this point, however, of whether it would be better to revise our view of folk painting and use the term itself in a broader sense, or to adopt some appropriate new coinage to take its place.

It is for this reason that I would suggest the use, for want of a better word, of the term "everyday" picture, in the sense that I have used it provisionally above. It seems to be not only less misleading than the well-worn phrase "folk picture," but also to embody a new, important, and far-ranging concept.

Everyday pictures are a type of decorative painting with a strong folk element intended for use in everyday life; they are painted and put on display in accordance with yearly rites and seasonal changes, and as such are associated with specific places and occasions. They also embrace elements of symbolism and the secular intentions of popular beliefs, and employ a particular style that gives expression to the *joie de vivre* inherent in a "folk" style. Furthermore, they have a quality of the popular, or the national, that could not exist if they were not a product of the participation, in the broadest sense, of a whole people. They are, in short, paintings that sum up everything meant by the word "folk."

These pictures in the "everyday" tradition, which have of course been omitted from mention in the histories of orthodox painting, gave birth to a vast number of varieties and were produced in great quantity, ranging in social status from "peasant" pictures to paintings on screens used at court.

Chief among the subjects depicted by everyday painting are the Ten Symbols of Longevity; peonies and rocks, symbolizing wealth and prosperity; flowers and birds with various auspicious connotations; Chinese characters symbolizing filial and fraternal piety and faithfulness; and dragons and tigers symbolizing happiness and freedom from various misfortunes. These subjects were popular not only for use in ordinary families but also at the court, in official residences, and at temples. It follows that the pictures range from crude affairs done by itinerant painters to major works done by artists in the service of the court. Everyday pictures for use by ordinary families can be divided into an upper and a lower category, a division

prompted by the marked discrepancy in style and composition between the works of untrained painters and highly sophisticated, if unofficial artists; anyone who has experience in collecting folk paintings will, I am sure, feel this division to be justified.

Although everyday pictures are undoubtedly for practical use, many of them are more than simply decorative art, achieving a high level of expression as pictures. Nor is that all; as pictures, what they express is often deeply imbued with elements of religious faith, and even pictures on secular themes allude to spiritual mysteries. To put it differently, they are *salm* pictures with *mŏt* and *ŏl*, thus including all the basic elements just mentioned. A word of caution is necessary here. Many everyday pictures take the form of screen paintings, but this is characteristic of Yi painting as a whole, including orthodox painting, which is itself often closely associated with the interior spaces in which human beings live and can in this sense be considered as "everyday." Accordingly, for an everyday picture to qualify as a true folk picture, it has to fulfill a number of other, specific conditions.

First of all, as a folk picture the everyday picture is not aimed principally at artistic appreciation as it is known in orthodox artistic circles, but is closely associated with everyday life and customs. It is in some ways a symbolic picture, incorporating elements of folk belief, and it is executed in a folk style not to be found in academic painting. Thus though certain academic paintings may be typically "everyday" in some of their aspects, the absence of the true folk approach disqualifies them as folk paintings.

Let us now, then, take a look at the specifically folkloric element in the everyday pictures of the Yi dynasty. Insofar as it is painted and put on show in response to yearly rites and customs, folk painting has a special significance in terms of folklore or the nation. Records in old almanacs on seasonal events and symbols (*Sesigi*) show that auspicious pictures known as *sehwa* were often put out at the New Year. The chief kinds of pictures mentioned as typical are the *suroin-do*, symbolizing long life and happiness; the *sŏnnyŏ-do*, depicting a female mountain spirit; the Ten Symbols of Longevity; and the pictures of tigers, lions, dogs, and cockerels intended to ward off evil.

It is worth noting, too, that the old records say that the models for *sehwa* were provided by the court. The gate-guarding pictures of the court were also, of course, painted by official painters, yet though they are in style similar to academic painting, they were not treated as orthodox painting and can be considered a type of folkloric art. Though the yearly rituals based on popular religious beliefs might be carried out at the court, they were not referred to as court customs and can be considered as "folklore." In this sense, the everyday pictures of the court can perhaps likewise be placed in the category of folk painting.

Another season at which folk paintings were accorded an importance second only to that given them at the New Year was the Buddha's birthday on April 8. At Buddhist temples there is a custom of hanging a large Buddhist painting, known as a "hanging Buddha," outside the temple. Hanging Buddhas surviving today include one in Sŏnŏm-sa temple which measures 13.6 meters by 15 meters and is said to be the largest such work in the world. Apart from this, all kinds of other hanging pictures were painted. It is astonishing that so much Buddhist painting should have been executed in the Yi period, when anti-Buddhist policies were in force. The works were all presented to the temples by ordinary believers, so that quite apart from other factors, the motives inspiring their execution place them definitely as "pictures of the people."

A type of folk painting similarly associated with the Buddha's birthday which should be mentioned here is the "lantern picture." The tradition of holding lantern-carrying processions on the Buddha's birthday survives to the present day, but the pictures on the lanterns themselves have all, unfortunately, disappeared, though the National Folk Museum preserves a certain amount of material concerning them; their *Sesigi* in particular records the various types in detail. According to this, the themes were not so much specifically Buddhist as, overwhelmingly, themes peculiar to folk painting. Even today, one finds murals in the folk style inside Buddhist temples in Korea; in all kinds of out-of-the-way corners there are pictures of the type found in ordinary homes—tigers, dragons, hares, flowers-and-birds, the Diamond Mountains, the Ten Symbols of Longevity—all of them showing the influence of folk painting.

A month after the Buddha's birthday comes the festival of the fifth-day-of-the-fifth-month—the Tano Festival. At this time, appropriately enough for a festival of early summer, pictures painted on fans were placed on display. The Tano pictures of the "Twelve Thousand Peaks of the Diamond Mountains" are another everyday picture that forms one of the outstanding categories of Korean painting. Almost all the countless pictures of the Diamond Mountains surviving today were painted for use at this festival, some of them in one of the official styles,

others in the folk style. This type of painting, in fact, can be seen as "everyday" in a truly national sense. There is even a record which notes that at the royal court fans without any picture were bestowed on the courtiers so that they could paint pictures of the Diamond Mountains on them—an example of a type of folk painting involving both monarch and subjects! Old records note that the Diamond Mountains, as well as other typical folk painting themes such as flowers-and-birds and long life and happiness, were a favorite subject for painting on fans among the ordinary people. At the Tano Festival, pictures of the guardian gods of the gate were often put on display also. These are the paintings designed to ward off evil and known as *munbae-do*, the most popular being pictures or prints of tigers, lions, cockerels, and dogs. They are different again from the gate gods of China. The "good demon" generally found in Japan and known as Shōki in Japanese (Zhongkui in Chinese) does not seem to have become particularly popular in Korea, where portraits of such deities as Ch'iu and Ch'ŏyong were favored.

Besides annual rituals, there were plenty of domestic rituals in the family's everyday life that prompted the creation of folk paintings. Outstanding among these were the wedding ceremony and the banquet celebrating longevity. Of the symbolic pictures associated with weddings, the screen paintings of flowers-and-birds or peonies are typical. Among the former, pictures of mandarin ducks or wild ducks were considered the most suitable themes for weddings, a fact that can be deduced from the number of examples surviving today. On the screens executed to celebrate birthdays, all kinds of pictures symbolizing long life and happiness make an appearance. For the celebration of an individual's sixtieth birthday (*hwan'gap*), which occasioned the greatest rejoicing over an individual to be found in family life, the children of the person concerned would customarily present him with the finest folding screen they could afford—a custom that is still continued today. Similarly, with the ceremony that was the equivalent in marriage of the sixtieth birthday celebration, a special type of folding screen— usually a documentary portrayal of the congratulatory feast held on the day—was made to commemorate the occasion. One should also doubtless include among everyday pictures the pictures of shrines used at the ancestor festival and the various symbolic paintings used at funerals.

Folk paintings were also an indispensable feature of rituals carried out by the village as a whole. Rites to pray for rain, for example, were a major event involving all the inhabitants; records tell that it was customary from olden times to hang a picture of a dragon from a pole as a prayer for rain. Inspired as they were by popular belief in the dragon as the spirit of the rain, these pictures sometimes have a remarkable spiritual power. There are also various rites—such as the village festivals—that are peculiar to Korea, their characteristics varying from district to district. Thus in the mountains of Kangwŏn Province, where there were yearly festivals to honor the Mountain Spirit, banners depicting the Mountain Spirit were naturally popular, while on the east coast, with its rites to propritiate dragon gods, pictures of the Dragon King have always had a special importance. At the entrance to a village, there normally stand two carved wooden posts representing the guardian deities of the village, and beneath the "spirit tree" (*sindangmok*) stands the village shrine. The shamanistic folk paintings that form a focal point of these shrines should not be overlooked.

Thus the folk pictures of the Yi period were painted and displayed in connection with annual rites or on special occasions or sites affecting the family or the village. They differ from pictures intended purely for aesthetic appreciation in that the particular occasions in daily life on which they were intended to be shown were clearly defined. A gate-guarding picture of a dragon and tiger made for display on a wooden gate would never have been stuck on the wall of an inner room, where a charming picture of flowers and birds, or pictures of fish or the "Hundred Boys"—symbols of fecundity—would be appropriate. The gate-guarding pictures themselves, again, come in a number of fixed types: tigers or cockerels for the main gate; *haet'ae* (mythical beasts)—which guard against fire—for the kitchen entrance; dogs to frighten away thieves at the entrance to the storehouse.

Folk Pictures and Popular Beliefs

As we have just seen, folk pictures were intended for practical, social purposes, and as such their production and display were associated with particular occasions and places. This is closely related to the fact that their motifs incorporate a symbolic aspect representing various popular beliefs. A type of religious feeling, in fact—ŏl—stands at the heart of folk pictures; they would not be true folk pictures without it.

Just how deep this mystic aspect goes can be seen from the flower-and-bird pictures that form the most numerous category of folk painting, and in particular the pictures of mandarin

ducks. Mandarin ducks, of course, have always in Oriental art symbolized marital harmony and constancy, and the extent to which Korean folk pictures were imbued with ŏl can be comprehended by a visit to an old shrine called Tongnakchŏng. The shrine, also known as the "mandarin duck" shrine, has as its deities figures of an old man and woman, symbols of conjugal harmony, while around the base supporting the statues are stuck pictures of pairs of mandarin ducks with joined bills. It is said that if a husband and wife who are on bad terms come and pray here, their relationship will become as harmonious as that of the ducks. These pictures are not simply compositions of charming birds and beautiful flowers, but pictures of sacred birds with souls; that is what qualifies them as truly "folk" pictures.

Common flower-and-bird motifs include such familiar fowl as chickens, sparrows, pheasants, cranes, magpies, and swallows, the last four being particularly important as sacred birds symbolizing the repayment of an obligation. Thus the type of popular belief found in folk tales is precisely reflected in the underlying spirit of these paintings. And such beliefs still persist today. As I write, I have by me a newspaper cutting sent to me from Korea and dealing with a pair of cranes that were living in Ŭmsŏng. I had previously read an article telling how several years ago the male bird of the pair, which were designated for special government protection, was killed by an ignorant hunter. The bereaved female was left to lead a solitary life; there was some talk of purchasing another male bird in Japan, but I had lost track of what happened thereafter.

The latest newspaper clipping, however, was a follow-up on the original story. A villager named Yun, who had for many years looked after the lone female bird as if it were his own child, died suddenly in his sixties. At this, the doubly bereaved crane suddenly switched her nest to another tree because, it was said, from that tree she was able to look down on the dead man's grave. The story might be dismissed as a fabrication of the popular imagination, but one comes across a surprising number of similar stories even today.

Another story concerns a turtle. The Koreans have an affection for turtles quite unlike the feelings of the Chinese (among whom it is said that the way to start a quarrel is to liken the other man to a turtle), and the animal figures prominently in Korean art. All kinds of examples show the ingenuity of the Koreans in this respect, from small buttons for everyday use to the countless stone plinths in the shape of a turtle carved for memorial tablets from the Silla period up to the Yi period, and the turtle-shaped jade seal used for five hundred years by all the kings of the Yi dynasty.

The spiritual roots from which the use of such turtle motifs springs seem to go very deep. Large turtles often come ashore on the west coast of Korea, and it is customary on such occasions for people living along the coast to give the turtle plenty of good things to eat, then return it to the water. On one occasion during the Vietnam War, a turtle came ashore in the territory of an ROK expeditionary force. Taking this as a sign of good fortune, the troops fed it royally for three days, then inscribed on its back "lasting good fortune in battle for the White Tiger Unit" before releasing it.

The turtle is numbered among the Four Divine Animals and Ten Symbols of Longevity; each has its own symbolism, but in Korea the less sophisticated type of faith in the virtues of the turtle gradually deepened to an almost religious intensity; the pictures of turtles were of course a product of this deep faith.

Another good example is provided by the screens with paintings of the "Hundred Boys." During our hunt for folk paintings, we came across an old woman in her eighties who had a screen painting of this kind that had been her most treasured possession all her life. In her youth, when she had desperately wanted a male child, she had prayed to the screen—and had duly given birth. Ever since then, the Hundred Boys screen had been cherished as though it were magical.

What of the relationship, then, between folk paintings and the followers of Confucianism, which urges scepticism toward miracles and the supernatural? A few years ago, a shrine known as Pokkaedang in Seoul was shifted to the Emille Museum on account of road-widening work near the original site. The shrine in question is particularly interesting in that, although it is a Confucian shrine, countless stories are told of people in the neighborhood who became rich or gave birth to male children as a result of praying at the shrine. Moreover, fragments of the original beams were found inside the roof, and the red and green crests on them were all pomegranate motifs—a symbol of fecundity and prosperity. It is evident, in other words, that even Confucianism, which in theory abhors all such popular superstitions, in fact depended to quite an extent on perfectly ordinary worshipers who found themselves obliged to believe in miracles.

As to just what religion is represented by the beliefs with which folk paintings are imbued, it is not so easy to say. The "magic peach" that is one of the ten symbols of long life is said to be Taoist in origin, but in Buddhism also there is a type of picture showing monkeys holding out peaches, while peaches also put in an occasional appearance in the decoration of shamanistic shrines. Similarly, the decoration on Buddhist buildings in Korea consists largely of pictures of flowers, birds, and animals that in practice have no direct connection with Buddhism at all. This suggests, in short, the existence beneath the three religions of Confucianism, Buddhism, and Taoism of an undercurrent of popular beliefs that serve as a kind of common denominator, beliefs that represent man's deep desire for happiness in the present world and that appear in folk paintings in the form of motifs symbolizing long life, happiness, and the avoidance of harm. Beneath these three great religions, in short, lies a primitive, shamanistic, ur-belief.

Everyday paintings do, of course, include works whose religious affiliation is quite explicit, but the majority of them, it seems safe to say, can be grouped together within a shamanistic symbolism aimed at long life, happiness, and the avoidance of evil. The motive power behind them, in short, is neither poetic nor philosophical nor aesthetic, but a quite unsophisticated set of popular beliefs. This is borne out by a more systematic look at the origins of their themes.

In the past, people in Korea as elsewhere did not simply paint what they saw with their eyes, but also gave naive, uncomplicated expression to the images that occurred to their minds, whether of heaven, earth, or the world of men. First, they painted the entities presiding over the universe—the sun, moon, and stars—both in their own and in divine form. They painted the gods of the elements, and groups of gods presiding over the four quarters, the zodiac, and so on. They painted the four seasons, and the natural phenomena—the snow, frost, mist, and dew—that are associated with them. Together, these constituted a catagory of painting associated with Heaven, that existed prior to any of the academic theories of Oriental painting.

On Earth, their feelings for nature developed from a simple love into a kind of worship. They painted mountains and streams, but they also painted mountain gods and gods of the water. They admired the beauty of trees and rocks, flowers and birds, grasses and insects, fish and animals—and at the same time put them into pictures as auspicious symbols. In this way, they created a category of pictures dealing with Earth as opposed to Heaven. Then they went further, and painted men and their everyday daily lives, and men who were deified. They showed the founders of the nation, kings and emperors, ministers and faithful retainers, and women renowned as models of chastity, as well as religious ceremonies, weddings, and banquets celebrating the attainment of old age. To these they further added other human figures: children, fishermen, woodcutters, farmers, women attending to silkworms, and the various gods and sages of Confucianism, Buddhism, Taoism, and shamanism.

Thus the various pictures developed for practical purposes came to form three main categories dealing respectively with Heaven, Earth, and man and embracing both aesthetic appreciation and worship. The aesthetic aspect, further refined, gave birth to "orthodox" or "pure" painting, while the impulse to worship found lasting embodiment in religious painting. As a result, the history of art as it is usually taught generally places emphasis on academic painting and religious painting, while everyday painting as such has somehow fallen by the wayside.

Now, however, the everyday pictures of the Yi dynasty, so many of which have been miraculously preserved, make possible a rediscovery of painting under its proper aspects of practical use, faith, and aesthetic beauty. In short, they represent painting as it was before its essentially artificial division into orthodox painting and religious painting. Their themes accordingly include some that correspond with the themes of Oriental painting as a whole and others that have close connections with religions. However, in practice the real importance of a picture lay not so much in what it literally portrayed as in its symbolic significance, a significance often indicated by the popular name applied to the type as a whole—as when, for example, a picture of peonies and rocks is referred to as a "long life and prosperity" picture, or a picture of a pair of wild ducks as a "conjugal harmony" picture.

The approach to symbolism indicated by these popular titles is not that of any particular religion, but indicates a strong belief in the efficacy of such symbols in securing happiness in the present life. For this reason, rather than considering the themes of Yi folk painting under headings such as Confucianism, Buddhism, and Taoism, it seems much more appropriate to think of them in terms of the symbols that belong to the popular sphere and underlie all those religions: symbols of happiness, evil-avoidance, and the nation.

There are, of course, various problems inherent in any attempt to identify such themes, since over the centuries their original significances have sometimes been confused, or com-

bined, or ignored. The Ten Symbols of Longevity picture that is one of the most popular types, for example, is a composition embracing the categories of trees-and-rocks, ornamental plants, fruit-and-vegetables, flowers-and-birds, and animals, so that it is meaningless to place it in any one particular category. Its one essential characteristic as a type of folk painting is that it symbolizes long life, and as such it is only really at home in a special category of its own.

Again, one might put the pictures of dragons and tigers in the category of animals or sacred animals, but insofar as they are used as gate-guarding charms, it would be more appropriate to create a special "evil-averting" category. Similarly, the real significance of leaping carp as folk pictures can only be made clear by classifying them as pictures symbolizing happiness in the form of worldly advancement or male children. Another interesting problem arises from the large number of screen paintings embodying a mixture of themes and thus difficult to categorize—for instance, one screen might include flowers-and-birds, sacred animals, flowering plants, landscapes, human figures, popular tales, fish, grasses-and-insects, genre themes, and Taoist and Buddhist themes. The only thing these themes have in common is that they all symbolize human desires for a better life.

The Aesthetics of the Folk-Style Picture

So far we have examined folk painting from two of its three aspects—practical use and religious feeling—dealing with it first of all as something for decorative use, then as something associated with folk beliefs. Now, let us look at it in the light of its purely pictorial, or aesthetic, qualities.

Folk painting has given rise to a unique style that breaks the conventional bonds of Oriental art. Its beauty is not simply that of decorative art, for it has a style that can stand comparison with such examples of "pure" painting as Literati and Zen (Sŏn in Korean) painting. The "folk style"—as I shall refer to it here—is marked by the use of many and strong colors; its brushwork is unhurried rather than rapid; and the treatment tends to the patternized and abstract. The element of amusement, with satire and humor typical of the folktale, is also prominent. The fanciful, lively manner creates a pervasive sense of something otherworldly. And the anonymity of the picture is invariably preserved.

Where the degree of abstraction is particularly pronounced, one can distinguish between what one might call a "childish" and a "childlike" style. The first refers to a markedly primitive style, dashed off with the innocence of infants by painters without artistic training; the latter refers to pictures in an abstract style created by more sophisticated artists with a training in art who sought to break out of the confines of conventional Oriental art. The former is represented by the "low folk" picture and the shamanistic picture, crude yet effective and valuable in representing, as it were, the "pure" folk painting in the old sense.

Whatever method of classification is adopted in the future, these two types will almost certainly figure centrally among folk painting in the narrower definition. In the broader definition, however, one must consider, along with the folk style, what can be called the "court style." This differs from the academic style adopted in orthodox painting, being a kind of mixture of the latter and the folk style. It is not correct to refer to everything painted by painters at the court as being in the academic style; among the court paintings popularly referred to as "painting bureau pictures," there are many that are closer to the folk style than to the academic style, though they are commonly lumped together under the latter heading because of the failure, in studies of orthodox painting, to exert real care in classifying the examples of the academic style available.

In short, to adopt the narrower definition of folk painting involves distinguishing between folk and court painting, much as a distinction is made between Korean folk embroidery and court embroidery. If one adopts the broader definition, however, "folk" painting comes to embrace both the court style and the folk style, thus giving one a much more distinguished body of art, one whose aesthetic claims to world attention can be asserted with some confidence. It has become clear from the number of specimens collected that the paintings of the Ten Symbols of Longevity in the court style were in many cases mass-produced, while many of the "bookshelf" pictures that have been discovered should be considered as decorative pictures in the court style rather than in the academic style. In other types of pictures, a few large works in the academic style have been found, but almost all the rest seem to me to be everyday paintings in the court style. To sum up, one is obliged to include pictures in the court style in any consideration of folk painting in the "everyday" sense—which means that folk painting includes within its scope decorative paintings of an extremely high artistic quality.

The Artists of Folk Painting

Folk paintings are usually thought of as unsigned, and this anonymity is in fact one of their chief characteristics compared with orthodox paintings, which were normally produced, one at a time, by a small number of artists, and with which individuality and artistic renown were inseparably associated. There seem to be a number of misunderstandings, however, concerning the anonymous artists who produced folk paintings. One is the assumption that because the pictures are unsigned their authors were obscure itinerant painters. Just as the folk song is commonly considered to be music of the masses that somehow developed spontaneously out of their midst, whereas in fact there must have been hidden geniuses at work, so something similar was almost certainly true of folk painting.

Nor is that all. Even the painters of the painting bureau, who served at court, directed the production of everyday pictures, such as *sehwa* and Tano pictures, that had a folkloric quality. To take tiger pictures as one example, almost all those painted during the five hundred years of the Yi dynasty are in the folk painting tradition, yet they include quite a number done in the folk style by major artists such as Ko Un, Yi Sang-jwa, and Pyŏn Sang-byŏk of early Yi and Kim Hong-do, Yi Ŭi-yang, Yu Suk, and Sim Sa-jŏng of the latter Yi dynasty; unfortunately these have always been dismissed in the past as pictures pandering to the popular taste, or at least sullied by popular elements. The same is true of the pictures of the Diamond Mountains. Mention of such pictures immediately brings to mind the eighteenth-century artist Kyŏmjae, a national master who specialized in Korean-style landscapes painted from life, creating a highly stylized type of Diamond Mountains picture. A large number of fan-paintings of the Diamond Mountains by him, painted for use at the Tano Festival, have been discovered. These pictures had a widespread influence—less as orthodox paintings than as folk-style paintings—on the world of folk painting, a fact powerfully demonstrated by the large number of folding screens with pictures of the Diamond Mountains in the folk-painting style that survive today.

Another class of artist that should not be forgotten is the professional painters of Buddhist pictures. The brushwork of the folk picture is closer to that of Buddhist painting than that of orthodox painting, and good folk paintings done by Buddhist artists are quite common.

There are signs, thus, that top-ranking artists also had a hand in guiding the development of the folk painting. As the *Sesigi*, for example, records, the *sehwa* put on display at the painting bureau were copied by large numbers of humble provincial painters, and it was their activities in turn that gradually created the world of "low" folk painting. Such humble painters were still to be found throughout Korea until only sixty or seventy years ago. These were not only itinerant painters; some of them would take a room in a town and use it as a shop to sell their works. I myself have bought paintings left over from just such a business. (The considerable number of Ten Symbols of Longevity pictures done without preliminary sketches suggests that the artists must have worked more or less mechanically to produce such large numbers of the same picture.)

Thus if one wished to identify to some extent the anonymous authors of these folk paintings, one could classify them into court painters, professional painters of Buddhist pictures, and itinerant painters. As for the well-known painters who had an influence on folk painting insofar as the folk style is concerned, examination of available specimens has made it possible to identify Lady Shin, or Saimdang (grasses-and-insects); Yi Am and Pyŏn Sang-byŏk (animals); Nam Kye-u (butterflies); Pak Ki-jun (one-hundred-fan paintings); Kim Hong-do (hunting); Shin Yun-bok (erotic pictures); Yi Ŭi-yang ("fur-and-feathers"); Kyŏmjae (Diamond Mountains pictures); Yu Suk and others (tigers). These master painters not only influenced the orthodox school of painting, but continued to exert a powerful sway over folk painting as well.

Folk Painting and Aesthetic Criteria

It is usual to stress the fact that folk paintings were painted, not "for art's sake" but for use in everyday life, yet to over-emphasize this is to give the mistaken impression that they are crude efforts remote from any artistic standards. To look on them as pictures of the masses is permissible; the trouble is that many people assume that they have therefore no artistic value, or that they are cheap commercial art. To do so is to miss the special quality of Yi folk painting; for in fact it displays a particular and exclusively Korean quality that is not to be found in the orthodox painting of China and elsewhere.

There are artistic criteria other than those propounded in the theories of orthodox painting. The popular (nonacademic) aesthetic sense has its own delicate and rigorous artistic norms. To take a single, very simple example, the Korean people are generally sensitive about the color

white, and in admiring, say, the hue of a piece of white porcelain will talk of a "celadon" white, a "snow" white, a "milky" white, a "cotton" white and so on, applying their own criteria in judging the subtle nuances. Similar criteria apply to the bluish-green of Korean celadon. And it seems safe to assume that the same, characteristically Korean aesthetic sense is present also in the attitude to folk painting.

In Korean art, as I have suggested earlier, the aesthetic value of an art form is judged by how it gives expression to *mŏt*. This applies of course as much to folk painting as to any other art form. Let us then consider this element of *mŏt* in terms of various Korean expressions that are used in relation to it.

First there is the word *shiwŏn-hada*; this refers to a refreshing quality, like a draught of clear, cold water when one is very thirsty. Two other expressions, *ttŏlttŏl-hada* and *t'ŏpt'ŏp-hada*, suggest a type of beauty that makes the most of the natural state, eschewing everything pretentious and forced, with an apparent unsophistication that is yet extremely refined. *Ŏullinda*, a word that is often used almost unconsciously, refers to a state of harmony, or of balanced contrast. Another commonly used word, *pudŭrŏpta*, has connotations of soft, graceful, approachable. Finally there is a pair of related expressions, *changnan'gi* and *ukkinda*. The former signifies "playful" or "childlike"—a naive, innocent quality—while the latter signifies "interesting" or "amusing," and has connotations of humor.

Folk painting, thus, is not simply a matter of visual beauty such as is suggested by *shiwŏn-hada* and *ŏullinda*, but also requires an element of *mŏt* that includes a delicate sensibility, an almost textural beauty of the kind suggested by the words *ttŏlttŏl-hada* and *pudŭrŏpta*; it is these more than anything that constitute the peculiar yardstick of beauty created by the ordinary man's view of art.

Materials and Techniques

So far, I have discussed the nature of folk painting in generalized terms, having reference incidentally to both folk art and Korean painting as a whole, but in conclusion I would like to say something briefly about the types of materials and techniques employed.

KŬRIM

It is said that the Korean word corresponding to the English "painting" is *kŭrim*, but the latter concept is in fact broader, being applicable to graphic work as a whole. Thus the folk pictures that I have often referred to here for convenience's sake as "folk painting", or "folk picture," are not in fact simple pictures painted using pigments and hair brush on paper or cloth but include, as we shall see below, all kinds of two-dimensional compositions executed with a variety of materials and techniques.

PAT'ANG

The term *pat'ang* as used in reference to Korean art refers to the base—the substance on which a picture is executed—be it paper, cloth, board, a clay wall, or ceramic. The paper may be Korean handmade paper, Chinese, or Western. The traditionally favored base for Korean pictures, however, one that is responsible for much of their special quality, is the tough, rough-textured mulberry paper called *changji*. For more delicate work, a type of paper known as *tadŭmiji*, softened by beating with a wooden club, is sometimes used, and so is dyed paper.

COLORS

In its liking for a wide range of strong colors, folk painting differs from orthodox painting, with its emphasis on Chinese ink monochrome or light color. Folk painting and embroidery in fact are the two exceptions to the preference of traditional Korean art for simple coloring. The pigments most favored are mineral pigments dissolved in glue, though in more recent periods water-soluble vegetable colors from plant roots and leaves as well as Chinese white and Chinese ink came to be used along with these. Gold dust mixed with glue was widely used—not only in Buddhist or court paintings—and there are occasional examples of the use of fruit or flower juices. There are, for example, pictures done in grape juice.

A point worthy of special note where coloring is concerned is that the type of cinnabar used in producing a vermilion pigment was believed to have magical powers in averting evil, and its use was considered obligatory in painting, for example, charms. This, and the use of blue pigments as a way of keeping insects at bay, suggest that the connection between colors and popular folk beliefs might be an interesting subject of study.

WOODBLOCK PRINTS

There are various other techniques besides the brush that are used in folk pictures. The first of them, woodblock printing, is far wider in its applications than the brush-painted picture. It is

used on everything from large folding screens and hanging scrolls to stationery and for decorative stamps. Calligraphy and monochrome paintings can be made available to a broader public by being turned into prints, and they were familiar in everyday life in the form of wood blocks for use on the covers of books and for dyeing fabrics; they are almost all Chinese ink monochromes.

LEATHER PICTURES

This form of folk picture, normally used chiefly for "letter" pictures and the like, is done with a flat-tipped brush, and was one of the cheapest forms of folk picture. Originally, pieces of willow wood are said to have been used, but in more recent times pieces of leather came into use; hence the generic name.

"POKERWORK" PICTURES

The only surviving examples of this type of picture made by burning the picture on the surface with a heated iron, are small and executed on wooden surfaces such as that of a wooden fan, but there were also large folding-screen pictures done on *changji* paper. Surviving examples suggest that they were a cheap popular form of folk picture that existed alongside the multicolor paintings.

CUT-PAPER PICTURES

Surviving specimens are very rare, but folding screens have been discovered that were made by pasting cut-out flower-and-bird pictures on a base of dyed colored paper.

CHARCOAL PICTURES

These consist mostly of large preliminary sketches, and were executed using willow charcoal enclosed, in the same way as the lead of a modern pencil, in a rigid container.

FRAMES AND MOUNTS

Folk pictures are sometimes mounted on folding screens or hanging scrolls, sometimes framed, and sometimes contained in handscrolls or albums. However, unlike religious pictures, which took the form mostly of frames without a border or hanging scrolls, or pictures of the orthodox type intended solely for artistic appreciation, the folk paintings appeared chiefly on folding screens. These screens might have two, six, eight, ten, or twelve (in a pair of sixes) panels, but eight-paneled screens have been most common among those discovered.

One characteristic type of folk picture is the single sheet of paper bearing for example a picture of a guardian deity and intended for sticking on a gateway or elsewhere. Such pictures were of course exposed to the wind and the rain, so that even when they took the form of hanging scrolls they were normally made in a rough-and-ready fashion.

MARBLED PATTERNS AND "PULLED STRING" PICTURES

Both of these were usually used for the covers of books and the like, but occasional folding screens are discovered bearing full-scale "marble pattern" designs, made by pouring Chinese ink onto the surface of water, stirring it about, then laying a sheet of paper on the surface so that it soaks up the ink to form an abstract pattern. The "pulled string" picture, known in Korean as *silppobi kŭrim*, is made by enclosing pieces of string painted with Chinese ink between two sheets of paper, then pulling them out while applying pressure from above, thus creating a bizarre, abstract pattern.

List of the Color Plates

Most of the captions refer to catefories of pictures as described in the text rather than to details of the specific work. Dates are conjectural.

1. Peonies (detail), silk, 19th century, full size 42 × 99 cm. (16.5 × 39 in.)

2. Peonies (one panel of eight-panel screen), paper 18th century, 57.5 × 120 cm. (22.7 × 37.2 in.)

3. Peonies (one panel of eight-panel screen), paper, 19th century, 44.3 × 94.6 cm. (17 × 37.2 in.)

4, 5. Peonies (two panels of eight-panel screen), paper, 18th century, each panel 26 × 37.2 cm. (10.2 × 14.7 in.)

6. Plants and insects (detail from eight-panel screen), cotton, 18th century, full size of each panel 37.3 × 92.2 cm. (10.2 × 36.3 in.)

7. Plants and insects (one of set of six), paper, 18th century, 44.5 × 80.3 cm. (17.5 × 31.6 in.)

8. Plants and insects (one of set of two), silk, 19th century, 31.6 × 63 cm. (12.4 × 24.8 in.)

9–12. Plants and insects (details from set of five), silk, 19th century, full size of each 37.2 × 73 cm. (14.7 × 28.7 in.)

13–15. Plants and insects (three of set of six), paper, 18th century, each 32.6 × 82.4 cm. (12.8 × 32.5 in.)

16–18. Ornamental plants (three of set of four), paper, early 18th century, each 27.8 × 99 cm. (10.8 × 39 in.)

19, 20. Plants and insects (set of two), paper, early 20th century, each 31.6 × 51.6 cm. (12.4 × 20.3 in.)

21, 22. Plants and insects (set of two), paper, 19th century, each 28.7 × 40.3 cm. (11.3 × 15.8 in.)

23. Flowers and birds, piscine pleasures (one of set of two), paper, 19th century, 36.6 × 65.8 cm. (14.4 × 25.9 in.)

24–28. Flowers and birds (five of set of six), paper, 19th century, each 30 × 49.6 cm. (11.8 × 19.5 in.)

29. Flowers and birds (one of set of eight), paper, late 18th century, 42 × 68.7 cm. (16.5 × 27.1 in.)

30, 31. Flowers and birds (two of set of five), paper, early 19th century, each 34.5 × 56 cm. (13.6 × 22.1 in.)

32–35. Flowers and birds (four-panel screen), paper, 19th century, each panel 34.5 × 61.7 cm. (13.6 × 24.3 in.)

36. Flowers and birds (single picture), paper, 18th century, 37 × 65.6 cm. (14.6 × 25.8 in.)

37–39. Flowers and birds (set of three), paper, 19th century, each 40 × 88.8 cm. (15.7 × 35 in.)

40–42. Flowers and birds (details of three of set of six), paper, early 19th century, full size of each 42 × 69 cm. (16.5 × 27.2 in.)

43. Flowers and birds (one of set of two), paper, 19th century, 33 × 53 cm. (13 × 20.9 in.)

44–48. Pleasant themes (five panels of eight-panel screen), paper, early 19th century, each panel 38.5 × 91.5 cm. (15.2 × 36 in.)

49. Hawk and hares (single picture), paper, 19th century, 31.2 × 74 cm. (12.3 × 29.1 in.)

50. Piscine pleasures (single picture), paper, early 19th century, 34.8 × 57.6 cm. (13.7 × 22.7 in.)

51, 52. Flowers and birds (set of two), paper, 19th century, each 37 × 63 cm. (14.6 × 24.8 in.)

53. Cranes (one of set of two), paper, 19th century, 35 × 55.4 cm. (13.8 × 21.9 in.)

54, 55. Piscine pleasures (two panels of four-panel screen), paper, 18th century, each panel 62.2 × 53 cm. (24.5 × 20.9 in.)

56. Carp (single picture), hemp, 19th century, 34.6 × 62 cm. (13.6 × 24.4 in.)

57. Carp (single picture), paper, 19th century, 40.7 × 65 cm. (16 × 22.5 in.)

58. Lotuses (single picture), paper, 20th century, 27.2 × 79.4 cm. (10.7 × 31.3 in.)

59. Lotuses (single picture), paper, 19th century, 32 × 80.2 cm. (12.6 × 31.5 in.)

60. Lotuses (single picture), paper, 19th century, 30.5 × 72.2 cm. (12 × 28.4 in.)

61. Lotuses (single picture), paper, 19th century, 41.6 × 100.5 cm. (16.3 × 39.6 in.)

62. Flowers and birds (detail from set of eight), paper, 19th century, full size of each 38.5 × 90.5 cm. (15.2 × 35.6 in.)

63, 64. Lotuses (two of set of four), paper, 19th century, each 27.2 × 80 cm. (10.7 × 31.5 in.)

65. Lotuses (four panels of ten-panel screen), silk, 19th century, each panel 30.5 × 94.5 cm. (12 × 37.2 in.)

66. Detail of Plate 65.

67. Tiger (single picture), paper, 19th century, 59.4 × 72 cm. (23.5 × 28.3 in.)

68. Tiger (single picture), paper, 19th century, 67 × 99 cm. (26.4 × 39 in.)

69. Tiger (single picture), paper, 19th century, 38 × 60 cm. (15 × 23.6 in.)

70, 71. Tiger-skin (two panels of six-panel screen), paper, 19th century, each panel 39.8 × 92.2 cm. (15.7 × 36.3 in.)

72–75. The Twelve Horary Signs (set of four), paper, 19th century, each 33 × 27.4 cm. (13 × 10.8 in.)

76. Dragon (single picture), paper, 18th century, 72.3 × 111.6 cm. (28.4 × 43.9 in.)

77. Dragon (single picture), paper, 19th century, 70 × 90 cm. (27.6 × 35.4 in.)

78. Dragon (single picture), paper, 18th century, 64.8 × 91.6 cm. (25.4 × 36 in.)

79. Hunting (detail of one panel of eight-panel screen), paper, 18th century, full size of panel 53 × 113.4 cm. (20.9 × 44.6 in.)

80, 81. Hunting (detail of two panels of eight-panel screen), paper, 19th century, full size of each panel 53 × 86.5 cm. (20.9 × 34.1 in.)

82. Hunting (detail of two panels of eight-panel screen), paper, 19th century, full size of each panel 36.6 × 78.7 cm. (14.4 × 31 in.)

83. Hunting (detail of two panels of eight-panel screen), paper, 18th century, full size of panel 58.3 × 137 cm. (22.9 × 53.9 in.)

84, 85. Episodes from *Sanguozhi* (details of two of set of eight), paper, 18th century, full size of each panel 48.2 × 85.9 cm. (19 × 33.8 in.)

86–89. Episodes from *Sanguozhi* (four of set of eight; see Plates 84, 85).

90–93. Episodes from *Sanguozhi* (four panels of eight-panel screen), paper, 19th century, each panel 33.8 × 62.1 cm. (13.3 × 24.4 in.)

94. Phoenix (single picture), paper, 18th century, 48 × 88.6 cm. (18.9 × 34.9 in.)

95. Sun and moon (eight-panel screen), paper, 19th century, each panel 55.9 × 162.6 cm. (22 × 64 in.)

96. Landscape (single picture), paper, early 19th century, 36 × 54 cm. (14.2 × 21.3 in.)

97. Landscape (one of set of four), paper, 19th century, 34.2 × 51 cm. (13.5 × 20.1 in.)

98, 99. Diamond Mountains (two panels of six-panel screen), 19th century, each panel 44 × 85 cm. (17.3 × 33.5 in.)

100, 101. Court observances (two panels of ten-panel screen), paper, 19th century, each panel 48.8 × 147.9 cm. (19.2 × 58.2 in.)

102. Turtle-boats (five panels of ten-panel screen), silk, 19th century, each panel 40.4 × 114.2 cm. (15.8 × 45 in.)

103. Boating party (single picture), paper, 18th century, 69.5 × 73.8 cm. (159.1 × 29 in.)

104, 105. Bookshelf pictures (two of set of six), paper, 19th century, each 29.2 × 63 cm. (11.5 × 24.8 in.)

106. Letter picture (single picture), paper, 19th century, 33.6 × 74 cm. (13.2 × 29.1 in.)

107, 108. Letter pictures (two of set of eight), paper, 19th century, each 39.2 × 102 cm. (15.4 × 40.2 in.)

109–111. Letter pictures (three of set of six), paper, 19th century, each 35.6 × 92 cm. (14 × 36.2 in.)

112. Letter picture (one of set of eight; see Plates 107, 108).

113, 114. Letter pictures (set of two), paper, 19th century, each 30 × 52 cm. (11.8 × 20.5 in.)

115. Bookshelf picture (single picture), paper, 19th century, 30.8 × 60.4 cm. (12.1 × 23.8 in.)

116. Bookshelf picture (one of set of two), paper, 19th century, 37 × 88 cm. (14.6 × 34.7 in.)

117, 118. Bookshelf pictures (set of two).

119–126. Bookshelf pictures (eight-panel screen), paper, 19th century, each panel 37.4 × 135 cm. (14.8 × 53.1 in.)

127. Bookshelf pictures (six panels of eight-panel screen), paper, 19th century, each panel 56 × 128.2 cm. (22.1 × 50.5 in.)

128, 129. Bookshelf pictures (four panels of eight-panel screen), paper, 19th century, each panel 50.2 × 119.4 cm. (19.8 × 47 in.)

130. Bookshelf pictures (eight-panel screen), paper, 18th century, each panel 35.6 × 145.6 cm. (14 × 57.3 in.)

131–138. Letter pictures (eight-panel screen), paper, 20th century, each panel 42 × 75 cm. (16.5 × 29.5 in.)

139–142. Letter pictures (four panels of eight-panel screen), paper, 19th century, each panel 27 × 60.5 cm. (10.6 × 23.8 in.)

143–147. Letter pictures (five of set of six), paper, 19th century, each 33 × 69 cm. (13 × 27.2 in.)

148. Letter picture (one of set of five), paper, 20th century, 40.3 × 65 cm. (15.8 × 25.6 in.)

149–156. Letter pictures (eight-panel screen), paper, 18th century, each panel 42.2 × 74.2 cm. (16.6 × 29.2 in.)

Acknowledgments

The authors wish to express their gratitude to the many people involved in this complex project.

Shoichiro Shuwachi was the driving force behind the original Japanese version and was the overall producer. It was his enthusiasm and support that made this book a reality. Hiroshi Mizuo was a key editorial advisor.

In producing the English-language version, the editors and translator were required to grapple not only with English but Korean, Chinese, and Japanese words and customs, surely an editor's nightmare. For their efforts in the face of this onslaught, we are indebted to Yuzo Tazawa, Shigeyoshi Suzuki, and Barry Lancet at Kodansha International and to Eiichi Tsunoda and Yutaka Tamura, who smoothed the way over troubled waters. Our especial thanks also goes out to John Bester for managing the translation with aplomb, to Beverly Nelson for long hours spent in clarifying Korean customs and language, and to Bruce Carpenter for assisting with the Chinese-language terms.

Design duties were handled with admirable skill by Shigeo Katakura and Yusaku Kamekura, who was also one of the editors of the original Japanese edition. Photography was left in the capable hands of Shoko Hashimoto and Mitsuhiro Nishimura.

We are also deeply grateful to Tsuyuko Nishi and House of House Japan (*sic*) for permission to publish the present volume.

This publication would not have been possible without the kindness and cooperation of the Korean and Japanese collectors, institutions, and organizations who generously allowed us to photograph their paintings, which are, of course, the very essence of this book. Therefore, we wish to extend our sincere gratitude to all of the following:

Hae-dong Chŏng
Hae-sŏk Chŏng
Emille Museum
Ho-am Misulgwan (museum)
Yusaku Kamekura
Kim Kok Pangmulgwan (museum)
Kurashiki Mingei-kan (museum)
Ok-yŏn Kwŏn
Sŏn-u Lee
U Fan Lee
Mashiko Sanko-kan (museum)
Pyŏng-yu Min
Minjok-ch'on Pangmulgwan (museum)
Musashino Bijutsu Daigaku (university)

Klaus Neumann
Nihon Mingei-kan (museum)
No-sŏng Pak
Chong-ha Pyŏn
Keisuke Serizawa
Tong-jin Shin
Sogetsu-kai
Yusaku Tawara
Tokyo Gallery
Un-hyang Misulgwan (museum)
Sogen Yanagi
Masue Yasukawa
Keisuke Yoshida